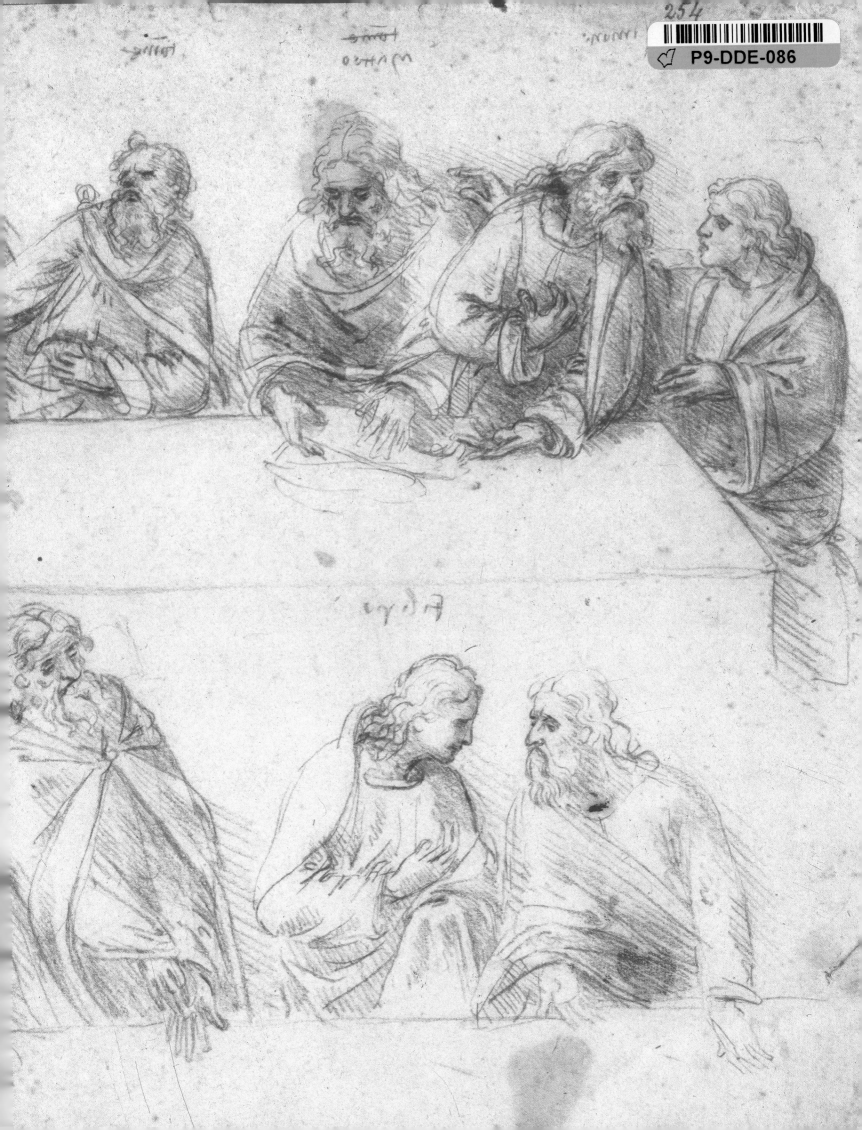

THE SECRET LANGUAGE OF THE
RENAISSANCE

Decoding the Hidden Symbolism of Italian Art

Richard Stemp

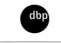

DUNCAN BAIRD PUBLISHERS
LONDON

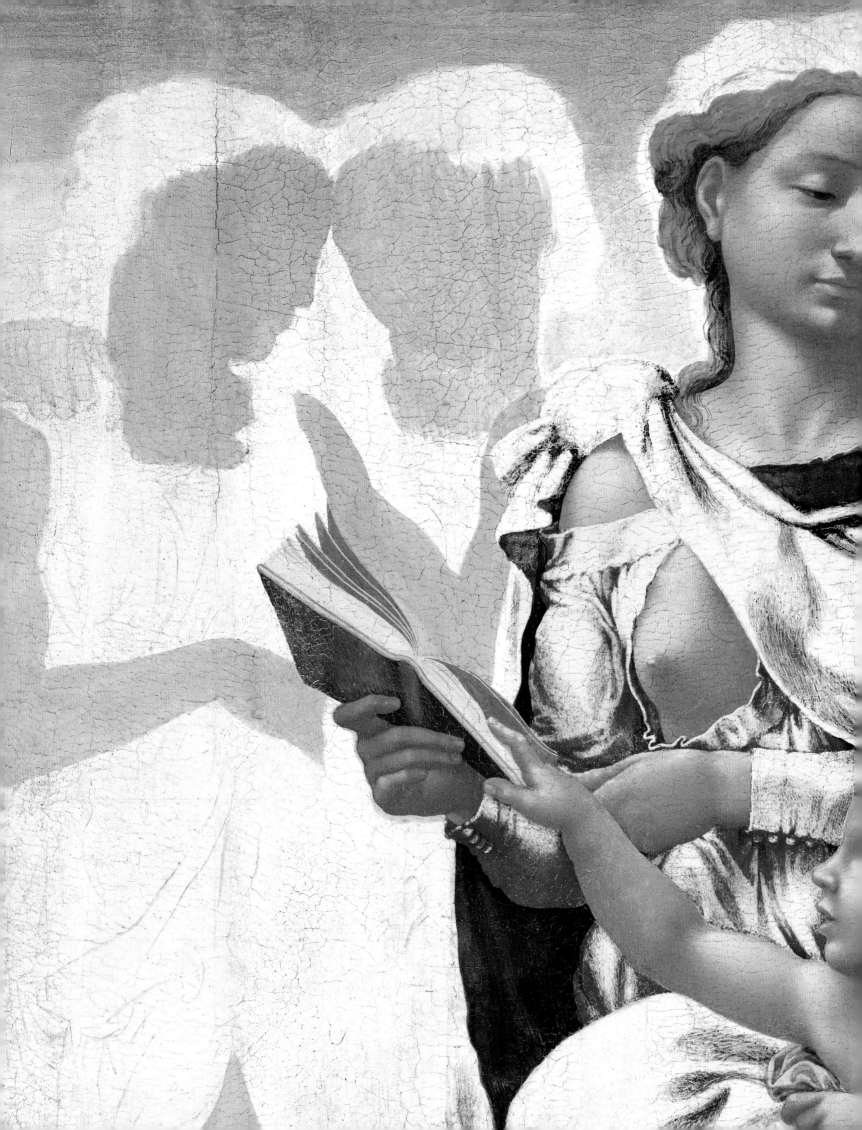

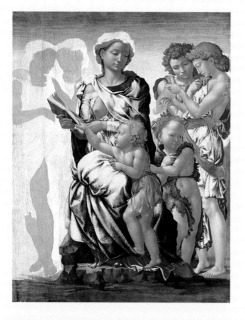

**⬙ MADONNA AND CHILD
(THE "MANCHESTER MADONNA")**
Michelangelo, ca. 1497 (NATIONAL GALLERY, LONDON)

Michelangelo's genius was such that his ideas out-
stripped the time he had to execute them, and many
of his works, such as this one, remain unfinished.
This allows us to see the process of creation. Painted
on a wooden panel, the surface would first have been
covered with a smooth layer of white gesso (gypsum,
or calcium sulphate), visible in the figures on the left
(see detail, pages 2–3). An underdrawing (also visible
on the left) would follow, and the flesh areas prepared
with a green pigment known as *terra verde*, or "green
earth". The Madonna's robe displays a new technique.
If it had been finished with expensive ultramarine, the
black and white areas would have looked like shadows
and highlights on the surface of the blue material.

**Endpapers:
STUDY FOR THE LAST SUPPER**
Leonardo da Vinci, ca. 1494 (ACCADEMIA, VENICE)

The Secret Language of the Renaissance
Richard Stemp

First published in the United Kingdom and Ireland in 2006
by Duncan Baird Publishers Ltd
Sixth Floor, Castle House
75–76 Wells Street
London W1T 3QH

Conceived, created and designed by Duncan Baird Publishers

Editor: James Hodgson
Designer: Allan Sommerville
Managing Editor: Christopher Westhorp
Managing Designer: Manisha Patel
Picture Researcher: Louise Glasson
Map: Gary Walton

Library of Congress Cataloging-in-Publication Data is available

10 9 8 7 6 5 4 3 2 1

ISBN-13: 9-781844-834136 ISBN-10: 1-84483-413-1

Typeset in Adobe Garamond (designed by Robert Slimbach based
on a High Renaissance model by Claude Garamond)

Color reproduction by Colourscan, Singapore
Printed and bound in Singapore

Dedication
*For my colleagues – and friends – at Art History Abroad and the
National Gallery. Let's have lunch!*

CONTENTS

INTRODUCTION

The artistic splendours of the Renaissance are universally admired, but in the twenty-first century they are not always easy to understand. The signs and symbols they contain, which were once part of everyday life, are now unfamiliar to us, and that is what this book aims to explain. With an increased understanding of the meaning of the paintings and sculptures, our admiration of them can only be enhanced.

"RENAISSANCE MAN"

Among the notions discussed by Burckhardt in his groundbreaking book was that of the *uomo universale*, or "Universal Man". The modern notion of a "Renaissance Man", someone who has achievements in many different fields, was derived from this. Burckhardt's model was Leon Battista Alberti, who believed that "Men can do all things if they will." Alberti, who was a painter and architect, was also said to excel in sports and music, law and mathematics, and wrote on subjects from painting, sculpture and architecture to family life. The most famous example of all is probably Leonardo da Vinci, who is well known as a painter, an engineer, and for his tireless investigation of the natural world and of the human body, but perhaps less so as a musician, sculptor and prankster, and as a designer of fancy-dress costumes and bizarre animated models. But any well-educated man of the time was expected to excel in any number of disciplines, and Baldassare Castiglione's *Book of the Courtier*, published in 1528, discusses the achievements that the ideal man should have. Not only should these include knowledge of a wide variety of subjects, and the ability to discuss them, but he should also be skilled in practical matters such as music, sports, warfare, painting and writing. Above all, he should be able to do all of this with apparent ease, a notion Castiglione expressed with the word *sprezzatura* – a lightness of touch that implies that such accomplishments come naturally.

The meaning of the term "Renaissance" is open to any number of different interpretations, and any historian or art historian you ask is likely to give a different definition. The word itself – the French for "rebirth" – is not in dispute, but the terms of reference are. This is partly because it was not a concept known to the artists and writers of the time. In fact it didn't become a common term until the end of the nineteenth century, after the Swiss historian Jacob Burckhardt (1818–1897) wrote *Die Kultur der Renaissance in Italien* in 1860, translated into English in 1878 as *The Civilization of the Renaissance in Italy* – the use of the French word was therefore popularized by a German speaker, albeit one from a country in which French is one of the official languages. The Renaissance was, after all, a phenomenon that was felt throughout Europe, even though this book, like that of Burckhardt, restricts itself to Italy. Although not a unified whole politically, and diverse artistically across the peninsula, Italian art nevertheless forms a body of work that stems from the same basic ethos, and that can be distinguished from the aims, techniques and meanings conveyed by works north of the Alps – even if northern European art did prove to be one of the greatest influences on Italian painting in the fifteenth century.

As well as limiting the geographical range that will be discussed, the book restricts the time span that is considered. There is much debate about what period the Renaissance covers. Some of its most characteristic traits, such as an interest in – and reliance upon – the art of the classical past, can actually be seen in works of art as early as the thirteenth century (notably in the sculpture of Nicola Pisano in the mid-1200s), and the realistic depiction of space and strong sense of humanity is clearly visible in the paintings of Giotto from the early fourteenth century. Much of the ideology behind the Renaissance is embodied in literature from the fourteenth century, although most authorities would accept

Alberti: *see page 15;* **Giotto:** *see pages 16–17;* **northern European painting:** *see page 18;* **Nicola Pisano:** *see page 22*

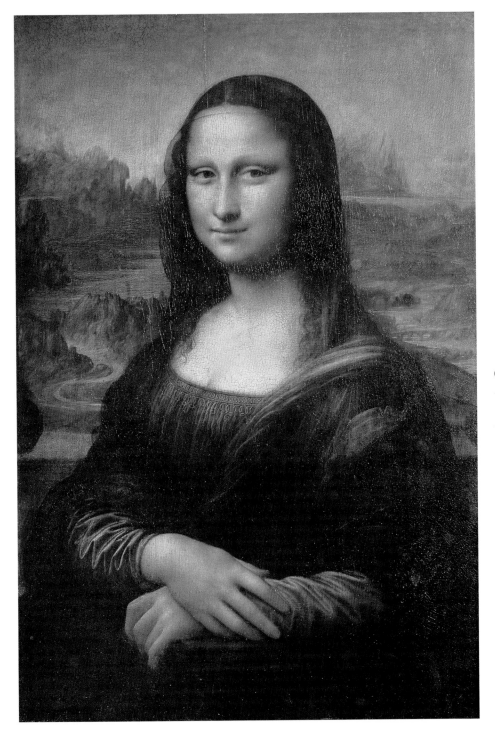

◐ MONA LISA
Leonardo da Vinci, ca. 1503–1513
(LOUVRE, PARIS)

To many people, the mystery of the *Mona Lisa* is why it is so famous rather than the identity of the woman it depicts. Originally untitled, it became known as *La Gioconda* ("the cheerful woman"), and gained its better-known name through a corruption of Vasari's *Monna Lisa*, or "Lady Lisa", referring to the name of the sitter (see main text). Acquired by the French king Francis I after Leonardo entered his service, it later adorned the bedroom of Napoleon, has been stolen, and even attacked with acid. In 1893 it was the subject of a lengthy panegyric by art historian Walter Pater, which included the poetic assertion that "She is older than the rocks among which she sits; like the vampire, she has been dead many times, and learned the secrets of the grave." Such fame – or notoriety – rarely dies.

that its full flowering, and its expression in the visual arts, did not occur until the fifteenth century. By the middle of the sixteenth century, the impact of the Reformation on the Catholic Church, and upon Italian life and culture generally, meant that the nature and purpose of the arts were changing, and consequently this book includes very few works that date from after 1550, the lion's share coming from the preceding 150 years.

The art of the Renaissance includes some of the world's most famous imagery, which gains its power from the exploration of new ideas and the rediscovery of the old. Artists moved away from the presentation of a symbolic realm to the depiction of the world in which we live and breathe. As a prime example of this, one of Leonardo da Vinci's achievements in the *Mona Lisa* (see above) is not only the imaginative, and yet real, landscape that surrounds the subject, but

Reformation: *see pages 128 and 134*

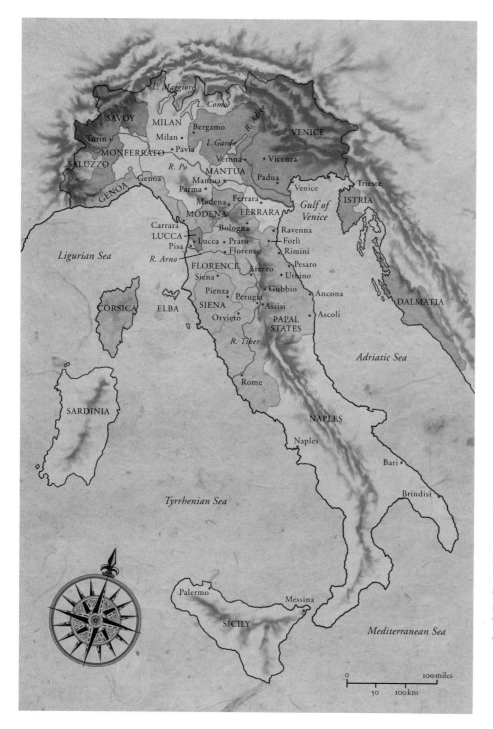

◐ **MAP OF THE ITALIAN STATES**
at the end of the 15th century

The boundaries of the city-states of the Italian peninsula changed throughout the Renaissance: this map shows the situation at the end of the 15th century. The three most important artistic centres, the cities of Venice, Florence and Rome, were in control of three of the larger regions, although geographical size was not necessarily related to artistic production: Naples and Milan, although both important courts, had a lower proportion of notable artists, particularly if we discount Leonardo da Vinci from the latter. The duchies of Modena and Ferrara were both ruled by the Este family, with their rule dependent on the Holy Roman Emperor and the pope respectively: when the family fell out of favour with the pope at the end of the 16th century, the Este were forced to retreat to one part of their realm, the duchy of Modena, and many of their artistic treasures (including Titian's *Bacchus and Ariadne*; see page 153) were appropriated and dispersed.

also the sense that the painting is united by a single atmosphere – that she breathes the same air that blows over the distant mountains. The discovery of the landscape was one of the themes picked out by Burckhardt, who also looked at the growing interest in the individual, expressed artistically in the development of portraiture, which was the preferred way for the new merchant classes to record their wealth and status. Renaissance artists knew of classical references to painted portraits, but no examples were known at the time; sculptural busts of the ancient Romans, however, were numerous, and hugely influential. Again, the *Mona Lisa* embodies this tendency. Although for years her identification has been disputed, recent documentary evidence confirms that she is, as the artist and writer Giorgio Vasari suggested in the sixteenth century, Lisa Gherardini, the wife of a wealthy silk merchant, Francesco del Giocondo. The economic power of many cities

the Este: *see page 174;* **landscape painting:** *see pages 70–73;* **portraiture:** *see page 88;* **rivalry between pope and Holy Roman Emperor:** *see page 174;* **Vasari:** *see pages 15 and 16;* **Venice:** *see pages 176–177*

◉ DAVID
Michelangelo, 1504 (BARGELLO, FLORENCE)

The "David", as Michelangelo's sculpture is often known, was never intended to be an independent work of art: the sculpture should have been erected high on the roof of Florence's cathedral. However, the beauty of the finished work was considered such that it should remain in full view and a committee, including Leonardo da Vinci and Sandro Botticelli, was set up to decide where it should go.

– and notably Florence – owed much to the grouping of such merchants and craftsmen into guilds, and the patronage of these guilds was just as important as that of individuals such as Francesco del Giocondo, if not more so.

But, above all, the interest in the individual expresses the way in which humankind became in itself a subject worthy of study, in terms of the way in which people live, where they live, how they feel, how they react, and, especially, what they look like. This sense of the nobility of the human spirit, and of the human form, is perfectly expressed in Michelangelo's *David* (see right). The sculpture is also a typical product of the Renaissance in that it was not produced as a work of art in its own right, but was intended to be part of a decorative scheme, the meaning of which was inextricably bound up with the location for which it was made.

Unlike other introductions to the Renaissance, this book will not present the art through a chronological survey, but will break it down thematically. We will look at different aspects and elements of the artistic production of Italy over roughly two and a half centuries to give you the tools to enable you to analyze and decode countless other works not included here. Part One includes introductions to the different forms of artistic production: literature, painting, sculpture, architecture and the decorative arts. Part Two looks at single elements of each work – such as light and colour – to build up a vocabulary of symbols and meanings that are perhaps not obvious to us today. Having become familiar with the language of Renaissance art, in Part Three we explore broader themes, and analyze some of the richer and more complex creations of the period, allowing these inspiring works to reveal their secrets.

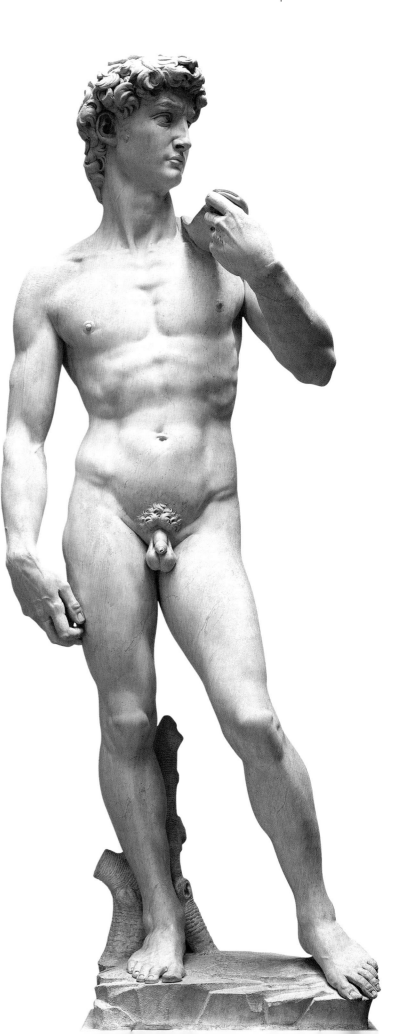

David: *see pages 98–100;* **guilds:** *see pages 182–183;* **patronage:** *see pages 82–85*

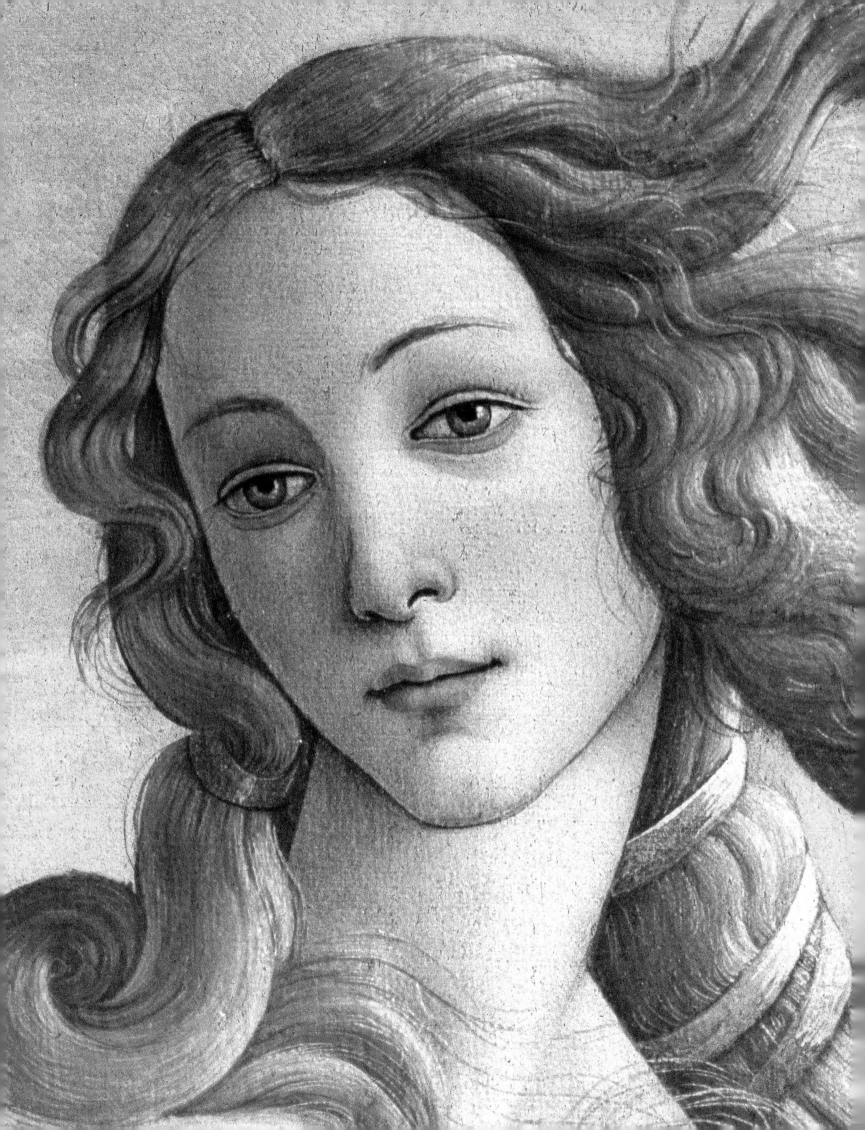

NEW ART
FROM
OLD IDEAS

PART ONE

The revival of interest in classical culture, learning and mythology that was to be so influential in all areas of Renaissance creativity is seen first in the literature of the fourteenth century. Consequently, this part of the book begins with an introduction to those great authors – Dante, Petrarch and Boccaccio – whose work preceded and informed the Renaissance, as well as considering how literature of the period charted changing attitudes to art. We then trace the developments that occurred within each of the principal fields of the visual arts, starting with painting, which evolved through complex crosscurrents of styles and influences. Architecture and sculpture, too, went through their own revolutions, many of the changes being influenced by the Roman artefacts and ruins still visible across the Italian states. Finally, we look at the decorative arts. The Renaissance paintings that we admire today in museums were originally created as interior decoration: art galleries as we know them simply did not exist at that time, and the artistic production of the period extended beyond painting and sculpture to include all aspects of daily living.

◀ BIRTH OF VENUS (detail)
Sandro Botticelli, ca. 1485 (UFFIZI, FLORENCE)

The face of Venus gazing languidly from Botticelli's painting is so familiar that we often do not stop to question where the artist found his inspiration. While the subject of the work derived from the Roman narrative of the Greek myth about the origins of Aphrodite (the Greek deity with whom the Romans equated Venus), Botticelli's depiction of the goddess was, in fact, inspired by a classical sculptural pose, the *Venus pudica*, or "modest Venus". (See full painting, page 21.)

LITERATURE

"Cimabue thought he held the field in painting, but now everyone talks of Giotto, and the former's fame is obscured."

Dante, *Purgatorio*, canto xi, verse 95

It may seem odd to start a book on the visual arts with a section on literature, but the fact is that many of the interests we associate with the Renaissance are seen first in the work of three notable writers of the fourteenth century: Dante Alighieri, Francesco Petrarca and Giovanni Boccaccio. The first of these, Dante Alighieri (1265–1321), was a contemporary of the artist Giotto di Bondone (ca. 1267–1337), and they may well have been friends. Dante's reference to Giotto has often been misinterpreted as implying that Giotto was a better artist than Cimabue, suggesting an idea of progression within the arts, which can be seen as part of the Renaissance ideal. However, the verse in question occurs in the context of a discussion on fame, and is spoken by a recently deceased poet who is warning Dante that worldly glory does not last. This has a double irony: first, because Dante's own renown has not decreased, and second, because by citing these two artists Dante crystallized their reputations in one of the most important works of Italian literature. To this day many surveys of Italian art history start with Cimabue and Giotto.

The quotation comes from Dante's *Divine Comedy*, an extensive poem set out in three books, which describes the afterlife. The poet talks of having lost his way, effectively a form of mid-life crisis, and is guided first through hell, then purgatory, and finally through heaven. Each book has thirty-three sections, or cantos – with an additional introductory canto this makes a total of one hundred. In this way Dante conveys a sense of symmetry, structure and order that would become central to Renaissance art. Rather than being written in Latin, which was traditional for all forms of writing, the poem was composed in Italian. Shortly before writing the *Divine Comedy*, Dante had started work on *De Vulgari Eloquentia*, an exploration of the use of the vernacular. He believed that our natural language – the one we learn as a child – was the most direct and noble way of expressing ourselves. This ideal has parallels in the Renaissance interest in depicting the world with which we are all familiar.

Francesco Petrarca (1304–1374), or Petrarch, trained initially as a lawyer and later served as an ambassador. His journeys around Europe allowed him to search for lost works of classical literature. As well as discovering some of Cicero's letters, he also commissioned a Latin translation of the works of Homer. Cicero was particularly important, as he was seen as the best model for eloquence – the appropriate use of language. In the fifteenth century this would influence the writer Leon Battista Alberti, whose treatise *On Painting* stressed the appropriate use of imagery, thus encouraging a pictorial form of eloquence. From Cicero Petrarch also derived many of his ideas on philosophy, combining these with the writings of St Augustine to explore man's responsibility for his own salvation. This combination of classical and Christian thought was at the root of humanism, an influential intellectual movement of the Renaissance which emphasized the dignity of humanity and the importance of a moral philosophy based on human experience.

Petrarch's own writings in Latin included versions of classical history and biographies of famous men of antiquity – using these as moral exemplars for his contemporaries – but he was equally known for his poetry in the vernacular. He is also credited, perhaps anachronistically, with inventing mountaineering, having described an ascent of Mont Ventoux that he made in 1336. The idea of climbing a mountain just for the experience was entirely new, and can be seen as a precursor of the Renaissance interest in exploring and understanding (and, ultimately, depicting) the world around us.

A contemporary and friend of Petrarch, Giovanni Boccaccio (1313–1375) was also destined for a career in law,

Alberti: *see page 15;* **St Augustine:** *see pages 104 and 172–173;* **Cimabue:** *see page 16;* **combining classical and Christian:** *see pages 20 and 68;* **Giotto:** *see pages 16–17;* **landscape painting:** *see pages 70–73;* **symmetry and harmony:** *see pages 58–61, 137 and 146*

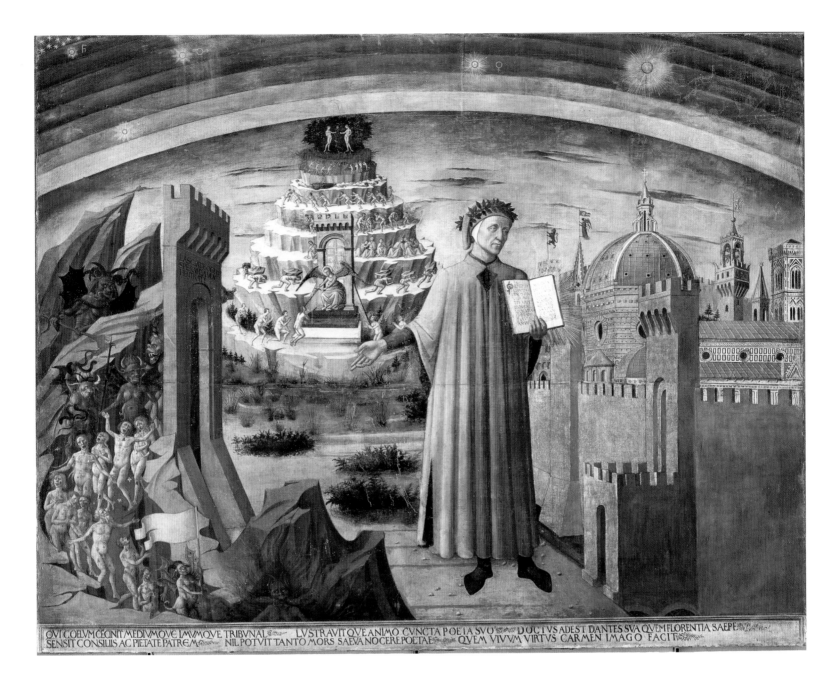

QVI COELVM CECINIT MEDIVMQVE IMVMQVE TRIBVNAL · LVSTRAVITQVE ANIMO CVNCTA POETA SVO · DOCTVS ADEST DANTES SVA QVEM FLORENTIA SAEPE · SENSIT CONSILIIS AC PIETATE PATREM · NIL POTVIT TANTO MORS SAEVA NOCERE POETAE · QVEM VIVVM VIRTVS CARMEN IMAGO FACIT ·

but went against his family's wishes and became a writer. He too wrote in both Latin and the vernacular, his writings including the *Genealogy of the Pagan Gods*, which remained essential for the study of classical mythology for several centuries. His most famous work, the *Decameron*, was set in 1348 during the Black Death. Seven women and three men escape plague-ravaged Florence and on each of ten days everyone tells a story – making one hundred stories altogether. Six of these are about artists, including one in which Boccaccio discusses the realism of Giotto's painting, and the artist's fame. The stories are grounded in reality and concerned with the emotions and experiences of normal people. They deal with illicit love affairs, badly behaved priests, abuses of authority,

◯ **DANTE HOLDING A COPY OF THE** *DIVINE COMEDY*,
Domenico di Michelino, 1465 (MUSEO DEL DUOMO, FLORENCE)

Dante was born in Florence in 1265. A prominent member of a political faction called the White Guelphs, he was driven from the city in 1302 when a rival group, the Black Guelphs, came to power. He spent the rest of his life in exile. In later years the Florentines regretted this, and have always proudly claimed Dante as their own. This painting shows the poet outside the city walls, holding a copy of the *Divine Comedy* and pointing to an illustration of his ideas. At the bottom left condemned souls are led down to hell, while over his shoulder others struggle up the hill of purgatory. Arching across the sky is the vault of heaven, with the sun, moon and planets in their respective spheres.

Black Death: *see page 16;* **Florence cathedral:** *see pages 26–27;* **heaven and Earth:** *see pages 136–143*

○ *IL FILOCOLO* BY GIOVANNI BOCCACCIO
ca. 1460 (BODLEIAN LIBRARY, OXFORD)

Before the age of printing, any literary work had to be written out by hand, as a manuscript (see above). However, printing enabled numerous copies of the same text to be produced in a fraction of the time. Although expensive, books became available to a far wider range of collectors. The first printing presses in Venice were installed by 1469, and two years later the first book in Florence was printed. Not only did this new technology make the works of classical authors more readily available, but new ideas – the concepts on which the Renaissance was based – could also be circulated more widely and rapidly.

and above all the human ability to cope with a diverse range of problems. In the context of the plague, in which the normal rules of society were rendered irrelevant by the enormous death toll, people had to seek solutions to their own problems, and the authority of Church and state was undermined. It is hardly surprising that Boccaccio was not always popular with these authorities, and preachers such as Bernardino of Siena tried on several occasions in the fifteenth century to have his books banned.

In contrast to the fourteenth century, the fifteenth has been described as the "century without poetry" – poems were written, including some by people as notable as Lorenzo de' Medici and his friend Luigi Pulci, but there are no claims for these as great literature. It was not until the sixteenth century that authors such as Ludovico Ariosto (1474–1533) and Torquato Tasso (1544–1595) wrote epic poetry that would – like the works of their fourteenth-century predecessors – influence the artists of later generations.

Words and Pictures

Renaissance literature is important not only in its own right but also for what it tells us about art. The development of the Renaissance can be economically illustrated with reference to three works: a practical manual, a theoretical treatise with practical applications, and a history. The first, dating from the end of the fourteenth century, was written by Cennino Cennini (ca. 1370–ca. 1440), an artist who had trained with Agnolo Gaddi, whose father had been a pupil of Giotto: it can be seen as the summation of the practical experience that these master craftsmen had developed over the decades. Called *Il Libro dell'Arte*, or "The Craftsman's Handbook", it describes in detail how to paint, from the creation of the wooden panel and the preparation of the paints, to the application of gold leaf, of the paint, and finally of the protective varnish. He also explains how to paint in fresco, how to make brushes, and how to prepare paper for drawing. In addition to the practical advice, the book is interspersed with prayers to ensure that the work is carried out well, and

Bernardino of Siena: *see page 41;* **gold:** *see page 48;* **Lorenzo "the Magnificent" de' Medici:** *see pages 198–199;* **Luigi Pulci:** *see page 199*

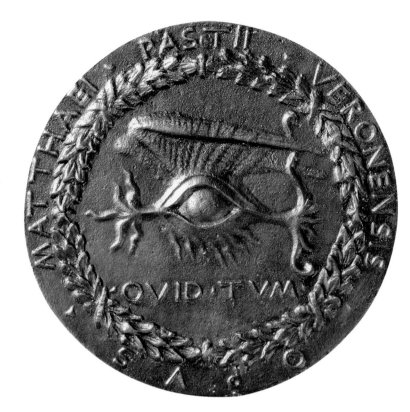

◉ MEDAL OF LEON BATTISTA ALBERTI (reverse)
Matteo de' Pasti, ca. 1450 (RIMINI)

The portrait medal was one of the innovations of the Renaissance. One side carried a portrait, which showed what the subject looked like. The other (see right) carried the emblem, or *impresa*, which revealed something about the person's character. The motto, "Quid tum", can be translated as "what next?" – perhaps alluding to Alberti's continuing quest for knowledge (his books include writings on painting, sculpture, building, ancient ships, oratory, horses and even the family). However, it can also be translated as "so what?", and may proclaim indifference to his own illegitimacy, a considerable social stigma in the 15th century, which he had managed to overcome. Alberti probably intended both meanings. The winged eye can be seen either as the eye of God, or of Alberti himself, moving with speed across the artistic concerns of the period.

solemn advice about clean living: for example, dallying with women could result in an unsteady hand.

If Cennini's book is almost entirely practical, instructing the artists how to paint, in 1435 Leon Battista Alberti (1404–1472) wrote a book called *De Pictura* ("On Painting"), telling them what to paint and why. As well as being an intellectual analysis of what painting is, it also suggests what it should be. Written in Latin, it was soon translated into Italian (*Della Pittura*) for the sake of the artists.

Several of his statements are fundamental to an understanding of the Renaissance. Among these is his assertion that when he paints he starts by drawing a rectangle, "which is considered to be an open window through which I see what I want to paint". This is the first statement that art is a realistic view of the world in which we live. He also says that, "man is the measure and mode of all things", thus placing humankind at the centre of the universe, the starting point for our observation and understanding of the world around us. Making man the subject of study, rather than God, has been seen by many as the essential break between the medieval and Renaissance worlds.

Alberti's main aim was to emphasize that everything the artist does must be focused on making his painting clearer, on telling the *istoria* ("story") as well and as appropriately as possible. He also advises the artist on what sort of stories to depict: those with a pleasing variety would impress the viewer with the artist's inventiveness, for example. He recommends including a figure to introduce the viewer to what is going on, a bit like the chorus in a Greek tragedy, in order to make the *istoria* more immediate. The implication is that artists are not just normal craftsmen – the book suggests they can use their minds as well as their hands – and also that some can be better than others.

In the middle of the sixteenth century, Giorgio Vasari (1511–1574) – himself an artist and architect – wrote *Le Vite de Più Eccelenti Architetti, Pittori, et Scultori* ("Lives of the Most Excellent Architects, Painters and Sculptors"). The development embodied by Alberti was effectively complete. Whereas Cennini was describing how to paint, and Alberti was advising on the nature of art, Vasari makes the artists the subject. Their status is increased to the extent that they are themselves worthy of study.

imprese: see pages 40 and 42–43

PAINTING

By writing the *Lives of the Artists*, Vasari effectively invented art history, and his schema for the development of art in the Renaissance is one that can still be helpful today, even if it is an oversimplification. He suggested that after the fall of the Roman Empire the arts fell into decline, and only gradually did things improve. The earliest artists he discusses he does not consider to be particularly good, even if better than those who came before. Then there was a second group of artists whom he thought able to create works as good as nature, and a final group, leading up to Vasari's own time, who even exceeded nature in their skill and invention. These three stages roughly correspond to the more modern labels "Gothic", "Early Renaissance" and "High Renaissance". Vasari was aware that some artists did not fit into such a clear-cut definition, and he was unsure where to include certain artists he considered to be particularly good. Another problem is that the arts progressed along different paths in different parts of Italy, and even in the same city more than one style might have been current at any one time.

The first artist discussed by Vasari was Cimabue (ca. 1240–1302) – perhaps having been inspired by Dante's mention of him. He is the first "named" artist to be considered to have broken away from the traditions of Byzantine icon painting, which was flat and formalized (a style sometimes described as "hieratic"). Cimabue's followers took these developments in new directions. Giotto, whose influence was felt most in Florence, developed a remarkably realistic form of painting. Although single-point perspective, as we understand it, was not developed until the fifteenth century, he had a very clear understanding of spatial representation. This is particularly clear in his painting of the *Last Supper* (see opposite), in which the apostles are grouped on both sides of the table, and we can see the legs of those closest to us in the darkened space under the bench. They also have a sense of weight and breadth that is unprecedented – notice the way their bottoms spread across the bench – and there is a strong sense of humanity in the relationship between the characters. Nevertheless, the realism is undermined to a certain extent by their haloes. As symbols of the apostles' holiness, they also make the heads stand out, although they do appear to be directly in front of the faces of the apostles on our side of the table. Jesus' status is made clear by his position at the head of the table, and his halo is enhanced with gold leaf. For the apostles, on the other hand, Giotto used silver leaf, which has tarnished and now looks black.

The followers of Giotto in Florence continued to paint in a broad figure style, whereas in Siena artists were far more influenced by another follower of Cimabue, Duccio di Buoninsegna (before 1278–1319), whose style was more fluid, with supple figures and elongated, flowing forms. In contrast, Venetian painting in the fourteenth century – and, indeed, the fifteenth – continued to be strongly influenced by Byzantine traditions, as the city had strong trade links eastward across the Mediterranean, and effectively controlled Constantinople, the Byzantine capital, until 1453.

In Siena and Florence a major change in style occurred after 1348, the year of the Black Death (see box, left). Some of

THE BLACK DEATH
One of the most destructive epidemics in human history, the Black Death interrupted progress in all aspects of the burgeoning Renaissance, not least the arts. The plague is believed to have been carried to Europe from Asia by rats on merchant galleys that landed at Messina, Sicily, in 1347. The most lethal outbreak occurred the following year, with crowded cities providing the best conditions for the disease to spread. Florence was particularly badly hit: the city's pre-plague population of up to 100,000 was reduced at one point to 30,000.

Dante: *see pages 12 and 13;* **perspective:** *see page 52–55*

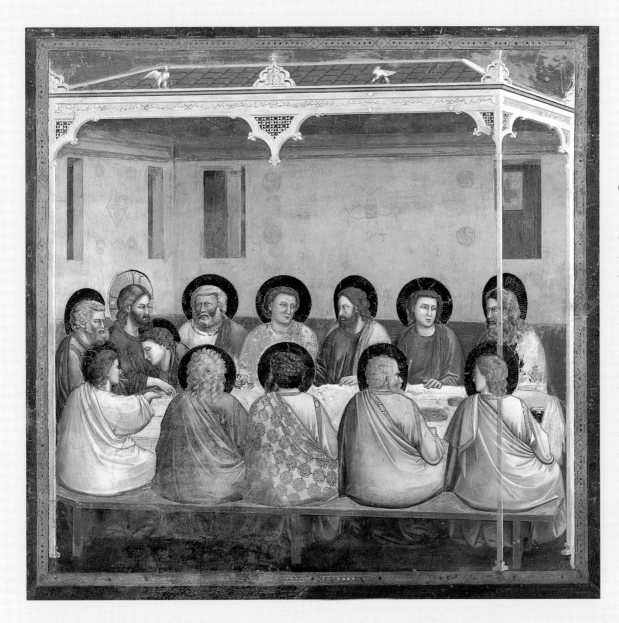

◀ **LAST SUPPER**
Giotto di Bondone, ca. 1303–1305 (SCROVEGNI CHAPEL, PADUA)

The Scrovegni Chapel was commissioned by the Paduan banker Enrico Scrovegni to atone for the misdeeds of his father Reginaldo – notably usury, the practice of charging interest on loans, which was considered a sin. Enrico engaged Giotto to decorate the chapel with scenes from the life of the Virgin and the life and passion of Christ. The cycle culminates in a *Last Judgment* (see page 63) which covers the entire entrance wall.

the progress toward realism was curtailed, and art returned to a more stylized form. Many works were designed to affirm the authority of the Church: it is as if the Black Death was considered a punishment from God, in response to which art would show the path to salvation. This is certainly the case for Andrea Bonaiuti's *Triumph of the Church* (see pages 130–131).

By the end of the fourteenth century, a more relaxed and florid style had entered Italy. Examples could be found across Europe, and as a result it is sometimes known as the International Style. Paintings and sculptures show an interest in highly realistic details, although the spatial construction of the works is not necessarily coherent. There is often a use of rich colours and materials, and an interest in elaborate and decorative line: Gentile da Fabriano's *Adoration of the Magi*

(see pages 70–71) is one of the best examples. However, in Florence this style coexisted with the new developments of Masaccio, who took the solidity, breadth and spatial awareness of Giotto and added to it the newly rationalized system of perspective developed by Brunelleschi, and a more coherent use of light, thereby creating a solid reality within his paintings. Later artists were influenced by both trends. In his *Annunciation* (see pages 90–91), for example, Filippo Lippi deploys Masaccio's rational use of space and lighting for the Virgin's house, whereas the plants around the angel, and the angel's wings show Gentile's realism of natural detail and richness of materials. Some artists sought a synthesis of these ideas, developing a style which was realistic, and yet ordered, balanced and harmonious. Paintings such as Antonio and

Brunelleschi: *see page 26;* **Last Supper:** *see pages 122–123 and 134;* **light and shade:** *see pages 48–51;* **realism:** *see pages 70–73;* **symmetry and harmony:** *see pages 58–61, 137 and 146*

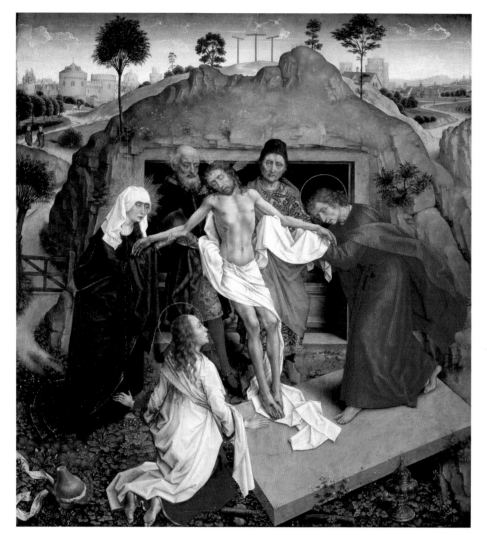

◀ **ENTOMBMENT**
Rogier van der Weyden, 1450
(UFFIZI, FLORENCE)

Northern European painting was one of the greatest influences on Italian painting in the 15th century. Medieval and Early Renaissance artists in the Italian states painted with egg tempera. Although oil paint was known, and used occasionally to create specific effects, it was in the north of Europe that the technique was perfected; Italian artists gradually adopted oil painting in the second half of the century. The works of artists such as Rogier van der Weyden were prized for the realistic effects of light and texture and the naturalistic details of landscape that oil painting allowed them to achieve. Rather than the idealized forms painted by the Italians, the northern artists painted each individual surface with loving attention to detail, and depicted "real" faces, with wrinkles, receding hairlines and in some cases even "warts and all". Leonardo da Vinci clearly knew this painting, as the pose of the kneeling Magdalene, with the veil hanging over her right arm, is clearly the basis for the angel he painted in Verrocchio's *Baptism* (see opposite). Influences went both ways: Rogier took the rectangular opening of Christ's tomb from a painting by the Florentine artist Fra Angelico.

Piero del Pollaiuolo's *Martyrdom of St Sebastian* (see page 60) or Raphael's "Mond Crucifixion" (see page 89) are the apotheosis of this trend, and are among the works considered to be on the boundary between Vasari's second and third groups of artists, or the Early and High Renaissance.

Collaboration and Inspiration

Most pieces of art created during the Renaissance were, in some way, collaborative productions rather than the work of a single artist. Apart from the carpenters who would be responsible for the construction of the wooden panels and frames, there were also goldsmiths who would apply and pattern the elaborate gold decoration, although this became less important as the Renaissance developed. However, even the act of painting itself was also collaborative.

In the Middle Ages painting was seen as a craft, and an artist was required to go through an apprenticeship in the same way that a stonemason, ironmonger or silk-weaver would. The apprentice would learn from and work with an established master: Cennino Cennini claimed that he trained with Agnolo Gaddi for twelve years. The pupil would learn to draw, handle the materials and paint exactly as the master did, in such a way that exactly the same style resulted. Thus large or complicated works could be executed

Cennini: *see pages 14–15;* **landscape painting:** *see pages 70–73;* **Mary Magdalene:** *see pages 88–89 and 108*

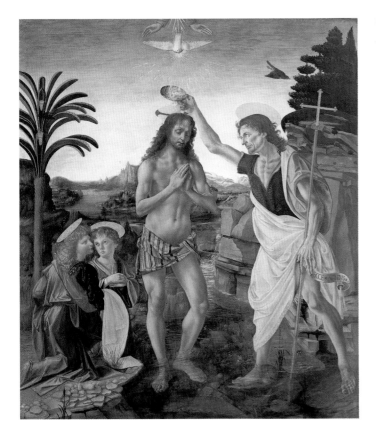

◄ **BAPTISM**
Andrea del Verrocchio and Leonardo da Vinci, ca. 1472
(UFFIZI, FLORENCE)

by a workshop without there being any noticeable inconsistency in quality or style. Nevertheless, contracts for paintings might specify that the master himself must paint certain parts of the painting – the most important characters, for example, or all of the faces. Once trained, an artist could set up as an independent master, at which point he would inevitably develop his own style.

Particularly active workshops might not rely solely on the apprentices, but could employ assistants who were themselves fully trained. This seems to be the case in the *Baptism* (see above), which was commissioned from Andrea del Verrocchio's workshop. It is clearly a collaborative work, and appears never to have been finished. The hands of God the Father releasing the Holy Spirit at the top of the painting were added by a particularly inept artist. The palm tree on the left is also crudely executed, and is a remarkable contrast to the subtle and atmospheric background of the painting, and to the delicate observation of reflection and transparency

in the water around Christ's feet. Even the faces of the two kneeling angels are different. That on the right is usually attributed to Verrocchio, whereas the other has more delicate features, a softer, more powdery complexion and each hair appears to have been painted separately. This figure is usually attributed to Leonardo da Vinci, who also executed the beautifully observed background.

Writing in the sixteenth century, Vasari suggested that Leonardo had been working as Verrocchio's apprentice, but that on seeing the young man's work the master realized that he would never be as good, and so renounced painting in favour of sculpture. This explanation expresses the result, if not the motivation. According to one of his tax declarations, Verrocchio had trained as a goldsmith, but because there was no work, he had decided to work as a painter. Later his workshop became remarkably busy, and he was involved in numerous prestigious commissions for painting, sculpture and engineering – he erected the gilt-bronze ball on top of the dome of Florence cathedral, for example. In order to fulfil all the commissions he may have needed to take on extra assistants, and paintings from his workshop were executed by artists such as Lorenzo di Credi and Leonardo da Vinci. So, rather than an act of pique, as Vasari suggests, Verrocchio's career change seems far more pragmatic: if a master had an artist as skilled as Leonardo in his workshop, it would make sense to let him do the painting, while the master got on with the sculpture.

Mythology and Mannerism

Most surviving Early Renaissance paintings are religious, and there are two main explanations for this. The first is that the main reason to paint was to decorate churches, or to provide a focus for private devotion in the home. The second is that holy images were revered, and therefore carefully looked

Florence cathedral: *see pages 26–27;* **goldsmiths:** *see page 33;* **Holy Trinity:** *see page 96;* **Leonardo da Vinci:** *see page 6;* **Vasari:** *see pages 15 and 16;* **landscape painting:** *see pages 70–73;* **symmetry:** *see pages 60, 61, 137 and 146*

after. Any secular work, were it damaged, or considered old-fashioned, would have been discarded. However, as soon as artists began to be seen as interesting in their own right, then their works became collectable, and were more carefully looked after, regardless of the subject matter. So, more non-religious paintings, such as Paolo Uccello's *Rout of San Romano* (see page 193), survive from the 1430s onward.

The interest in the classical past quickly had an impact on painting. Not only were classical ruins used as the inspiration for the buildings that were depicted (as they were for contemporary architecture), but ancient sculptural forms were used as models for figures in paintings. For example, the *Venus pudica* (bashful, or modest, Venus) was used by Masaccio as the model of Eve being banished from the garden of Eden (see page 74), and also by Botticelli for his *Birth of Venus* (see opposite). The latter is also an example of another major development: as well as having a stylistic effect on the arts, classical influences were also felt in terms of subject matter, and as well as Christian stories artists started to illustrate episodes from classical, pagan mythology.

The depiction of myths created a new problem. When painting a "Baptism" or "Annunciation", artists could draw inspiration from the many preceding examples. But when Botticelli was asked to illustrate the Birth of Venus there were no precedents. He would have known what to paint only by referring to classical and contemporary literature. Very often the patrons, in this case the Medici family, would provide artists with the texts that they wanted to be illustrated, and artists may well also have discussed the subjects with humanist scholars working for the patrons. But this may not have helped Botticelli work out the composition. What he seems to have done is go back to religious art. A brief description of the painting, with a naked figure in the water in the centre, a figure on the right leaning over, and two characters with wings on the left, would also be a good summary of most paintings of the Baptism of Christ (compare it to the Verrocchio/Leonardo version on page 19, for example). If this is where Botticelli found his inspiration,

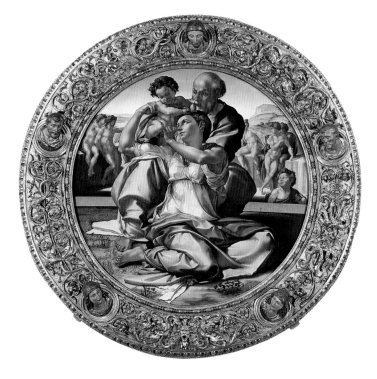

then rather than using classical forms to influence Christian imagery, he was using a Christian form for the depiction of a pagan myth: as with much of the art of the Renaissance, new forms were being derived from an old idea.

Nevertheless, Botticelli's style does not adhere to one of the major interests of the Early Renaissance, the accurate depiction of human anatomy. One of Venus's legs is longer than the other, her right ankle appears dislocated and her left shoulder has collapsed. At roughly the same time, Antonio del Pollaiuolo was capable of painting bodies with a more realistic articulation of the limbs, as he did in the *Martyrdom of St Sebastian* (see page 60). This is a reminder that not all artists share the same interests, even if they were working in the same city at the same time. Botticelli distorted his figures to pattern his painting with sinuous curves and elegant lines. Indeed, having learned how to paint figures in proportion, in perspective, and placed convincingly in a space in order to tell a story clearly, many artists aspired to be more "artistic". A genius such as Michelangelo could do this without the viewer noticing. Initially his *Holy Family* (see above) appears

Adam and Eve: *see page 120;* **anatomy:** *see page 74;* **the Medici:** *see pages 42, 186–187, 198–199 and 202;* **patronage:** *see pages 82–85;* **perspective:** *see pages 52–55;* **proportion:** *see pages 56–57;* **Venus:** *see page 114*

◖ HOLY FAMILY
Michelangelo, ca. 1504 (UFFIZI, FLORENCE)

Agnolo Doni, a wealthy Florentine banker, commissioned Michelangelo to paint this grouping of the Holy Family with the infant John the Baptist. For this reason, it is often known as the "Doni Tondo" (a *tondo* is a circular painting).

◗ BIRTH OF VENUS
Sandro Botticelli, ca. 1485 (UFFIZI, FLORENCE)

Venus was created when Uranus was castrated and his genitals fell into the sea, fertilizing the water. Here she is delicately balanced on a shell, and wafted ashore by the winds, with no hint of her violent origins.

to be a completely harmonious grouping of three figures, but on further investigation we realize that Joseph's right shin is the same length as Mary's torso: if the couple stood up he would be a couple of feet taller than her. Also, she is also not sitting in the most comfortable of positions, or taking the Christ Child from Joseph in the most practical manner. These elements, adding drama and tension to the image, are paralleled in a flamboyant use of colour and an exaggerated sense of perspective. In works by other artists these distortions are more obvious – for example, Bronzino's *Allegory with Venus and Cupid* (see pages 159–160). Known as the "maniera nuova" ("new style"), the Italian term gives us the English name: Mannerism. One of the expressions of the High Renaissance, Mannerism was an idiosyncratic style in which the artist's concern was to display his skill in manipulating the human form, colour, light and space for aesthetic rather than narrative reasons.

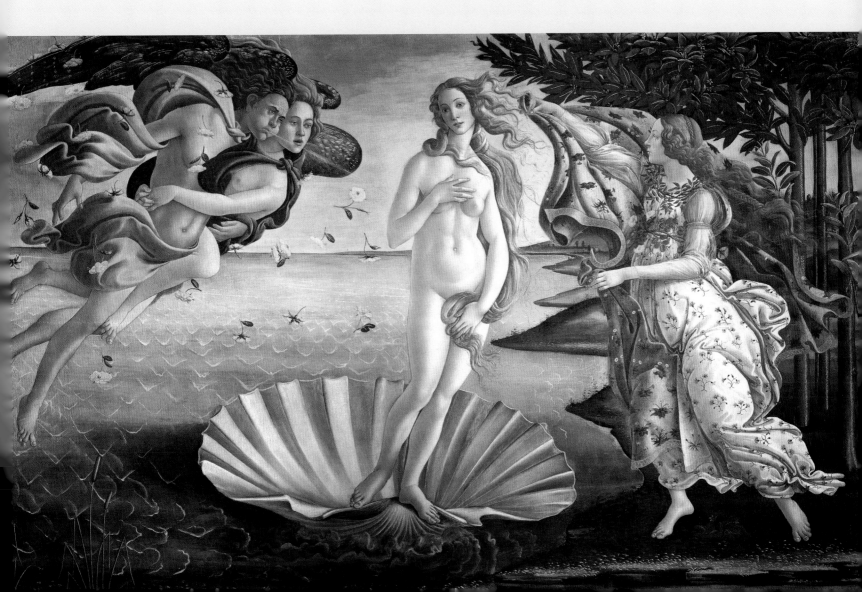

SCULPTURE

For various historical reasons, including the history of taste, the sculptural precursors of the Renaissance are not as famous in their field as, say, Giotto is in his, but if there is a sculptor who can be seen as equivalent, it would be Nicola Pisano (active 1258–1278). His main works are the pulpits in the Baptistery in Pisa (the city of his birth) and the cathedral in Siena, the latter executed in collaboration with his son Giovanni (ca. 1248–after 1314), who went on to carve a pulpit for Pisa cathedral. In these works there is a gradual development from a solid and broad monumentality, which Nicola learned from the classical sarcophagi that survive to this day in Pisa, to a fluid and expressive if angular Gothic style employed by Giovanni.

A third "Pisano", Andrea, was no relation, although he was also from Pisa. Andrea was responsible for the first phase of one of the most important sculptural projects of the Early Renaissance in Florence, casting the first of three sets of bronze doors for the Baptistery between 1330 and 1333. The reliefs depict the life of John the Baptist (the building is

effectively a church dedicated to him) in a series of twenty panels each with a quatrefoil (literally "four-leafed") frame. It was not until 1401 that a competition was held to determine who should make the next set of doors – a reasonably common procedure for determining which of the available craftsmen could best carry out a set commission. This competition involved making a test panel, with a subject chosen from the Old Testament. Two of these panels survive (see below) – by Filippo Brunelleschi (1377–1446), now better known as an architect, and Lorenzo Ghiberti (1378–1455), the sculptor eventually chosen to make the doors.

The nominated subject was the Sacrifice of Isaac. As an old man, Abraham was blessed with a son, seen as a gift from God. Within a few years, though, he was visited by an angel who asked, as proof of Abraham's love and devotion, for a

◐ **"SACRIFICE OF ISAAC" TEST PANELS**
Filippo Brunelleschi (left) and Lorenzo Ghiberti (right), 1401
(BARGELLO, FLORENCE)

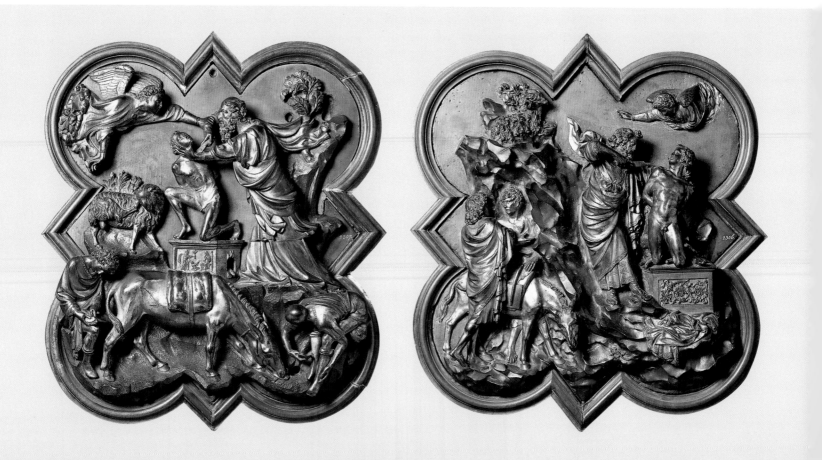

sacrifice – of his son Isaac. Abraham reluctantly prepared the sacrifice, taking the boy to the top of a hill, accompanied by two men and a donkey, but as he was about to strike, he was stopped by an angel who reassured him that his devotion would be rewarded, and told him to sacrifice instead a ram that was caught in a nearby bush. This story was considered important by Christians, because it tells of a father prepared to sacrifice his only son, in the same way that God would sacrifice his son Jesus for the sake of humankind.

Both of the surviving panels – there are known to have been five other "finalists" in the competition – include details that can seen as typical of the Renaissance. For example, both are interested in the classical past. The nude figure of Isaac in Ghiberti's version may have been inspired by the torso of an antique sculpture, and the foliage on the front of the altar is reminiscent of classical decoration. Brunelleschi uses an identifiable quotation: the man sitting at the bottom left of his relief, trying to remove a thorn from his foot, is a clothed version of a classical bronze figure known as the *spinario*. Both this, and the awkward posture of the man on the bottom right, demonstrate the artist's ability to depict the human form in complex poses, and the ram demonstrates his skill with naturalistic representation. Brunelleschi's telling of the story is physically dramatic: Abraham presses his thumb onto Isaac's neck, pushing his head back as he prepares to stab, and has to be physically stopped by the angel. Ghiberti, on the other hand, has a far more psychological interpretation, as father and son stare into each other's eyes, almost a dramatic pause while we wait for the angel to fly into the scene and prevent the sacrifice. This psychological depth can also be seen as an indicator of the Renaissance. Rather than being laid out flat against the background, as Brunelleschi's figures are, Ghiberti groups them in more interesting ways spatially, with the two men and donkey overlapping in the bottom left-hand corner.

Ghiberti's victory was not necessarily based purely on artistic merit. He may well have been chosen because technically his relief was more accomplished – the reasoning

A LASTING RIVALRY

Personal rivalry can be seen as one of the major spurs to excellence during the Renaissance, and that between Brunelleschi and Ghiberti was one of the fiercest of the era. Vasari suggests that, when Ghiberti was awarded the commission for the North Doors of the Baptistery, Brunelleschi swore to give up sculpture forever. He was also resentful when Ghiberti was put in joint command, with him, of the construction of the dome of Florence cathedral, despite his inferior technical knowledge. At one point, according to Vasari, Brunelleschi even went as far as to feign illness so that Ghiberti would be left in charge of the project and his lack of expertise exposed. Having demonstrated his superiority, Brunelleschi assumed sole responsibility for the construction.

behind decision-making for other competitions at the time. Brunelleschi used a traditional goldsmith's technique. Each of his figures was modelled separately, and then attached to the background, whereas only the figure of Isaac in Ghiberti's relief is made this way. The rest of the relief is a single piece of bronze. Ghiberti's refinement of the technique meant that he needed less bronze, and he may have been chosen for purely practical – and economic – reasons.

Nevertheless, the survival of both panels suggests they were both valued. To complete large decorative projects as quickly as possible more than one artist might be commissioned, and this would inevitably also lead to a comparison of their work, as with the competition panels for the Baptistery doors. The desire by one artist to outdo another – whether on grounds of technical skill, economy, clarity of storytelling or complexity of composition – was one of the major driving forces for the development of the Renaissance.

New Forms and New Materials

The bronze doors which Brunelleschi and Ghiberti were competing to make were just one form of sculptural production. Altarpieces were not just painted, but could also be

the antique: *see pages 144–145;* Florence Baptistery doors: *see pages 52 and 119;* Florence cathedral: *see pages 26–27;* goldsmiths: *see page 33;* St John the Baptist: *see page 108;* linking the testaments: *see pages 120–121;* old and new: *see pages 66–69;* psychological truth: *see pages 74–77;* Vasari: *see pages 15 and 16*

carved from wood or stone, and the façades of churches were also decorated with sculptures carved in stone. Free-standing works were less common, but could include tomb monuments both inside and outside churches. However, in all cases sculpture was almost always part of some other complex.

One of the major developments of the Renaissance was that sculpture became independent: rather than being functional – as a door, altarpiece or tomb is – it developed into a form in its own right, and rather than being carved on the surface of a building, or enclosed in a niche, sculptures could now stand alone.

Sculptors attempted to imitate surviving examples of free-standing classical forms, and also to recreate lost works described by classical writers. An increasing appreciation of classical sculpture also resulted in the development of the portrait bust, a form of statuary unknown in the Middle Ages, as well as the portrait medal, cast from bronze. The development of small bronzes occurred for similar reasons: their compact size and expensive material meant they could be collected and treasured, and the intricacy of workmanship they required made them ideal vehicles for the display of artistic skill. Classical authors had discussed the brilliance of sculptors who could express the strength of Hercules in an object so small, and Renaissance sculptors took up the challenge to emulate – and surpass – the masters of antiquity.

Antonio del Pollaiuolo's *Hercules and Antaeus* (see opposite) is a brilliant example. Antaeus gained his strength from the ground, and so to defeat him Hercules had to lift him into the air. Antonio has created a complex arrangement of overlapping limbs that is interesting from all sides – and, because Antaeus tips his head back and looks up into the sky, it is also interesting from above. Set on a triangular base, the two figures are also supported in three places: by Hercules' legs, and the lion skin that is tied around his waist. This encourages the viewer to look at the sculpture from more than one point of view, and, being small, it is easy to pick up and turn in one's hands, making it an object that is both a pleasure to look at and interesting to hold.

medals: *see page 40;* **terracotta:** *see page 76*

As well as new forms of sculpture, new materials were introduced. Clay could be used to make models of sculptures in the same way that drawings provided the preparatory sketches for paintings. A clay model, or *bozzetto*, could be shown to a patron before a more expensive bronze or marble version was created, and could also be used as the basis to make a mould for bronze casting, or to allow an assistant to carve the rough shape from a marble block. However, it also became a material in its own right, again inspired by references in classical texts. When fired, the clay gets harder and more durable, and terracotta ("baked earth") was used as a sculptural material in its own right from relatively early in the fifteenth century. The original function of Antonio Rossellino's *Virgin and Child* (see below) is not known. The

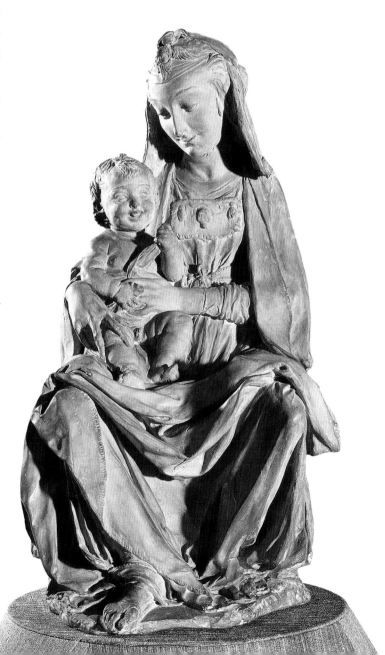

back of the sculpture does not have a high finish: it may have been intended as an independent sculpture to be placed against a wall. Alternatively, the lack of finish at the back may imply that it was intended as a very high relief, and it may have been a model, or *bozzetto*, for a marble sculpture that was either never executed or has since been lost.

Luca della Robbia refined the use of terracotta by glazing it. It is not clear how or why he developed this technique, although he must have been inspired by ceramic bowls and vases. The resulting sculptures can be coloured – initially he used white for the figures, to imitate the appearance of marble, and blue for the background, and gradually introduced more colours as the technology developed. The advantages of glazed terracotta were numerous. It was relatively light, making it easy to transport. The hard, shiny glaze was resistant to the weather for sculptures exhibited outside, but it could also reflect light in dark interiors. Clay was easier to work than marble, and was relatively cheap, which meant that even modestly wealthy families could own sculptures.

○ HERCULES AND ANTAEUS
Antonio del Pollaiuolo, early 1470s (BARGELLO, FLORENCE)

○ VIRGIN AND CHILD
("THE VIRGIN WITH THE LAUGHING CHILD")
Antonio Rossellino, 1460s (VICTORIA AND ALBERT MUSEUM, LONDON)

ceramics: *see pages 32–33;* **Hercules:** *see page 114;* **Madonna and Child:** *see pages 214–215*

ARCHITECTURE

The role of "architect" did not really exist during the Middle Ages: there were builders, stonemasons and carpenters who all worked together on the construction of a building under the leadership of a foreman, or master builder. A new building project would be presented in the form of a model, often made out of wood, and the foundations traced out onto the ground prior to construction. In Florence this created a notorious problem. Construction of the cathedral had started in 1294 and all Florence knew what it would look like when it was completed. In the 1360s Andrea Bonaiuti had even painted a monumental image of it (see page 131). However, by the beginning of the fifteenth century the Florentines had still not worked out how they were going to erect the vast dome, which was more or less the same size as the Pantheon in Rome and the largest dome to be constructed since antiquity. Arches, roofs and domes were traditionally constructed by building scaffolding up from the ground, with a wooden version of the structure on top. Building of the vaulting was carried out over the wood frame until it was sufficiently complete to support its own weight. But the vaulting for the dome proposed for Florence cathedral was too high up and too extensive for this to be practical with the existing groundwork, and the commissioning wardens did not want to enlarge the pillars or add buttresses.

With the design agreed, a competition was announced in 1418 to find a solution to the engineering problems that the huge, self-supporting dome presented. The winner was the local goldsmith-turned-sculptor Filippo Brunelleschi, and in 1420 he and his great professional rival Lorenzo Ghiberti were put in joint charge of the construction.

As well as finding the solution for the construction of the dome (see caption, opposite), Brunelleschi also designed new buildings, and is widely recognized as creating the basis of Renaissance architecture. Whereas medieval churches in Italy were decorated with frescoes telling Bible stories and

illustrating aspects of theology, Brunelleschi wanted the form and proportions of the church itself to convey a divine message. There was to be little colour, but a lot of light – representing the light of God, and of understanding – so he preferred the walls to be painted white. The architectural features were articulated with a cool grey sandstone called *pietra serena*, so that the harmony and proportions could be more easily appreciated. The reduction of decorative detailing and simplification of forms, usually relying on elements inspired by classical precedents, with clear harmonic relationships, was to become the main aim of Renaissance architecture.

However, it was not Brunelleschi but Alberti who was responsible for developing the concept of the architect in his treatise *De Re Aedificatoria* ("On the Subject of Building"). He states, "An architect is not a carpenter or joiner ... the manual worker being no more than an instrument to the architect. Him I call an architect who by sure and wonderful skill and method is able, both with thought and invention, to devise and ... to complete his work." Thus, unlike a master builder, who would achieve his status by rising from the ranks of the craftsmen, an architect would approach design on a theoretical basis. Master builders would also participate in the construction of the building, whereas architects could leave this to a team of builders and engineers, although in practice most architects continued to supervise the construction of their work.

De Re Aedificatoria was the first major work to comment on the only surviving classical text on architecture, the *Ten Books of Architecture* by Vitruvius, an architect and writer from the first century AD. Alberti did not simply base his ideas on those of Vitruvius, but developed them according to his own learning and his experience of contemporary living. His book was completed in manuscript form by 1452, and first printed in 1485 – the year before the first printed version of Vitruvius. The advent of print led to a greater

Alberti: *see page 15;* Brunelleschi and Ghiberti: *see pages 22–23;* light: *see pages 48–51;* printing: *see page 14;* proportion: *see pages 56–57*

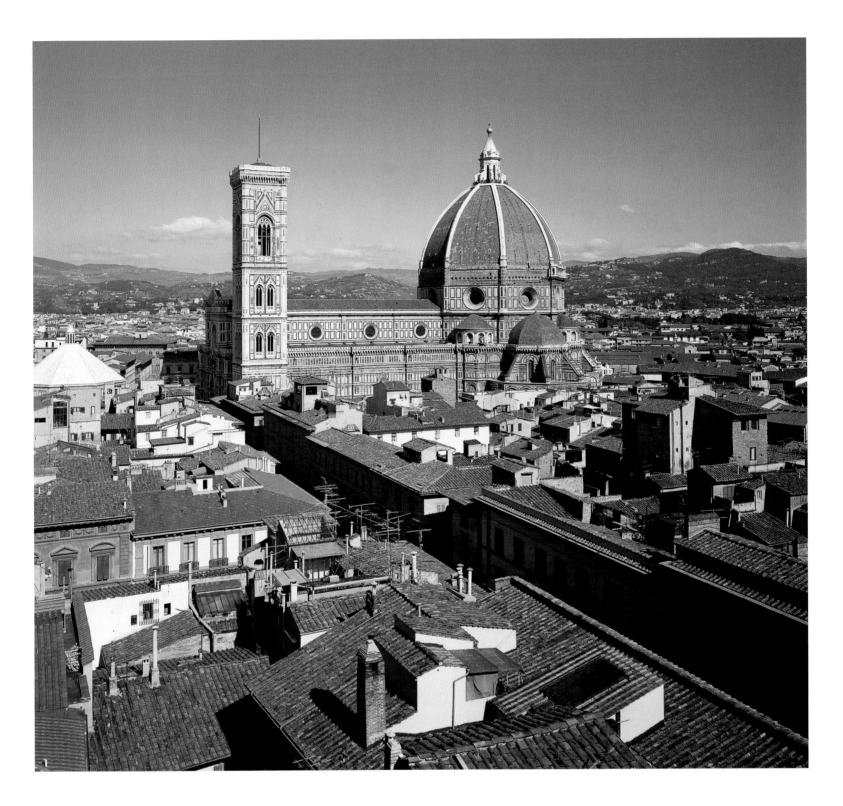

distinction between "architects" and "builders", as it became easier for the educated to learn the theory behind building than to gain practical experience.

In some ways, the apotheosis of this development was Andrea Palladio (1508–1580). His life can be interpreted as an embodiment of the changing status of the architect. Initially trained as a stonemason, he was effectively "adopted" by the humanist patron Giangiorgio Trissino, who encouraged him

⬥ **FLORENCE CATHEDRAL**
Dome by Filippo Brunelleschi, 1420–1436

The construction of the dome of Florence cathedral presented the greatest architectural puzzle of the age. Brunelleschi's solution included laying the bricks in such a way that they would support themselves, rather than relying on scaffolding built up from the ground, resulting in a herringbone pattern in the brickwork. This was only one of his innovations: he also developed new winch systems to lift large loads, and installed kitchens between the two shells of the dome, so that the workers did not break for too long at lunch time.

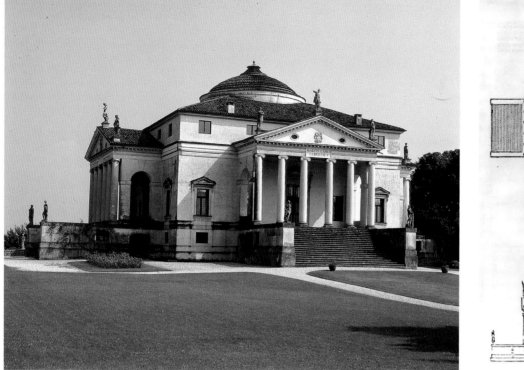

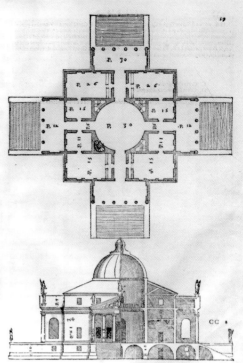

○ VILLA ROTONDA

Andrea Palladio, begun late 1560s (VICENZA)

The Villa Rotonda (above) and its ground plan (top) and elevation (bottom) illustrated in Palladio's *Quattro libri dell'architettura* (1570) reveal its perfect symmetry, the central, circular hall under the dome being embedded within a square building. This symmetry was possible because the Villa Rotonda had no function other than as a temporary retreat from the city and place of entertainment. Form and location – it is on a promontory looking over the landscape in four directions – are everything, and convey a sense of harmony with nature.

to study, and took him to Rome to see classical remains at first hand. Not only did he become an architect in his own right, but he also illustrated Daniele Barbaro's commentary on Vitruvius, before going on to write and illustrate his own books, the *Quattro Libri dell'Architettura* ("Four Books of Architecture"), published in 1570. From humble craftsman he had become an architect, scholar and theoretician.

The "Rules" of Architecture

The ideas behind the theory of architecture were derived from a careful analysis of Vitruvius, combined with close observation of the surviving monuments. For example, Vitruvius identified four ways of building, which have become known as the "orders" of architecture. In his *De Re*

Aedificatoria, Alberti described these four orders, but also observed that the Romans had used a fifth order not mentioned by Vitruvius. For a long time anyone wishing to understand the orders had to be content with verbal descriptions of them, although they could easily be identified on ruins (and, increasingly, on contemporary buildings). Finally, in 1540 an illustration of the five orders was published by Sebastiano Serlio in his treatise on the subject, and in 1562 Giacomo Barozzi da Vignola followed suit (see opposite).

The engraving shows the basic unit of each order, which consists of a column (the vertical element) and an entablature (a horizontal "beam" supported by the column). The column is made up of the base, the shaft and the capital (the often decorative element at the top), while the entablature is divided into the architrave (the part resting on the capital), the frieze and the cornice. The most basic order is the Tuscan. There is almost no decoration, the capital being little more than a plain ring. The Doric is similarly plain, but slightly less broad. The main difference is in the frieze, in which there is a set of three vertical strips, known as a triglyph, above each column. The spaces between the triglyphs are called metopes, and can be blank or contain a carved motif. The Ionic order has a scrolled capital, and a

the antique: *see pages 144–146;* **symmetry and harmony:** *see pages 58–61, 137 and 146;* **villas:** *see page 202*

plain frieze (although it can be curved), and the architrave has three flat strips, or fascie. The Corinthian order is distinguished by the acanthus leaves which surround the capital, and the Composite order – the one described first by Alberti – is, as its name suggests, a composite of the Ionic and Corinthian, with acanthus leaves surmounted by scrolls.

Each order was seen as having its own character. This idea derives from Vitruvius, who described the Doric as having "the proportion, strength and grace of a man's body", whereas the Ionic has a "feminine slenderness", and the Corinthian the "slight figure of a girl". For the Renaissance architect this suggested how the orders should be used – the Doric to honour male saints, for example, the Corinthian for virgin martyrs, and the Ionic for older women, or for that matter, more scholarly men. These ideas were suggested by Serlio in 1540, although buildings that illustrate these ideas can also be found in the preceding decades.

Following from this, and from observation of buildings such as the Theatre of Marcellus and the Colosseum in Rome, a standard way of using the orders on successive storeys of a building was adopted. The more solid Doric was seen as the ideal support, and was placed at the bottom, with the increasingly slim and elegant Ionic and Corinthian above it. This arrangement was used, in part, by Jacopo Sansovino in his construction of the Marciana, the library of St Mark's in Venice (see page 166). He uses Doric for the ground floor, and Ionic for the first floor. His mastery of the orders was displayed in other buildings nearby. In the adjacent Mint (just visible at the left of the illustration on page 166) the Ionic is again above the Doric. However, this time the Doric is on the first floor and the Ionic on the second floor. The ground floor is constructed of rough-hewn masonry – a style described as rustication. As a building so closely associated with Venice's wealth, the Mint had to show its impregnability, precisely the message conveyed by rustication.

The development of a perfectly balanced architecture based on classical prototypes was perfected by Sansovino and Palladio, but already architects were starting to move in a

different direction. In the same way that artists were moving on from the established canon of symmetry, proportion and balance in painting, so architects started to break the "rules" of architecture. This Mannerist approach is illustrated well by the vestibule of the Laurentian Library, designed by Michelangelo (see page 168). In some cases it is as if Mannerist architects were playing jokes – when assessed according to architectural conventions these buildings should not function, yet many of them have stood firm for up to five hundred years.

◆ THE FIVE ORDERS OF ARCHITECTURE FROM *REGOLE DEGLI CINQUE ORDINI*

Giacomo Barozzi da Vignola, 1562 (ROME)

This illustration from Vignola's influential book shows the five orders, from left to right: Tuscan, Doric, Ionic, Corinthian and Composite.

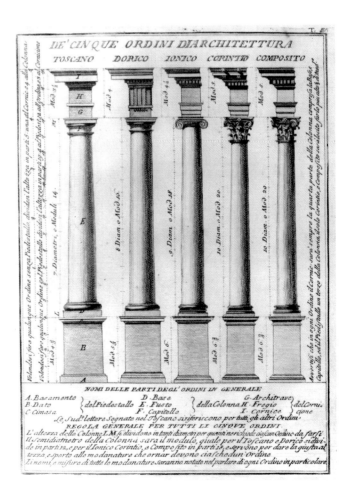

male and female: *see pages 86–89;* **Mannerism:** *see pages 20–21;* **rustication:** *see page 202*

THE DECORATIVE ARTS

The "decorative arts" are areas of artistic production that do not, strictly speaking, fall within the categories of painting, sculpture or architecture, but might include objects of a more functional nature – furniture, ceramics, fabrics and so on. They are normally considered to be the preserve of craftsmen rather than artists. However, this is an attitude that started to develop only during the Renaissance, which was the first period since antiquity to recognize the special talent of artists. The distinction between functional and artistic objects was also new: paintings and sculptures themselves had a function – particularly in the religious context, in which an altarpiece was designed to focus attention on the Mass and to communicate key aspects of Christian theology.

In the modern world financial value is attached to works of art according to the fame of the artist. A characteristic of the Renaissance was that, as it developed, patrons became more concerned with the skill of the artist than the quality or quantity of the materials to be used for a commission. For

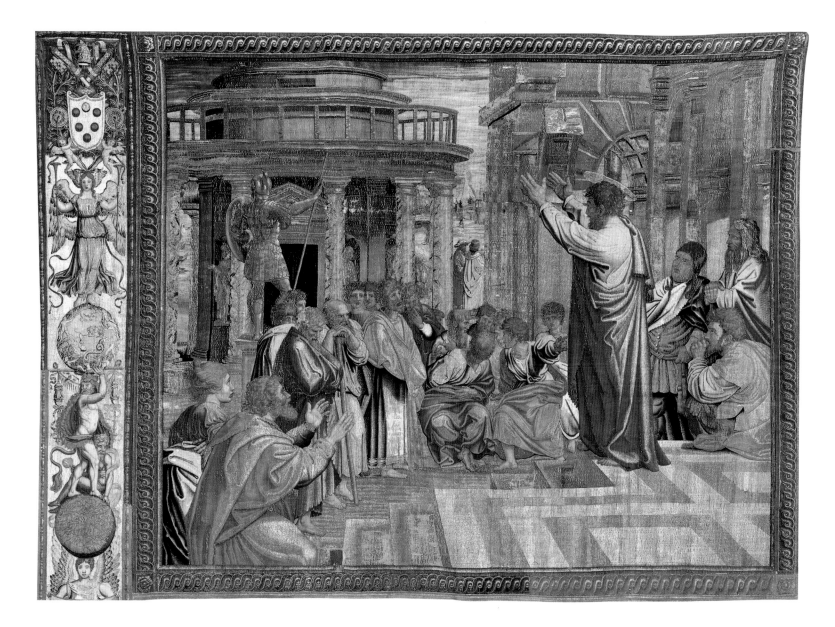

example, it might be stipulated that the main figure on an altarpiece be painted by the artist rather than his assistants. However, this was not always the case – an example to the contrary being the tapestries commissioned by Pope Leo X (reigned 1513–1521) for the Sistine Chapel (see opposite). Nowadays weaving would be considered part of the decorative arts – almost more of a craft – but throughout the Middle Ages, the Renaissance and beyond, tapestries were far more valued than paintings because of the expensive materials from which they were made, including not only the finest wool (see box, right) and silk but frequently also threads spun from silver and gold. In addition to the immense wealth that they embodied, tapestries were invaluable for insulation. Unlike frescoes, they could also be moved – and frequently were. The majesty of kings, princes and popes was emphasized, even in temporary settings, by the magnificence of their surroundings. Because tapestries were so highly prized, frescoes and panel paintings were often designed to emulate them, thus implying the same sense of wealth, even if the actual cost was, by comparison, minimal. Benozzo Gozzoli's decoration of the chapel in the Palazzo Medici (see page 187) and Paolo Uccello's *Rout of San Romano* (see page 193) are just two examples.

Leo X commissioned Raphael to paint cartoons for the tapestries that were to hang on the lower part of the walls in the Sistine Chapel. A contemporary report tells us that Leo paid Raphael 100 gold ducats (equivalent to 4,400 euros)

◑ ST PAUL PREACHING IN ATHENS
Raphael, ca. 1515 (TAPESTRY, VATICAN MUSEUMS)

This tapestry shows St Paul preaching in Athens. The Acts of the Apostles says that he preached on the Areopagus, the northern slopes of the Acropolis: the King James Bible says "he stood in the midst of Mars' Hill" (Acts 17.22). Raphael shows a statue of Mars apparently turning away from Paul, looking toward a temple, which is actually a version of Bramante's Tempietto (see page 147) completed, in all probability, about a decade before. Raphael has also included a portrait of his patron Leo X, the plump man in a red hat just behind Paul. The crossed keys at the top of the border are papal insignia, and below them the coat of arms with six balls is that of the Medici family, of which Leo was a member.

THE WEALTH ENDOWED BY WOOL
Florence owed much of its wealth to the wool industry. Once the sheep had been sheared, the wool was washed, separated (or "carded") into fibres, spun into yarn and then woven into cloth. Then came the "finishing" process, which involved yet more stages, including fulling, drying, brushing and dying. The result was the most prized cloth in Europe. At its peak, in the early 1300s, half of all Florentines worked in the wool industry – and much of the construction and decoration of the cathedral was funded by the wool merchants, the city's most powerful guild.

for each cartoon, whereas the tapestries themselves cost 1,500 ducats (65,700 euros) each, because of the rich materials and labour-intensive process of weaving. The cartoons were sent to the studio of Pieter van Aelst in Brussels – long known as the leading centre of tapestry production – where they were cut into narrow strips. These were laid next to the looms, and the weavers worked on a section at a time. The precise history of the cartoons is not known, but many other versions of the tapestries were made from them. For example, Henry VIII of England commissioned a set in 1540.

By 1623 the cartoons, still in strips, had reached Genoa, and were purchased by Charles, Prince of Wales (soon to become Charles I of England) who wanted tapestry makers in his kingdom to create another set. It was not until the late 1690s that William III had the strips reassembled to be exhibited as works of art in their own right.

The history of the cartoons is instructive. For almost two centuries until William's intervention, it was the tapestries that were the object of envy and pride, rather than the cartoons. This should caution us against dismissing objects as merely "decorative": it implies a value system that was only in its infancy during the Renaissance. Nevertheless, the choice of Raphael to design the tapestries was not coincidental, as his involvement undoubtedly added to the value of the objects: material value was enhanced by artistic prestige.

form and function: *see pages 90–93;* **guilds:** *see pages 182–183;* **keys:** *see pages 128–129;* **Pope Leo X:** *see page 199;* **St Paul:** *see page 108;* **patronage:** *see pages 82–85;* **portraiture in paintings:** *see page 51;* **power and wealth:** *see pages 184–191;* **Sistine Chapel:** *see page 84*

Furniture and Fittings

As well as designing items that were then made by someone else – as Raphael did for the tapestries – artists were also responsible for decorating works that they either made themselves or created in collaboration with others. Much furniture was decorated, either with carved details (for example, the mirror frame decorated with relief carvings of Mars and Venus made for the Medici family; see page 43) or with paintings: Filippo Lippi's *Annunciation* (see pages 90–91) was originally part of an "interior décor" scheme and was probably designed to go above a door. Rooms were often lavishly decorated to celebrate a wedding: the bride and groom would effectively be given a new bedroom with all its furniture, carved and decorated according to the wealth of the families concerned. This furnishing could be painted by the greatest artists: Botticelli's *Mars and Venus* (see page 93) was probably part of such a scheme.

Households also needed objects from which to eat and drink, and the wealthy liked to show that they could afford the best. The Renaissance era saw increasing value placed on objects made from glass, and it was considered that the technique of contemporary glassmakers equalled that of the Romans. One of the main centres of production was Venice, and the skill of the glassmakers was so highly prized that the craftsmen were forbidden to leave the lagoon on which the city stands on pain of death. Although their freedom was restricted in this way, they were afforded considerable privileges in other respects: on one occasion a glassmaker guilty of murder was pardoned on condition that he return to work.

In the field of ceramics, it was widely believed that the skill of the ancients had been exceeded. This was in part due to the development of a tin-glazed pottery known as maiolica (see, for example, the dish on page 84). Not only could maiolica be modelled into light and delicate forms but it was also appreciated for its smooth, white surfaces, which could be decorated with an array of brightly coloured glazes. In some respects this was more technically challenging than

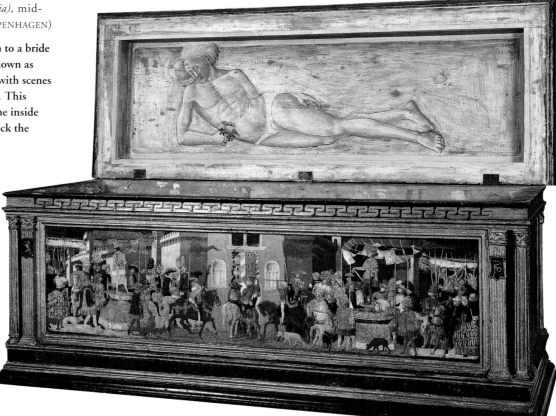

◗ *CASSONE*
Giovanni di Ser Giovanni (Lo Scheggia), mid-1400s (MUSEUM OF FINE ARTS, COPENHAGEN)

Included among the furniture given to a bride and groom would be two chests, known as *cassoni*, **which would be decorated with scenes considered appropriate to marriage. This** *cassone* **features a naked figure on the inside of the lid – perhaps designed to shock the blushing bride who opened it.**

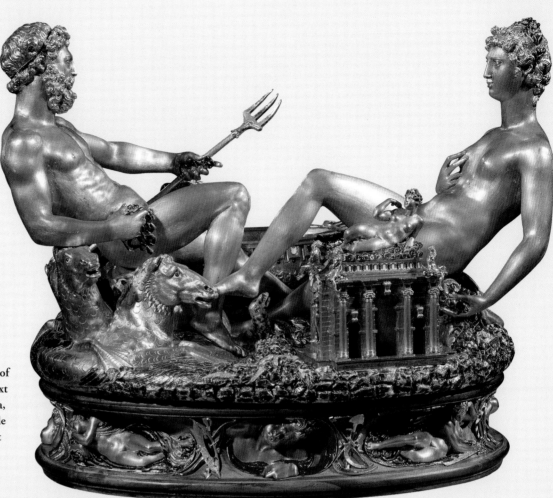

SALT CELLAR
Benvenuto Cellini, 1540–1543
(KUNSTHISTORISCHES
MUSEUM, VIENNA)

As well as being a work of art of great
intricacy, this cellar was a working item of
tableware. The salt was put in a boat next
to the male figure who represents the sea,
while the small temple next to the female
"land" figure contained pepper. The salt
cellar was stolen in May 2003, but was
recovered in January 2006.

painting on panel, as the final colours of a glaze are not
revealed until the piece is fired. The humble materials from
which the objects were made were considered to be enriched
by the "noble" art of painting.

Although maiolica is a notable example where artistry
added value to an intrinsically worthless material, gold
and silverware were still prized for the materials themselves.
The architect Brunelleschi and the painter and sculptor
Verrocchio both trained as goldsmiths, and Benvenuto
Cellini, who became known as a sculptor, did not move into
that field until he was in his forties. He too started life as a
goldsmith, and his most remarkable work, the salt cellar (see
above) he made for Francis I of France (1494–1547), illus-
trates the limitations we can put on something by relegating
it to the decorative arts. His intentions can be easily under-
stood from the several descriptions he himself wrote. He said
that the salt cellar represents, "… the Sea and the Earth both
seated, their legs intertwined as when certain inlets of the sea
enter the land, and the land enters the sea …".

The salt cellar clearly advertises Cellini's technical skill
and inventiveness. It also tells Francis's guests that he could
afford the best materials and the most brilliant artists to
work them, as well as cleverly expressing a number of his
interests. The sensuous figures would have appealed to the
king's well-known taste for the erotic, but the salt cellar also
conveyed a political message. Salt has always been a valuable
commodity: at the beginning of Francis's reign about six per
cent of his state's revenue came from taxes on salt, and
Francis made sure this increased. He also tried to develop
trade routes that would outstrip both Venice and Portugal's
prowess in the importation of pepper and other spices.

Thus Cellini's salt cellar is neither just a fine example of
the decorative arts, nor a functional object that happens to
include small-scale sculpture, but a work of art which
expresses not only the artist's skill both technically and intel-
lectually, but also the patron's artistic and political concerns.
It embodies these different layers of meaning in a remarkably
decorative and compact form.

the antique: *see pages 144–145;* **cassoni:** *see pages 92–93;* **Francis I:** *see page 160;* **layers of meaning:** *see pages 98–101;* **Venice:** *see pages 176–177*

THE LANGUAGE OF THE RENAISSANCE
PART TWO

In the same way that a spoken language is made up of words, which are put together to form phrases and sentences, works of art can be broken down into different elements. Looking at these elements separately, and considering what they mean, can help us to understand the work as a whole. The language of the Renaissance is not made up of words as such, but of different aspects of representation, such as the objects depicted, the colours used, or even the position of an object or person within the image. For example, if a painting includes a number of different objects, each of which has a separate meaning, then these meanings can be put together like words to form a sentence, which in this case would be the meaning of the painting as a whole. Part Two of the book looks at a wide variety of categories, examining the ways in which they can convey meaning, and how they can be used as tools to help analyze any work of art.

◀ **MADONNA AND CHILD (detail)**
Masaccio, 1426 (NATIONAL GALLERY, LONDON)

Masaccio uses many techniques to create an illusion of space within his *Madonna and Child*. As well as perspective, objects such as this lute are foreshortened – a form of perspective applied to a single thing – and the angle at which the lute is held helps to lead our eye into the painting. He also uses the light and shade to make it three-dimensional. The light shining brightly on the left, with shadows on the right, tells us the shape of the instrument. (See full painting, page 55.)

OBJECTS & THEIR MEANINGS

The most common way for artists to convey meaning in paintings was through the use of symbolic objects. Some symbols are easy for the modern viewer to decipher: a halo, a glow of light around someone's head, tells us that the person is holy. Other symbols require more explanation. The painting by Carlo Crivelli (see opposite) gets its name from one such symbol: it is called the *Madonna della Rondine*, or the Madonna of the Swallow, after the swallow perched on the top left of Mary's throne. Whereas today we know that swallows migrate, and we can track their movements with sophisticated technology, previously it was not known where they went in the winter: it was commonly believed that they hibernated in holes in the muddy banks of rivers. Because they went away and then came back again, they were seen as a reminder of Jesus, who was buried, and then rose again from the dead: the swallow is therefore a symbol of Christ's resurrection.

The apple that Jesus holds in the painting refers to the forbidden fruit of the garden of Eden: Adam and Eve, having done wrong, were ejected from paradise, and it is only through Christ's sacrifice that Christians believe we can return to a state of grace. Thus Jesus, even as a child, is, by grasping the apple, offering to take original sin upon himself.

Other objects help us to identify the characters portrayed. On the left is St Jerome, responsible for translating the Bible into Latin. In his right hand he holds the bibles he has translated, on which rests a model church, symbolic of his status as one of the Doctors of the Church. Next to him is a miniature, symbolic lion, which refers to a story in which St Jerome removed a thorn from a lion's paw, and the lion stayed with him for the rest of its life. He is dressed in red – the robes of a cardinal – even though that office had not been created when he was alive. The broad-brimmed red hat and a full-sized lion can also be seen in the predella (the name given to the images running along the base of an altarpiece): this is Jerome again, depicted kneeling in penitence before the Cross. Thus Jerome has a number of objects which go together to identify him. Any of these things, the lion, the hat, and the books in combination with an elderly man, would help to identify him as Jerome. Similarly,

◀ MARZOCCO
Donatello, 1419 (BARGELLO, FLORENCE)

The meaning of a symbol can change according to its context. An example of this is the lion, which is one of the attributes of St Jerome (see above). However, a winged lion represents St Mark, the patron saint of Venice, and so is used as a symbol of Venice. But a lion known as Marzocco (the name may derive from Mars, the god of war) is also a symbol of Florence. Donatello's sculpture carries a shield with a lily, another Florentine symbol: the name "Florence" comes from the Latin for "flower". An earlier, medieval lion was for many years the only sculpture in the main square of Florence, and can be seen in the background of several paintings. It was crowned, and had an inscription with the following verse: "Corona porto per la patria degna,/A ciò che libertà ciascun mantegna" ("I wear this crown for the worthy fatherland, so that everyone will maintain its liberty"). This lion is therefore a symbol of Florence's status as a free city, and came to stand for its republican ideals.

▶ MADONNA DELLA RONDINE
Carlo Crivelli, after 1490 (NATIONAL GALLERY, LONDON)

Adam and Eve: *see pages 120–121;* **St Jerome:** *see pages 102 and 109;* **Latin Doctors of the Church:** *see pages 102–104;* **Madonna and Child:** *see pages 214–215;* **St Mark:** *see page 102;* **Resurrection:** *see pages 120 and 215;* **sacra conversazione:** *see page 64;* **translation of the Bible:** *see page 120*

◀ **MADONNA DELLA RONDINE (details)**
(SHOWN IN FULL ON PREVIOUS PAGE)

Food was considered a gift from God, so it is hardly surprising that it was often endowed with symbolic meaning. Crivelli includes numerous examples in the *Madonna della Rondine*. They are examined here, alongside important examples from other paintings.

The "fruit of the tree of knowledge of good and evil", or forbidden fruit, is most often identified as an **apple** (see right). However, the Bible does not specify a particular fruit, and there are other suggestions. These include the fig. After all, Adam and Eve dressed themselves in fig leaves, which must therefore have been close to hand.

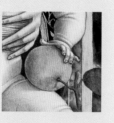

Another suggestion was the **quince** (see left), seen hanging above Sebastian, although in other contexts it can symbolize fertility and marriage.

At the Last Supper Jesus gave wine to the apostles, saying "This is my blood …". As wine comes from **grapes** (see below), they represent Jesus' suffering on the Cross. Here they are painted next to a **pear**, the rounded shape of which refers to Mary's fruitfulness or fecundity, and hence to the incarnation – God made flesh.

The **pomegranate**, another important fruit, can be seen in Filippo Lippi's *Madonna and Child* (see page 91). In Greek myth Persephone was taken into the Underworld by Hades. She was allowed to return to the land of the living only if she had not eaten while she was there, but as she had eaten some pomegranate seeds, she was forced to spend one third of every year in the Underworld. This myth gives the fruit its Christian symbolism: it refers to Christ's death and resurrection. However, because it has many seeds in one body, the pomegranate is also a symbol of the Church, which contains many souls.

Mentioned in the story of Jonah, who was swallowed by a whale for three days before being regurgitated onto dry land, the **gourd** (see left) can be seen as a symbol of Christ's resurrection. However, as Jonah sits under a gourd tree after God has forgiven the people of Nineveh, it may also be a symbol of forgiveness.

Yet another suggestion for the forbidden fruit was the **orange**. However, in Domenico Veneziano's *St Lucy Altarpiece* (see page 47) and Botticelli's *Primavera* (see pages 154–157) it is probably used as a reference to the Medici family. As well as resembling the golden balls on the Medici coat of arms, the orange was sometimes known as the *malus medicus* or "medicinal apple" – creating a pun on the family name.

underneath the young man on the right is a scene of execution. This is St Sebastian, a Roman soldier turned Christian, whom the Romans attempted to kill by shooting him with arrows. As the young saint in the main panel is holding an arrow, this identifies him as Sebastian.

The symbols that saints carry, or with which they are associated, that help us to identify them are known as attributes. What is not often realized is that the Christ Child is effectively one of Mary's attributes: he is often the most distinctive aspect of her appearance.

Objects as Observation

With the increasing realism of paintings in the Renaissance, it is sometimes difficult to tell which objects are meant to be symbols, and which are simply careful depictions of elements from everyday life. Such is the case in another painting by Carlo Crivelli, the *Annunciation* (see page 49). The apple and gourd at the bottom of the painting are clearly symbolic, as they are placed so prominently, and the still life elements in Mary's room also have symbolic value. However, with other details Crivelli seems to be showing off his skill. These include the rug, hanging over the balcony at the top right, and the birdcage just above it. The former has a remarkably complex pattern which would be hard to paint, particularly as the fabric is distorted by folds; and the latter is a delicate display of three-dimensional illusionism. Each has a counterpart on the bridge in the left background: Crivelli seems to be saying that not only can he paint these objects well, but he can do so on different scales to create a sense of space and distance.

However, the artist is not just showing off. These rugs would have been recognizable as expensive items imported from across the Adriatic: anyone seeing the painting would have been able to assess the value of the objects depicted, thus forming another kind of relationship with the painting. The depiction of recognizable objects was important to engage the interest of the viewer, thus making the message and meaning of the painting more immediate.

Hades (Pluto): *see page 114;* **Jonah:** *see page 120;* **Last Supper:** *see pages 122–123;* **the Medici:** *see pages 42, 186–187, 198–199 and 202;* **saints:** *see pages 106–109;* **St Sebastian:** *see pages 60–61*

◐ *INTARSIA* **PANEL FROM
THE *STUDIOLO* OF FEDERIGO
DA MONTEFELTRO**
Benedetto and Giuliano da Maiano, 1476
(PALAZZO DUCALE, URBINO)

Single vanishing-point perspective is only
an approximation of the way we see things.
The different viewpoints of each eye help
us to appreciate three-dimensional form,
and to estimate how far away an object is.
Illusionistic images such as this *intarsia* panel
would therefore be far more impressive if we
were monocular, and as such were ideal for
the patron, Federigo da Montefeltro, who
had lost one of his eyes in a jousting accident.

"Showing off" was clearly one of the aims of the *studiolo*,
or "little study" created for Federigo da Montefeltro, duke of
Urbino (1422–1482). Probably designed by artists including
Botticelli, and executed by Benedetto and Giuliano da
Maiano, the lower half of the small room is decorated with
intarsia – pictures made from tiny pieces of inlaid woods.
The objects depicted are of deliberately complex shapes,
which would be hard enough to draw or paint, let alone fash-
ion from wood. The aspect of spatial illusion is particularly
important, and most of the objects are shown as if resting on
the shelves of cupboards: the open doors are some of the best
examples of spatial illusionism (see above). Some of the
objects are chosen simply for their shape. Others, such as the
astronomical instruments displayed on the upper shelf, illus-
trate the duke's many interests and achievements. Whatever
the message conveyed by the objects depicted, as a whole the
room clearly demonstrates that Federigo appreciated – and
could afford – the most brilliant and skilled artists in Italy.

Federigo da Montefeltro: *see pages 86–87;* **illusionism:** *see pages 172, 190 and 214–215;* **perspective:** *see pages 52–55;* ***studioli:*** *see page 172*

EMBLEMS & ABBREVIATIONS

A common feature of Renaissance culture was the use of emblems by prominent families or individuals. Each *impresa* (*imprese* in the plural) could be used to express something about the character or interests of the people concerned, or qualities that they were thought to embody, and frequently consisted of an image combined with a motto. One example of this was the winged eye used by Alberti, which appears on the reverse of his portrait medal above the phrase "quid tum" (see page 15). Indeed, medals were a particularly popular place to display such *imprese*, as the portrait of the sitter on the front (obverse) of the coin could be complemented by the *impresa* on the back (reverse).

○ **MEDAL OF LUDOVICO III GONZAGA (reverse)**
Antonio Pisano (Il Pisanello), ca. 1447 (BRITISH MUSEUM, LONDON)

The Latin inscription reads "Opus Pisani Pictoris", meaning "the work of the painter Pisano".

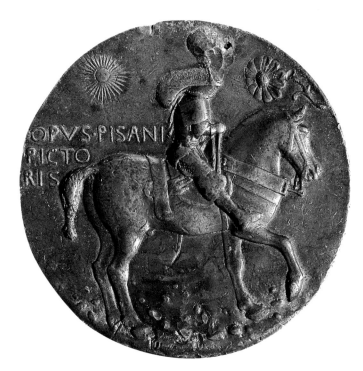

This is the case with the medal of Ludovico III Gonzaga (1414–1478), marquis of Mantua, which is signed on the reverse by its creator Pisanello (see below). Next to the signature Ludovico is depicted in armour on horseback, celebrating his military successes: like many courtly rulers he had made his money as a *condottiere*, or mercenary soldier. The elaborate helmet he wears is not strictly functional, though: it evokes the chivalry of ages past. The heroic deeds of the knights of old as described in medieval romances, notably those from France, were particularly popular. This is also reflected in the choice of medieval French for one of the Gonzaga mottoes: "par un désir" ("for one wish"). There was an implicit association between this motto and the sunburst *impresa* seen at the top left of the medal. The sun ("sol" in Latin) becomes a form of pictogram, representing the phrase "par un sol désir" – "for just one wish". Although the meaning of this phrase was open (as it was with Alberti's "quid tum"), it becomes clearer when combined with another Gonzaga *impresa*, the marigold, seen at the top right. The flower turns its face toward the sun, and in the same way the Gonzaga were considered to turn to the light: their "wish" was to follow the correct path, and seek out the light of truth – not only does this suggest that they would act only for the best, but also affirms their faith in God. The sun was also chosen because Ludovico was born on a Sunday. A letter from the court astrologer flattered him, saying, "those people who have the sun as the signifier of their nativity are the best Christians in the world", and for Ludovico Sunday was always regarded as an auspicious day.

Sacred Letters

Although one of the main reasons to paint was to present Bible stories and the lives of the saints to an audience who could not read, words, or abbreviations of words, were frequently used in images to enhance their meaning. Mary

astrology: *see page 142;* **the Gonzaga:** *see pages 190–191;* **light:** *see pages 48–51*

Magdalene, in this detail from the *Coronation of the Virgin* attributed to Jacopo di Cione (see right), wears a red robe embroidered with two abbreviations, which look like "IhS" and "XPS". They are in fact shortened versions of the Greek for Jesus Christ – she is showing her devotion by having Christ's name embroidered onto her clothes. The abbreviation "XPS" was rare. The combination of "X" and "P" – the Greek letters "chi" and "rho" – was an early symbol of Christianity, but this had fallen out of fashion by the fourteenth century. The abbreviation "IhS" was used more commonly. The line above the monogram (added to make it clear that letters were omitted) was often combined with the vertical of the "h" to form a cross. The "name of Jesus", as this symbol was known, was particularly venerated and promoted by the Franciscan Bernardino of Siena (1380–1444), who was canonized in 1450. He used it as a focus for many of his sermons, and to unite warring factions who would otherwise have assembled under their own emblems.

"Alpha" and "omega" ("A" and "Ω", or "W"), the first and last letters of the Greek alphabet, were often used to represent God's timelessness: "I am Alpha and Omega, the beginning and the end, the first and the last" (Revelation 22.13). Another commonly depicted abbreviation, particularly in scenes of the Crucifixion, is "INRI", standing for "Iesus Nazarenus Rex Iudeorum", or "Jesus of Nazareth, king of the Jews", which was written by Pontius Pilate in Hebrew, Greek and Latin, and fixed to the top of the Cross (John 19.19–20). Some paintings show all three languages, but most only include the abbreviated form of the Latin inscription.

● **CORONATION OF THE VIRGIN** (detail)
Jacopo di Cione (attr.), 1370–1371
(NATIONAL GALLERY, LONDON)

The detail of Mary Magdalene, shown here, is from the bottom left-hand panel of a large twelve-panel altarpiece originally commissioned for the church of San Pier Maggiore in Florence (see pages 106–107).

Crucifixion: *see pages 126–127;* **Mary Magdalene:** *see pages 88–89 and 108*

Signs of Ownership

A portrait medal is a highly personal object, small enough to be held in the hand, but, being a collector's item rather than common currency, it is not a suitable vehicle for mass communication. However, the emblems which encoded the medals with such intricate ideas could also be used to designate the ownership or patronage of sites or works of art that were within the public domain. This is in some ways subtler than the use of coats of arms, although these were also used frequently. For example, the coat of arms at the bottom of Crivelli's *Madonna della Rondine* (see page 37) is that of Ranuzio Ottoni, one of the patrons of the altarpiece. But

although a coat of arms can tell us who the patron was, it says little about his or her character or beliefs.

One of the greatest families of patrons in Renaissance Italy were the Medici of Florence, who attained wealth and power through their skills in banking, trade and diplomacy. One of their emblems was a diamond ring, sometimes combined with the word "semper" – Latin for "always" (the combination can be interpreted quite literally as "diamonds are forever"). The implication is that the Medici were hard and brilliant, like diamonds, and that their power would endure.

This imagery is used repeatedly on the tomb of Piero and Giovanni de' Medici (see left), which was designed by Andrea del Verrocchio for the church of San Lorenzo, just next door to the Medici Palace. A diamond, cast in bronze, sits on top of the sarcophagus, in between two cornucopia – horns of plenty – which indicate the wealth and abundance that the family had supposedly brought to Florence. There is also a bronze diamond embedded at the top of the arch, and diamond rings carved among the foliage and flowers on the marble of the arch itself.

The sarcophagus stands on bronze lion's feet, which rest on a marble platform. This in its turn is supported by four tortoises (one at each corner – the tomb is two-sided). These may refer to another Medici emblem, much favoured in the Renaissance. The tortoise, particularly if shown with a sail attached to its back, illustrated the motto "festina lente", or "make haste slowly" – a Latin version of the saying "more haste, less speed". The implication is that careful and determined application will achieve better results than rushing at the same problem unprepared.

As with other symbols, the elements of these *imprese* could have different implications according to the context. While the sail attached to the back of a tortoise refers to the motto "festina lente", a sail on its own refers to the idea of

◑ **TOMB OF PIERO AND GIOVANNI DE' MEDICI**
Andrea del Verrocchio, 1469–1472 (S. LORENZO, FLORENCE)

lion: *see page 36;* **the Medici:** *see pages 42, 186–187 and 198–199;* **Piero "the Gouty" de' Medici:** *see pages 169 and 186;* **Palazzo Medici:** *see page 202;* **patronage:** *see pages 82–85;* **power and wealth:** *see pages 184–191;* **Verrocchio:** *see page 19*

◀ **MIRROR FRAME WITH RELIEFS OF VENUS AND MARS AND PUTTI**
Unknown craftsmen, ca. 1460–1465
(VICTORIA AND ALBERT MUSEUM, LONDON)

As well as displaying patronage outside the home, personal emblems were used in interior decoration to "personalize" domestic spaces and remind important visitors of the qualities that their hosts aimed to represent. Such is the case with this mirror frame in the form of a diamond ring, which was in all probability owned by a member of the Medici family (the Rucellai also used the diamond ring as an *impresa* after the families intermarried). The mirror itself would have been relatively small, and would have fitted into the circle in the centre of the carved wooden relief. In the 15th century glass could not be made in large pieces, and the frame is as much an object of display as a functional item. The images of Venus and Mars – similar to those in Botticelli's painting (see page 93) – suggest that the mirror was made to celebrate a wedding. Unfortunately, the coat of arms at the top of the frame has been defaced, so we cannot be sure which families were involved.

fortune or chance, because our luck can change like the wind: a sail with this meaning was used by the Rucellai family. Other emblems may be an illustration of the family name. The Scaliger, or della Scala, family from Verona used a ladder ("scala" means staircase or ladder), and a church built for one of the family in Milan eventually gave its name to La Scala, the famous opera house. However, the same emblem was also used by a hospital in Siena, which had a steep staircase leading up to the front door. The della Rovere family, which provided two of the most important Renaissance popes, including Julius II, had an oak tree on their coat of arms, as "rovere" is Italian for oak tree – but they also used acorns to represent their name "in a nutshell", as it were.

WORDPLAY AND WITTICISMS

The meaning of emblems often relies on a form of visual pun. Spoken puns were also widely appreciated, and were discussed by Baldassare Castiglione in the *Book of the Courtier* (1528). At all times, he instructs, "the courtier should guard against ... repeating witticisms and quips merely to tease and wound." He also warns that, "one must ... avoid those [puns] that cause the joke to fall flat and seem too laboured, or, as we have said, are too wounding." He suggests, for example, that it would be wrong to make jokes about people with only one eye, or without a nose – a Renaissance version of "political correctness".

the della Rovere: *see pages 83–85 and 175;* **glass:** *see page 32;* **ladder:** *see pages 206–207;* **Mars:** *see page 114;* **the Rucellai:** *see pages 82–83;* **Venus:** *see page 114*

COLOUR

There is little point in defining a symbolism for colours in paintings. Although colours have always been interpreted symbolically, the meanings for each one vary according to the context, the place and the time. However, colour is significant, and can be used to represent ideas in different ways.

Materials and Meaning

One way in which colour communicates meaning is related to the value of the materials themselves. By far the most expensive pigment was ultramarine blue. It was derived from a semi-precious stone, lapis lazuli, which was known from only one source, modern-day Afghanistan, and was imported into Venice (see box, below) across the Adriatic: "ultramarine" means "over the sea". Because there was only one, distant source, and because it was difficult to extract the pigment from the stone, the richest, darkest ultramarine was more expensive to use on paintings than gold. It was therefore used on the most important areas of the painting, as a sign of status or respect.

This can be seen clearly in the *Ascension* attributed to Jacopo di Cione (see opposite). Although his name cannot be connected to the work with absolute certainty, accounts relating to expenditure for the painting survive. They tell us that three different grades of ultramarine were used, costing 11 soldi (equivalent to 240 euros), 8⅓ soldi (180 euros) and 2 soldi (45 euros) per ounce. The white paint, by comparison, was relatively cheap, costing thirty-six times less than the most expensive ultramarine. The Virgin Mary can be seen at the back of the circle of apostles: her blue robe is notably darker than that of the apostle at the front right, or for that matter, than the sleeve of St Peter kneeling immediately next to her. The pigment used would have been the most expensive, thus demonstrating the respect that was due to her.

This painting also displays other important functions of colour. Saints were often colour-coded for ease of identification. St Peter almost always wears yellow and blue, whereas St John the Evangelist often wears red and green, and so can be identified as the saint kneeling next to Peter. Jesus is wearing white: although this is related to the shroud in which he was buried, it is also a sign of his purity. It is lined with red, reminiscent of blood, and therefore symbolic of the suffering he has overcome. At the Resurrection he frequently carries a flag with a red cross on a white background – known as the Flag of Christ Triumphant – which is included in Sassetta's *St Francis Meets a Knight Poorer than Him ...* (see page 46).

Mixed Messages

In one system of colour symbolism, white, green and red stand for the three cardinal virtues: faith, hope and charity. Perhaps because of this association, the colours were also adopted by several leading families, and used by them both

THE DISTINCTIVENESS OF VENETIAN ART

A simplification of the difference between Florentine and Venetian artists would be that the Florentines were more interested in line, and the Venetians in colour. There are many reasons for this feature of Venetian art. First and foremost was the city's location. At the north of Italy, but on the sea, it could trade across the Mediterranean, inland to Italy and across the Alps to Germany. This privileged position put Venice at the centre of the pigment trade, which meant that Venetian artists simply had access to more colours. The buildings themselves were highly coloured. For example, St Mark's Basilica was encrusted with red and green marbles brought from Constantinople after the sack of 1204, and its interior was lavishly decorated with mosaic. Then there is the remarkable quality of light in Venice. Not only does the sun shine from above, but light is reflected up onto the buildings from every canal below. The richness of colour in the city, part of everyday life, is reflected in the paintings.

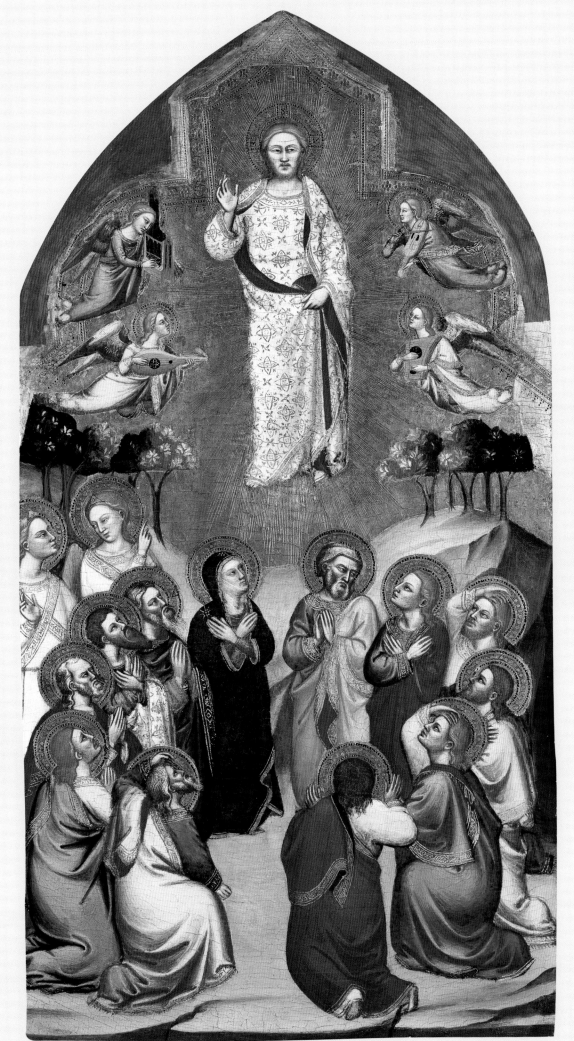

◁ **ASCENSION**
Jacopo di Cione (attr.), 1370–1371
(NATIONAL GALLERY, LONDON)

The *Ascension* was one of nine
panels painted as pinnacles to
the *Coronation of the Virgin*
altarpiece (see pages 106–107).
Although the main panels are
highly stylized, this pinnacle has
more of the realism introduced
by Giotto at the beginning of
the 14th century. For example,
the apostles and Mary are laid
out spatially in a convincing
circle, and the trees in the
distance are lit by Christ's glory,
represented by incisions in the
gold background. Mary is given
prominence, as she is, with
Christ, the central subject of
the altarpiece, while Peter is
placed centrally as the patron
saint of the church for which
the painting was intended, San
Pier Maggiore in Florence.

● ST FRANCIS MEETS A KNIGHT POORER THAN HIM AND HAS A VISION OF THE FOUNDING OF THE FRANCISCAN ORDER

Sassetta, 1437–1444 (NATIONAL GALLERY, LONDON)

This painting illustrates two stories from the life of St Francis. In the first, he gives away his coat, and in the second, an angel tells him in a dream that he should serve God. It has been suggested that because the coat is painted in ultramarine blue, the contemporary audience would have considered it particularly generous to give it away. However, although blue was the most expensive pigment for paint, red was one of the most prized colours for fabrics. Although Francis's red robe appears today to be worn out and dull, it was originally a rich burgundy painted over silver leaf, and would have been recognized as a luxurious item. In the next scene he sleeps in the same robe, wrapped in a scarlet cloak and resting his head on a cushion made from cloth of gold. He had been kind in the first scene, but he could afford to be. When he later abandons his possessions and seeks the protection of the Church, his act is more striking because we know how much he is giving up.

in the decoration of buildings and as an element in the design of clothing. Although today red, white and green are immediately recognizable as the colours of its national flag, Italy was not unified until 1871: in the Renaissance the "tricolore" did not have such a significance. The colours were adopted by the Medici, and are used by Verrocchio in the tomb of Piero and Giovanni de' Medici (see page 42): the sarcophagus is made of red porphyry, with a green roundel made of serpentine, and other elements were carved and constructed from white marble. However, the Medici were not the only family to choose these colours: they were also favoured by the Gonzaga of Mantua and the Este of Ferrara.

Domenico Veneziano's *St Lucy Altarpiece* (see opposite) was painted in Florence, and so his choice of red (or, at least, pink), white and green for the setting could be a reference to the Medici family. The oranges in the background, a Medici emblem, support this idea. Perhaps more significantly, these three colours were used in the building of the city's cathedral and Baptistery. The white marble is from Carrara, and the green from Prato, both near Florence, whereas the red marble comes from Verona. The cathedral is gothic in style, like the arcade under which Mary is sitting, whereas the Baptistery – an octagonal structure – is romanesque. The alcove in the painting contains round-topped niches and is a half-octagon: the two architectural features may, therefore, be references to Florence's two major religious buildings. This suggests that the artist is deliberately placing the work within a Florentine context, an idea supported by the presence of two of Florence's patron saints – John the Baptist and Zenobius – one on each side of the Virgin and Child.

However, there may be yet another colouristic reference here. Although Alberti did not expound a colour symbolism in *Della Pittura*, he did talk about the different qualities of colours. He suggested that, "Grace will be found when one colour is greatly different from the others near it. When you paint Diana leading her troop, the robes of one nymph should be green, of another white, of another rose, of another yellow …". In Domenico's painting Mary wears rose and

Alberti: *see page 15;* **the Este:** *see page 174;* **Florence Baptistery:** *see pages 22–23, 52 and 119;* **Florence cathedral:** *see pages 26–27;* **St Francis:** *see pages 76, 78 and 108;* **the Gonzaga:** *see pages 190–191;* **St John the Baptist:** *see page 108;* **the Medici:** *see pages 42, 186–187, 198–199 and 202;* **oranges:** *see page 38;* **red clothing:** *see page 87;* **Verrocchio:** *see page 19*

yellow, while her seat is covered with a green cloth and white surrounds her in the architecture. Alberti also says, "There is a certain sympathy of colours so that one joined with another gives dignity and grace. Rose near green and sky blue gives both honour and life": again these are the colours of the architecture and of Mary's mantle. The same colour combination – rose, green and sky blue – is used by the Pollaiuolo brothers in their *Martyrdom of St Sebastian* (see page 60).

⬤ ST LUCY ALTARPIECE

Domenico Veneziano, ca. 1445 (UFFIZI, FLORENCE)

Medieval altarpieces were often polyptychs, but by the Renaissance a single panel was in favour, with the saints in the same space as the Virgin and Child, a type of painting known as a *sacra conversazione*, or "holy conversation". In this Renaissance painting, Domenico subtly refers to the earlier tradition. The arcade spanning the painting is made up of three pointed, or gothic, arches, which could be read as the three panels of a triptych. Jesus and Mary are framed by the central arch, and each pair of saints is contained by one of the side arches.

sacra conversazione: see page 64

LIGHT & SHADE

Medieval artists all used gold leaf in the background of religious paintings. Churches were dark, having only small windows – and often these had stained glass, which further restricted the entry of light. The churches would have been lit by candles and lanterns, often placed on the altar directly in front of the paintings. The light from the candles would reflect off the gold, thus helping to make the church brighter. But the light reflected by the gold leaf was also rich in symbolism. In the Bible Jesus is described as the "light of the world", and light represents qualities such as knowledge, truth and understanding.

However, by the time of the Renaissance artists were discouraged from using gold. Alberti said, "I should not wish gold to be used, for there is more admiration and praise for the painter who imitates the rays of gold with colours." Alberti was advocating a complete change in outlook. Whereas medieval artists used real gold to reflect real light, in the Renaissance paint was used to depict imaginary light reflecting off imaginary objects to make them look real.

This was not an instantaneous change, and many artists continued to use gold leaf throughout the fifteenth century. Some used gold to reflect real light, while also painting illusionistic light, communicating different ideas with these different techniques. Carlo Crivelli's *Annunciation* (see right and opposite) is a rich example of this dual treatment.

Seeing the Light

Cennino Cennini, in his *Libro dell'Arte*, suggested that the direction of the light in a painting should be determined by the fall of light in the space for which the work was being made – so that if there was a window to the right of a painting, the light in the painting should also fall from the right. This would add to the sense of realism in the work.

The artist who appears to have been the first to put this theory consistently into practice was Masaccio (1401–ca.

⏵ ANNUNCIATION
Carlo Crivelli, 1486 (NATIONAL GALLERY, LONDON)

This painting was commissioned to celebrate the granting of rights of self-government to the city of Ascoli Piceno in the Marche, a model of which is held by Emidius, the patron saint of Ascoli, who kneels in the foreground next to the archangel Gabriel.

Crivelli uses light coming from outside the painting at the top left to establish the reality – and so the credibility – of the scene. The **gourd** and **apple** sitting on the front step cast shadows to the back right, as do Gabriel and St Emidius: this locates them within space and shows them to be solid objects.

A **beam of light** bursts from the sky at the top left, and shines diagonally downward onto Mary. The angel is announcing that Mary, a virgin, will become the mother of God. This is the moment at which Jesus is conceived, and the "light of the world" becomes flesh: Crivelli uses gold leaf to represent this supernatural light. Thus, the light which allows us to see the real objects in this painting is imaginary, whereas the spiritual light is real light reflected from the gold leaf, a distinction that accords with the belief that our future life in heaven should be more important to us than our brief time on Earth.

Two of the objects on the shelf in Mary's room can be interpreted as relating to the symbolism of light. The **candle** (left) may suggest that Jesus is just about to be conceived: it is not lit because the light has not yet come into the world. The **glass vase** (below) has a remarkably complex symbolism. Jesus, as well as being described as the "light of the world", is also referred to as the "water of life". Thus, the vase, which contains water, becomes a symbol of Mary, who will become the "container" of Jesus when he is in her womb. The fact that it is made of glass is also important. In the same way that light can pass through glass without breaking it, so Jesus was conceived and born without Mary losing her virginity. This is similar to the even richer symbolism of stained glass in medieval church windows: the light passes through the glass and takes on its colour without the glass being affected, in the same way that God passed through Mary and took human form without altering her.

Alberti: *see page 15;* **Annunciation:** *see pages 80–81;* **apple:** *see page 38;* **Cennini:** *see pages 14–15;* **archangel Gabriel:** *see page 104;* **gourd:** *see page 38*

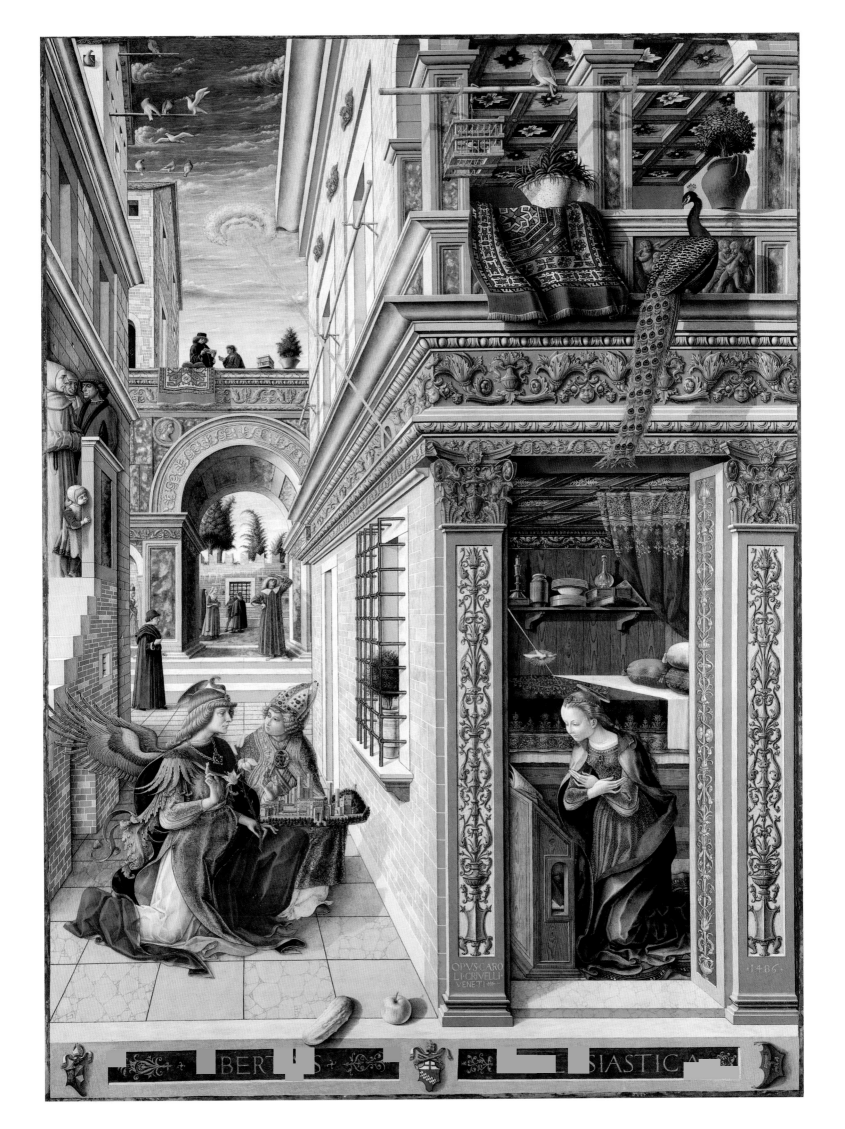

OPVS CARO
LI·CRIVELLI
VENETI

·1486·

BERT─S ─SIASTICA

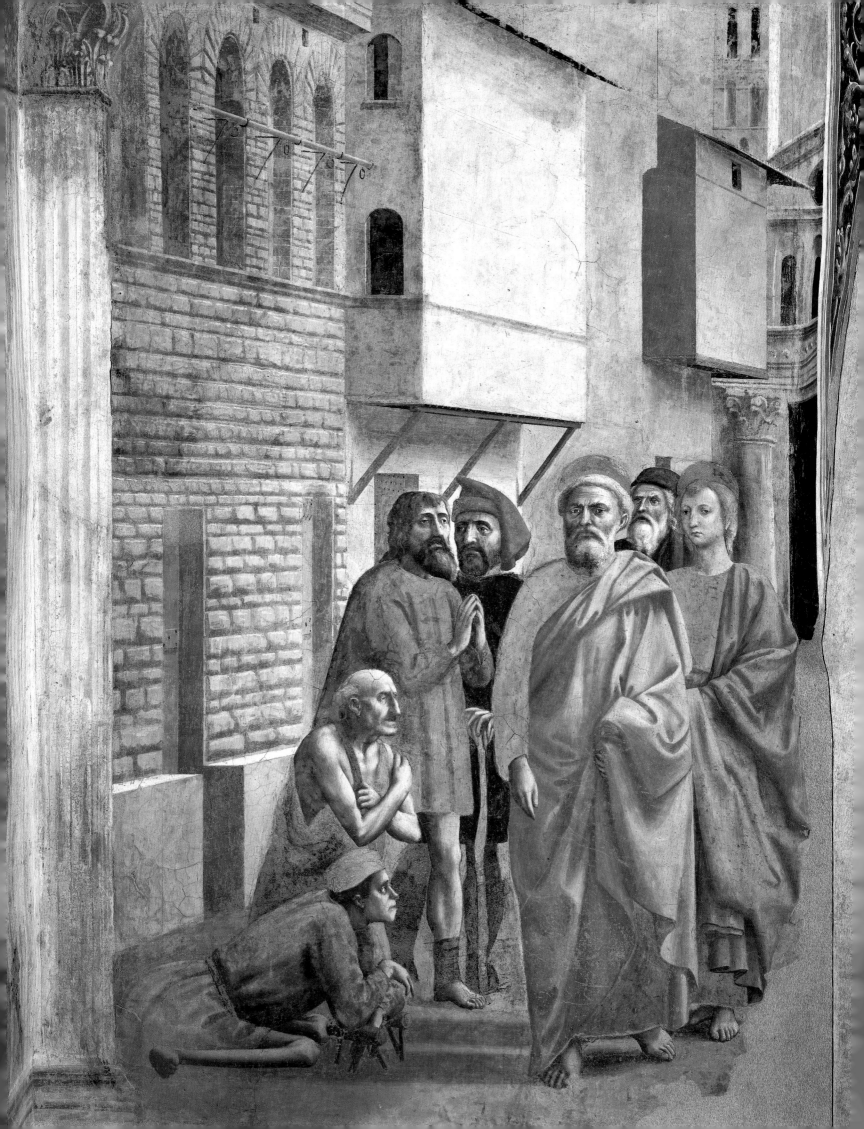

1428) – who also pioneered the use of single vanishing-point perspective. One of the clearest, most powerful uses of light is in his fresco of *St Peter Healing with his Shadow* (see opposite), part of the decoration of the Brancacci Chapel in Florence. The scene is depicted on the left of the altar, with a window above the altar – so the light comes into the right of the painted image as if from the window in the chapel, as Cennini specified.

With his customary blue and yellow robes, Peter is clearly the most prominent person in the narrative. Behind him is a young man in red and green: John the Evangelist. The lighting can be seen best on Peter's face, the right of which (from our point of view) is brilliantly illuminated, while the left is in deep shadow. This gives a strong sense of the sculptural form of the face. The same is true of the buildings in the background. All of the walls on the façades are well lit, whereas the elements that face the viewer are in shadow, and the rustication of the nearest building is clearly articulated by the light and shade: we can believe in these as solid and real buildings. They are, however, not buildings that Peter himself would have recognized, but an image of the streets of Florence that the congregation would see when they left the chapel. Like the solidity and realism of individual objects, the familiarity of the setting would have helped the contemporary audience to relate to this story.

As Peter walks toward us, his shadow is cast onto the floor across the front of the fresco (notice how Masaccio has lit his left foot to emphasize the movement). On the left of the painting are three figures. The nearest is crouched down in an exaggerated, awkward posture, leaning on wooden supports: he is clearly crippled. Further back another man is kneeling, and the third standing. This sequence is like an animation – as if the figures are standing up as Peter passes. The story comes from the Acts of the Apostles:

"And by the hands of the apostles were many signs and wonders wrought among the people ... Insomuch that they brought forth the sick into the streets, and laid them on beds and couches, that at least the shadow of Peter passing by

FAMILIAR FACES
One way to help the contemporary audience to engage with the story being depicted in a work of art was to include portraits of recognizable figures of the day. Alberti was aware of this, and suggested that, "Where the face of some well-known and worthy man is put in the *istoria* ... that well-known face will draw to itself first of all the eyes of anyone who looks at the *istoria*." For example, it has been suggested that the man with his hands raised in prayer in Masaccio's *St Peter Healing with his Shadow* (see opposite) is a portrait of Donatello. In another painting, now lost, Masaccio was said to have included portraits of many notable Florentines, such as Donatello, Brunelleschi and members of the Medici and Brancacci families. Other examples include the likenesses of artists such as Michelangelo and himself that Raphael included in the *School of Athens* (see pages 148–151).

might overshadow some of them. There came also a multitude out of the cities round about unto Jerusalem, bringing sick folks, and them which were vexed with unclean spirits: and they were healed every one." (Acts 5.12, 5.15–16)

Masaccio has embodied the "multitude" of the biblical narrative with just three people. As Peter passes they are touched by his shadow, they are healed and can stand up. Without an ability to paint the real world as we see it, Masaccio could not have made Peter look solid, nor could he have painted the flat floor along which he walks and on which the shadow is cast. These artistic innovations allowed the story to be depicted convincingly. The spiritual results of the healing are also shown. Those who have been healed are looking toward the right of the image, and so toward the real-life altar and window of the chapel: they have been converted, and have, quite literally, seen the light.

◐ ST PETER HEALING WITH HIS SHADOW
Masaccio, 1425–1426 (BRANCACCI CHAPEL, S. MARIA DEL CARMINE, FLORENCE)

Alberti: *see page 15;* **apostles:** *see pages 102 and 122–123;* **colour:** *see pages 44–47;* **istoria:** *see page 15;* **St John the Evangelist:** *see pages 106 and 123;* **the Medici:** *see pages 42, 186–187, 198–199 and 202;* **perspective:** *see pages 52–55;* **St Peter:** *see pages 95, 106 and 128–129;* **portraiture:** *see page 88;* **rustication:** *see page 202*

PERSPECTIVE

The first description of the technique for painting single vanishing-point perspective was included in Alberti's *Della Pittura* in the mid-1430s. It is a technique used by Ghiberti in his relief of the *Story of Isaac* (see opposite), one of the panels from the second set of doors he created for the Florentine Baptistery, known as the "Gates of Paradise". Isaac is seen standing prominently on a small step at the left of the relief talking to his son Esau. He can also be seen seated to the right, where he has been tricked into blessing Jacob, the slightly younger twin of Esau. The rest of the story is spread around the surface of the relief in the spaces that Ghiberti has been able to create through his control of perspective. It is not clear when this relief was modelled, but as he was given the contract for the doors in 1425, and they were erected in 1452 their creation spans the writing of *Della Pittura*. It seems likely that Ghiberti and Alberti would have discussed perspective, and it is also possible that both learned from Brunelleschi, who first developed it. The extent to which they shared the technique can be seen by comparing Ghiberti's relief to Alberti's text:

"First of all about where I draw. I inscribe a quadrangle of right angles [i.e. a rectangle], as large as I wish, which is considered to be an open window through which I see what I want to paint. Here I determine as it pleases me the size of the men in my picture. I divide the length of this man in three parts. These parts are to me proportional to that measurement called a *braccio* … With these *braccia* I divide the base line of the rectangle into as many parts as it will receive."

The diagram (see opposite, left) shows that this is exactly what Ghiberti has done: the measurement from the step on which Isaac is standing to the top of his head is precisely the length of three of the tiles which make up the floor. As the grid shows, he has used this as a unit all over the relief.

Alberti goes on to describe the positioning of what is now known as the vanishing point, which he calls the "centric"

point, as it is the position from which a central ray in the visual field will pass directly into the eye of the beholder:

"Then, within this quadrangle … I make a point where the central ray strikes. For this it is called the centric point. This point is properly placed when it is no higher from the base of the quadrangle than the height of the man that I have to paint there. Thus both the beholder and the painted thing he sees will appear to be on the same plane. The centric point being located as I said, I draw straight lines from it to each division placed on the base line of the quadrangle."

Again, this is just what Ghiberti has done. The vanishing point is at Isaac's eye-level, and the receding lines of the pavement – known as the orthogonals – are traced from the divisions at the front to the vanishing point (see diagram opposite, right). The horizontal lines, parallel to the front of the image, are known as the transversals. Alberti says that there is more than one way of doing this. His description relies on imagining that you are standing looking down at the pavement of tiles through the surface of the painting: the lines of sight cross through the surface, and this is where you should draw the transversals. However, you can do this diagrammatically by using the edge of the image as if it were the front.

Ghiberti has used a slightly different technique: imagining a close viewing distance, he drew diagonals from the edge of the relief at Isaac's eye-level to the divisions at the front, and placed the transversals where these crossed the orthogonals and each other.

The Uses of Perspective

Even in the early fourteenth century Giotto had been able to depict a convincing three-dimensional space, but many artists were simply not interested in realism – or illusionism – and preferred to paint in a flattened, decorative style. As with the use of directional lighting, it was the rationalization of perspective that was important for the Renaissance, and it

Alberti: *see page 15;* **Alberti's "window":** *see page 15;* **Florence Baptistery:** *see pages 22–23;* **Gates of Paradise:** *see page 119;* **Ghiberti and Brunelleschi:** *see pages 22–23;* **Giotto:** *see pages 16–17;* **Isaac:** *see pages 22–23;* **man as a measure:** *see page 15*

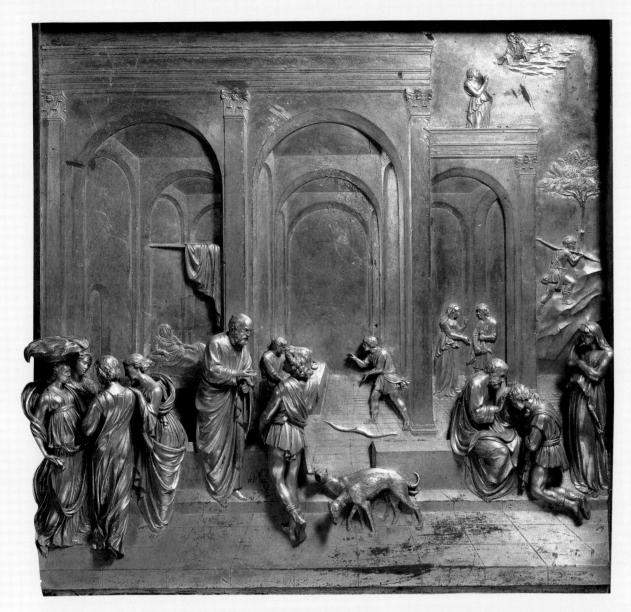

◀ STORY OF ISAAC (FROM THE "GATES OF PARADISE")

Lorenzo Ghiberti, 1425–1452 (BAPTISTERY, FLORENCE)

As the two diagrams below the main image illustrate, Ghiberti has applied the principles of perspective described by his contemporary Alberti (see main text, opposite). The size of the panel is directly related to the size of Isaac: it is a square whose side is three times his height (see below, left). The second diagram (see below, right) shows the vanishing point (1). Lines traced from this point to the front of the pavement, and from the edges of the relief (2) to the front, cross each other, and so define the position of the transversals, the horizontal lines that get gradually closer together as the pavement floor recedes into the distance.

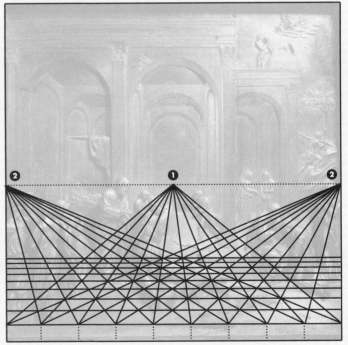

was Brunelleschi who was responsible for this. In about 1415 he created two demonstration panels, now sadly lost, showing the Florentine Baptistery and the Piazza della Signoria in perspective, which were said to be remarkable for their realism: it was not for another twenty years that artists were able to study the technique in *Della Pittura*.

The main reason for the development and use of perspective was to make pictures – whether painted or carved in low relief – look real. However, this was not merely a display of artistic skill, but a means to assist artists to communicate with their audience, and to convey the *istoria* ("story"), to use the word used by Alberti. Medieval paintings were more or less flat, with elements arranged vertically on the picture plane, rather than placed realistically in space, so that they could all be seen. Such works would impress with their size and scale and with the richness of their materials. For paintings using perspective, the viewer gets a sense of what a space would look like if it were real. What is more, the vanishing point is supposedly at our eye-level: it is theoretically our

⬇ ADORATION OF THE MAGI
Masaccio, 1426 (STAATLICHE MUSEEN, BERLIN)

This panel was originally positioned below the *Madonna and Child* (see opposite) on the Pisa Altarpiece. The vanishing point of the *Madonna and Child* – the Christ Child's foot – becomes the focus of this scene, placing the viewer in the same act of homage as the magi.

point of view, how we would see this scene, making it far more personal to us. This focus on man as the starting point for our understanding of the world and how we see it is essential to the development of the Renaissance.

In Masaccio's *Madonna and Child* (see opposite) the vanishing point is defined by the throne on which Mary sits, and although the only real orthogonals are at the top of the throne and on the sides at a level with Jesus' head, the vanishing point is easy to determine. It is at our eye-level: we are clearly looking down onto the step on which the angels are sitting in the foreground, and also down onto the step on which Mary's feet rest. However we look up to the parts of the throne which define the perspective, but cannot see the level at which Mary is seated. This is, therefore, our eye-level, and is indeed at the level of the vanishing point.

The use of perspective implies that Mary and Jesus are in the same physical space as us, but in case this seems sacrilegious, we should realize that they are above us. In fact our eyes, as defined by the vanishing point, are directed toward the Child's foot. The reasoning behind this is made clear if we look at the painting that was originally located in the central part of the predella, directly beneath the *Madonna and Child*. It shows the *Adoration of the Magi* (see below), with the eldest magus kneeling in humility in front of the Child in the act of kissing his right foot. Although they are clothed

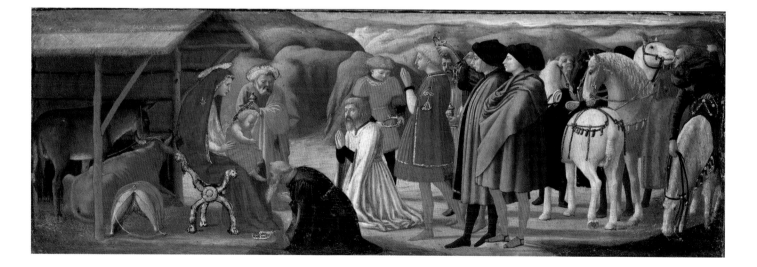

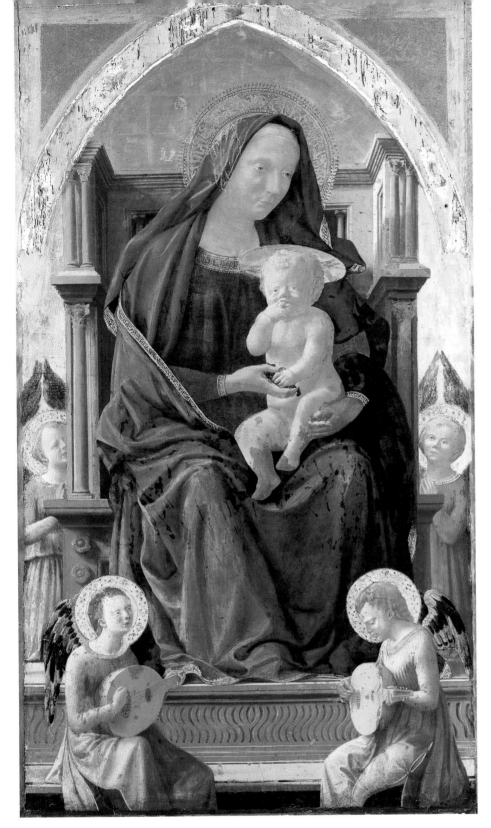

⚫ MADONNA AND CHILD
(THE "PISA MADONNA")
Masaccio, 1426 (NATIONAL GALLERY, LONDON)

Painted for the church of Santa Maria del
Carmine in Pisa, this is the oldest surviving
panel painting that uses a coherent single-
vanishing point perspective. As the diagram
(below) shows, it is the throne on which Mary
is seated that defines the perspective. The
vanishing point – the point to which our
gaze is directed – is at the toes of the Christ
Child's right foot.

differently and seated on a different chair, the image of Mary
and Jesus is nevertheless equivalent to that in the main
panel: they are in more or less the same position, but seen
from the side. The implication is that when looking at the
main panel we should have the same attitude as the magus:
we are imagined to be kneeling in front of Mary, and could
lean forward to kiss Jesus' foot.

Thus perspective can be used to foster an illusion of real-
ity, creating a space that we could theoretically reconstruct,
or even enter – the orthogonals effectively lead us into the
picture, involving us in a way that might not happen in a
flatter image. And it is also used to direct our attention to an
important part of the image, or convey meaning by implying
what position we might occupy within the scene.

illusionism: *see pages 39, 172, 190 and 214–215;* orthogonals: *see pages 52–53*

PROPORTION

The reason why perspective appears realistic is that everything is in proportion – the further away something is, the smaller it appears to be: there is a direct mathematical relationship between its apparent distance and its apparent size. Thus when a painting is in perspective, size reveals how near someone is, unlike many medieval paintings, such as Jacopo di Cione's *Coronation of the Virgin* (see pages 106–107), in which size determines how important they are: the bigger they are, the more important they seem. The Renaissance artist could of course achieve both aims: by placing someone in the foreground of a painting he or she would look bigger, and also have more prominence, so the more important people tend to be shown further forward.

However, in order to depict things realistically it was also important to keep the proportions of each individual figure as close to nature as possible – and this was especially relevant to the human form. This idea is given its most iconic illustration in a drawing by Leonardo da Vinci (see below), known as the "Vitruvian Man" because it illustrates a theory about the proportions of the body recorded by Vitruvius in the third of his *Ten Books on Architecture*:

"If a man be placed flat on his back, with his hands and feet extended, and a pair of compasses centred at his navel … the fingers and toes of his two hands and feet will touch the circumference of a circle described therefrom. And just as the human body yields a circular outline, so too a square figure may be found from it. For if we measure the distance from the soles of the feet to the top of the head, and then apply that measure to the outstretched arms, the breadth will be found to be the same as the height."

Leonardo has illustrated this idea in a clear and elegant drawing, in which he also explores other proportions within the human body: he has divided the height of the man into four equal units at the chest, the hips and the knees, dividing the span with the same divisions at the elbows. The notes around the drawing – in Leonardo's typical left-handed back-to-front writing – are about these proportions and their relationship to the height of the man.

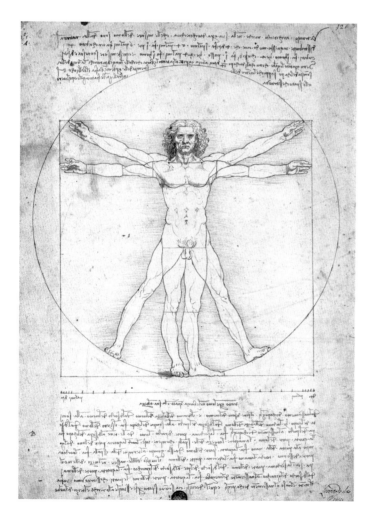

◖ PROPORTIONS OF THE HUMAN FIGURE ("VITRUVIAN MAN")
Leonardo da Vinci, ca. 1487 (ACCADEMIA, VENICE)

This celebrated drawing by Leonardo strives to attain the ideal – a perfectly proportioned man confirming Vitruvius's geometrical formula. However, Leonardo's later investigations of the human body and its appearance would stress its great variety of forms. As well as carrying out thorough studies of human anatomy, he was one of the artists responsible for the development of caricature.

circle and square: *see page 137;* **geometry:** *see pages 58–61;* **idealism and variety (Plato and Aristotle):** *see pages 150–151;* **Leonardo da Vinci:** *see page 6;* **man as a measure:** *see page 15;* **Vitruvius:** *see pages 26 and 28–29*

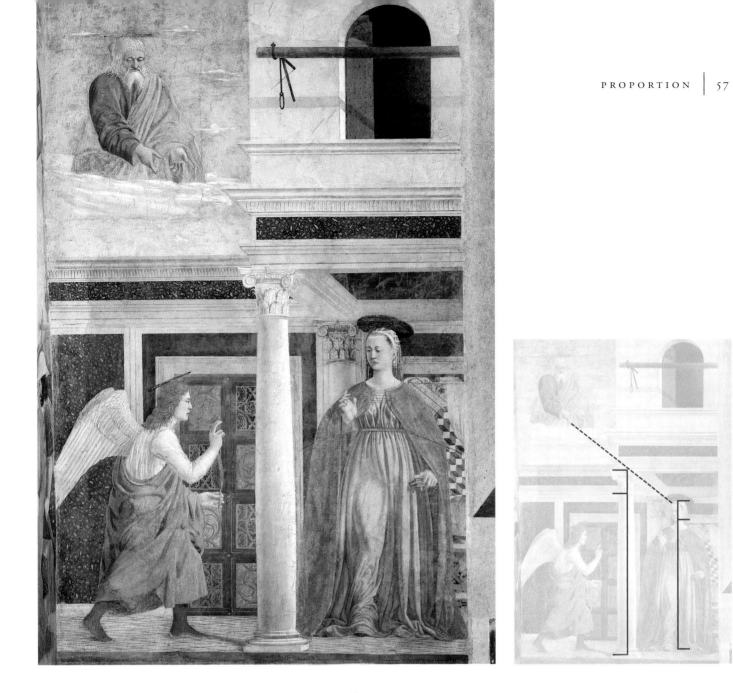

However, one might wonder why Vitruvius is talking about human proportions in a book on architecture. It is because he wanted buildings to be harmonious and well proportioned, in the same way that a body is: only then would the buildings suit our needs. As he himself said:

"Without symmetry and proportion there can be no principles in the design of any temple, that is, if there is no precise relation between its members, as in the case of those of a well shaped man."

These ideas were followed by many of the artists and architects working in the Renaissance and beyond, and help us to understand why order and symmetry were of such importance in the construction of buildings and the composition of paintings.

○ ANNUNCIATION
Piero della Francesca, 1452–1466 (S. FRANCESCO, AREZZO)

The relationship between the proportions of the human body and those used in architecture is present even in the terminology. The word "capital", for example, comes from the Latin *caput*, meaning "head". This link is explicit here: Mary stands under a portico, with an upper storey held up by two columns. The architrave that they are supporting forms a diagonal line which traces part of an imaginary path from God's hand to Mary's head (see diagram, above). And the ratio of the height of the capitals to the total height of the columns equates to that of Mary's head to her height. The merchant community would have seen this straight away. Any boy destined to go into any trade would have had a similar schooling. Among the sums he would have learned was how to calculate the weight of a column given its height and circumference and the density of the marble. This use of forms familiar to potential viewers through a shared educational experience was another way of getting the audience to engage with the work.

Annunciation: *see pages 48 and 80–81;* **architrave:** *see page 28;* **capital:** *see page 28;* **symmetry and harmony:** *see pages 58–61, 137 and 146*

SACRED GEOMETRY

The interest in proportions was not just for aesthetic reasons: there were also theological concerns associated with the subject. The study of mathematics may have been developed by men, but its laws were believed to define the underlying structure of the universe, and so, it was concluded, must have been created by God himself. The idea, expressed in the Book of Proverbs, that God had "set a compass" on his creation led some theologians to think of him as a "divine mathematician". He had created a world in which the sun, moon and stars rotated in perfect circles around the Earth: it was only humans, in the form of Adam and Eve, who had spoiled it. One of the reasons for creating balanced and ordered paintings and buildings was to try to restore a sense of God's creation: the geometry and symmetry themselves contain a sense of the divine.

One of the proofs for this notion was constituted by Pythagoras's discoveries about musical harmony, illustrated in a treatise on musical theory published in Naples in 1480 (see below). Each separate picture includes elements of different sizes which are labelled with the same numbers. At the bottom right, the men are blowing pipes which are labelled 8 and 16, and one is twice as long as the other. These two pipes will play the same note, but the shorter one will be an octave higher (there are seven notes, named from A to G, in the musical scale, an octave being the interval between two notes of the same letter). So the ratio 1:2 represents an octave. The ratio 2:3, on the other hand, represented by the pipes labelled 4 and 6, or 8 and 12, creates the interval known as a fifth (five notes on the musical scale), while the ratio 3:4 (the pipes labelled 9 and 12, or 12 and 16) creates a fourth. In fact, the scale with its seven notes is created by a series of simple number ratios: this is part of the mathematical order of the universe. The fact that there were also considered to be seven heavenly bodies (in addition to the sun and the moon, only five of the planets were known) led philosophers to associate the two, giving rise to the idea of the music of the spheres: God's perfect and harmonious universe. Seven also related to the act of creation itself, which took six days, with the seventh as a day of rest.

The number seven thus acquired particular significance. It is the sum of three and four, the former being important because it is the number of the Trinity (God the Father, Son and Holy Spirit), and the latter for many reasons, not least of

◐ **FRONTISPIECE TO** *THEORICA MUSICE*
Franchino Gafurio, 1480 (NAPLES)

The number sequence on the title page of this book about musical theory was thought to relate to not only music but the entire cosmos.

Adam and Eve: *see pages 74 and 120–121;* **heaven and Earth:** *see pages 136–143;* **Holy Trinity:** *see page 96;* **proportion:** *see pages 56–57;* **Pythagoras:** *see page 150*

◯ PORTRAIT OF LUCA PACIOLI

Jacopo de' Barbari, 1495 (CAPODIMONTE, NAPLES)

It was not only simple number ratios which fascinated the Renaissance mind: in 1509 Luca Pacioli published a book called *De Divina Proportione* ("On the divine proportion"). A particular ratio struck Pacioli as one that occurred in nature with such regularity that it must have been instituted by God himself. This proportion has become known as the "golden ratio". Pacioli, as this portrait suggests, was a Franciscan monk as well as a mathematician. He knew Leonardo da Vinci and Piero della Francesca, and shared mathematical ideas with them. Here he is demonstrating an obscure aspect of Euclid's geometry, which explains how to draw an equilateral fifteen-sided figure by drawing first an equilateral triangle, and then a pentagon. The pentagon is of particular interest as the triangle made between its base and apex contains the golden ratio. The triangular shape formed by the figure of Pacioli (see right) echoes the geometrical theme of the painting, which is also evoked by the dodecahedron, made up of twelve pentagons, bottom right, and the hanging rhombicuboctahedron, top left.

Euclid: *see page 151;* **golden ratio:** *see page 61;* **Leonardo da Vinci:** *see page 6*

⬥ MARTYRDOM OF ST SEBASTIAN

Antonio and Piero del Pollaiuolo, 1475 (NATIONAL GALLERY, LONDON)

The geometrical arrangement of the figures is particularly intricate. The upper diagram shows
how the composition of the work is based around the "golden triangle" (see main text, opposite).
The lower diagram illustrates Antonio's use of rotational symmetry: the three archers numbered
1 are in the same position as each other, but seen from different angles. Similarly, the two
executioners numbered 2 are in identical poses but are facing in opposite directions.

St Sebastian: *see page 38*

which was the inclusion of four gospels, Matthew, Mark, Luke and John, in the New Testament. Their product is twelve, the number of the tribes of Israel, of Jesus' apostles, and, for that matter, of the months of the year. For the medieval and Renaissance mind, this harmony was a sign of God's presence in all things.

Subtle Symmetry

The *Martyrdom of St Sebastian* by Antonio and Piero del Pollaiuolo (see opposite) is one of the crowning achievements of the Early Renaissance. At first glance it may appear entirely realistic. Antonio, the elder of the two brothers, would have been the head of the workshop and was responsible for the overall design, and also seems to have been responsible for the majority of the painting. Vasari believed him to have been the first artist to carry out dissections on the human body, and there is certainly evidence here to suggest that he had good anatomical knowledge. The bodies are in proportion, and we can see not only where the clothes are under the drapery, but also where the muscles, bones and even veins and tendons are under the skin.

Similarly, the landscape is real: objects get smaller the further away they are, and there is an atmospheric haze in the distance. However, in other respects this is not a realistic painting. The six archers would be unlikely to arrange themselves in this formation: apart from anything else, if those at the front missed they might hit those at the back. They are arranged in a pyramidal composition – ideally balanced for aesthetic effect, perhaps, but it is not quite so simple. The diagram (see opposite, above) shows that they are arranged in a very specific triangle, the one which forms the basis of the pentagon. This particular isosceles triangle (meaning that two of the angles are the same, and two sides have the same length) is sometimes known as the "golden triangle", because the ratio of the short and long sides is the golden ratio. A golden rectangle has the same proportions, and if you cut a square from it, the remaining rectangle will also be "golden": snail shells, among numerous other natural

phenomena, grow according to this ratio. In the same way, if you bisect one of the two equal angles in the golden triangle, one of the triangles created is "golden". Although pyramidal structures are often used to create stability in a composition, the use of this particular triangle is relatively rare. (Raphael was to use it about thirty years later in a depiction of the Crucifixion – see page 89.)

Why Pollaiuolo chose to use this triangle is not clear, but it was definitely deliberate. If a pentagram is superimposed on it, then the heads of the archers at the back coincide with the horizontal, and the base of the tree to which Sebastian is tied falls at the intersection at the centre of the original triangle. The level at which Sebastian is standing is at half the height of the triangle. Nevertheless, Sebastian's head does not coincide with the top of the triangle. The painting has been trimmed in the past: you can see this from the way in which the elbows of the archers are cut off on either side. Although there is no evidence that it was as tall as the height of the triangle suggests, part of the meaning of the structure can be inferred by the direction of Sebastian's gaze: up toward heaven. The summit of the triangle may be intended to suggest the presence of God, and the overriding symmetry to imply a divine plan. Even in acts of violence like this God's purpose can be seen.

However, it is not just the composition which is geometrical. The inner two executioners are both bending down to load their crossbows: both in the same position but facing in different directions (see diagram opposite, below). Similarly, the men at the front left and right, and at the back right, are standing in the same way. This is rotational symmetry, in which objects are the same shape, but you have to turn them round to get them into the same position. Although this is related to sacred geometry, it is also a game played with the viewer, and designed to show off the artist's ability. It is very much an intellectual idea: whereas in the Middle Ages painters were seen as artisans and craftsmen who used their hands, in this painting Antonio is showing that he can also use his mind – a central development in Renaissance art.

anatomy: *see page 74;* **apostles:** *see pages 102 and 122–123;* **collaboration:** *see pages 19 and 208–209;* **Evangelists:** *see page 102;* **landscape painting:** *see pages 70–73;* **months:** *see page 142;* **twelve:** *see pages 102, 122 and 136–137*

WHERE & WHY

The arrangement of the elements in a painting, known as the composition, is extremely important, and more often than not forms part of its meaning. In deciding the composition of a work the artist is aiming to communicate something, which may be purely artistic (for example, balance, beauty, chaos), or it may relate to other issues, such as morality or status. Both these meanings can be seen in Giotto's fresco of the *Last Judgment* in the Scrovegni Chapel in Padua (see opposite). Although the other paintings for the chapel, illustrating the lives of Mary and Jesus, are strongly three-dimensional, this iconic scene, which expounds ideas rather than telling a story, is quite flat, and the different elements are spread out on the picture plane so that they can be seen clearly.

Christ sits in judgment in the centre of the painting. The position of the other figures in relation to him – whether to his left or right, alongside him or below him – is heavy with significance. Giotto's inspiration for the composition is clearly biblical:

"When the Son of man shall come in his glory, and all the holy angels with him, then shall he sit upon the throne of his glory. And before him shall be gathered all nations: and he shall separate them one from another, as a shepherd divideth his sheep from the goats. And he shall set the sheep on his right hand, but the goats on the left." (Matthew 25.31–33).

Style and Substance

The composition of a painting is not only related to its meaning, but also to the period in which it was painted. This is amply illustrated by two altarpieces painted in Venice in the sixteenth century by artists from different generations working in very different styles. Bellini's *Sacra Conversazione* (see page 64), painted as the high altar of the church of San Zaccaria, dates from 1505. The painting is extremely balanced. The Madonna and Child are enthroned, and an angelic musician sits on the steps in front of them. They are

◐ LAST JUDGMENT

Giotto, ca. 1303–1305 (SCROVEGNI CHAPEL, PADUA)

The largest of Giotto's fresco cycle decorating the Scrovegni Chapel, the *Last Judgment* fills the wall above the main entrance to the chapel.

A clear moral distinction was made between right and left. At the bottom of the painting, the **naked bodies of the blessed** climb out of their tombs (see left). Although on our left in the painting, they are at Christ's right, and he raises his right hand to imply they will be saved, and will join him in heaven. Several souls, now clothed, are escorted by angels at the bottom left of the painting.

The palm of Christ's left hand is turned down, and rivers of fire sweep the unrighteous down to hell, where the **souls of the sinful** (see right) are punished. The moral implications of left and right survive in the English language. Dextrous, from the Latin "dexter" ("right") implies you are good with your hands, whereas the Latin for "left" is "sinister": left-handed people were considered fundamentally suspect.

Consequently, the best place to be is at Christ's right hand (to the left of him, as we look at the painting). The closest person to Christ on his right is **St Peter** (see left): Peter is, to use another phrase that survives in English, his "right-hand man", and the place occupied by Peter is known as the "position of honour".

Seated to Christ's left is **St Paul** (see right). This is not a bad place to be: he is, after all, alongside Christ, rather than before him in judgment. The remaining apostles are on the same level, which indicates their high status, although there is a sense that the closer they are to the throne the more important they are.

There is also a contrast between up and down. Christ's right hand raises the blessed up to heaven, whereas with **his left hand** (see left) the damned are sent down to hell. The idea that heaven is "up" and hell "down" survives even when perspective is used, although a person further up the picture surface may actually be further back in space.

apostles: *see pages 102 and 122–123;* **Early Renaissance:** *see pages 16 and 19–20;* **Giotto:** *see pages 16–17;* **St Paul:** *see pages 102 and 108;* **St Peter:** *see pages 95, 106 and 128–129;* **Scrovegni Chapel:** *see page 17;* **stories and statements:** *see pages 94–97*

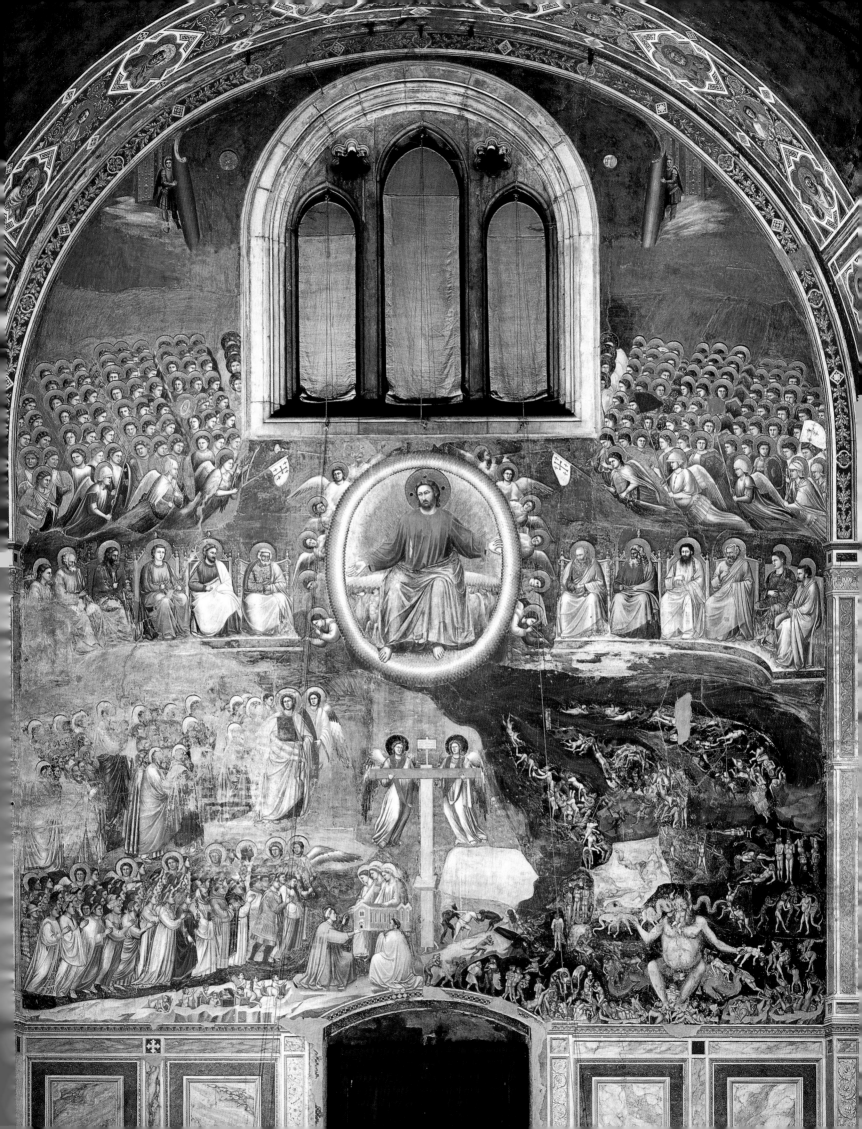

flanked by four saints, Peter and Catherine on our left and Lucy and Zacharias on our right. In each case the male saint stands in the foreground facing the viewer, and the female saint is positioned further back and in profile.

This symmetrical composition helps to create the reverential air for which Bellini's paintings are famed. This is enhanced by the harmonious and balanced disposition of colours and the soft, atmospheric light which is diffused throughout the space. Even though this is the type of painting known as a *sacra conversazione*, or "holy conversation", the figures do not talk, or even look at each other; they maintain a contemplative and reverential silence. Within this

ordered structure there are subtle references to status. The Madonna and Child are clearly the most important, because they are in the centre, and, although seated, they are also higher in the painting. The saints at Mary's right hand (our left) are presumably of higher status than those on her left. Zacharias was the father of John the Baptist, and was the titular saint of the church. Although the patron saint would often take the position of honour, Zacharias is a relatively minor figure, and certainly subordinate to St Peter, hence his position to Mary's left.

The two male saints are given prominence, and therefore status, by being placed closer to us, whereas the female saints are given status because they are closer to the Virgin. Nevertheless, they are partly hidden by the male figures – a feature that may relate to the nature of the building itself. San Zaccaria was a convent, and for the nuns who lived there this depiction of holy but secluded virgin martyrs would have had direct relevance. Like Catherine and Lucy, the nuns would have been considered closer to God and yet they were hidden from view. The perspective used makes the viewer's status clear. Our point of view is level with that of the angel, at the Virgin's feet: we must look up to them all.

Tintoretto's painting (see opposite) is a complete contrast. It would be hard to identify the subject of the painting as "Saints George and Louis of Toulouse", given that the most prominent feature is a crowned princess apparently riding a dragon. These are merely attributes of St George, included in the painting to tell us who he is, so why does Tintoretto make them so prominent? And why does he make the princess ride the dragon, something that does not happen in any account of the story? And why does St Louis appear to be looking over his shoulder with such disdain? This is all a

◀ SACRA CONVERSAZIONE
Giovanni Bellini, 1505 (S. ZACCARIA, VENICE)

Bellini's elegiac painting was made for the high altar of San Zaccaria in Venice. The continuity of the painted architecture and the design of the frame would have enhanced the realism of the image – making it look as if the holy figures were in a portico just behind the altar.

attributes: *see pages 36–38;* **St Catherine:** *see page 109;* **St George:** *see pages 75–76 and 194;* **St John the Baptist:** *see page 108;* **St Lucy:** *see page 108;* **Madonna and Child:** *see pages 214–215;* **male and female:** *see pages 86–89;* **perspective:** *see pages 52–55;* **St Peter:** *see pages 95, 106 and 128–129;* **position of honour:** *see page 62;* **symmetry and harmony:** *see pages 58–61, 137 and 146*

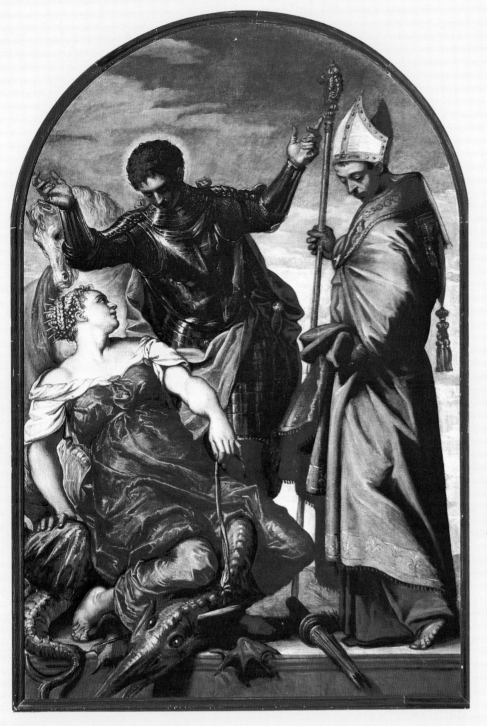

◀ **SAINTS GEORGE AND LOUIS
OF TOULOUSE**
Jacopo Robusti (Tintoretto), ca. 1552
(ACCADEMIA, VENICE)

Both St George and St Louis were popular
figures in the Christian world. George, and
his defeat of the dragon, came to represent
the triumph of Christianity over paganism,
whereas Louis was seen as an exemplar
of virtue. Born to be king of Naples, he
abdicated to become a Franciscan monk
and died in poverty tending to the sick.

result of the development of the concept of "art" – of what it can do and what it is for. Although this is still a devotional painting, it is also a chance for Tintoretto to show his skill, depicting the bodies not just with realism, but also with movement and drama. In many ways, though, this goes against Alberti's idea that the artist's main aim should be to illustrate his *istoria* as clearly and appropriately as possible. It does not have the balance and symmetry of Bellini's work,

and clearly belongs to the later style, Mannerism. A product of the High Renaissance, the precise limits and definition of Mannerism are much debated, but it implies that the "rules" are being broken. Thus colour, light, composition and perspective are often used not to create realism and focus the viewer's attention on the most significant part of the image, but to scatter attention across the surface and impress with bravura displays of skill.

Alberti: *see page 15;* **broken lance:** *see page 194;* **High Renaissance:** *see page 16; **istoria:** see page 15;* **Mannerism:** *see page 21*

OLD & NEW

Just because "Renaissance" means "rebirth" it should not be assumed that all of the ideas were new. One of the driving forces behind developments was a growing interest in and knowledge of classical culture and civilization. The way in which "old" and "new" things – whether ideas or objects – were used by artists and architects is indicative of the extent to which classical ideas were actually accepted and adapted.

The survival of classical ruins allowed artists and architects to study Roman buildings at first hand, but there was also Vitruvius's *Ten Books on Architecture*, which became an increasingly important literary source. A large number of sculptures also survived. However, classical painting was unknown: the majority of the examples that we have today were not discovered until the eighteenth century. Consequently, the influence of the "old" on painting was restricted to depictions inspired by ruins, sculptures or, more commonly, features derived from references to classical literary sources. In the attempt to renew the arts, and indeed culture generally, the fifteenth-century Italians tried to emulate their classical forebears by adopting similar habits and practices. What were new forms in Renaissance art – such as the

medal, the small bronze and the portrait bust – were in fact revivals of forms widely adopted in the distant past.

Different cities saw their relationship to the classical past in different ways. The Byzantine Empire was the last bastion of the Roman Empire, and after its capital, Constantinople, had been sacked by the Venetians in 1204 the doge (or duke) of Venice was given the title "Ruler of a quarter and half a quarter of the Roman Empire": this sense of being heir to ancient Rome survived in Venice into the Renaissance era. The Florentines had the advantage that, unlike Venice, their city really was Roman in origin, but they also referred to it as the "New Athens on the Arno", believing that they shared the wealth of culture and sophisticated debate enjoyed by the ancient Greeks. Despite its obvious claim to be the inheritor of the illustrious legacy of the past, the once-great city of Rome was relatively unimportant at the beginning of the fifteenth century. However, the papacy made the link with the classical past explicit by claiming the title "Pontifex Maximus" (meaning Supreme Pontiff, or High Priest), which had once been given to Roman emperors as head of the pagan state cult.

○ RAPE OF GANYMEDE
After Michelangelo, MID-1500S (ROYAL LIBRARY, WINDSOR)

This drawing was long considered to be by Michelangelo, but is in all probability a copy by one of his followers: the original has been lost. It illustrates a story from Ovid's *Metamorphoses*. Jupiter, king of the gods, disguised himself as an eagle in order to capture the beautiful shepherd-boy Ganymede and take him as a lover. Even though homosexuality was illegal during the Renaissance, the story remained popular, partly because it was seen as allegorical: in the humanist interpretation the story represents the journey made by the human soul (Ganymede) toward God.

Jupiter: *see page 114;* **medals:** *see pages 15 and 40;* **small bronzes:** *see page 24;* **Venice:** *see pages 176–177;* **Vitruvius:** *see pages 26 and 28–29*

One's social standing at this time might be enhanced by implying a good knowledge of classical ideas. This could be displayed in your choice of imagery, hence the commissioning of classically inspired paintings, sculptures or buildings. It could also be made clear by the extent of your library, or collections of classical artefacts. On these terms, Lorenzo Lotto's portrait of Andrea Odoni (see above) marks the subject as one of the "in crowd" of the Renaissance. In his right hand Odoni clasps a statuette of Diana of Ephesus, while behind him are three sculptures of Hercules (the one on the left shows Hercules fighting with Antaeus) and one of Venus

⬥ PORTRAIT OF ANDREA ODONI
Lorenzo Lotto, 1527 (ROYAL COLLECTION, WINDSOR)

bathing. In the foreground is another Venus, and a bust of Emperor Hadrian. The attitude toward the classical past was, however, extremely complex: these were, after all, pagan gods, and the society was profoundly Christian. In his left hand Odoni holds a small gold crucifix: he may be interested in the sculpture of the past, but it is the true faith which is close to his heart.

classical artefacts: *see page 144;* **Hercules:** *see page 114;* **Hercules and Antaeus:** *see page 24;* **libraries:** *see pages 166–169;* **Venus:** *see page 114*

Conflicting Attitudes

Although many leading figures embraced the culture of learning based on the classical past, the Church was frequently in conflict with this idea of "progress" (see box, below). However, this attitude did not hold for every member of the Church. Pope Julius II was himself one of the great collectors of classical statuary, and he commissioned Bramante to build the octagonal courtyard in which his collection can be seen to this day. It had eight doors leading into it, but in the early 1520s the notably dour Dutch pope, Hadrian VI, shut off all the doors except one. However, he did not destroy the sculpture, leaving it as a lesson as to the depths of depravity into which the ancients had sunk.

Despite these conflicting attitudes, the interest in the classical past continued, although it was often given a moralizing slant. The study of mythology was justified on the basis that the ancients must have "heard" the word of God, but had misunderstood it. Thus Jupiter, king of the gods, was their version of the Christian God, whereas Juno, queen of the heavens, was a version of Mary, the queen of heaven.

The myths themselves were seen as allegorical, illustrating Christian ideals, as in the somewhat surprising interpretation of the rape of Ganymede by Jupiter (see page 66).

There was in any case a moral to be learned from the fact that the Roman Empire had fallen. One message of the Odoni portrait (see page 67) is that all of these pagan deities were now fragmented, and the civilization which created them had passed away, whereas God's kingdom would endure forever. This idea is often present in Christian imagery, such as the Madonna and Child by a follower of Verrocchio (see opposite). Although we think of Jesus being born in a stable, the Bible does not specify a location. However, the setting was unlikely to be a classical ruin: the building is clearly symbolic. The ruination of the building has a number of different implications. Augustine, in his book *De Civitate Dei* ("On the City of God") contrasts the perfection of God's city with the decay of the Roman Empire: the ruin represents the fall of classical civilization, which is followed by the growth of the Christian realm. Another reference is given by Jesus himself, when he says "Think not that I am come to destroy the law, or the prophets: I am not come to destroy, but to fulfil" (Matthew 5.17). His fulfilment of the Law of Moses nevertheless changed its direction, and the ruin can also represent the "Old Dispensation", while Jesus symbolizes the new. The use of a pagan temple is therefore a generic reference to old forms of worship which are superseded by Christ's birth. A final reference also comes from Jesus. When asked for a sign, he replied "Destroy this temple, and in three days I will raise it up" (John 2.19). The reference was to his own body and resurrection. The ruined temple of this painting could therefore also refer to Christ's future death, and to the triumph over worldly concerns that is constituted by his resurrection.

THE BONFIRE OF THE VANITIES

One of the most notable opponents of the Renaissance interest in the classical past was Girolamo Savonarola (1452–1498), a Dominican monk who became the prior of San Marco in Florence, and took control of the city after the expulsion of the Medici in 1494. He lamented the sinful ways into which the Florentines had fallen and ordered the Bonfire of the Vanities, in which works of classical literature and depictions of pagan gods were burned in the Piazza della Signoria, along with profane paintings, excessively fashionable clothing, hairpieces and mirrors: all were condemned equally. However, his time in power was shortlived: in 1495 he was charged with heresy and excommunicated two years later. Following popular uprisings in protest at the Bonfire of the Vanities, Savonarola was executed in 1498. Florence returned to republican rule and in 1512 the Medici regained power.

○ VIRGIN ADORING THE INFANT CHRIST
Workshop of Andrea del Verrocchio, 1470 (NATIONAL GALLERY OF SCOTLAND, EDINBURGH)

St Augustine: *see pages 104 and 172–173;* **Bramante:** *see page 146;* **classical "misinterpretation" of the Christian truth:** *see page 150;* **Julius II:** *see pages 83–85;* **Madonna and Child:** *see pages 215–215;* **Moses:** *see page 120;* **Resurrection:** *see pages 120 and 215;* **Roman Empire:** *see page 174;* **Verrocchio:** *see page 19*

THE WORLD AROUND US

There are many ways in which a painting can be "realistic" – it might be through the use of single vanishing-point perspective, which is a reasonable approximation to the way in which we see space and the variation of size with distance, or perhaps through the use of a coherent light source, which will model objects in three dimensions. However, this is a "theoretical" realism, and not quite the same as the careful depiction of the world around us. Alberti advocated using nature as an inspiration: his observation that the portrait of a well-known person within a painting will engage the viewer's attention has already been noted, and he went on to say, "For this reason always take from nature that which you wish to paint, and always choose the most beautiful."

As well as painting animals and plants realistically, a convincing setting also became important, and a recognizable landscape became increasingly more valued than a flat gold background. However, not all artists will approach this notion of realism in the same way: there is often more than one style in vogue at any one time, and Florence in the Early Renaissance was no exception. Gentile da Fabriano's *Adoration of the Magi* (see opposite) was painted in 1423, just three years before Masaccio's "Pisa Madonna" (see page 55), and yet the styles are extremely different. Whereas Masaccio conquers single vanishing-point perspective and the use of a single coherent light source, Gentile's use of space is far more intuitive (but certainly no less interesting), and his depiction of light is both varied and evocative.

Gentile's realism is different from that of Masaccio, and is constituted by a very careful and detailed depiction of individual elements, with a rich variety of animals and plants. In the main panel these are mainly on the right. There are two horses seen from different points of view, and a dog turning round after it has been kicked by one of the horses. Further back there are also monkeys and camels, as well as birds flying through the air, including a hawk owned by one of the sporting members of the kings' retinue. These details are not essential to the story, but they do imply that the magi were wealthy and influential people who could afford to support a large entourage. They also add to the variety of the image, and act as a display of the artist's skill, and therefore also of the wealth of the patron, Palla Strozzi, who is shown facing us just above and to the right of the youngest magus. However, not everyone was happy with the sumptuous nature of such images. St Antoninus, who before he was canonized had been one of Savonarola's predecessors as prior of San Marco, and was later bishop of Florence, said, "… to paint curiosities into the stories of saints and in churches, things that do not serve to arouse devotion but laughter and vain thoughts – monkeys, and dogs chasing hares and so on, or gratuitously elaborate costumes – this I think unnecessary and vain." The frescoes painted in San Marco by Fra Angelico and his workshop are notably devoid of these details.

However, overall the painting cannot be said to be realistic. Even if each item depicted is very life-like – as are the delicately painted flowers which seem to grow out of the frame (see detail, opposite) – the composition of the main panel is incredibly crowded, and there is no coherent sense of the landscape. This combination of rich materials, vivid colours and realism in individual details if not in the overall composition belongs to the transition between the late medieval period and the Early Renaissance, and is sometimes known as the International or Courtly Style.

Looking at the Landscape

Although artists such as Gentile da Fabriano were including naturalistic elements in their paintings in the 1420s, the realistic depiction of landscape had to wait a little longer. In Italy it was very much influenced by the popularity of paintings from northern Europe, such as Rogier van der Weyden's *Entombment* (see page 18). The northern interest in the

Fra Angelico: *see page 127;* Early Renaissance: *see pages 16 and 19–20;* International Style: *see page 17;* light: *see pages 48–51;* magi: *see pages 54–55, 108 and 151;* Monastery of San Marco: *see page 127;* perspective: *see pages 52–55;* portraits within paintings: *see page 51;* Savonarola: *see page 68;* the Strozzi: *see page 186*

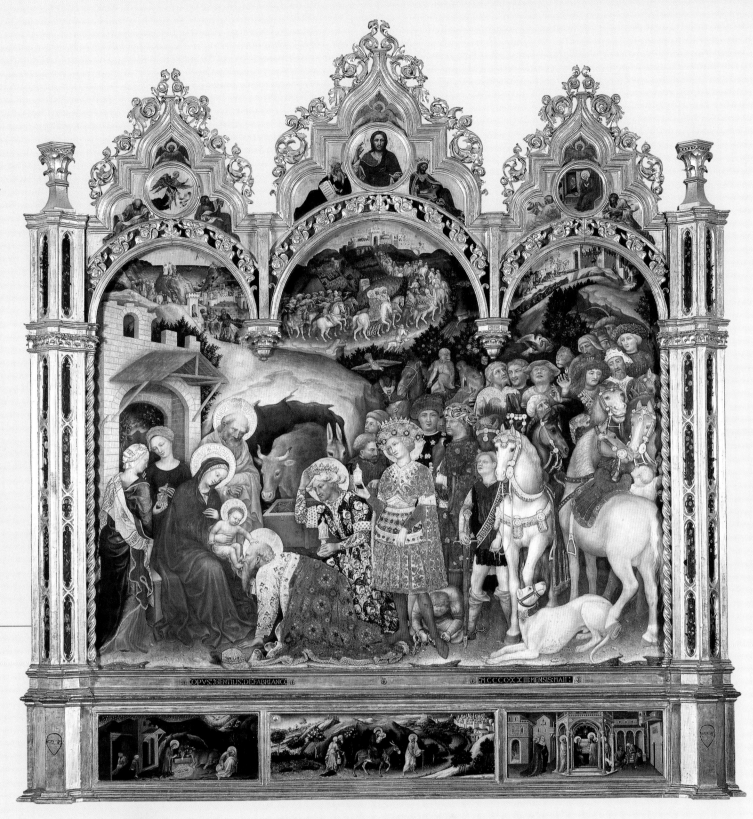

⬡ ADORATION OF THE MAGI

Gentile da Fabriano, 1423 (UFFIZI, FLORENCE)

The richness of materials used to produce this altarpiece makes it one of the most splendid of the 15th century. The painting also boasts an astonishing profusion of detail, such as the irises which appear to be growing within the trellis-like frame (see detail, left). As well as showing Gentile's skill at realistic representation, they can also be interpreted symbolically. With their sword-shaped leaves (indeed, the German for iris is *Schwertlilie*, "sword lily"), they refer to Simeon's statement to Mary: "a sword shall pierce through thy own soul" (Luke 2.35).

gold: *see page 48;* **objects and their meanings:** *see pages 36–39;* **pastiglio:** *see page 103*

realism of detail, of surface texture and of landscape resulted from an intuitive appreciation of space and light which was more akin to the spirit of Gentile's work than the rational approach of Masaccio.

Landscapes were included in the background of many of the religious paintings and portraits which were imported into Italy, often by merchants who had been working "beyond the Alps". When artists in the Italian states started to emulate these works they either copied sections of the landscapes from the paintings, or headed out to observe their own countryside. When this was combined with the understanding of perspective fostered in Florence from earlier in the century the results were impressive. The landscape

○ STUDY OF A TUSCAN LANDSCAPE
Leonardo da Vinci, 1473 (UFFIZI, FLORENCE)

Leonardo's drawing of the Tuscan landscape is dated, at the top left, 5th August 1473: it is the first dated landscape drawing to survive, and as such is a remarkable document of the developing interest in the world that we see all around us. It is not surprising that we owe this to Leonardo, whose investigations of nature would later lead him toward studies that we would see as scientific rather than artistic – an attempt to understand and quantify the world, which was at the heart of much Renaissance endeavour. The drawing is a record of what he saw on a particular day, the date recorded as if to clarify that it would not have looked the same on other occasions. This attitude in itself, let alone the trembling movement of the trees created by the slightly curving and free-formed horizontal strokes of the pen, is worthy of the Impressionists and their interest in the "here and now" which would not be manifested for another 400 years.

Leonardo da Vinci: *see page 6;* **northern European painting:** *see page 18*

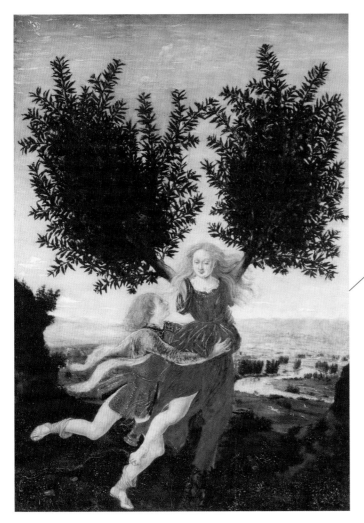

◐ APOLLO AND DAPHNE
Antonio del Pollaiuolo, ca. 1470–1480 (NATIONAL GALLERY, LONDON)

Like the Rape of Ganymede (see page 66), the story of Apollo and Daphne comes from Ovid's *Metamorphoses*. Cupid, angered by an insult from Apollo, shot the sun god with a golden arrow and the beautiful nymph Daphne with one made of lead. While Apollo was inflamed with passion the opposite was true for Daphne, who had in any case sworn a vow of eternal chastity. During the chase which ensued, Daphne called out to her father, a river god, to save her virtue by whatever means he could, and he obliged by transforming her into a laurel tree. Roots shot from her toes and branches from her hands, and by the time Apollo threw his arms around her body he found he was touching bark.

we see in Antonio del Pollaiuolo's *Apollo and Daphne* (see above) features the Arno, the river running through Florence, and a minute depiction of the city and its cathedral in the distance. As well as its use of linear perspective, demonstrated by the way in which objects get smaller the further away they are, even if there are no actual lines of perspective in the painting, it also shows a clear mastery of atmospheric perspective. This is the way in which the air, or atmosphere, changes the appearance of distant objects: they are fainter, and appear hazy, with distant mountains being given a bluish tinge as if the sky has got in the way. Given that the painting measures only 29.5 × 20 cm (12 × 8 in) – roughly the size of an A4 (US letter-size) sheet of paper – the detail in

the background is miraculous: the cathedral itself is only 2 or 3 mm (⅒ in) high.

Why Pollaiuolo should set this story within the Tuscan landscape is not clear. For religious paintings, such as his *Martyrdom of St Sebastian* (see page 60), it would imply that Florence is seen as holy. However, here too the realistic depiction of the landscape makes the story itself more credible, and the artist would be applauded for making the mythical seem real. The small proportions of the painting suggest it was created as a luxury item, to be held in the hand and treasured, and Antonio's skill at depicting a known place so well on such a tiny scale would have added not only to its value, but also to the praise due to the artist.

Apollo: *see page 114;* **Florence cathedral:** *see pages 26–27;* **perspective:** *see pages 52–55*

BODY & MIND

The realistic depiction of the human body has been mentioned so far in relation to the appreciation of its proportions, as seen in Leonardo's drawing of the "Vitruvian Man" (see page 56), and in the anatomical realism of Antonio del Pollaiuolo's figures in his *Martyrdom of St Sebastian* (see

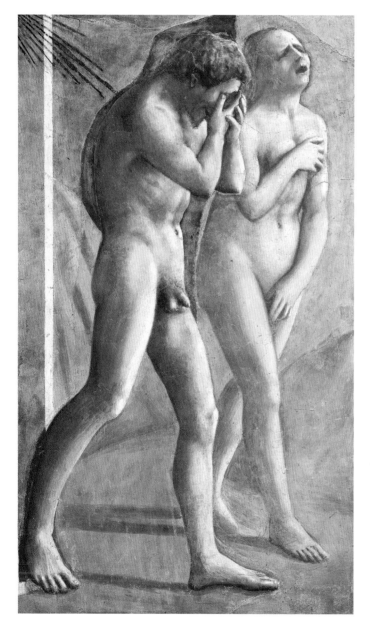

page 60). Antonio's knowledge of human anatomy may have come from his observation of dissections, and it is known that Leonardo dissected bodies himself and recorded his findings in numerous highly detailed drawings. However, not all artists were interested in a realistic depiction of the human form: Botticelli notably distorts the body in favour of elegant and flowing lines, and Mannerist artists such as Bronzino exaggerated the possibilities of complex poses to create intriguing, if physically improbable, compositions.

Even for artists who were interested in anatomical accuracy, another realism became important: the depiction of a psychological truth, and the ability to portray emotions. Grief, particularly at the crucifixion and entombment of Christ, were commonly shown, but as paintings and sculptures moved away from iconic and symbolic representations toward something viewers could identify with rather than simply identify, then the ability to depict realistic and subtle emotions became more important. As Alberti was aware, a person's mental state can be judged from "the movements of the body": this was something he could have seen in the work of Donatello, an early master of psychological realism, and one of the artists he praised in *Della Pittura*. According to Vasari, Michelangelo is reported as having said of Donatello's

◑ **EXPULSION**

Masaccio, CA. 1424–1427 (BRANCACCI CHAPEL, S. MARIA DEL CARMINE, FLORENCE)

Although Masaccio's appreciation of the human form was not equal to that of Antonio del Pollaiuolo, painting half a century later, there is still a strong sense of the human physique in this work. Masaccio uses the contrasting physical reactions of Adam and Eve to pinpoint a psychological difference between them. Whereas Eve covers her body, in imitation of a classical *Venus pudica*, Adam covers his face. It is as if Adam is ashamed of his mind and of his own identity, whereas Eve is ashamed of her body, her face distorted in an almost expressionistic display of grief.

Adam and Eve: *see page 120;* **Alberti:** *see page 15;* **distorted representations of the human form:** *see pages 20–21 and 214;* **gesture and body language:** *see pages 78–81;* **Leonardo da Vinci:** *see page 6;* **Mannerism:** *see page 21;* **Vasari:** *see pages 15 and 16;* **Vitruvius:** *see pages 26 and 28–29*

St Mark that, "he had never seen a sculpture that had more the air of a good man than this one, and that if St Mark were such a man, one could believe what he had written." The *St Mark* was commissioned by Florence's Linen Weavers' Guild for a niche on the oratory-cum-guildhall called Orsanmichele (see page 183), and soon afterwards Donatello created another trustworthy figure for a niche on the other side of the building, his *St George* (see above).

Earlier images of St George identified him by his chief attribute, the dragon, and he is often shown either on horseback dealing the fatal blow, or standing serenely atop the beast with his lance piercing its mouth. Although there is a narrative relief below the niche in which St George stands,

○ ST GEORGE

Donatello, ca. 1410–1415 (BARGELLO, FLORENCE)

Donatello created his *St George* for the Armourers' Guild. Originally, the sculpture would have held a sword in its right hand, projecting out over the heads of passers-by, and holes in the head show that it was also fitted with a helmet. Presumably, these items would have been made by a member of the guild, and this sculpture could be seen as an early form of product placement: even St George obtains his equipment from the armourers. The sculpture and niche were both carved for Orsanmichele, but replaced by replicas, which can be seen at the far left of the illustration on page 183.

guilds: *see pages 182–183;* **St Mark:** *see page 102*

⬧ LAMENTATION (and detail, opposite)
Niccolò dell'Arca, ca. 1463 (S. MARIA DELLA VITA, BOLOGNA)

Little is known about the life of Niccolò dell'Arca. He came from Apulia in southern Italy, but is known only through his work in Bologna. His acquired name derives from his work on the tomb ("arca") of St Dominic in the church of San Domenico, to which Michelangelo was later to contribute three small figures. Niccolò was not alone in creating terracotta sculptural groups. The medium was common in the region around Bologna because of the absence of quarried marble. The use of terracotta also has theological connotations. According to the Bible, "... the Lord God formed man of the dust of the ground" (Genesis 2.7): by modelling the human figure from clay the artist is effectively mimicking the act of Creation.

the sculpture itself shows no sign of the dragon. Donatello has rethought the representation, and imagined the saint's appearance before the fight. He stands firmly, with his legs apart, one hand resting on his shield, as he keeps watch. His head is twisted slightly to his left, and the pupils show that he is looking further in that direction. His eyebrows are slightly raised and pulled together, and his forehead is wrinkled with concentration and no little worry: Donatello is showing us how George feels as well as what he looks like. This heroic if tense characterization was to be particularly influential: naked, with his left hand raised to his shoulder and looking further to his left, it would be identical to Michelangelo's *David* (see page 9). Inspired by Donatello, Michelangelo does not include Goliath's head, but imagines David prior to his encounter with the giant.

Emotional Extremes

The development of psychological depth is one of the many ways in which artists increased their ability to communicate with their audience, a sense of empathy with the characters depicted being essential to an understanding of the stories in which they are involved. In many ways this goes back to St Francis of Assisi, whose ministry focused on the simple down-to-earth people rather than the rich and supposedly sophisticated. He realized that to achieve an understanding of Christ's message, it should be appreciated in human terms, and so Franciscan imagery often shows the most human moments of Jesus' life on Earth – his birth and death. It was Francis who popularized the Christmas crib, for example, believing that if people could see and hold a model of the baby Jesus they would understand the sacrifice God had made to become a helpless child. Images of the Crucifixion were also important to help us to imagine the suffering that Christ endured for our sake, and Francis himself carried an image of the Crucifixion in his own body, in the form of the stigmata, the wounds of Christ, which he miraculously received toward the end of his life.

If Christ suffered for mankind, a proper response ought to be grief at his death, an emotion both depicted and evoked by Niccolò dell'Arca's remarkable sculptural group (see left). Consisting of seven life-size figures modelled in terracotta, the astonishing depiction of a varied but extreme grief would originally have been all the more life-like as the sculptures were polychrome – painted with realistic colours. Time and changes in taste have resulted in the loss of most of the original colour, and at one point the sculptures were even painted white to look like marble. Even in their present form, though, the group is surprisingly emotive. The figure of the dead Christ lies in the centre of the group, with John the Evangelist standing silent at the back, his chin on his hand and his face contorted by grief. Next to John, bowed over with her hands clasped together is the Madonna, while Mary Magdalene runs in from the right (see detail, opposite), her elaborate costume flying out behind her, clinging

Crucifixion: *see pages 126–127;* **David:** *see pages 98–100;* **St Francis:** *see pages 78 and 108;* **infant Christ:** *see page 215;* **St John the Evangelist:** *see pages 106 and 123;* **Mary Magdalene:** *see pages 88–89 and 108;* **terracotta:** *see pages 24–25*

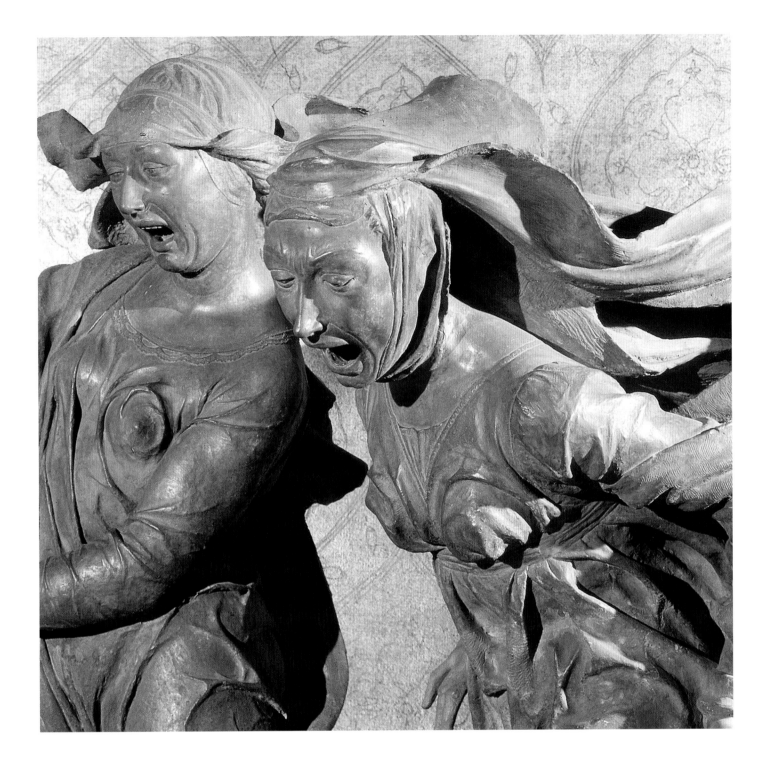

to her legs and torso, enabling us to see Niccolò's mastery of the human figure. The drapery is all the more remarkable when we realize that it is modelled from thin clay.

Two other holy women are present, adopting different, but equally contorted poses, their open mouths making it clear that, like the other two, they are crying – even wailing – with anguish. The volume of sound implied by the women's expressions is balanced by the suppressed sorrow of the two men. The kneeling figure on the left is Nicodemus, a follower of Christ, who holds in his left hand the nails with which Christ was crucified and in his right a mallet. He looks toward us, thus creating an emotional connection with the rest of the scene, which is enhanced by the arrangement of the sculptures. They are all placed on the other side of Christ, and we are therefore encouraged to join with the sculptures in a circle of mourning over the death of Jesus.

Alberti's chorus figure: *see page 15*

GESTURE &
BODY LANGUAGE

Human nature is such that certain aspects of body language and gesture have remained the same over many centuries, and any reasonably observant artist will be able to depict a narrative in such a way that it conveys what is going on even if we don't know the story. For example, in Masaccio's *Tribute Money* (see page 94), Christ and St Peter both point to the left of the image, and as Peter appears for a second time on the left, we can read the gestures as an instruction. Similarly, Granacci's soldier (see page 101) grasps his sword to show he is ready to fight, and Masolino's Christ opens his arms to welcome his mother into heaven (see page 105). Reading these gestures may not explain the origins of a situation, or for that matter its outcome, but at least we can determine what is happening in the image. This is certainly true for Sassetta's telling of the story of the Wolf of Gubbio (see opposite).

▶ LEGEND OF THE WOLF OF GUBBIO
Sassetta, 1437–1444 (NATIONAL GALLERY, LONDON)

This is just one of eight scenes telling the life of Francis of Assisi which were painted for the back of a double-sided altarpiece in the church of San Francesco in the city of Borgo San Sepolcro near Arezzo.

The wolf itself is seen on the far right of the image, its paw raised and in the left hand of Francis. The saint turns and gestures toward the **scribe** (see left), who is poised to write down instructions given to him by Francis. The reason for this unusual transaction is clarified by details in the space above the wolf's head.

Outside the city, on the edge of a forest, are human remains: a severed leg, and a head attached to a shoulder and arm. Further back, numerous **bones** (see left) are scattered beside a path that leads into the forest. It is clear from the location of these elements in relation to the wolf that the creature has been terrorizing the people of Gubbio, killing and eating them. St Francis, with

his legendary ability to talk to the animals, has come to negotiate with the wolf. It will leave the people alone on the condition that they provide it with an alternative source of food. However, the length of the scribe's parchment suggests that the wolf's dietary requirements are extensive!

The story is told from the few elements mentioned so far, but Sassetta has elaborated the narrative to create a complex image rich in human incident. The story takes place at the city gates. The **women** (see right) peer timidly over the battlements, while a group of men have come to observe the transaction. Each responds differently, their thoughts being communicated by their gestures.

Next to the scribe a conversation about the wolf takes place (see left). A **disembodied hand points at it**, and a man in a black hat turns back, looking into the city, with his **left hand spread out** at waist level, as if to say, "It's about this high". A blond youth holds his hands out, the left over the right, **imitating the wolf's jaws**.

Over the shoulder of the man with the large hat we can just see someone with his **hands together, praying** for a successful outcome (see right).

To the left of Francis is another Franciscan monk, who appears to have hidden his hands in the sleeves of his habit, perhaps fearful of being bitten, whereas behind the saint a braver citizen bends down toward the wolf in a gesture that is similar to that of Francis. This last gesture is particularly important: **the person is imitating Francis** (see below). Franciscan monks, some of whom commissioned this painting, were, in a more general sense, expected to do the same. And in imitating Francis, they were also imitating Christ. Francis's aim had been to return, as wholly and profoundly as possible, to the teachings of Christ. The extent of his success can be judged by the title given to him by his followers, as *alter Christi*, or "another Christ". This is hinted at in the body language in the painting: with his hands extended toward the wolf on one side and the scribe on the other, Francis takes up a position similar to that of Christ on the Cross, a similarity driven home by the stigmata visible in his left hand and his ribs.

Crucifixion: *see pages 126–127;* **St Francis:** *see pages 76 and 108;* **male and female:** *see pages 86–89;* **stigmata:** *see page 76;* **stories and statements:** *see pages 94–97*

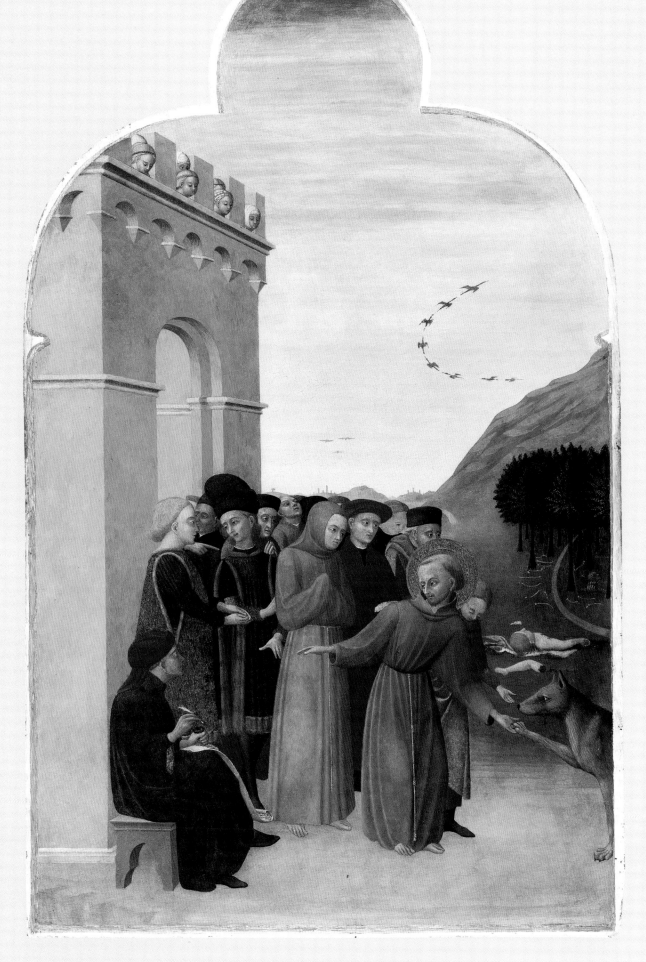

A Lost Language of Gesture

The thoughts of the people of Gubbio can be easily understood: even if the account on page 78 does not convey exactly what Sassetta intended, it cannot be far wrong. However, anyone travelling overseas will know that different gestures are used, or that the same gesture can mean different things. This is also true in art after a gap of some half a millennium. Nevertheless, some of these gestures recur sufficiently often for them to be interpreted. For example, in Crivelli's *Annunciation* (see page 49) Mary crosses her hands over her chest, a gesture also adopted by the Magdalene in Jacopo di Cione's *Coronation* (see detail, page 41), where it is adapted so she can hold the jar of ointment which is her attribute. This is an old gesture of prayer, also used by one of the sick men in Masaccio's *St Peter Healing with his Shadow* (see page 50).

That the interpretation of this gesture is accurate is confirmed by a historical source, a book written in the fifteenth century called *De Modo Orandi*, "On the manner of praying". It is illustrated with a series of woodcuts showing positions which can be adopted during prayer and the most appropriate accompanying gestures. One of these shows the hands crossed across the chest, while in another the two hands can be held up, palms open, in front of the body: this might explain the stance of St George in Tintoretto's painting (see page 65), although it would be a particularly flamboyant demonstration of that mode of prayer.

Printed material such as this can be very important, particularly when the image is combined with an explanatory text. One unexpected source is a book about chess, in which all of the pieces are illustrated as different characters. The Queen's Bishop's Pawn, for example, is characterized as an innkeeper (see below), and the inscription underneath it reads that, "… he took this form. It was a man who had his hand stretched out like a person who is inviting." In the illustration, not only is his hand stretched out, but the palm is also raised toward the person he is welcoming, with the fingers slightly curled. This gesture occurs in numerous paintings.

For example, in Botticelli's *Annunciation* (see opposite), Mary's right arm is almost identical to that of the innkeeper in the woodcut. It is at an angle, partly because it is extended down toward the angel, but also because her body is bent over in a gesture of humility. In fact, Mary is so keen to welcome the angel that she makes the gesture with both hands, perhaps to compensate for her initial shock, not only at the sight of the angel but also the implications of his greeting: that she, a virgin, would become pregnant, and would be the mother of God. The angel too adopts the same gesture, a reciprocal idea that shows their unity of purpose, which is also implied by the continuity of the diagonal formed by their two arms. This makes sense both as a gesture of greeting and as a gesture of invitation: while Mary is inviting the angel to enter her home, the angel invites Mary to accept God's purpose for her (Gabriel uses the same gesture in Crivelli's *Annunciation*).

⊙ THE INNKEEPER (WOODCUT FROM *LIBRO DI GIUOCHO DELLI SCACCHI* BY JACOBUS DE CESSOLIS)
ca. 1493 (FLORENCE)

Although the book from which this illustration comes is entitled "The Book of the Game of Chess", the work is in fact an allegory of the social order, pointing out how the roles of people in society are equivalent to the hierarchical arrangement of the pieces in a game of chess.

Annunciation: *see page 48;* archangel Gabriel: *see page 104*

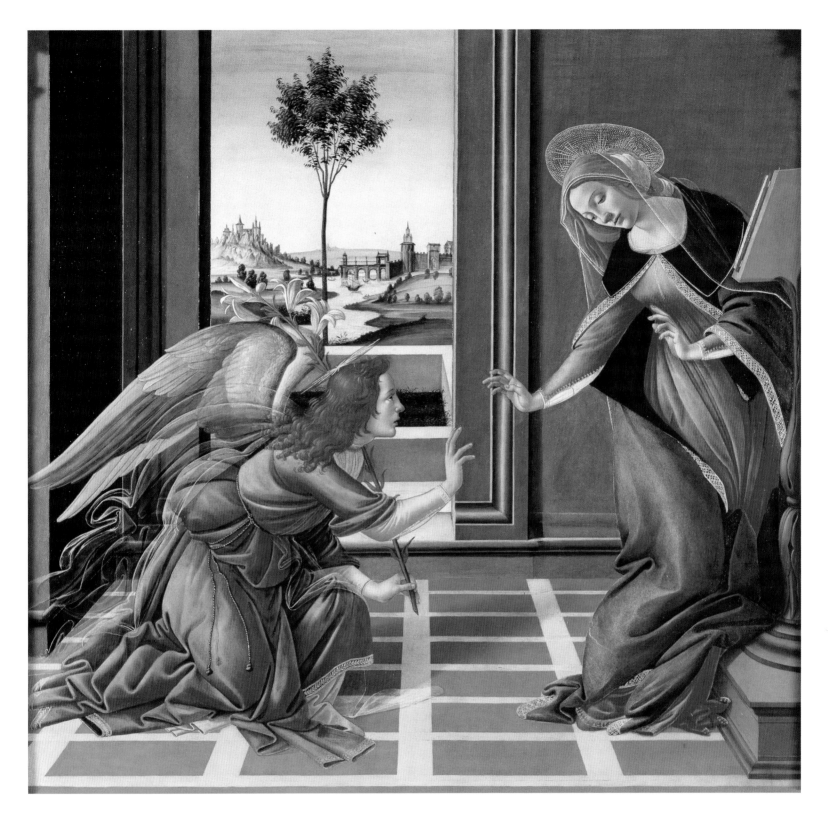

⬥ ANNUNCIATION

Sandro Botticelli, ca. 1489 (UFFIZI, FLORENCE)

As well as communicating through gestures, Botticelli's use of body language and expression is eloquent. Gabriel has been sent by God to tell the most perfect woman in creation about her imminent pregnancy. He kneels on the ground, crouched as low as possible in the presence of God's chosen vessel, and looks up at her with an expression of extreme awe. Mary, who has been standing at her lectern in prayer, is almost knocked sideways by the news. This display of shock and surprise is counteracted by her lean toward Gabriel, indicating acceptance of his news, while her face is cast down in reverence and humility. Behind Gabriel a door opens onto a walled garden. This is a reference to the Song of Solomon, which was interpreted as containing numerous allegorical references to the Virgin Mary. The verse, "A garden enclosed is my sister" (Song of Solomon 4.12), gives rise to the imagery of the *hortus conclusus*, or "closed garden", a symbol of Mary's virginity.

allegory: *see pages 158–165*

PATRONAGE

The appearance of Renaissance paintings, sculptures and buildings was determined by many things, but one of the unifying factors was money – artists and architects did what they were paid to do. Those paying – the patrons or donors – exercised a varying degree of control. As the concept of art and an appreciation of artistic genius developed, more enlightened patrons commissioned works on the understanding that they were paying for a talented individual's specific outlook on the world; they might allow the artist to do whatever he liked, but more often than not contracts were restrictive. The patrons would want to ensure that the finished work would fulfil their requirements.

There were (and are) many reasons for being a patron of the arts, but relatively few of them were connected to aesthetics. A contemporary statement can help us to understand the motivation of much patronage. It comes from Giovanni Rucellai (1403–1481), head of one of the leading

families in Florence in the fifteenth century, and the man who commissioned Leon Battista Alberti to complete the façade of Santa Maria Novella (see opposite), the principal Dominican church in the city. He said, quite simply, that his commissions served "the glory of God, the honour of the city, and the commemoration of myself".

Each of these in its own right might be a sufficient reason to commission art or architecture, but often they fed into one another. The creation of a church façade clearly added to God's glory, as it made his "house" more magnificent, and so a more worthy expression of the devotion that was due to him. In a similar vein, families often took responsibility for decorating individual chapels inside a church. Such activities also served to increase the honour of the city, as the more glorious the monuments that it could boast, then the better it would be regarded for its evident wealth, style and splendour. Even the construction of an imposing family palace, if done with taste, would improve the appearance of the city, and so could be presented as a generous act. However, both these reasons pale beside Rucellai's third, and surprisingly frank, motivation – the commemoration of himself. The decoration of chapels did improve the appearance of the churches, but they also provided a burial place for the family, and were often enhanced with family *imprese* and coats of arms – a blatant display of status and wealth. Similarly, whatever the addition to the appearance of a city, a fine palace was of far more benefit to its owners.

Rucellai's honesty is matched by the brazenness with which he is commemorated on the façade itself. Alberti did not design the whole thing, but completed a decoration that had already been started. To the lower half he added green half-columns and inserted a Renaissance frame around the central door (the side doors have notably gothic frames). The entablature supported by these columns has a frieze decorated with the sail of fortune, one of the Rucellai *imprese*.

THE PATRON–ARTIST RELATIONSHIP

The relationship between patron and artist varied from one commission to another. A private patron may commission an artist only once, or they may extend the arrangement. Vasari says that Cosimo "il Vecchio" de' Medici would commission work from the ageing Donatello to ensure that he kept busy: this seems to have been an act of friendship as much as anything else. Artists could also form lasting relationships with a certain organization, such as a guild, or be employed as members of a court: Mantegna was the court artist for the Gonzaga in Mantua, and had to ask permission to work for other patrons. Patrons tended to hold sway according to their status: Michelangelo's work was both propelled and disrupted by the succession of popes whose changing attitudes prevented him from completing one task, while forcing him to set to work on another.

Alberti: *see page 15;* the Gonzaga: *see pages 190–191;* guilds: *see pages 182–183; imprese: see pages 40 and 42–43;* Cosimo "il Vecchio" de' Medici: *see page 186;* power and wealth: *see pages 184–191;* the Rucellai: *see page 43;* sails: *see page 43;* Vasari: *see pages 15 and 16*

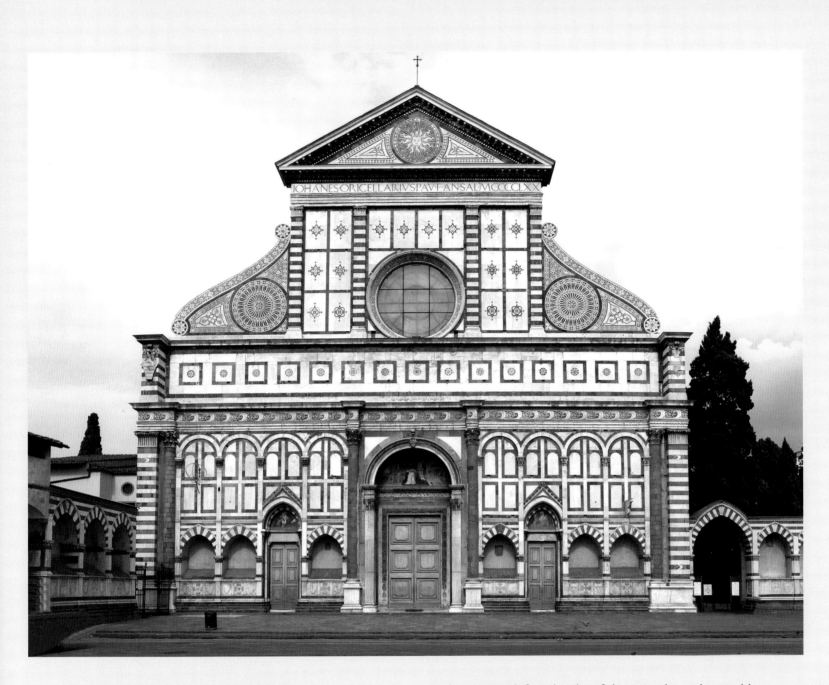

○ FAÇADE OF SANTA MARIA NOVELLA

Leon Battista Alberti, 1458–1470 (FLORENCE)

One of Alberti's challenges in completing the façade for Santa Maria Novella was to integrate classical architecture with the structure of a medieval church, which has a tall central nave and smaller aisles on both sides. To resolve this he placed a temple design – with a triangular pediment supported by four pilasters – on the broader lower section, linking the two with scrolls, or *volute*s, on each side.

At the extreme left and right of the strip above the entablature are the Rucellai coats of arms. But this is as nothing compared to the inscription in the frieze of the top "temple" façade. One might expect an inscription in praise of God, or relating to the dedication of the church to Mary. Instead, in an abbreviated Latin, is written "Giovanni Rucellai, son of Paolo, in the year of salvation 1470".

Julius II

One of the most influential patrons of Renaissance Italy was Pope Julius II (reigned 1503–1513), a member of the della Rovere family and nephew of Pope Sixtus IV. Whereas for a private family patronage was important to ensure that status was communicated and maintained, within the papacy there

the della Rovere: *see page 43;* **entablature:** *see page 28;* **Sixtus IV:** *see pages 175 and 198*

⬥ DISH WITH THE ARMS OF POPE JULIUS II

Workshop of Giovanni Maria Vasaro, 1508 (METROPOLITAN MUSEUM OF ART, NEW YORK)

This richly elaborated dish provides a telling insight into Julius II's priorities.

In the centre is the family coat of arms, the *rovere*, or oak tree, of the della Rovere family. Above that, and equally prominent, is the triple tiara and crossed keys that tell us he was pope.

At the bottom there are signs of Julius's warrior status – **axes, a quiver full of arrows, a shield and a sword** (see right) are arranged behind a coat of arms, with more weaponry on the left and right under two fauns. These mythical creatures, with goats' legs and horns, are clearly pagan.

Julius's love of music and literature is emphasized by the **books** (see left) at the top left and right, while the benefits of his papacy are represented by the two cornucopia – horns of plenty – on which two of the putti are standing.

Given that Julius was head of the Church, there is surprisingly little religious imagery. It is limited to the small cloth bearing the image of **Christ's face** (see right), held by the putto at the top of the dish.

are other factors to consider. One role of patronage is to commission works of art which reinforce the primacy of the institution – imagery of St Peter, Jesus' chosen successor, is often used in this respect. As the pope is elected, it is unlikely that the power of the papacy will remain for long with a particular family, and so popes often gave prominence to their own families within a commission. This occurs in Raphael's portrait of Julius II (see opposite), the back of whose chair is adorned with two gilt acorns, symbols used by the della Rovere in connection with their name.

It was also the case that popes would tend to build upon the patronage of family members who had preceded them. Julius's uncle, Sixtus IV (reigned 1471–1484), is remembered in the name of the chapel he had built in the 1470s: the Sistine. In the early 1480s he had the walls decorated by leading artists of the time, including Botticelli and Ghirlandaio. Julius continued this work by commissioning Michelangelo to paint the ceiling: whereas Sixtus's paintings showed the parallel lives of Moses and Jesus, Julius's ceiling illustrated the creation and fall of mankind. Thus the scheme was complementary, representing the world before the Law, the world under the Law of Moses, and then under Christ.

Sixtus also rebuilt the church of Santa Maria del Popolo, which Julius later extended. Raphael's portrait was painted to stand on the high altar of the church, to represent the presence of the pontiff even when he could not actually be in attendance. Papal patronage also extended to town planning. In addition to the Sistine Chapel, there is also a Sistine Bridge, still used as a footbridge over the River Tiber in Rome and originally constructed to assist the movement of pilgrims during the Jubilee of 1475. In his turn Julius commissioned roads leading from the bridge on either side, including the Via Giulia, which he named after himself.

Thus through his patronage Julius sought to strengthen the della Rovere name, which would continue to enhance its prestige even after he died and the family had lost control of the papacy. But there were other sides to his patronage. His name, Julius, was chosen in memory of Julius Caesar: he

keys: *see pages 128–129;* literature: *see pages 12–15;* **Moses:** *see page 120;* music: *see page 58;* oak tree and acorns: *see page 43;* St Peter: *see pages 95, 106 and 128–129;* **triple tiara:** *see page 103*

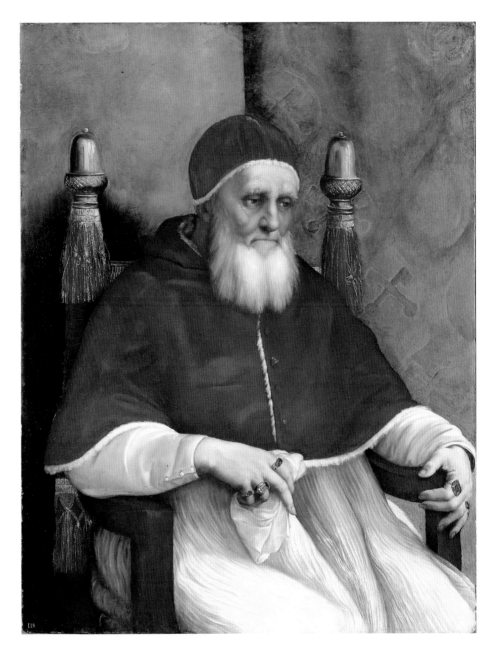

◗ JULIUS II
Raphael, 1511 (NATIONAL GALLERY, LONDON)

When the Papal States lost control of the city of Bologna in June 1511, Julius grew a beard, in imitation of the Roman emperors who would mourn the loss of their territories in the same way. Even as an old man, the two aspects of the pope's character, as both patron of the arts and warrior, are subtly conveyed by Raphael in the way he depicts the two hands. Whereas the "artistic" right hand delicately holds his silk handkerchief, the strong and claw-like left hand firmly grasps the arm of the chair.

intended to rule not just the Church but also, like Caesar, a considerable amount of the Italian peninsula. He was as well known as a soldier as he was as a priest. In imitation of the ancients he also amassed a considerable collection of classical sculptures, and commissioned Bramante to build an octagonal courtyard to house his collection. Bramante was also commissioned to connect the Vatican with the Palazzo Belvedere, built by Julius's predecessor Alexander VI, in the process constructing a garden reminiscent of classical Roman villas. Most importantly he also designed the new St Peter's, replacing the fourth-century Constantinian Basilica. At the same time Raphael was decorating Julius's private apartments, known as the Stanze, and Michelangelo was painting the Sistine ceiling. Few patrons can have had three such important and influential artists working for them at one time within what was effectively the same building.

Bramante: *see page 146;* **Stanze:** *see pages 134 and 150;* **villas:** *see page 202*

MALE & FEMALE

The roles of men and women were strictly defined in Renaissance culture. Men were expected to go out to work, rule or fight, whereas women would stay at home, caring for the household and the children – or at least ensuring that the staff did so. Women of any social standing would not be expected to work: their lives were confined to the domestic sphere, and rarely would they venture outdoors. Clues to these customs are visible in Piero della Francesca's portraits of Federigo da Montefeltro, duke of Urbino (see opposite), and his wife Battista Sforza (see left). Even without considering their clothes the characterization is notably different. Whereas Federigo's skin is tanned and wrinkled, and has a scattering of moles and blemishes, Battista's is clear, pale and without a mark: a tan might have implied too much exposure, and would have been regarded as "common". As with many other "princely" rulers, Federigo achieved his status and fortune by working as a *condottiere*: a mercenary soldier who is given the command of a group of men. His rough and rugged appearance displays his manly virtues, whereas Battista's pure and untarnished complexion embodies the feminine ideal.

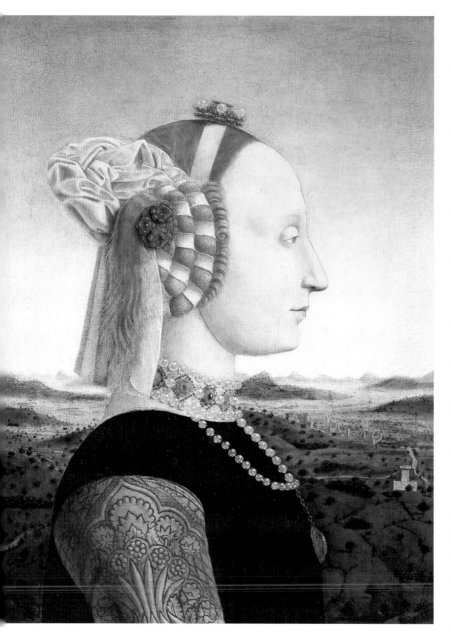

In this instance there are other factors that guide Piero's portrayal of the couple. Their placing, with Battista on the left, is unusual: traditionally the wife would be on the right – as they are, for example, in the kneeling donor portraits painted by Masaccio in his *Trinity* (see pages 210–213). So why did Piero swap them round? A clue is given by Federigo's bizarrely shaped nose, flat at the top under a particularly hollow eye socket. As a young man he had fought a joust in honour of a mistress he had seduced in the hollow of a blasted oak. He entered the field with his visor up, a sprig of oak attached to his helmet, and in the process he lost an eye. In line with Alberti's observation that "The ancients painted the portrait of Antigonos only from the part of the face where the eye was not lacking", Piero has depicted Federigo in left profile. After his foolish behaviour Federigo felt that he was punished for his sins, culminating in the death of Battista shortly after the long-awaited birth of a son. Her portrait may have been commissioned posthumously, giving added resonance to the pallor of her skin.

Alberti: *see page 15;* **Federigo da Montefeltro:** *see page 39;* **position of honour:** *see page 62;* **right and left:** *see page 62;* **war and peace:** *see pages 192–199*

Humility in the face of Battista's death might explain the simplicity of Federigo's dress. Red fabric was among the most expensive, and in some realms was specifically restricted to members of the ruling classes: as such it is ideal for Federigo. However, in other states, such as republican Florence, red clothing such as this might indicate a wealthy merchant. More than one member of the Medici family and their entourage wears a similar red beretta (a type of hat) in Benozzo Gozzoli's fresco of the *Procession of the Magi* (see page 187). Although displaying his wealth, through the choice of red, Federigo does little to display his status. In other portraits he is not only more elaborately dressed but also wears the Order of the Garter and the Order of the Ermine, which he was awarded by Edward IV of England and Ferrante of Naples respectively. Battista, on the other hand, appears tastefully decked with jewelry, in line with the idea that she reflects her husband's wealth and glory, and becomes, effectively, little more than a decorative attribute. Her hair is held in place by impressively set jewels, and the crown of her head is covered by a delicately painted transparent veil, held in place by a white band surmounted by another jeweled ornament. It is important that her head is covered, and her hair dressed: no woman of marriageable age would appear in public with her hair loose; she would not have been considered respectable.

Battista's dress is apparently simple: a dark-coloured bodice, with rich, gold brocade sleeves. The sleeves were usually detachable, and women could change an outfit simply by combining different bodices with different sleeves. However, there were laws to curb the use of dress as a means to make excessive displays of wealth. These were known as sumptuary laws, and might restrict, for example, the numbers of sleeves a woman was allowed to own, what materials could or could not be worn, or the number of rings people of a specific rank could wear. As a duchess Battista would have

⬇ PORTRAITS OF FEDERIGO DA MONTEFELTRO AND BATTISTA SFORZA
Piero della Francesca, ca. 1472 (UFFIZI, FLORENCE)

The portraits of Federigo (below) and Battista (opposite) are double-sided, and are both painted with an image of the sitter on a triumphal carriage on the other side.

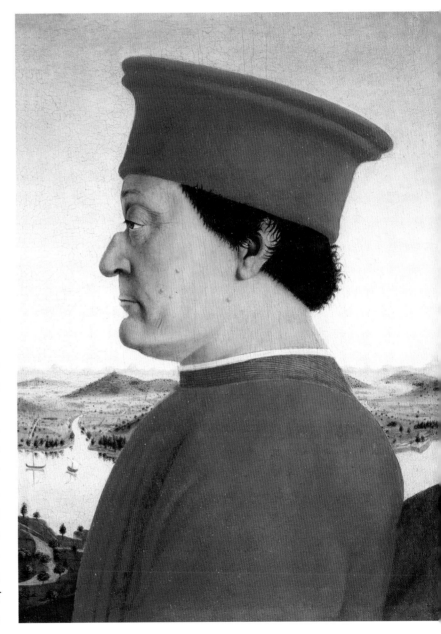

Ferrante of Naples: *see page 198;* **the Medici:** *see pages 42, 186–187, 198–199 and 202;* **portraiture:** *see page 88;* **sumptuary laws:** *see pages 184 and 200*

been exempt from such laws, but nevertheless, despite the wealth displayed in her jewelry, she is dressed in accordance with the modesty expected of a respectable woman.

The Place of Women

The women whose lives are reflected in art are almost inevitably those from the stratum of society that was commissioning art – the wealthy, and the ruling classes. For well-to-do women life was fairly predictable: they either married or embraced a life of religious retreat in a convent. Whereas working-class women might enter domestic service or become involved in some form of manufacturing or craft, such sources of income were less readily available to educated girls from impoverished branches of the gentility, who might conceivably embrace prostitution. The highest stratum of the world of prostitution was that of the courtesan, effectively a kept woman. It

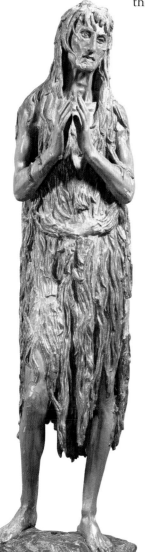

◀ MARY MAGDALENE

Donatello, ca. 1453–1455 (MUSEO DEL DUOMO, FLORENCE)

The figure of Mary Magdalene as understood from Renaissance art is a composite built up by the Catholic Church from biblical references which are now seen as representing at least three different people, and who have always been accepted as separate by the Eastern Church. Thus Mary was not necessarily the penitent prostitute forgiven by Christ. Donatello's haggard image draws on material that is not even biblical: after Christ's death and resurrection she is said to have withdrawn to the desert, and led her life in repentance, neglecting the beauty which had once been the source of her income. She also renounced fine clothing, and is dressed only in her own hair. This sculpture was commissioned for the Florentine Baptistery. Mary Magdalene's ascetic, desert life allied her with John the Baptist, often shown as similarly hirsute (although dressed in camel skin) and haggard.

even had some advantages over marriage: access to society, to the sources of learning, and to conversations with the richest and most intelligent members of society. As a result Venetian courtesans were among the most educated and talented women in European history before the nineteenth century.

As a wife you were expected to be at home and run the household, and images of women very often reflect this. Whereas portraits of men show their learning, their interests, or their strength as warriors, portraits of women show them as modest and retiring ideals of femininity. Thus male portraits show what the sitters are, whereas female portraits show what they should aspire to be.

At its extremes the depiction of women can be seen as polarized – they are shown as either "virgin" or "whore", and it is no coincidence that the two women closest to Jesus are interpreted in this light. In Raphael's *Crucifixion* (see opposite), the Virgin Mary stands to our left, and Mary Magdalene is kneeling on the right. She was identified with the sinful woman who washed Jesus' feet with oil (Luke 7.36–50), and her sin has traditionally been considered to be prostitution. Although condemned by the Church, prostitution was common throughout the Renaissance and sanctioned in different ways. In Venice, for example, there were specific areas where women were allowed to display themselves all but topless, and to this day there is more than one "Ponte delle tette", or "Bridge of the Breasts". Nevertheless, the example of Mary Magdalene was used to encourage repentance from sin, and to offer hope for women – particularly prostitutes – who had succumbed to temptation.

The Virgin, on the other hand, is a role model to which women should aspire. As a respectable matron, her head is completely covered by her cloak, whereas the kneeling Magdalene's hair can be seen (although it is tied up with a ribbon). As a contrast to this, the hair of the figure standing on our right falls freely, which tells us that he is male. Renaissance artists frequently depicted young men in an effete, even feminine way. (After all, boys have high voices and no beards, just like girls: this is a similarity often noted

Crucifixion: *see pages 126–127;* **Florence Baptistery:** *see pages 22–23, 52 and 119;* **St John the Baptist:** *see page 108;* **life and society:** *see pages 200–207;* **Mary Magdalene:** *see page 108*

CRUCIFIED CHRIST WITH THE VIRGIN MARY, SAINTS AND ANGELS (THE "MOND CRUCIFIXION")
Raphael, ca. 1502–1503 (NATIONAL GALLERY, LONDON)

The balance and symmetry of Raphael's *Crucifixion*, and its setting within a realistic landscape, place it at the heart of the Renaissance. However, it has some notably medieval features, such as the images of the sun and moon, with human faces, at top left and right, and the use of gold and silver leaf. The painting contains a strong mystical element, notably in the pyramidal structure which uses the same "golden triangle" as the Pollaiuolos' *Martyrdom of St Sebastian* (see page 60).

in Shakespeare, and used by him in the comedies that rely on mistaken identity and cross-dressing.) Wearing red and green, this young man can be identified as John the Evangelist who, like the Madonna and Mary Magdalene, was present at the Crucifixion according to the biblical narrative.

The second kneeling figure is St Jerome. As he lived in the fourth and fifth centuries, he could not have been present at

the Crucifixion, but is associated with the Magdalene because, like her, he went into the desert to repent. Unlike the three biblical figures, Jerome is imagined as being in front of an image of the Cross, as if seeing a vision. In a medieval painting this contradiction might not have been apparent: the realism favoured by the Renaissance disguises the symbolic nature of the representation.

golden ratio: *see page 61;* **St Jerome:** *see pages 36, 102 and 109;* **St John the Evangelist:** *see pages 106 and 123;* **landscape painting:** *see pages 70–73;* **realism:** *see pages 70–73;* **symmetry and harmony:** *see pages 58–61, 137 and 146*

FORM & FUNCTION

A lot can be learned about a work of art from its shape. Although we are most used to seeing rectangular paintings hung on the walls of galleries, this was not always the case: the concept of "art" as it is understood today simply did not exist then, and there were no true art galleries until the eighteenth century. Most of what are now considered to be works of art originally had some function, whether it was as an altarpiece, focusing the congregation's attention on the altar and the Mass being celebrated there, or as a decoration, which may also have communicated some message. And because location was important, each separate type of artistic product effectively had a shape associated with it. Most early altarpieces were polyptychs (they were made of several panels), and usually had structures similar to the churches for which they were made, with pointed, gothic arches. Even when they took a rectangular format more like Alberti's "window", they were still often flanked by supporting pilasters, with a predella underneath, or, like Raphael's *Crucifixion* (see page 89), had a Renaissance-era, round-topped arch.

However, not all religious paintings were destined for sacred buildings – Christian imagery was regularly painted for domestic settings. Fra Filippo Lippi's *Annunciation* (see right) is known to have come from the Medici Palace, but even without this provenance a Medicean origin would have been suspected: their *impresa* of the diamond ring combined with three feathers is carved at the front of the balustrade that supports the vase of lilies. Precisely where Lippi's work was located in the palace is not known, but its unusual arched shape has led to a number of suggestions. It may have been intended as a bed head, although the surface does not show enough wear and tear to suggest it was part of a piece of furniture that was regularly in use. A more likely idea is that it was painted to go above a door, a practice referred to in archival evidence. Sculptures were certainly placed above doors: a number survive in their original position, and other examples can be seen in paintings, such as Giovanni Mansueti's *Miraculous Healing of the Daughter of Ser Niccolò Benvegnudo of San Polo* (see page 201). The choice of the Annunciation as a subject is ideal, as someone entering

⬤ ANNUNCIATION
Filippo Lippi, ca. 1450–1453 (NATIONAL GALLERY, LONDON)

One of the more obscure elements of theology that was debated was the precise way in which Mary actually became pregnant. In Filippo's painting the hand of God appears at the top centre of the image, while the dove of the Holy Spirit hovers low, close to Mary's knees. There is a tiny gap in her dress just in front of her stomach, from which small, golden rays project. The implication is that she became pregnant through her stomach. If you compare this to Crivelli's *Annunciation* (see page 49), it is clear that the beam of light from heaven disappears just behind her head. Some theologians believed that as Mary heard the angelic salutation, she must have become pregnant through her ear.

Alberti: *see page 15;* **Annunciation:** *see pages 48 and 80–81;* **diamond:** *see page 42;* ***imprese:*** *see pages 40 and 42–43;* **lily:** *see page 36;* **pomegranate:** *see page 38;* ***tondo:*** *see page 21*

▶ MADONNA AND CHILD WITH SCENES FROM THE LIFE OF THE VIRGIN

Filippo Lippi, 1452 (PALAZZO PITTI, FLORENCE)

The circular shape of this work derives from a function hinted at within the image itself. In the foreground we see the Madonna and Child. Behind is another scene in which a woman has given birth. Both mother and child have haloes, and yet it cannot be the birth of Christ, because of the well-appointed interior: it is in fact the birth of the Virgin. At the far left is a woman with a circular tray on her head, and another, with a basket, approaches from the right. A similar figure can be seen in Ghiberti's relief of the *Story of Isaac*, in front of the depiction of the birth of Jacob and Esau (see page 53). In 15th-century Florence a woman who had just given birth would be given sweetmeats on a round tray, known for this reason as a *desco da parto*, or birth dish. These were often decorated with suitable images – children or scenes of childbirth. Soon the platter became more important than the sweetmeats, giving rise to the genre of circular paintings such as this one.

a room will often bring some form of communication, in the same way that the Archangel Gabriel brings news to the Virgin. Paintings of the Annunciation were often commissioned to celebrate a new arrival, and this one may be related to the birth of Lorenzo de' Medici in 1449.

The Art of Marriage

The format of both of the paintings on these pages is similar – wide, but not very high. Again, the unusual format is a clue to their origins as "interior decoration" rather than as art for its own sake. One of the most common reasons to commission a new interior was to celebrate a wedding: the bride and groom would effectively be given a new bedroom. The wedding procession would lead from the bride's father's house to her husband's house together with all of the gifts. This constituted an unparalleled opportunity for display, as the more elaborate and copious the gifts, the greater the combined wealth of the families must be.

Included among the gifts would be two chests, or *cassoni*. The furniture was often carved or painted with relevant subject matter – stories of love or marriage, for example.

Comparing the long, thin format of Lo Scheggia's painting (see below) with a surviving *cassone* (see page 32), we can see that this panel comes from a similar piece of furniture. The subject is a historical marriage between two Florentine families, the Bardi and Buondelmonte. On the left we can see a wedding procession, with gifts including a richly caparisoned horse, and a bundle of linen carried on a lady's head. Struggling around the corner of a building is a workman carrying one of the *cassoni* on his shoulders: in a charmingly self-contained way the image refers to the history and function of the painting itself.

In addition to the provision of furniture, the bedroom itself would be decorated. The walls often had wooden wainscoting up to shoulder level, and above this there might be paintings. As the Italian for shoulder is "spalle", such paintings are called *spalliere*. The *Mars and Venus* by Botticelli (see opposite) is widely accepted as a *spalliera*: again it has a wide format, but the proportions are not as extreme as for a *cassone* panel. Otherwise it is not always possible, once they have been removed from their original context, to tell the difference. Composition can provide a clue. One looks down

○ *CASSONE* **PANEL SHOWING THE MARRIAGE OF LEONORA DE' BARDI AND IPPOLITO BUONDELMONTE**
Giovanni di Ser Giovanni (Lo Scheggia), mid-1400s
(PRIVATE COLLECTION, FLORENCE)

composition: *see pages 62–65;* **furniture and fittings:** *see pages 32–33;* **hair:** *see pages 87 and 88;* **jokes:** *see page 43;* **Mars:** *see page 114;* **Lorenzo "the Magnificent" de' Medici:** *see pages 198–199;* **Peace:** *see page 181;* **power and wealth:** *see pages 184–191;* **Venus:** *see page 114*

on to a *cassone*, as it stands on the floor, and so the elements tend to be gathered toward the lower half of the painting in order not to be obscured by the lid of the chest: this is certainly the case in the Bardi and Buondelmonte painting. On the other hand, *spalliere* were displayed at eye-level, and so there are more elements toward the top of the painting.

The subject in Botticelli's painting is also related to the theme of marriage. Mars and Venus were the Roman gods of war and love respectively, although here they are shown as contemporary Florentines. Mars is asleep at the right of the painting, reclining on his armour, while a series of fauns (half man, half goat) play around him. One has climbed through the armour on which he is resting (a symbol of peace), and three more have taken his lance and appear to be charging toward him. The one on the left wears his helmet – clearly far too large for him, while the one on the right blows into a conch shell next to Mars' ear, in an attempt to wake him up. Venus sits languidly on the other side of the painting, her hair elaborately braided and apparently attached to her dress. Her left hand rests on her thigh, and reveals a transparent under-skirt.

The overall message is clear: love is stronger than war – a perfect theme for a newly married couple. However, there is more to it. Even in the centuries before Freud, the phallic significance of the lance – particularly when aimed toward the hole in the tree – would have been obvious. Why is Mars naked? In what way is Venus stronger than him? The implication is that, having already made love, Mars is exhausted and has fallen asleep, whereas Venus is awake and alert, and has sent the fauns to re-awaken Mars. However, the suggestive positioning of his right hand, with its limp wrist and flaccid fingers, suggests that even if awoken he may not be up to entertaining her further. In this light, the nature of the painting becomes remarkably like aspects of modern-day weddings – notably the Best Man's speech, which traditionally contains numerous bawdy jokes at the groom's expense.

◉ MARS AND VENUS

Sandro Botticelli, ca. 1485 (NATIONAL GALLERY, LONDON)

Although the interior decoration of a room would be changed and discarded, paintings such as the *Mars and Venus*, particularly if by famous artists, would be framed and saved as "works of art".

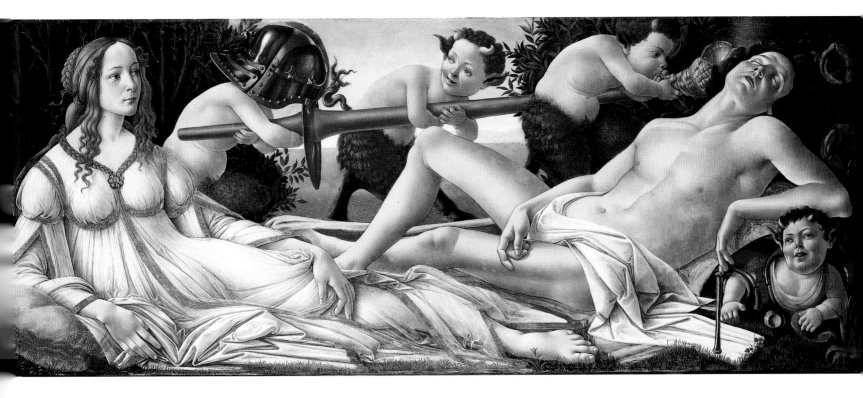

STORIES & STATEMENTS

All works of art are an attempt to communicate, whether they tell a story, illustrate an aspect of theology, disseminate a political message or simply convey a feeling. Usually the composition can help us to identify what type of idea is being transmitted. For example, altarpieces were designed to focus attention on acts of worship, and their imagery is related to saints worthy of particular devotion in the context of the church or chapel in which they are placed, or to the religious allegiances of the patron, or both. Although narratives may be included in an altarpiece, in order to expand our knowledge and understanding of the characters shown, the central elements usually have a symbolic, rather than a narrative, function, and the composition is usually static.

Narrative itself can be conveyed in a number of ways. It is often alluded to through symbols. For example, St Jerome's lion or St Sebastian's arrow can remind us of stories in their lives, as they do in the main panel of the *Madonna della Rondine* by Carlo Crivelli (see page 37). Alternatively, gesture and body language provide clues to what is happening, as they do in the *Legend of the Wolf of Gubbio* (see page 79). Artists frequently use one particular episode, a key moment, to enable the viewer to understand the full story, as Sassetta does with the *Wolf of Gubbio*. However, many stories are just too complex to get across in only one image. To tell the story of Isaac, Ghiberti includes seven different episodes in one relief, for example (see page 53): a technique known as continuous narrative. Although a common feature of medieval painting, it is also something in which Renaissance artists excelled, and was facilitated by their ability to create space, and consequently to separate out areas of the painting in which different episodes could take place. Masaccio's *Tribute Money* (see below) is a good example.

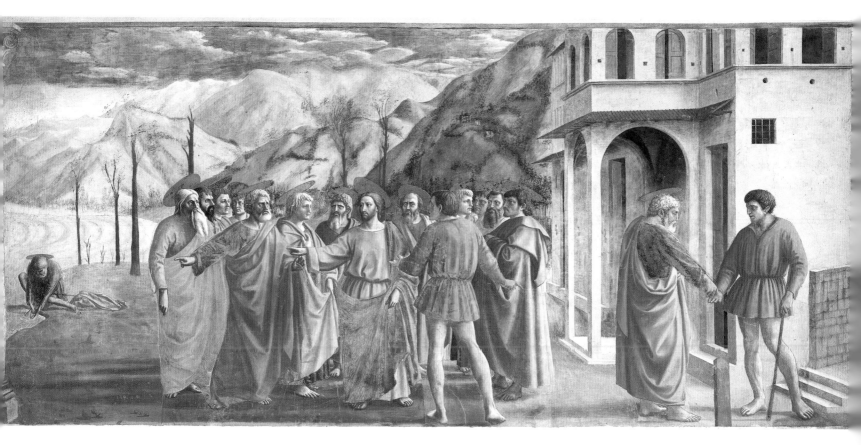

This painting also shows why the colour coding of saints was important. Although Jesus stands out in the centre of the twelve apostles, Peter, in his yellow and blue, can be seen three times: in the centre next to Jesus; on the far right; and also on the far left, next to the lake, although his yellow toga has been taken off and lies on the ground beside him. Another character, a tax collector, appears twice. The story comes from the Gospel of St Matthew (17.24–27). When Peter is asked if Jesus pays the tribute due to the emperor, Jesus sends him to the lake, and instructs him to open the mouth of the first fish he catches and look inside for a coin. We can see Jesus pointing toward the lake. Peter, as if doubting his instructions, echoes the gesture. The tax collector, with his left hand out to show he is expecting payment, points over to the right to appoint a meeting place. By the lake Peter is awkwardly crouching down and removing the coin from the fish's mouth, and on the right, at the appointed place, is using it to pay the tribute.

The three episodes are explained and linked by the gestures of the protagonists, but they are also isolated from one another by the background. On the left, Peter is placed against the lake, whereas the group in the centre has the distant mountains as a backdrop. On the right Peter is framed by the arched portico of a building.

⬇ TRIBUTE MONEY

Masaccio, ca. 1424–1427 (BRANCACCI CHAPEL, S. MARIA DEL CARMINE, FLORENCE)

In the *Tribute Money* Masaccio illustrates three episodes (see diagram, below). The first is in the central section, the second on the left and the third on the right. Peter, labelled 1, appears in all three sections, and the tax collector (2) appears twice. Nevertheless, the focus is on Jesus: the vanishing point, defined by the building, coincides with his face.

colour-coding: *see page 44;* gesture and body language: *see pages 78–81;* St Jerome: *see pages 36, 102 and 109;* landscape painting: *see pages 70–73;* lion: *see page 36;* perspective: *see pages 52–55;* St Peter: *see pages 106 and 128–129;* St Sebastian: *see pages 38 and 60–61*

Communicating Orthodoxy

Rather than telling stories, some works were conceived to convey a certain message. Allegories and other didactic works aim to expound ideas of varying degrees of sophistication. Filippino Lippi's *Triumph of St Thomas Aquinas* (see opposite) is a particularly complex example.

The considerable intellectual content of Lippi's fresco is made clear by the numerous texts in Latin on and around the throne, and by the discarded books, many of which contain inscriptions. Whereas the narrative of the *Wolf of Gubbio* (see page 79) is expressed by means of body language and gestures, things which can be intuitively appreciated by everyone, the full meaning of this painting can be deciphered only by those who can read, which would have been a minority of the population. In many ways this difference in approach characterizes the contrast between the people for whom they were painted. The central, enthroned man is Thomas Aquinas, whose white habit and black cloak mark him out as a follower of St Dominic. Unlike St Francis, whose vow of poverty led him to associate with the poor and emphasize an understanding of Christ's humanity and an empathy with his life and teachings, St Dominic's overriding concern was to stamp out heresy – beliefs which were incompatible with the teachings of the Church. To do this it was important to understand what the true doctrine was. This could be achieved only through rigorous study, and communicated through preaching. Consequently, Dominic's followers were known as the Order of Preachers, although they are almost always referred to as Dominicans. As a generalization it is possible to say that a painting expounding elaborate theological ideas is more likely to be found in a Dominican church, whereas Franciscan churches are more often the home for good storytelling. Andrea Bonaiuti's complex fresco the *Triumph of the Church* (see page 131) conforms to this rule of thumb. Painted for the Chapter House of Santa Maria Novella, the main Dominican church in Florence, it is opposite Bonaiuti's own version of the Triumph of St Thomas Aquinas.

allegory: *see pages 158–165;* Aristotle: *see pages 150–151 and 180;* Constantine: *see page 144;* St Dominic and the Dominicans: *see pages 109 and 130;* St Francis: *see pages 46, 76, 78 and 108;* Minerva: *see pages 114 and 164–165*

▶ TRIUMPH OF ST THOMAS AQUINAS
Filippino Lippi, 1489–1491 (S. MARIA SOPRA MINERVA, ROME)

The name of the church for which this fresco was painted, Santa Maria Sopra Minerva, derives from its location: directly above ("sopra") the Roman temple of Minerva, the goddess of wisdom. With their emphasis on learning, this was an ideal place for the Dominicans, symbolizing the replacing of pagan knowledge with Christian theology. Indeed, one of Aquinas's great achievements was the synthesis of Aristotelian thought with Christian belief.

A clue that this is an allegorical depiction is the way in which **Aquinas tramples someone underfoot** (see right): it is not appropriate to the dignity of his position, enthroned, central and higher than everyone else. The downtrodden man holds a scroll with a quotation from the Book of Wisdom: "Wisdom conquers Evil", implying that he is a personification of Evil.

Aquinas himself holds a book (see left) with the words "I will destroy the wisdom of the wise", a quotation from St Paul, referring to Aquinas's refutation of heretics. The other inscriptions articulate similar ideas. The female figures on either side of St Thomas represent Philosophy, Theology, Dialectic and Grammar, aspects of learning that are essential for the understanding and then communication of orthodoxy.

Aquinas was particularly concerned to stress the true nature of the Trinity: there is one God in three persons, the Father, Son and Holy Spirit. They are all God, but they are all different – a mystery which is beyond human comprehension. It is no coincidence that Masaccio painted his great exposition of this subject (see pages 210–213) for Santa

Maria Novella, a Dominican church. Gathered around the scattered books are six of the heretics whose ideas Aquinas refuted. The most prominent is the bearded **Arius** (see right). In front of him is an open book which expounds his "error": he believed that God the Father had created the Son from nothing, an idea which denies the equality and eternity of the three persons of the Trinity, and which led him to be condemned at the Council of Nicea in 325 AD. The complexity of the ideas represented in this fresco would have been accessible to only a few, and it illustrates how the Dominican approach to salvation stressed intellect over feeling.

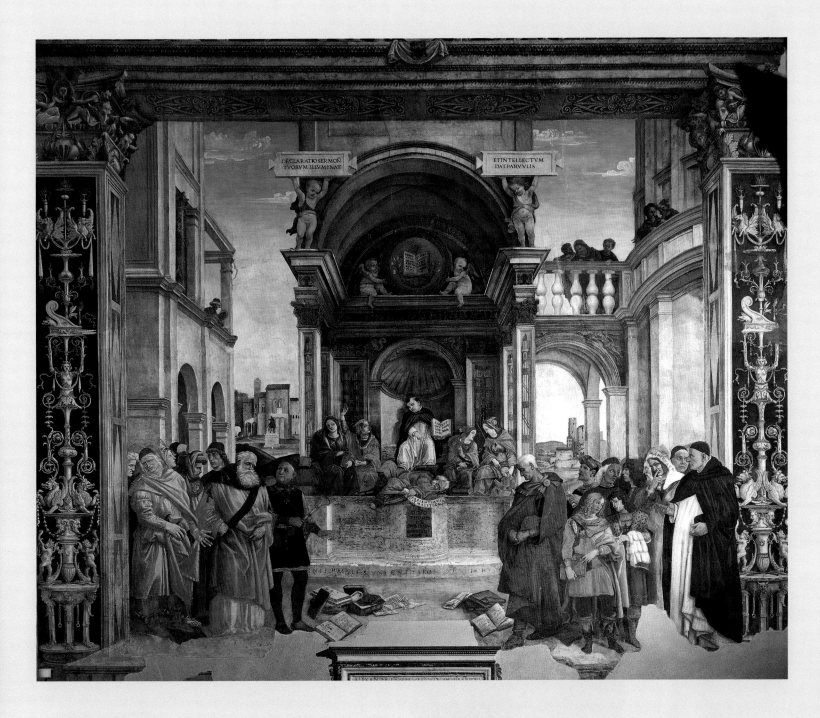

Opposite Arius stands **Savellius** (see left), wearing a red robe lined with green. He is the only heretic represented who preached in Rome, and so he is depicted beardless like a Roman Republican. His heresy is explained in one of the books at his feet: he thought that Father, Son and Holy Spirit were all part of the same substance, whereas orthodox belief requires that, although all three are God, they are all different from one another.

In the background Lippi includes the statue of **Marcus Aurelius** (see left), which for a long time was believed to represent Emperor Constantine (see page 144). Its depiction here may serve as a reminder that Constantine asked the Nicean council to resolve the Arian heresy. The position of the sculpture, just above and to the right of Arius, with its right arm extended over him, might support this hypothesis.

LAYERS OF MEANING

Renaissance art would be a lot simpler, if a lot less interesting, if it were possible to say that each symbol has only one meaning, but this is rarely the case: the meaning usually depends on the context. As a result, any one work of art can have more than one layer of meaning, and it is also possible that the meaning can change. One way to understand this is to look at two works by Donatello, a *David* and a *Judith*, and see the ways in which their meanings have altered with time.

Even before examining the idea of a work of art "meaning" something, there are degrees of observation we make about it which depend on the level of our background knowledge. For example, even if we do not know what this sculpture (see right) represents, we can see that it is a young man with a severed head at his feet. Knowledge of the Bible could tell us that a severed head might represent John the Baptist, Holofernes or Goliath. As the head is large and has a stone embedded in its forehead, it must be the giant Goliath who was slain by the shepherd boy David using a stone thrown from a sling (the sling itself would probably have been a strip of leather attached to David's hand). One layer of meaning, therefore, lies in the identification of the subject itself: the large head with a stone embedded in its forehead "means" that this is a sculpture of David.

The sculpture was carved between 1408 and 1409 to go on top of Florence cathedral. At the same time, another sculptor, Nanni di Banco, carved a figure of Isaiah. Their appearance in their intended location can be judged from Andrea Bonaiuti's image of the cathedral in his *Triumph of the Church* (see page 131), the roof of which bristles with sculptures. David, like Isaiah, was regarded as a prophet: the position of these two figures on the outside of the building was a metaphor, foretelling Christ's arrival before experiencing his

● **DAVID**
Donatello, 1408–1409 (BARGELLO, FLORENCE)

Florence cathedral: *see pages 26–27;* **St John the Baptist:** *see page 108;* **prophets:** *see page 102*

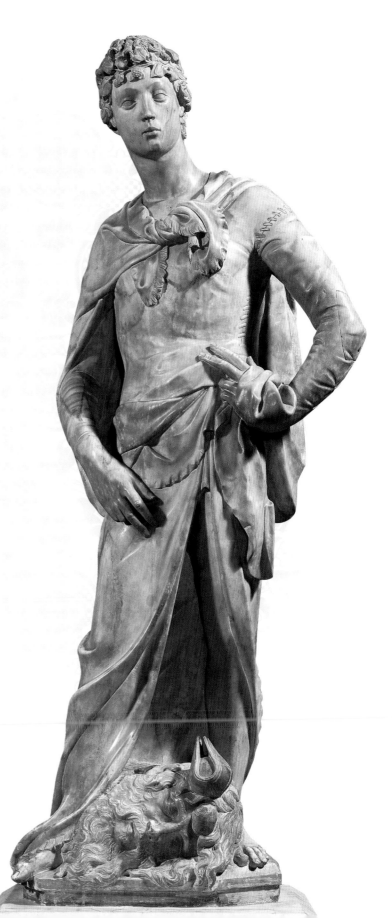

◉ **DAVID**
Donatello, ca. 1450s (BARGELLO, FLORENCE)

Much later in his career, Donatello made a second *David*, this time in bronze, which, like the *Judith and Holofernes* (see page 100), was first recorded as being sited in the Palazzo Medici and confiscated in 1494. Although the Bible says that David refused to wear armour, it does not say that he fought naked, nor can it explain why Donatello has given him a hat and boots. It is also unclear why Goliath wears a helmet: the stone would not have injured him. More bizarre still are the wings attached to the helmet, one of which caresses David's inner thigh. The sensual nature of this sculpture still has no convincing explanation: this enigmatic David refuses to reveal his secrets.

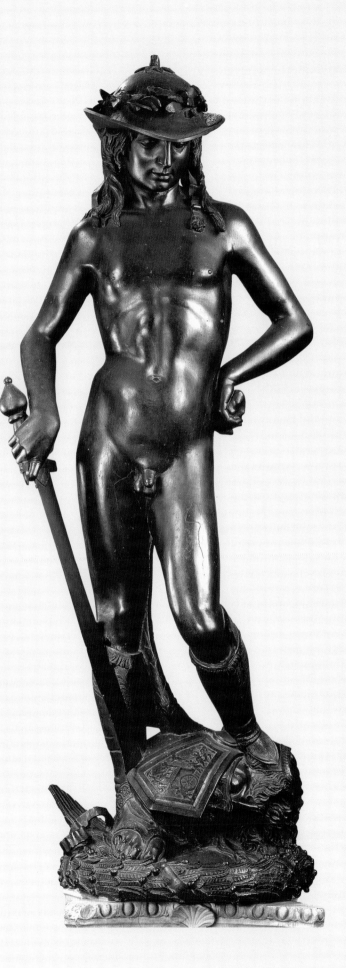

presence upon entering. But if they are meant to represent prophets, why did Donatello choose to show David as a young shepherd boy, rather than as the king whose psalms contain the prophecies? Clues to the answer to this question come from the subsequent history of the sculpture, as well as preceding events affecting Florence as a whole.

In 1409 one of the two sculptures – it is not clear which – was placed on top of the cathedral, and then taken down again, quite possibly because it was too small to be seen. Seven years later the *David* was transferred to the Palazzo della Signoria (the town hall, now known as the Palazzo Vecchio). It was put in a niche which was painted with a blue background and gold lilies. As the lily is one of the symbols of Florence, this set the sculpture within a Florentine context, explained by an inscription recorded many years later: "To those who bravely fight for the fatherland the gods will lend aid even against the most terrible foes."

The young shepherd boy who defeated the giant Goliath struck a chord with the Florentines. At the beginning of the fifteenth century, Giangaleazzo Visconti, the ruler of Milan, had tried to capture Florence. His troops were threateningly close when, in 1402, he died, the army retreated and the Florentines were safe. They saw this as God's protection, and, with little justification, as a great victory. A small and virtuous republic had defeated, with God's help, the large forces of the "tyrant" Visconti. The parallel with David's

lily: *see page 36;* **Palazzo Medici:** *see page 202*

▶ **JUDITH AND HOLOFERNES**
Donatello, late 1450s (PALAZZO
VECCHIO, FLORENCE)

To make the clothes more realistic,
Donatello dipped cloth into liquid clay.
However, some of the clay broke off,
revealing the weave of the material on
Judith's forehead. This is still visible
even in the final bronze cast.

story was clear: virtue can triumph
over strength. Thereafter, the image of
the shepherd boy became one of the
defining symbols of republican Florence,
and the Church's prophet had become the
"property" of the state.

Changing the Focus

The way in which a work of art conveys its meaning is called
the *iconography*. For Jesus and Mary, this varies according to
which period of their life or aspect of their character is being
depicted: obviously Christ appears different as a baby and as
an adult, but the way in which he is represented also varies
before and after his crucifixion. Most saints have only one
iconography, a notable exception being John the Evangelist,
who is shown either as the youngest apostle, beardless and
sometimes even effeminate, as he is in Raphael's *Crucifixion*
(see page 89), or as the elderly bearded author of the Gospel
of St John and Book of Revelation. David also has two
iconographies, as the young shepherd boy, or as a king, hold-
ing a lyre. The reason why a particular iconography is chosen
– in the case of the young David, because it refers to the tri-
umph of virtue over strength – is sometimes known as the
iconology. This extra layer of meaning can help us to under-
stand the context in which a work of art was commissioned.

Crucifixion: *see pages 126–127;* **infant Christ:** *see page 215;* **St John the Evangelist:**
see pages 106 and 123

PORTRAIT OF A MAN IN ARMOUR
Francesco Granacci (attr.), ca. 1510 (NATIONAL GALLERY, LONDON)

The identity of this soldier has not been established, nor is it known exactly when this work was painted, although as Michelangelo's *David* is visible in the background it must have been after 1504. The man is ready to draw his sword, implying that he is prepared to fight, and, as he is shown in front of the Palazzo Vecchio, or town hall, he is presumably prepared to fight for Florence. Although this square, the Piazza della Signoria, is now like an open-air sculpture gallery, only two statues can be seen (see detail, above): the *David* and the medieval lion, which, like the *David*, was a symbol of republican Florence. Their inclusion in the portrait suggests that not only is the soldier prepared to fight for the city, but also, specifically, that he will defend its status as a republic.

It is this level of meaning that can sometimes change. The story of Judith was popular in Florence for similar reasons to that of David. The Israelites in the city of Bethulia were besieged by the army of Holofernes. Judith crept out of the city and went to the enemy camp, pretending to have defected. She was entertained by Holofernes, and when he was relaxed and drunk she took down his sword and cut off his head. The army scattered and the Israelites were freed: Judith, a weak but virtuous woman had defeated the powerful Holofernes – again, virtue triumphed over strength.

Donatello's *Judith* (see opposite) was first recorded in the garden of the Palazzo Medici. A letter quotes from an inscription on the base of the sculpture that explains the "moral" behind the story: "Kingdoms fall through luxury, cities rise through virtues; behold the neck of pride severed by the hand of humility." Another source cited a different inscription: "Piero son of Cosimo Medici has dedicated the statue of this woman to that liberty and fortitude bestowed on the republic by the invincible and constant spirit of the citizens." Thus Piero was using the sculpture to show his support for the republic – even though the Medici by this stage were the *de facto*, unelected rulers of Florence. When they were expelled from the city in 1494, many of their possessions, including the *Judith*, were confiscated by the authorities. The sculpture was erected outside the town hall on a plinth with a new inscription: "Placed here by the citizens as an example of public well-being." From being a means for the Medici hypocritically to support the Florentine republic, it had become a warning that, in order to preserve this "public well-being", tyrants – such as the Medici – would be removed, even executed: its meaning had effectively changed.

However, the position of the *Judith* was not secure: when Michelangelo completed his *David* (see page 9) in 1504, it was decided that the statue should replace the *Judith*. This is where it can be seen in the background of a portrait attributed to Francesco Granacci (see above).

lion: *see page 36;* **Piero "the Gouty" de' Medici:** *see page 186;* **Palazzo Medici:** *see page 202;* **portraiture:** *see page 88;* **republican rule:** *see pages 176 and 180–181*

MEN & ANGELS

Despite the fact that human populations are fairly evenly divided between men and women, power has traditionally been held by the men, with the result that there are more male characters than female in Renaissance art. However, this section is not concerned with all men in paintings, but with specific groupings: if a particular group of figures can be identified it can help in the interpretation of a work of art.

Apostles and Prophets

A group of twelve men is most likely to be the twelve apostles. However, as Christ's choice of twelve apostles took its inspiration from the twelve tribes of Israel, the twelve could be the sons of Jacob, although that would probably become clear from the narrative setting. Any man holding a scroll – as opposed to a bible – is a prophet, and as there were twelve notable prophets it could also be them. But even if there is no doubt that they are apostles, a number of different personalities could be included. Before the arrest of Christ, such as at the Last Supper, or in the episode of the Tribute Money,

CONDEMNED TO OBSCURITY

Religious art in the Renaissance was more inspirational than condemnatory, and images of "sinners" were rare. In Florence, the walls of the Bargello, which was then a prison, were painted (sometimes by artists as well known as Botticelli) with the likenesses of those who had been executed. Wrongdoers are often portrayed allegorically, as being trampled under the feet of the virtuous, as the figure of Evil is in the *Triumph of St Thomas Aquinas* (see page 97). Images of sinners are most commonly found in paintings of the Last Judgment. Often inspired by Dante's *Inferno*, the souls of the condemned are subjected to hideous tortures, such as can be seen in Giotto's image of the damned in hell (see page 63).

they would include Judas, but afterwards, not. After Judas's act of betrayal and subsequent suicide, a twelfth member was appointed – St Matthias – but he is often omitted in favour of St Paul, for example in Giotto's *Last Judgment* (see page 63). St Paul was not an apostle during Christ's lifetime, but his status as one of the first leaders of the Church after Christ, along with St Peter, has given him this respected position.

Evangelists

When a building had four corners to be decorated, it was common to see groups of four men. More often than not these would be the four Evangelists – the writers of the Gospels – Matthew, Mark, Luke and John. Unlike Matthew and John, Mark and Luke were not apostles. The Evangelists were often represented in the act of writing, as they are by Lorenzo Ghiberti toward the bottom of the North Doors of the Florentine Baptistery (see page 119). Each is also symbolized by a winged creature, which derive from visions in the Book of Ezekiel (1.5–14), and Revelation (Chapter 3). Matthew is represented by a winged man (or angel), Mark by a winged lion, Luke by a winged ox and John by an eagle.

Doctors of the Church

The four men represented by Ghiberti below the Evangelists are the four Latin Doctors of the Church, the thinkers who interpreted the Evangelists and established the nature of the early Western Church: Jerome, Gregory, Ambrose and Augustine. They are also painted by Antonio Vivarini and Giovanni d'Alemagna on either side of the Virgin and Child (see opposite). On the left we see Jerome (342–420), who was responsible for translating the Bible into Latin. He is portrayed with almost the same iconography as that used by Crivelli in the *Madonna della Rondine* (see page 37), although without his lion. Next to Jerome stands Gregory the Great (ca. 540–604). Just as Jerome's broad-brimmed red hat marks

apostles: *see pages 122–123;* **Dante:** *see pages 12 and 13;* **eagle:** *see page 114;* **four:** *see pages 58–61;* **St Jerome:** *see pages 36 and 109;* **lion:** *see page 36;* **St Paul:** *see page 108;* **prophets:** *see page 126;* **tribes of Israel:** *see page 61;* **twelve:** *see pages 61, 122, 136 and 137*

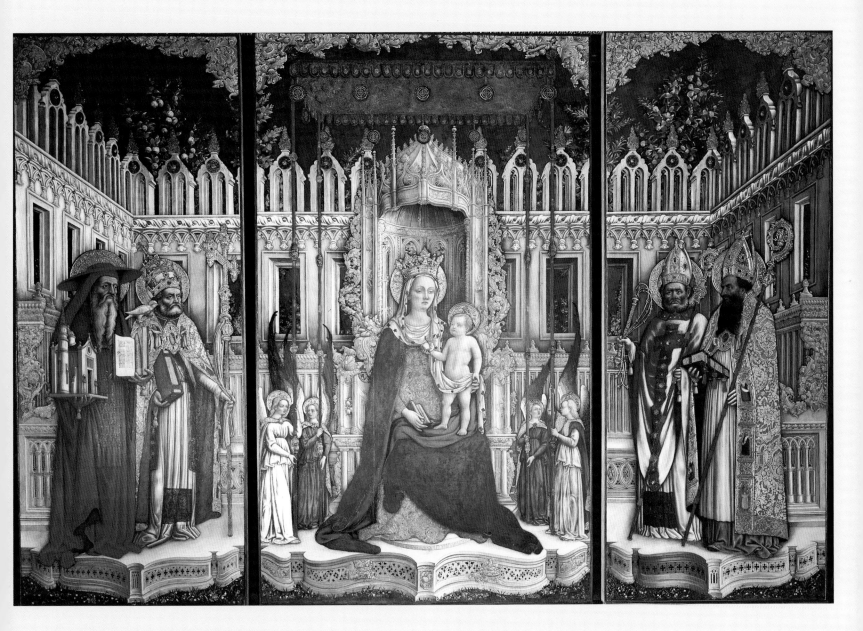

him out as a cardinal, Gregory's hat also helps to identify him. It is circular and pointed and includes three diadems. Known as the triple tiara, this is the hat that until relatively recently was worn by the pope. His inspiration by the Holy Spirit is symbolized by a dove flying close to his ear. Gregory was best known as an administrator, and was responsible for introducing the idea of celibacy to the priesthood: this enabled the Church to hold onto its wealth rather than see it go to the family of the priest. He also devised the forms of the Church service and of the music that should be used, still known as Gregorian chant.

The remaining Doctors were both bishops – each wears a mitre, flatter than the triple tiara and with two points of equal height. On the left is Ambrose of Milan (ca. 340–397),

⬡ MADONNA AND CHILD AND THE FOUR LATIN DOCTORS OF THE CHURCH

Antonio Vivarini and Giovanni d'Alemagna, 1446
(ACCADEMIA, VENICE)

This triptych, painted for the Scuola di Santa Maria della Carità, is still in the room for which it was made, which is now part of the main art gallery in Venice, the Accademia. It is a typical example of the International Style, with its rich materials, intricacy of detail and flowing line. Like Gentile da Fabriano's *Adoration of the Magi* (see pages 70–71), it includes *pastiglio* work: the gesso (a plaster-like substance applied to the wooden panel to create a smooth surface on which to paint) is built up and gilded on details such as the haloes, headgear and attributes to look like an encrustation of solid gold.

the Church: *see pages 128–135;* **International Style:** *see page 17;* **scuole:** *see page 177*

with Augustine of Hippo (354–430) on the right. Ambrose can sometimes be identified from the whip, which represents his (philosophical) attacks on heretics. He also did much to establish the authority of the Church over worldly powers. As bishop of Milan he influenced – and indeed baptized – Augustine. A hugely important theologian, Augustine's works include a study of the Trinity and *De Civitate Dei* ("On the City of God"), which contrasts the growth of Christianity with the decline of the Roman Empire.

Angels

While there are many different men who merit individual attention, there are only a few named angels. The most important of these, in terms of narrative if not in terms of status (see opposite), are all archangels. As God's messengers they are the ones who become involved in the biblical narratives. Of these the most commonly depicted is Gabriel, who announces the birth of Christ to the Virgin Mary. He is recognized either by his presence at the Annunciation, or by the white lily which he carries as a symbol of Mary's purity: he is on the right of Botticini's painting (see below). He is also considered to be the angel who announced the birth of John the Baptist to John's father Zacharias, and who heralded the birth of Christ to the shepherds.

The other commonly depicted archangel is Michael, who is described in the Book of Revelation (20.1–3) as having defeated the devil, and who expelled Adam and Eve from the Garden of Eden. He is also responsible for weighing souls at the Last Judgment: he often wears armour, and his attributes can include a pair of scales, or, as here (below, left), a sword and orb, which represent Justice. He is often shown standing on, or beside, the vanquished devil.

The central figure in this painting is the Archangel Raphael. Although he is only named in the Book of Tobit, his presence is assumed in other stories in the Bible, particularly ones associated with healing. He accompanies Tobias, the son of the blind Tobit, and his dog, to a far land in order to collect a debt. On the way a giant fish attacks Tobias. Raphael instructs him to kill the fish, which they eat, saving its gall bladder to heal Tobit's blindness. The fish that Tobias carries in this painting is too small to pose a threat, but is included as a symbol – as is the dog – to confirm that this is Tobias. Knowing that this is Tobias helps in turn to identify Raphael: it is as if the symbols are "nested" like coffee tables, stacked together to make the identification of the characters more succinct. As well as healing, Raphael was associated with trade. He was particularly invoked by merchants who, like Tobit, sent their sons on their first business trip.

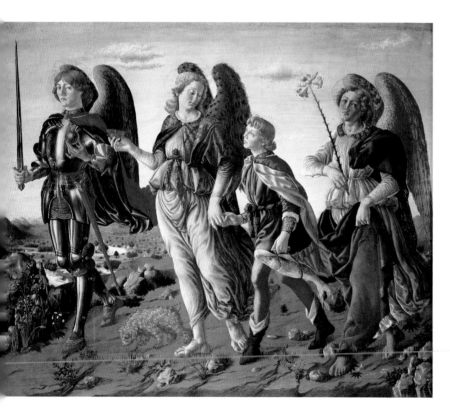

◐ THREE ARCHANGELS (TOBIAS AND THE ANGEL)
Francesco Botticini, CA. 1470 (UFFIZI, FLORENCE)

Botticini includes Michael and Gabriel in the journey of Tobias and the Angel (Raphael), making it look as if all four are travelling together. However, this is the result of the realism of the setting – there would have been no suggestion that this happened. Images like this are often given the wrong name: it is not an image of Tobias and the Angel, but of the three archangels. Tobias is only present as the attribute of Raphael.

Adam and Eve: *see pages 74 and 120;* **Annunciation:** *see pages 48 and 80–81;* **Assumption of the Virgin:** *see pages 140 and 214;* **attributes:** *see pages 36–38;* **St Augustine:** *see pages 172–173;* **choirs of angels:** *see pages 140–141;* **Dante:** *see pages 12 and 13;* **flag of Christ Triumphant:** *see page 44;* **Holy Trinity:** *see page 96;* **Last Judgment:** *see page 62;* **Roman Empire:** *see pages 66 and 144*

◐ ASSUMPTION OF THE VIRGIN

Masolino, ca. 1428–1429 (CAPODIMONTE, NAPLES)

There were originally believed to be nine different kinds of angel: all are depicted in Masolino's *Assumption of the Virgin.* The hierarchy was elucidated by an author known as Pseudo-Dionysius the Areopagite, and was well known to Dante who included it in his *Paradiso.* The angels were grouped in three choirs. The closest to God were the Cherubim (1), who were red, standing for Divine Love, Seraphim (2), blue, for Divine Wisdom, and Thrones (3), who, as their name suggests, support the Throne of God. These were surrounded by the Dominions, Virtues and Powers, with the furthest out (and thus, closest to us) being the Principalities, Archangels and Angels. However, this is not quite the order in which Masolino depicts them. Below the Thrones, the orbs and sceptres represent the power which the Dominions (4) have over the other angels, while the cross of St George is used to denote the Principalities (5), who protect religion (Pseudo-Dionysius put them two rungs further down). The angels in armour are the Powers (6), who protect the path of truth and combat demons, and below them – with a convenient label – are the Virtues (7), who perform miracles on Earth. The two lowest pairs have musical instruments: they represent the most familiar categories, the archangels (8) and angels (9).

SAINTS

The *Coronation of the Virgin* (see right) attributed to Jacopo di Cione constitutes a remarkable encyclopedia of the saints who were revered in the second half of the fourteenth century. In order for them to be seen clearly, they are arranged "up" the painting rather than "back" into space, which makes them more or less flat. Because their faces are similar, the saints must be distinguished by means of their clothes and attributes. The following describes the iconography of the most important ones depicted (see key, overleaf).

❶ **St Peter** can often be recognized because he carries the keys to heaven. On his knee is San Pier Maggiore, the church for which this altarpiece was painted, reflecting his status not only as the first head of the Church after Christ, but also as patron saint of this building. He is usually shown wearing yellow and blue, with a short grey beard and short grey hair.

❷ **St Bartholomew** was one of the apostles, although nothing of his life is reported in the Bible. He often wears a light robe decorated with gold patterns and he holds a knife because he was flayed alive.

❸ **St Stephen** is often described as the protomartyr, because he was the first person to be killed for his belief in Jesus. He was stoned to death, and is identified by the stone resting on his head (there are sometimes more on his shoulders). He carries a palm leaf, a symbol of victory over death, and so of martyrdom. Martyrs were believed to enter heaven instantly, and so their death can be considered a "reward".

❹ **St John the Evangelist** usually wears red and is identified here as a writer: he holds a quill and an inkwell. The open book contains the first verses of his gospel. In other situations he might be identified by an eagle (not to be confused with Jupiter's eagle), and can also be shown as a young, beardless man often with fairly long hair.

St John the Evangelist: *see page 123;* **St Peter:** *see pages 95 and 128–129*

◉ CORONATION OF THE VIRGIN

Jacopo di Cione (attr.), 1370–1371 (NATIONAL GALLERY, LONDON)

It is not certain who painted the high altarpiece of San Pier Maggiore in Florence, but circumstantial and stylistic evidence suggests that it was Jacopo di Cione. Overleaf is a key to help identify the saints.

❺ St Francis is identified by his monastic habit, which is brown (sometimes grey). The belt has three knots, symbolizing Francis's vows of poverty, chastity and obedience. He is distinct from other Franciscan saints because he has the stigmata – the wounds of Christ – in his hands, feet and side.

❻ St Mary Magdalene is usually identified by the jar of ointment used by an unnamed penitent prostitute to anoint Christ's feet. Even though there is nothing in the Bible to suggest that this woman was the Magdalene, the two characters became combined. Her lack of respectability is often indicated by her long flowing hair, which is uncovered, and she usually wears red.

❼ St Andrew was the brother of St Peter and is usually considered Christ's second apostle. He was crucified, and so carries a cross, although the diagonal form seen in the Scottish flag was a late development, and does not reach Italy until after the Renaissance. Instead, his cross usually has a long stem and relatively short crossbar. He tends to have long hair and a long beard, and usually wears green.

❽ St Gregory the Great, one of the four Latin Doctors of the Church, is identified by the papal triple tiara, and by the dove of the Holy Spirit next to his ear.

❾ St Benedict founded the first monastic order – and one of the strictest. He wears either black, the original habit of the order, or white, the habit of the Camaldolesi, a reformed Benedictine order. He frequently carries a rod, either to sprinkle holy water for exorcism (a frequently performed and depicted miracle), or to beat intransigent monks.

❿ St Lucy was an early Christian martyr from Syracuse. She carries an oil lamp, a reference to her name, which derives from the Latin word *lux*, meaning "light". A more familiar attribute is a pair of eyes, which she carries on a plate, in reference to a legend in which an ardent suitor told Lucy that her eyes were tempting him. To avoid this she plucked them out and gave them to him.

⓫ The Three Wise Men. Although there is nothing in the Bible to suggest that the magi became followers of Christ, they were clearly among the first to recognize him. As such they were considered holy and therefore effectively saints ("saint" means "holy"). Each has a crown and carries a gift.

⓬ St Paul was, with Peter, one of the first heads of the Church after Christ. He carries the sword with which he was beheaded, and here has a book open at one of his epistles. He is shown with a long dark beard, receding hairline, and wears red and green.

⓭ St Matthew often has an angel as an attribute, but here he holds a bible inscribed with the first words of his gospel.

⓮ St Laurence carries a martyr's palm and an iron grill. According to legend, despite extensive torture, Laurence still refused to renounce his Christianity, so he was roasted to death on a grill. In order to show his indifference to suffering, and his determination to get to heaven, a few minutes after the fire was lit Laurence is reported to have said, "You can turn me over now. This side's done."

⓯ St John the Baptist was the son of Mary's cousin Elizabeth. He retired to the desert, where he lived on honey and locusts and wore camel skin. He is shown in a camel skin, and often has a fairly wild appearance, with a ragged beard and tousled hair. He often carries a cross made out of reeds, as well as a scroll: he was considered the last of the prophets foretelling the arrival of Christ.

⓰ St Nicholas of Bari is the saint who later became known as Santa Claus, or Father Christmas. The tradition that he brings gifts arose from a story in which he encountered an impoverished nobleman who could not afford a dowry for his three daughters. To save them from having to resort to prostitution, he threw three bags of gold in through the window of their home to serve as their dowries. These are represented in art as three gold balls. He was bishop of Myra (in modern-day Turkey), and therefore wears a mitre.

St Andrew: *see page 194;* **colour-coding:** *see page 44;* **St Francis:** *see pages 46, 76 and 78;* **St Gregory:** *see pages 102–103;* **hair:** *see pages 87 and 88;* **Latin Doctors of the Church:** *see pages 102–104;* **St Laurence:** *see page 126;* **St Lucy:** *see page 64;* **magi:** *see pages 54–55 and 151;* **Mary Magdalene:** *see pages 88–89;* **St Matthew:** *see page 102;* **St Paul:** *see page 102;* **stigmata:** *see page 76;* **triple tiara:** *see page 103*

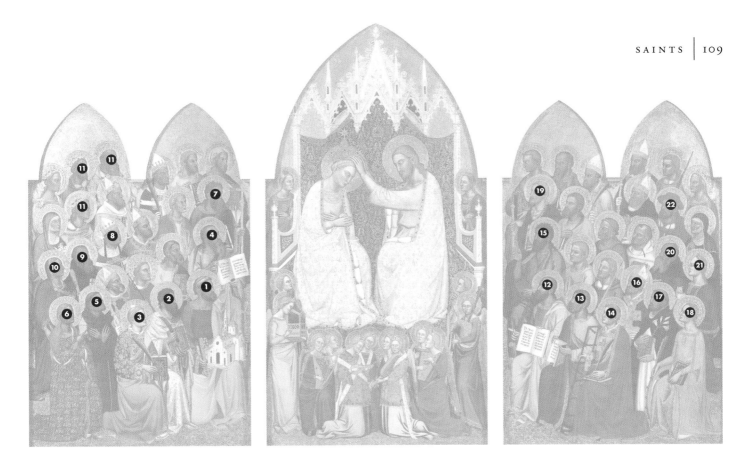

17 St Dominic founded the Order of Preachers, known almost universally as the Dominicans. He is identified by the white robe underneath a black cloak, together with the lily, a symbol of his chastity. He also sometimes has a star above or on his forehead, symbolizing the aura of sanctity with which he was imbued.

18 St Catherine of Alexandria wears a crown, as a princess, and holds a book because of her skills in preaching. She also carries a palm: the intention was to use the spiked wheel by her side to lacerate her, but according to legend God intervened and broke the wheel. Some paintings of this show fire coming down from heaven and sparks coming off the wheel like a firework: the Catherine Wheel is named after her. She was then beheaded, so is sometimes shown holding a sword.

19 St James Major, or James the Great, is the more commonly depicted of the two apostles called James (the other being known as James Minor). He is associated with pilgrimage, and carries a pilgrim's staff (it has rings at the top and just below his hand). He often wears the scallop-shell badge still awarded to pilgrims who have walked to Santiago de Compostela in Spain.

20 St Anthony Abbot was an early Christian hermit, and one of the founders of monasticism. He holds a staff with a handle like a letter T, or the Greek letter "tau", and sometimes has the "tau" on his habit. He often holds a bell, said to ward off evil spirits, and can be accompanied by a pig: in the Middle Ages the Antonine monks bred pigs, which were even given special privileged grazing rights.

21 St Agnes was martyred in Rome under the persecutions of Emperor Diocletian. According to legend this was a result of her refusal to marry the son of the Roman Prefect, having already devoted her life to Christ. The lamb she holds is a reference to Jesus, described by John the Baptist as the Lamb of God ("Agnus Dei"), but not to her name, which is derived from the Greek word meaning "chaste".

22 St Jerome is shown either as a cardinal, with a long red robe and broad-brimmed red hat, or as a penitent, clad in a simple tunic and beating his chest with a stone. Although the role of cardinal had not been instituted during his lifetime, as an advisor to the pope he was retrospectively given this position. In addition to the cardinal's robes and hat, his attributes include bibles, a model church and a lion.

apostles: *see pages 102 and 122–123;* **St Catherine:** *see page 64;* **St Dominic and the Dominicans:** *see pages 96 and 130;* **St Jerome:** *see pages 36 and 102*

VIRTUES & VICES

Virtues and vices are represented in art as personifications. Whereas in medieval art they were often shown in opposition to one another, from the Renaissance era the virtues were increasingly shown on their own – the art tended to be aspirational. A major location for the depiction of virtues was on funerary monuments, displaying the merits of the deceased. There were any number of virtues that could be chosen, according to the qualities for which the patron wished to be celebrated, although a core group of seven (three theological and four cardinal) were of particular importance.

The theological virtues were derived from Paul's statement, "And now abideth faith, hope, charity, these three; but the greatest of these is charity" (1 Corinthians 13.13). All three are represented on Verrocchio's *bozzetto*, or sketch model, for the monument to Niccolò Forteguerri (see below). Charity is shown directly above the kneeling portrait of the deceased. The wings with which she is depicted are not normal attributes of this virtue. She holds a child, and in other representations may have two or three more clinging on to her or clambering around her. Charity represents the unconditional love of and for God, and this is expressed by the idea of a mother's unconditional love for her children. It can also be represented by flames, either burning in Charity's hand, or above her head: in the *bozzetto* her right hand is raised, and she was meant to be holding a torch. Another attribute of Charity is a cornucopia, or horn of plenty, which shows how much she has to give. Faith is holding a chalice in her right hand and a cross in her left – items of faith – while Hope is seen in an attitude of prayer, with her hands crossed in front of her chest, and an upward "hopeful" tilt to her head as she looks up toward Christ. She is sometimes seen with an anchor, as hope was considered to hold you steady.

The four cardinal virtues were described by Plato as the qualities that members of the ideal republic should have.

◐ *BOZZETTO* FOR THE FORTEGUERRI MONUMENT
Andrea del Verrocchio, ca. 1476 (VICTORIA AND ALBERT MUSEUM, LONDON)

The advantages of terracotta were that it was cheap, light, and easy to model. Just as a drawing could have been shown to the patron of a painting, a sketch model, or *bozzetto*, such as this, was a good way for those commissioning sculpture to review proposals. It has a lively spontaneous feel, and an added energy because, like much of Verrocchio's work, it is slightly asymmetrical. This is particularly interesting at the top of the relief, where Christ is supported in a mandorla, or almond-shaped glory, by four angels. However, their hold on the mandorla does not seem entirely secure, and the top of it is tilted slightly to the left.

attributes: *see pages 36–38;* **bozzetto:** *see page 24;* **Plato:** *see pages 150–151 and 180;* **seven:** *see page 58;* **terracotta:** *see pages 24–25 and 76;* **Verrocchio:** *see page 19*

Accepted by the early fathers of the Church, they were one aspect of classical thought that was never "forgotten". Again they are often depicted in the context of funeral monuments, and all four appear on Luca della Robbia's ceiling for the Cardinal of Portugal's Chapel (see above).

The cardinal virtues are Fortitude, Justice, Temperance and Prudence. Most are shown in more than one guise. Fortitude, or strength, often wears armour, and, as here,

⬥ **CEILING OF THE CARDINAL OF PORTUGAL'S CHAPEL**
Luca della Robbia, ca. 1461–1462 (S. MINIATO, FLORENCE)

The glazed terracotta ceiling is the crowning glory of the Cardinal of Portugal's Chapel (see page 209), one of the greatest collaborative works of the 15th century. In the centre of the four cardinal virtues (clockwise from top left: Temperance, Fortitude, Justice and Prudence) is the Holy Spirit, surrounded by seven candles representing the seven churches mentioned in the Book of Revelation (chapters 2–3).

glazed terracotta: *see page 25*

○ ALLEGORY OF PRUDENCE
Titian, ca. 1565–1570 (NATIONAL GALLERY, LONDON)

Although the female personifications were the most common way to represent virtues, there were other means. The inscription on Titian's enigmatic painting, which has darkened and is now difficult to see, tells us that it is an allegory of Prudence. Each of the three heads, old, middle-aged and young, has a set of words written above it, which can be translated as "From past experience", "The present acts prudently", and "So as not to spoil future actions", the three together forming a coherent sentence. Rather than the mirror of self-knowledge (see main text, right), here it is the experience of the past which is called into account. Each head is accompanied by the head of an animal, which reflects its stage of life: an old, wily and grizzled wolf; a strong, maned lion; and an eager young dog. The colours are muted but balanced, with the old man's red cap and white hair being echoed in the dog's red tongue and white patch, while the beard of the central figure matches the lion's mane. Titian seems to have had the future of his family in mind. The old man is thought to be a self-portrait, while the figure in the centre may be his son Orazio, with his cousin and heir, Marco Vecellio, on the right.

carries a shield and mace. She may also carry a column – denoting strength, because it supports buildings – and can be associated with a lion. Justice frequently carries a set of scales, sometimes with a sword, although here she has a sword and an orb, the idea being that justice should rule the world. Temperance refers to the idea of moderation – not doing anything to excess – particularly eating and drinking. She is almost always seen pouring drink carefully from one container to another, although she can also be shown holding an hourglass, with its measured trickle of sand (see pages 180–183). Prudence – a sense of wisdom and caution applied to decision-making – is shown with a mirror. In order to make the right decision you need a certain amount of self-knowledge – although not too much: a mirror can also be an attribute of Vanity. Prudence also holds a snake, following Christ's instruction "be ye therefore wise as serpents" (Matthew 10.16).

An Array of Vices

Seven was also the number of the vices – although these were not necessarily the same as the Seven Deadly Sins. They are shown relatively rarely. In the Scrovegni Chapel in Padua, Giotto depicted the seven virtues at the bottom of the wall alongside the souls of the blessed going up to heaven, while opposite them, on the wall next to the depiction of hell, he showed their equivalent vices. Faith, Hope and Charity are opposite Infidelity, Despair and Envy. Infidelity is bound to pagan idols by a rope around her neck. Despair is illustrated as a suicide, which was considered contrary to God's law, as only he should decide when we live and when we die. Envy is consumed by the flames usually associated with Charity, and grasps a moneybag, rather than giving freely. Prudence is paired with Folly, Fortitude with Inconstancy, Temperance with Anger, and Justice, as might be expected, is paired with Injustice. However, these pairings of Virtues and Vices were not fixed: Ambrogio Lorenzetti uses different comparisons in his fresco illustrating the allegory of Bad Government in the Palazzo Pubblico in Siena (see opposite).

dog: *see page 173;* **Giotto:** *see pages 16–17;* **lion:** *see page 36;* **Scrovegni Chapel:** *see page 17;* **Titian:** *see page 152*

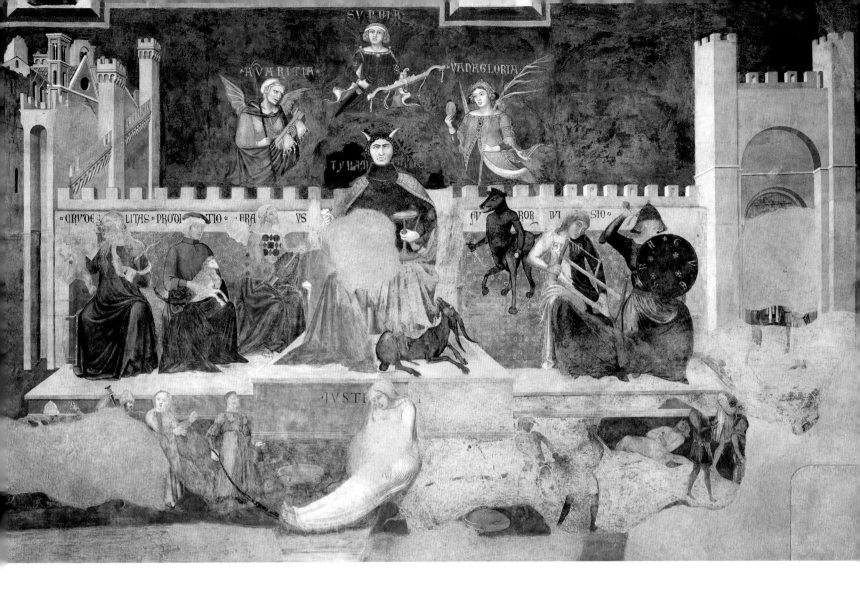

◆ ALLEGORY OF BAD GOVERNMENT (detail)
Ambrogio Lorenzetti, 1338–1339 (PALAZZO PUBBLICO, SIENA)

In keeping with the general preference for aspirational art, Lorenzetti's *Allegory of Good Government* (see pages 180–183) takes up an entire wall, and is flanked by another wall showing the *Effects of Good Government* in both town and country, whereas the *Allegory of Bad Government* and *Effects of Bad Government* occupy only one wall between them.

The main character in the *Allegory of Bad Government* is labelled **"Tyranny"** (see left), which was therefore seen as the opposite of good government. This attitude was echoed in later years by the Florentines, who rejoiced when their virtuous republic defeated the Milanese "tyrant" Giangaleazzo Visconti. Lorenzetti's figure represents one who governs for his own advantage. He wears a cloak adorned with gold embroidery and precious stones, and he holds a gold cup, both of which suggest his decadent behaviour.

The figure of **Justice** (see left) is bound at the bottom of the fresco, and her scales are broken and scattered on each side. By implication, Tyranny is presented as equivalent to Injustice.

Above the figure of Tyranny are Avarice (or Envy), Pride and Vainglory, in the equivalent positions to Faith, Charity and Hope in the *Allegory of Good Government*. Although Avarice and Pride are the wrong way round in relation to their respective counterparts Charity and Faith, **Vainglory** (see left) – looking at herself in a mirror – is in the same position as Hope, who looks up to a vision of Jesus.

The six seated vices could be considered as the opposites of the seated virtues in the *Allegory of Good Government*. They are, from left to right, Cruelty, Prodigy (that is to say, acts which are unnatural, or against the accepted order), Fraud, **Anger** (represented here as a beastly centaur, stamping on the bench like a wild animal; see right), Division, and War.

Division (see left) – the idea that a people will be divided and that factions will work against each other rather than for the common good – is shown dressed in black and white, the colours of the Sienese coat of arms, sawing her own leg off.

preference for aspirational art: *see pages 102 and 110;* **Giangaleazzo Visconti:** *see page 99*

GODS & GODDESSES

The classical gods and goddesses were many and varied, and there were also numerous heroes, whose special qualities usually derived from the fact that one of their parents was a deity. Most of the major figures were portrayed by Raphael's workshop in a villa constructed for Agostino Chigi (1466–1520), a Sienese banker who was a friend of Pope Julius II. The painting is on the ceiling of a loggia which was decorated to look like an outdoor pergola draped with tapestries: the border of this picture is scalloped, suggesting the ties which hold the tapestry onto a frame, and the pale blue just visible around the edges is meant to be the sky.

The following is a list of the Roman gods and goddesses shown here, with their equivalent Greek names in brackets.

❶ Jupiter (*Zeus*) was the king of the gods, and has as his attribute an eagle, and, in other images, thunderbolts. The eagle refers to the story of the Rape of Ganymede.

❷ Juno (*Hera*) was queen of the gods, and often wears a crown. Her attribute is a peacock. Aware of her husband Jupiter's infidelities she posted the many-eyed giant Argus to watch over him. Jupiter instructed Mercury to slay Argus, at which point Juno took the eyes and put them on the tails of her peacocks. In the Christian context the peacock becomes a symbol of everlasting life, and therefore of heaven, as it was believed that the body of a dead peacock did not decay.

❸ Minerva (*Athena*), the goddess of war and wisdom, usually wears armour. Her shield often bears an image of Medusa, as she lent this shield to Perseus to help him kill the Gorgon. Another attribute is an owl, representing wisdom.

❹ Ceres (*Demeter*) is shown with grain in her hair ("cereal" derives from her name). She was the goddess of agriculture.

❺ Neptune (*Poseidon*), god of the sea, is shown with a trident, or three-pronged fork.

❻ Cupid (*Eros*), the son of Venus, makes people fall in love by shooting golden arrows at them, although he can provoke hatred with arrows of lead. As well as his quiver full of arrows (not portrayed here) he also has wings, and sometimes wears a blindfold (because love is blind …). Usually shown as a baby, he is older here, in keeping with the narrative sequence to which this painting belongs: he has fallen in love with Psyche, a mortal despised by Venus because of her beauty.

❼ Pluto (*Hades*), god of the Underworld, is holding a bident, or two-pronged fork. At his feet is the three-headed dog Cerberus who guards the entrance to the underworld.

❽ Venus (*Aphrodite*) is the goddess of love and beauty. She is frequently shown semi-clad, if not naked, and often has Cupid by her side as an attribute. Her symbols also include the doves which pull her chariot (although it is sometimes pulled by swans), and pearls, a reference to her birth at sea.

❾ Mars (*Ares*), the god of war, is shown wearing armour.

❿ Apollo (*Apollo*) became known as the sun god through association with the notion of light, although originally he represented reason. As leader of the Muses he often carries a lyre or harp. He also carries arrows, which were likened to the sun's rays, but which were also said to cause plague.

⓫ Bacchus (*Dionysus*), the god of wine, and of the darker side of man's character, was in many respects the opposite of Apollo. He is often shown with vine leaves in his hair.

⓬ Hercules (*Heracles*) was Jupiter's son by the mortal Alcmena, and as such, an enemy of Juno. She tried to kill him in his cradle by sending two serpents, which Hercules, as a baby, promptly strangled. Although only a demi-god, he gained immortality as a result of his deeds. A muscular figure, his attributes include a club and the skin of the Nemean lion, which was impenetrable to human weapons.

Apollo: *see page 73;* **Bacchus:** *see page 152;* **birth of Venus:** *see page 21;* **Cupid:** *see page 157;* **eagle:** *see page 102;* **Ganymede:** *see page 66;* **Hercules:** *see page 24;* **Julius II:** *see pages 83–85;* **Jupiter:** *see pages 66 and 68;* **Mars and Venus:** *see pages 93 and 142;* **Minerva:** *see pages 164–165;* **tapestry:** *see page 31;* **villas:** *see page 202*

⬇ PSYCHE PRESENTED TO MOUNT OLYMPUS
Raphael and workshop, 1517 (VILLA FARNESINA, ROME)

This fresco is the penultimate scene from the story of Cupid and Psyche, told in a late Roman romance, *The Golden Ass*, by Apuleius (ca. 123–ca. 180). Prior to the marriage of the hero and heroine, Psyche is brought before Jupiter, king of the gods. In Raphael's interpretation, all the major deities are present. The key, right, will help to decipher who is represented.

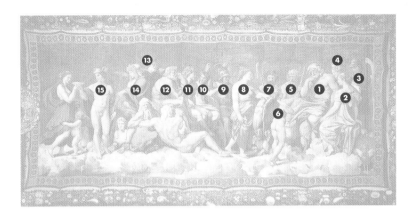

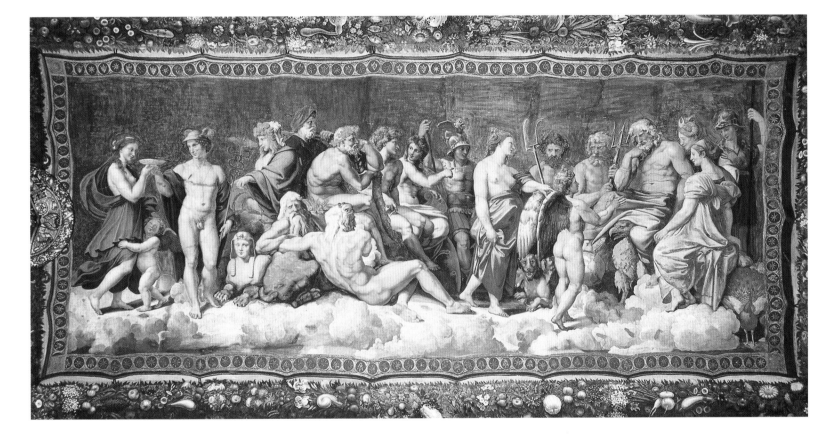

⓭ Vulcan (*Hephaestus*) the god of fire was thrown from Mount Olympus by his father Jupiter, and sustained injuries which left him crippled. He is therefore often shown as a hunchback, or with a crutch, and is depicted at his forge, or with an anvil or hammer.

⓮ Janus (*no Greek equivalent*) was the god of thresholds: he also therefore marks beginnings and endings, and has a face pointing in each direction. He gives his name to the month January, a time for looking forward and back.

⓯ Mercury (*Hermes*), the messenger god, wears a winged hat and winged sandals, to speed his delivery of messages. He also holds a caduceus, the staff of office he once used to kill two serpents, which are shown entwined around it. In this painting Mercury is accompanying Psyche, the human beloved of Cupid, before the court of heaven. Jupiter will resolve the dispute between Venus and Cupid, and allow the happy couple to marry.

Mercury: *see pages 156 and 182*

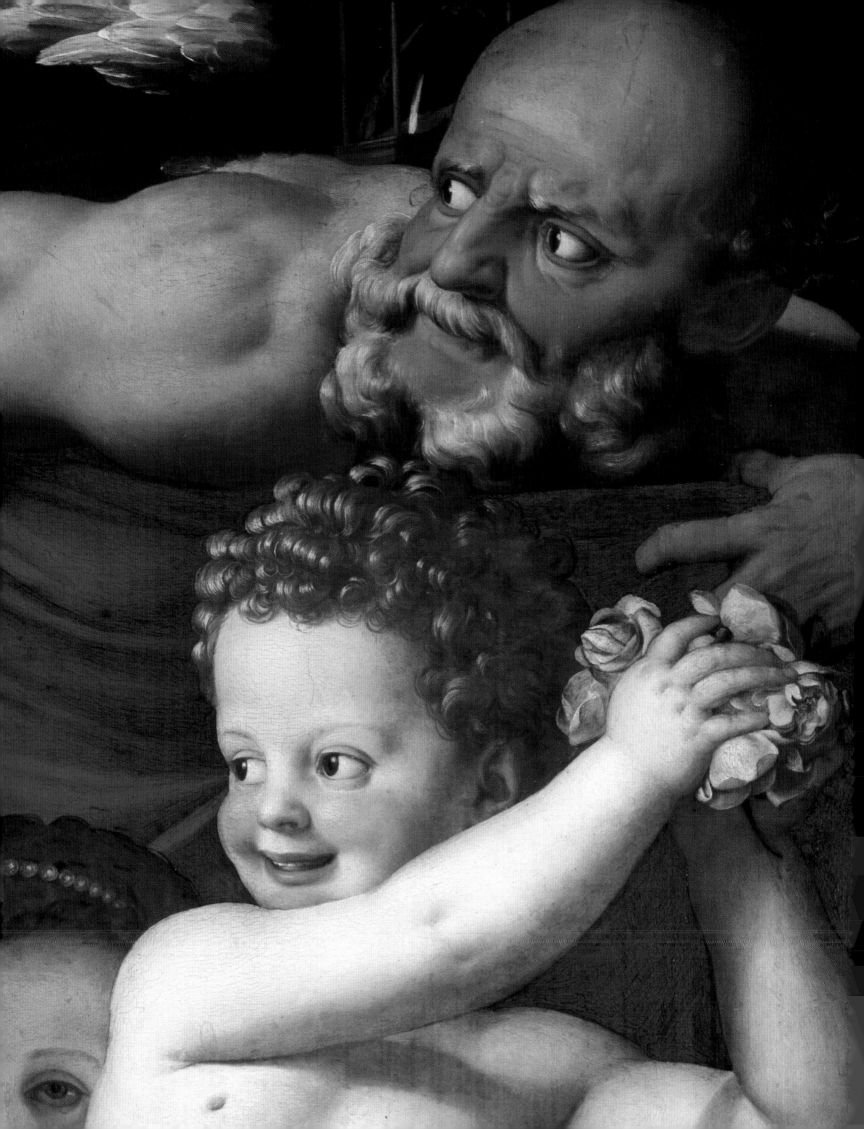

THE THEMATIC DECODER

PART THREE

———————————————○———————————————

In the second part of this book we considered individual aspects of art – the elements that artists used to build up meaning. Here we explore some of the themes that defined life in the Italian states during the Renaissance – and which were reflected in the art of the time. Using what we learned in Part 2, we "decode" some of the greatest and most complex Renaissance works of art. The most important aspect of society was religion, which we look at in terms of the Bible, the Church, and the relationship between heaven and Earth. However, religion coexisted – sometimes uncomfortably – with a renewed interest in the pagan culture and mythology of antiquity. Many of the scholars who unearthed this long-lost knowledge achieved positions of influence, advising rulers on how to govern responsibly, as well as on how to maintain their power and wealth. Art also reflected prevailing attitudes to war and peace and commented on other aspects of everyday life and society. One inescapable feature of life is its end – and for a profoundly religious society preparations for the afterlife were of utmost importance, so we conclude with a section on death and eternity.

——

◀ **ALLEGORY WITH VENUS AND CUPID (detail)**
Agnolo Bronzino, mid-1540s (NATIONAL GALLERY, LONDON)

As well as being part of a complex allegory, Bronzino's depiction of Time and Jest allow him to show his skill at painting contrasting effects. The two characters could hardly be more different – Time is old, bearded, wrinkled and bald, whereas Jest has the pink glow of childhood, smooth soft skin and a full head of golden curls. (See full painting, page 161.)

THE BIBLE

The Renaissance may have brought many changes, but one constant was the pre-eminence of the Bible as a source for art. Artists drew on stories from both the Old and New Testaments, often combining a New Testament event with its Old Testament precursor. Particularly popular were episodes that provided the opportunity to involve the viewer in moments of great emotional intensity, such as the consternation of the apostles when told by Jesus at the Last Supper that one of them was to betray him, or the grief exhibited by those present at his crucifixion.

The Bible (from the Greek *biblos*, meaning "book") is made up of the Hebrew Scriptures, originally written in Hebrew, Aramaic and Greek, and later Christian writings, composed in Greek. By the fourth century the canon of Old and New Testaments had been established and the pope commissioned Jerome of Dalmatia (ca. 342–420) to translate the Bible into Latin, the language of Western Christianity, to eliminate the confusion which arose from the variety of translations previously available. Completed by 382, Jerome's work was called the Vulgate and remained the standard Bible of the Western Church until the Reformation.

Although Jerome's translation was highly suited to priests, monks and scholars, who all understood Latin, it was inaccessible for the general population. By the Middle Ages a tendency for popular retellings of the stories had developed. These were often supplemented by material from the books excluded from the Bible – different accounts of the gospel stories, and lives of characters about whom little is mentioned, notably the Virgin Mary. It is often these, as much as a strict interpretation of the biblical text, which influence an artist's depiction of a particular event. There were also illustrated versions of the Bible for those who could not read. The *Biblia Pauperum*, or "Bible of the Poor", contained images of scenes from the Old and New Testaments placed next to each other, so that people could see how they related to each other.

Although relatively rare, another, more complex, form of Bible had developed by the early thirteenth century. Known as the *Bible Moralisée* or "moralized bible", it represents the most complex form of biblical analysis of the Middle Ages. Each story is interpreted in four ways, explained through written and pictorial commentaries. In addition to a purely literal interpretation – implying that the story describes what actually happened – a moral explanation was provided: what the story can teach us about how we should behave. It was also interpreted allegorically, implying that there is a second, hidden meaning behind the story, and anagogically – giving a spiritual interpretation of an apparently mundane event. If Bible stories were routinely subject to such complex analysis, then contemporary artists were bound to be coding some of these extra layers of meaning into their own work.

Seeing the Word

Paintings and sculptures of Bible narratives were clearly important – like the *Biblia Pauperum*, they illustrate the stories that most people could not read. Christianity is different from Judaism and Islam, both of which have followed Moses' second commandment not to create any imagery (Exodus 20.4). For the Church, this commandment was overruled by the need to communicate the message of the Bible widely and memorably – even out on the city street in the case of the bronze doors for the Baptistery of Florence cathedral (see opposite). Nevertheless, the use of images was a subject of bitter debate at many stages in the history of Christianity. One of the major results of the Reformation in the first half of the sixteenth century was the destruction, by Protestants, of many religious paintings and sculptures.

Baptistery doors competition: *see pages 22–23;* **the Church:** *see pages 128–135;* **Evangelists:** *see page 102;* **the Fall:** *see pages 36 and 121;* **Ghiberti:** *see pages 22–23 and 52;* **St Jerome:** *see pages 36, 102 and 109;* **Latin Doctors of the Church:** *see pages 102–103;* **Moses:** *see page 120;* **Reformation:** *see pages 128 and 134;* **stories and statements:** *see pages 94–97*

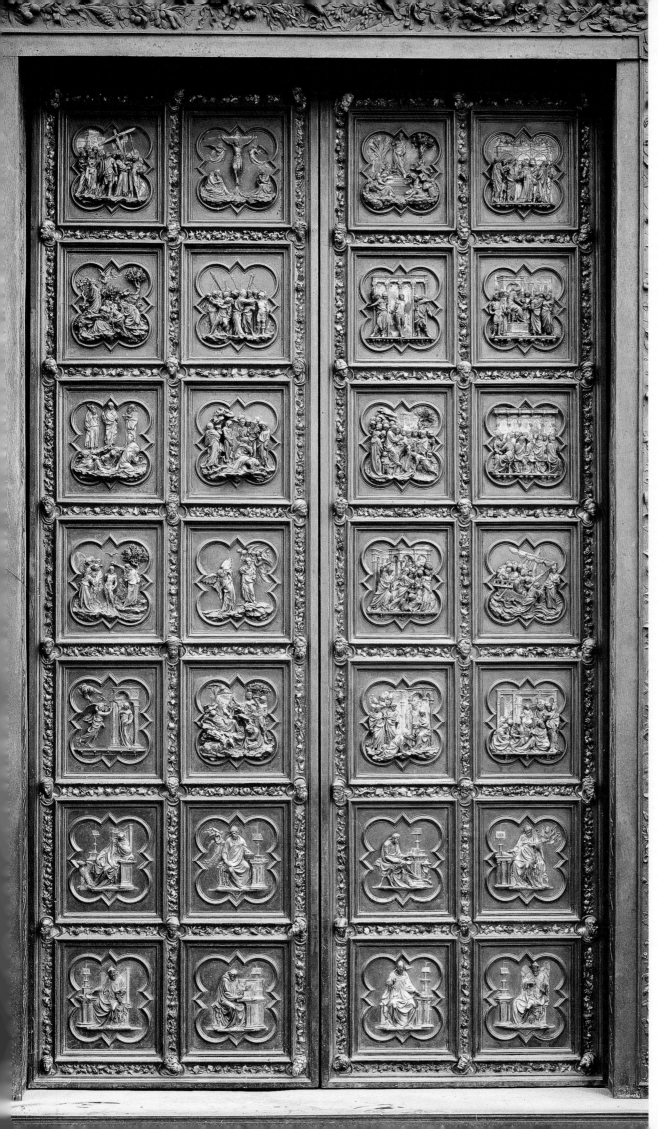

◆ NORTH DOORS

Lorenzo Ghiberti, 1403–1424
(BAPTISTERY, FLORENCE)

There are three sets of bronze
doors on the Baptistery in
Florence: on its north, east
and south sides. The first set,
the South Doors, was made in
the 1330s by Andrea Pisano,
and shows scenes from the
life of St John the Baptist.
Although the competition to
create the next set, the North
Doors, chose a subject from
the Old Testament – the
Sacrifice of Isaac (see page 22)
– the doors that Ghiberti
went on to make illustrate
the life of Jesus.

Ghiberti's East Doors
(1425–1452), known as the
"Gates of Paradise", depict
Old Testament scenes. These
start – as we would expect –
at the top left and end at the
bottom right. In contrast, the
scenes from the life of Christ
on the North Doors start
five rows down and read
upward (the bottom two
rows contain depictions of the
four Evangelists and the four
Latin Doctors of the Church).
The best explanation for this
is that Ghiberti is using the
order of the panels to reflect
the moral nature of the
narrative. On the Gates of
Paradise, the panels trace the
downward path of humankind
after the expulsion – the Fall –
of Adam and Eve. In contrast,
the upward progression on
the North Doors corresponds
to our redemption, which was
made possible by Christ's
incarnation, crucifixion and
triumph over death.

LINKING THE TESTAMENTS

One major difference between Judaism and Christianity is that Jews are waiting for the Messiah, or Saviour, whereas Christians believe that he has already come in the person of Jesus. For Christians it is important to demonstrate that Jesus is the Messiah who was prophesied in the Jewish scriptures, and that the New Testament is therefore, in the form of the covenant of Jesus Christ, the fulfilment of God's promises to Israel made in the Old Testament. Jesus himself was clearly well versed in the Hebrew Scriptures – even as a boy, he discussed matters of theology with the elders in the temple (often depicted as "Christ among the Doctors"), and in his adult life he frequently referred to Old Testament prophecies. The gospels of the New Testament all emphasize the way in which Jesus' mission fulfilled these prophecies.

Types and Antitypes

Although there are explicit links between the Old and New Testaments, from the earliest times Christian commentators began to discover more subtle ways in which the testaments related to each other. Everything in the Old Testament was considered to be a "type" of something in the New Testament – an anticipation of something that was to come. The most important of these was Moses, who gave the Israelites the Ten Commandments, and led them from captivity in Egypt. Similarly, Jesus was to bring the new law, and free mankind from sin. The first decorations of the Sistine Chapel, commissioned by Pope Sixtus IV (after whom the chapel is named), parallel the life of Moses on one wall with the life of Jesus on the opposite wall. For example, Moses receiving the Ten Commandments on Mount Sinai is directly opposite Jesus preaching the Sermon on the Mount. The fact that both events took place on a hill was not lost on the theologians: for them this was no coincidence, but part of God's plan. If Moses is the "type" of Jesus, Jesus is the "antitype" of Moses – the thing that is prefigured by the type.

Similarly, the Old Testament patriarch Joseph, who led his family and people into Egypt, thus saving them from famine, was a type of the New Testament Joseph, who led Mary and the infant Jesus into Egypt (the "Flight into Egypt"). Rather than famine, they were fleeing from Herod's soldiers, who had been ordered to kill all baby boys under the age of two to ensure that Jesus would be killed (the "Massacre of the Innocents").

Another common link was between Adam, given life by God in the Old Testament, and Lazarus, who is brought back from the dead – thus given new life – in the New Testament. The raising of Lazarus was also seen, within the New Testament, as a type for the resurrection of Christ himself. There were also several Old Testament types for the Resurrection, notably the story of Jonah. The fact that Jonah went into the dark belly of the whale only to be regurgitated on the third day was seen as equivalent to Christ's death, descent into hell, and resurrection. Jonah was often shown in decorative schemes that were based on types and antitypes, such as in the Scuola di San Rocco in Venice (see page 177).

THE NEW EVE
The links between the Old and New Testaments were sometimes surprisingly convoluted. One of the messages of the Church, important for men as much as for women, was that mankind had fallen as the result of a woman's actions – the temptation of Eve. However, we are also saved by a woman: the Virgin Mary. Mary is seen in many respects as the opposite of Eve, or as the new Eve, who gives us a chance to start again. Theologians identified a hidden significance in the first words spoken to Mary by the archangel Gabriel at the Annunciation, which were "Hail Mary". The Latin translation of this phrase is "Ave Maria". When reversed, "Ave" spells "Eva" – seen as another confirmation of God's remarkable plan.

Annunciation: *see pages 48 and 80–81;* **the Fall:** *see page 36;* **archangel Gabriel:** *see page 104;* **St John the Baptist:** *see page 108;* **Jonah:** *see page 38;* **predella:** *see page 36;* **Sacrifice of Isaac:** *see pages 22–23;* **Sistine Chapel:** *see page 84;* **Sixtus IV:** *see pages 84, 175 and 198;* **Virgin Mary:** *see pages 88 and 214–215*

○ VIRGIN AND CHILD ENTHRONED BETWEEN A SOLDIER SAINT AND ST JOHN THE BAPTIST

Lorenzo Costa with Gianfrancesco Maineri, ca. 1499 (NATIONAL GALLERY, LONDON)

Maineri began this altarpiece for members of the Strozzi family in Ferrara, and painted the throne and smaller scenes. Costa completed the painting – altering the main figures which Maineri had started – probably because the patrons were anxious for its delivery. By this stage Maineri may have been working elsewhere.

In the triangular sections on each side of the arch – called the spandrels – are carvings of the Annunciation. **Gabriel**, shown in this detail (see right) is on the left of the arch and Mary is on the right.

The scene in the top left corner probably represents the story of **Esther** (see right), an Old Testament heroine who dares to go before the ruler Ahasuerus to intercede on behalf of the Jewish people when they are threatened with persecution by one of his officials. As a virtuous woman who saves her people, Esther was seen as a type for Mary.

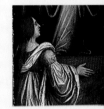

In the other corner, the **sacrifice of Isaac** (see right) reminds us that Christ – seen as a child in the painting – will be sacrificed for mankind's redemption. In this case Jesus is the antitype of Isaac.

The carving of **Adam and Eve** (see right) refers to the Fall, and to our need for salvation, as well as suggesting Mary's role as the New Eve. The turbaned heads on each side represent prophets.

The base of the throne takes the place of the predella in a medieval polyptych. Reading – unusually – from right to left, the stories represented are the Nativity, the Presentation at the Temple, the **Massacre of the Innocents** (see right), the Flight into Egypt and Christ among the Doctors.

A TIME AND A PLACE

Leonardo da Vinci's *Last Supper* decorates the refectory of the Milanese monastery of Santa Maria delle Grazie: while eating the monks were reminded of what could be described as the most important meal ever. The location of the painting is entirely traditional, but there is much about Leonardo's interpretation of the story that is unusual.

The mural is in a poor condition, because rather than painting on wet plaster, the traditional technique for fresco, Leonardo waited until it was dry. Already in 1517 – less than twenty years after its completion – the paint was starting to peel. It has since been subject to numerous re-paintings and restorations: what we see today is a ghost of the original. Nevertheless, the image still holds remarkable power.

Debate about the painting is focused on two main issues: who is present, and what is going on? The first is relatively simple to resolve as there are thirteen people: Christ and the twelve apostles. Their identities can be established from an early sixteenth-century copy of the work, which labels those present; and their physiognomies were in any case more or less standardized. The apostles are arranged in four groups of three, with Bartholomew, James the Less and Andrew on the far left, and Judas, Peter and John closer in – at Jesus' right hand. On the other side are Thomas, James the Great and Philip, with Matthew, Thaddeus and Simon Zelotes closing the composition on the right.

This arrangement is artificial: thirteen people at supper would sit on both sides of the table, as they do in Giotto's version of the story (see page 17). But here we can see them all – they appear as if at the High Table in the refectory. This was entirely traditional, although artists often placed Judas on our side of the table (as Leonardo did in his sketches for the fresco; see endpapers), thus separating him from Jesus, and reminding us, by his proximity to us, of our own fallibility.

Critics have tried to pinpoint which moment of the narrative is illustrated. However, Christ's gestures alone show that

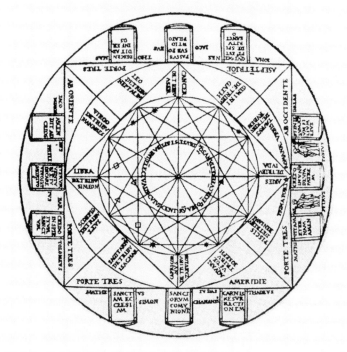

DVODECIM PORTE HIERVSALEM
correfpondentes duodecim tribubus / duodecim
fignis cœleftibus / & duodecim portiis Ro-
manæ urbis / & duodecim apoftolis /
& duodecim articulis fidei.

⬤ **TWELVE GATES OF JERUSALEM**
from De Tribus Peregrinis *by Fra Matteo Selvaggio*, 1542 (VENICE)

This illustration, from a 16th-century book about a conversation between three pilgrims, may help to explain Leonardo's grouping of the figures in the *Last Supper*. It proposes a link between the twelve gates of the New Jerusalem, as described in the Book of Revelation, and the twelve apostles. It also relates them to the gates of Rome, which had become established as a more accessible pilgrimage destination than the Holy Land. Other links are made to the twelve tribes of Israel, the twelve articles of faith and even the signs of the Zodiac. For example, the three gates at the south are associated not only with Matthew, Judas and Thaddeus, but also the signs of Sagittarius, Capricorn and Aquarius. Although not laid out in the same way, Leonardo's arrangement of four groups of three does emphasize the relationship between the apostles and the months of the year, grouped into four seasons of three months each.

apostles: *see page 102;* **astrology:** *see page 142;* **four:** *see pages 58–61;* **Last Supper:** *see page 134;* **Leonardo da Vinci:** *see page 6;* **painting on dry plaster:** *see page 127;* **three:** *see pages 58–61;* **twelve:** *see pages 61, 102, 136 and 137*

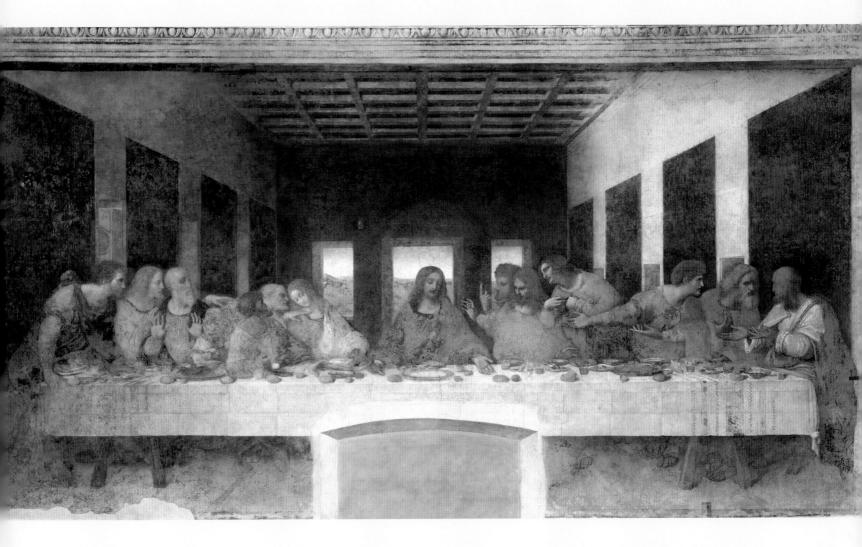

⬆ LAST SUPPER
Leonardo da Vinci, ca. 1494–1498 (S. MARIA DELLE GRAZIE, MILAN)

Leonardo is depicting more than one idea: his hands reach for the bread and the wine, two separate moments in the narrative. The lively debate among the apostles represents a third moment, and follows Christ's declaration that one of them would betray him, Leonardo demonstrating his belief that in a picture "the figures should be represented so that the viewer can recognize their thoughts from their actions, as if they could speak". Judas is shying away, clutching a bag containing thirty pieces of silver, his fee as a traitor. With his other hand he reaches for the same cup as Jesus: immediately after mentioning the cup Jesus says "But, behold, the hand of him that betrayeth me is with me on the table" (Luke 22.21).

It was traditional in paintings of the Last Supper to show John the Evangelist resting on Jesus: "Now there was leaning on Jesus' bosom one of his disciples, whom Jesus loved" (John 13.23) – the lack of name suggesting modesty on John's part, as he appears to be referring to himself. Recently, it has been suggested that this verse refers to Mary Magdalene, and that it is her whom Leonardo places next to Jesus, not John. However, the figure painted by Leonardo is entirely consistent with the image of John in Raphael's *Crucifixion* (see page 89), in which Mary Magdalene is also present, and notably different. The long hair of the figure in Leonardo's mural is not covered or styled, which tells us that this is a man. Leonardo is illustrating the next verse in the gospel, in which Peter calls over John to ask him who he thinks will betray Christ: "Simon Peter therefore beckoned to him that he should ask who it should be of whom he spake." The word "him" confirms that this is John not Mary. Traditionally, Peter and John were shown at Jesus' right and left, but Leonardo has put them both on his right, to facilitate their discussion. It also allows Leonardo to move John away from Jesus, leaving Christ as the focus of the painting. He is indeed at the vanishing point of the perspective, physically and psychologically separated from the apostles.

gesture and body language: *see pages 78–81;* **St John the Evangelist:** *see page 106;* **male and female:** *see pages 86–89;* **Mary Magdalene:** *see pages 88–89 and 108;* **perspective:** *see pages 52–55;* **St Peter:** *see pages 95, 106 and 128–129;* **right and left:** *see page 62*

1 The two saints in identical clothes are the healers Cosmas and Damian. As "medics" they were patron saints of the Medici family (even though the spelling of its name was the family's only link with medicine) and, more specifically, of the monastery's patron, Cosimo de' Medici.

2 The scrolls held by the characters in the border mark them out as Old Testament prophets, whose words refer to the birth and suffering of the Messiah. The green, white and red of the border reminds us that this monastery was under Medici patronage.

3 The Good Thief is at Jesus' right hand, and is blond, like Jesus. The Bad Thief at Jesus' left, or "sinister", side is dark and clearly suffering.

4 The pelican's act of regurgitating food was mistaken for a gesture of pecking at its breast to feed the young with its own flesh. This image, known as the "Pelican in her Piety", was seen as a symbol of Christ's sacrifice for us, and the act of feeding us with his body during the Mass.

5 The tablet at the head of the Cross includes the inscription "Jesus of Nazareth King of the Jews" in Hebrew, Greek and Latin.

7 St Laurence was the dedicatee of the church adjacent to the Medici Palace, also patronized by Cosimo de' Medici, and was the patron saint of his grandson, Lorenzo "the Magnificent".

8 John the Baptist, as the Precursor, points toward Christ. St John – or Giovanni – was one of the patron saints of Cosimo de' Medici's father, Giovanni di Bicci de' Medici.

9 The position in which Mary has fainted clearly echoes that of the crucified Jesus. She suffers along with him, and as his mother is essential for our redemption: she is sometimes referred to as the co-redemptrix. She is supported by John the Evangelist (the primary patron of Giovanni di Bicci de' Medici), Mary Magdalene and one of the other Marys. Fittingly, this holy group is placed at Jesus' right hand.

10 Jesus was crucified on Golgotha, "the place of the skull". This was believed by many to be the skull of Adam.

11 Dominic here holds a branch which winds round other members of his order, reminding the monks how many of their predecessors had been officially recognized as holy men.

6 Although ultramarine was highly prized as a pigment, it cannot be used in true fresco (that is, on wet plaster) because it reacts with the lime water with which pigments are mixed. Ultramarine was painted *a secco* – after the plaster had dried. Here it has flaked off, revealing a reddish colour painted in true fresco to enhance the rich colouring of the ultramarine.

THE CONTEMPLATION OF SUFFERING

The Crucifixion is one of the central themes of Christian art, bringing to our eyes the most dramatic episode in the narrative of salvation. Images of the event were designed to remind us of the way in which Christ suffered for us, to encourage us to repent of our sins. Fra Angelico's interpretation was painted for the Chapter House, or assembly room, of the Monastery of San Marco (St Mark's) in Florence. This was where the community would gather to deal with secular business, as well as to discuss their monastic responsibilities. It was an important place for instruction, and any decoration would be designed to communicate specific points.

The Bible mentions that two thieves were crucified alongside Jesus: as one repented and the other didn't, they are usually referred to as the "Good Thief" and the "Bad Thief". The Bible also refers to the presence of the Virgin Mary, John the Evangelist and Mary Magdalene, as well as two other holy women whose identity varies between the different gospel accounts, but who are often referred to as Mary Salome and Mary Cleophas. The remaining characters in Fra Angelico's painting were not actually present at the Crucifixion, but can be understood as contemplating Christ's suffering, as if they are seeing a vision or image of the event, rather than the real thing. The different ways in which the onlookers behave – from solemn contemplation to abject grief – would instruct the monks about the many ways in which they, in their daily life, could respond to this pivotal event.

◄ **CRUCIFIXION**
Fra Angelico, 1440s (S. MARCO, FLORENCE)

Fra Angelico, born Guido di Pietro, became a Dominican monk around the age of twenty, and probably started to paint relatively late in life. He lived and worked in San Marco, which was reconstructed in the late 1430s under the patronage of Cosimo de' Medici, who was using this opportunity to atone for the sin of usury. The choice of saints depicted reflects Cosimo's patronage.

12 St Dominic kneels at the foot of the Cross. The star on his halo is a symbol of his specific holiness: his forehead was said to glow with a supernatural light.

13 The inclusion of St Francis, together with saints from other orders, recognizes that despite theological disagreements these men's teachings should be respected.

colour: *see pages 44–47;* **St Dominic and the Dominicans:** *see pages 96, 109 and 130;* **St Francis:** *see pages 46, 76, 78 and 108;* **INRI:** *see page 41;* **St John the Baptist:** *see page 108;* **Cosimo "il Vecchio" de' Medici:** *see page 186;* **patronage:** *see pages 82–85;* **prophets:** *see page 102;* **ultramarine:** *see page 44;* **usury:** *see page 17*

THE CHURCH

Although the Bible is the main source for Christian belief, it should be remembered that most people could not read, and even if passages were read out they would have been in Latin, which, again, only the educated few could understand. People relied on the Church for their knowledge of the Bible and for an interpretation of its message – and it was in the Church's interests to make sure that they continued to do so. Art was therefore used to emphasize the God-given status of both the Church and the authority of the pope, as defined by Jesus' acknowledgment of Peter's primacy. It also underlined that the Catholic Church was the only path to salvation, and the only true authority on aspects of theology.

At the beginning of the fifteenth century the Church was experiencing a period of turmoil. From its earliest days there had been divisions, the most important of which was the separation, both culturally and ecclesiastically, into East and West – a Byzantine civilization centred on Constantinople and a Latin civilization centred on Rome and the popes. There were periodic attempts to reunite the resultant Orthodox and Catholic churches in the face of the common threat posed by Islam, but none was successful.

Although we now see the Vatican as the centre of the Catholic Church this was not always so: from the fourth century – shortly after Constantine legalized Christianity in 313 – until the fourteenth, the popes lived in the Lateran Palace on the other side of Rome, and in 1309 the papacy moved to Avignon, in southern France. With the election of Pope Urban VI in 1378, the papacy returned to Rome. However, disaffected cardinals established a rival papal court at Avignon, which was supported by both France and Spain. The Great Schism, as it was known, was further complicated with the election of a third pope, and did not end until 1417 when the Council of Constance elected Martin V and European unity was restored.

A far more wide-reaching break occurred in the sixteenth century. Reformers in northern Europe sought to challenge many of the errors into which they considered the Church had fallen. Led by Martin Luther, a monk who in 1517 nailed a list of his complaints against the Church to the doors of Wittenberg cathedral, the Reformation resulted in the split of the Western branch of Christianity into two distinct churches, Protestant and Catholic.

Both before and after the Reformation, the Catholic Church's main claim to primacy rested on the authority of none other than Christ himself. When his apostle Simon Peter acknowledged him as "the Christ, the Son of the living God", Jesus replied, saying "thou art Peter, and upon this rock I will build my Church; and the gates of hell shall not prevail against it. And I will give unto thee the keys of the Kingdom of Heaven: and whatsoever thou shalt bind on earth shall be bound in heaven: and whatsoever thou shalt loose on earth shall be loosed in heaven." (Matthew 16.18–19). "Peter" means rock, and Jesus uses his name to imply that he will be the very foundation of the Church. The keys that loose and bind were interpreted in many ways, but primarily that Peter would be the law-giver for Christians after Christ, and also that he had the power to exclude people from heaven. This is the origin of the popular idea that it is St Peter who welcomes new arrivals at the "Pearly Gates", and who decides whether or not you can enter.

Peter's successors are the popes, the continuing role of the papacy being known as the Apostolic Succession: they follow as heads of the Church in Peter's tradition and with God's sanction. The crossed keys became a symbol of their power, and St Peter's God-given right to continue Christ's mission was central to their continued legitimacy.

independent sculpture: *see page 24;* **Ottoman Empire:** *see page 192;* **St Peter:** *see pages 95 and 106;* **Reformation:** *see page 134*

◀ **DONATION OF THE KEYS**
Donatello, 1428–1430 (VICTORIA AND ALBERT MUSEUM, LONDON)

Although Christ's reference to the keys of heaven occurs during his ministry on Earth, and is best interpreted as a metaphorical allusion, Donatello has imagined Jesus giving the keys to St Peter as an actual event taking place at the time of the Ascension. On his physical departure from Earth, Jesus is officially appointing Peter his representative. The precise function of this relief is not known, although the low viewpoint – our eye appears to be at ground level – suggests that it may have been hung fairly high up. It may be one of the first relief sculptures made for its own sake rather than as part of the decoration of some larger structure. The brilliance of execution and minuteness of detailing would support this idea: in places Donatello appears to have drawn with his scalpel on the solid marble. Donatello himself pioneered this type of very low relief, an innovation of the Renaissance, which is known as *rilievo schiacciato*, or "flattened relief".

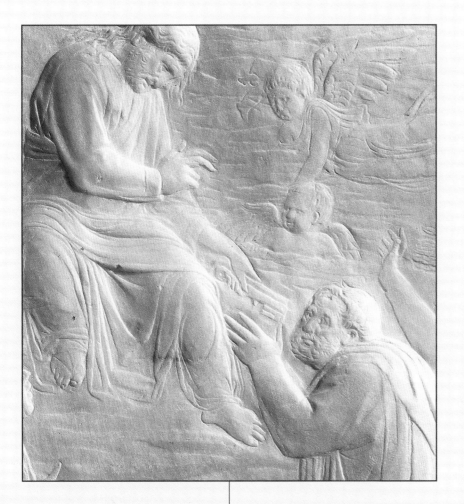

THE ROAD TO SALVATION

The vital importance of the Church in the process of salvation is emphasized in Andrea Bonaiuti's monumental fresco, painted for the Chapter House of the Dominican monastery of Santa Maria Novella in Florence. It would have helped to remind the assembled monks that their authority came from the pope via St Peter, and so ultimately, from Christ. Created in the 1360s, strictly speaking the painting predates the Renaissance, but it expresses ideas about the structure and role of the Church that continued to be relevant throughout the ensuing period.

◉ TRIUMPH OF THE CHURCH
Andrea Bonaiuti ("Andrea da Firenze"), ca. 1365–1367
(CHAPTER HOUSE, S. MARIA NOVELLA, FLORENCE)

This fresco, covering an entire wall, is just part of the decoration of the Chapter House of Santa Maria Novella. The Chapter House did not gain its present name, the Spanish Chapel, until the 16th century, when Eleanora da Toledo, wife of Duke Cosimo I, adapted the burial chapel behind the altar for use by the Spanish community in Florence.

The Church itself is represented by Florence cathedral (complete with **dome**, see right, even though the painting pre-dates Brunelleschi's structure by some seventy years). In front of the cathedral sit figures of authority. The hierarchy is clear – the pope is central, as God's representative on Earth. On the pope's right are subordinate religious authorities: a cardinal, a bishop and a monk, in descending order of importance; and to his left are the temporal or earthly rulers – the Holy Roman Emperor, a king and a mayor.

The **pope**, wearing the triple tiara, is larger than the other characters to emphasize his status, and is also fully visible and perfectly framed by the architecture behind him. The **cardinal**, with his red hat, is wearing the black-and-white habit of the Dominican order, and has clearly risen from their ranks to a position of importance within the Church. He is slightly smaller than the pope, and his status is also lessened by the architecture which does not frame the form so well, and by the people standing in front of him. Nevertheless, he is at the pope's right, the position of honour. The **Holy Roman Emperor** carries a sword and orb, to show his earthly power. He appears slightly larger, and less obscured than the cardinal, but is at the pope's left – so he is powerful but perhaps not as respected.

Through the action of the monks – notably preaching, **confession** (see right) and spiritual guidance – the souls of the blessed are welcomed at the gates of heaven (under Jesus' right hand) by St Peter, and join the company of saints adoring the throne of God. St Peter carries very prominently the keys given to him by Christ, to underline that the authority of the popes comes from their position as his successors.

More feckless souls (on Jesus' left) continue in a dissolute life, which appears to us as apparently innocent music-playing and dancing, while ignoring the Church's message.

The learned Dominican monks, who liked a good pun, realized that their name – deriving from their founder St Dominic – could also be broken down to "Domini canes", which is Latin for the "Hounds of the Lord". In the bottom right hand corner of the fresco, Dominic can be seen sending his hounds out to fight heresy – their black-and-white coloration reflects the black-and-white habits of the order. The Dominicans regularly contested points of theology with the Franciscans, who wore brown habits, so it is interesting to observe **two black-and-white dogs overpowering a brown one** (see above, right) at the bottom of the painting.

Above the dogs, onlookers are converted by the preaching of the Dominicans, and **heretics rip up their profane texts** (see right) at the sight of the Bible.

Chapter House: *see page 127;* **church of Santa Maria Novella:** *see pages 82–83;* **St Dominic and the Dominicans:** *see pages 96 and 109;* **Florence cathedral:** *see pages 26–27;* **St Francis:** *see pages 46, 76, 78 and 108;* **heresy:** *see pages 96–97 and 140;* **Holy Roman Emperor:** *see page 174;* **keys:** *see pages 128–129;* **St Peter:** *see pages 95, 106 and 128–129;* **pope:** *see pages 128 and 174–175;* **right and left:** *see page 62*

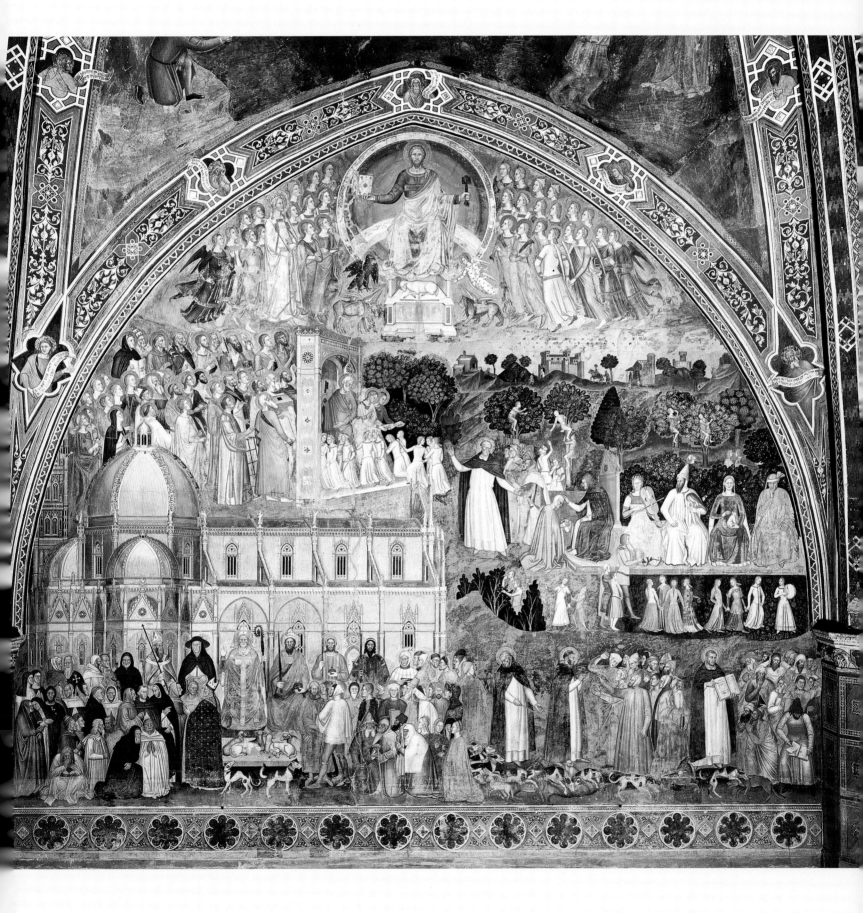

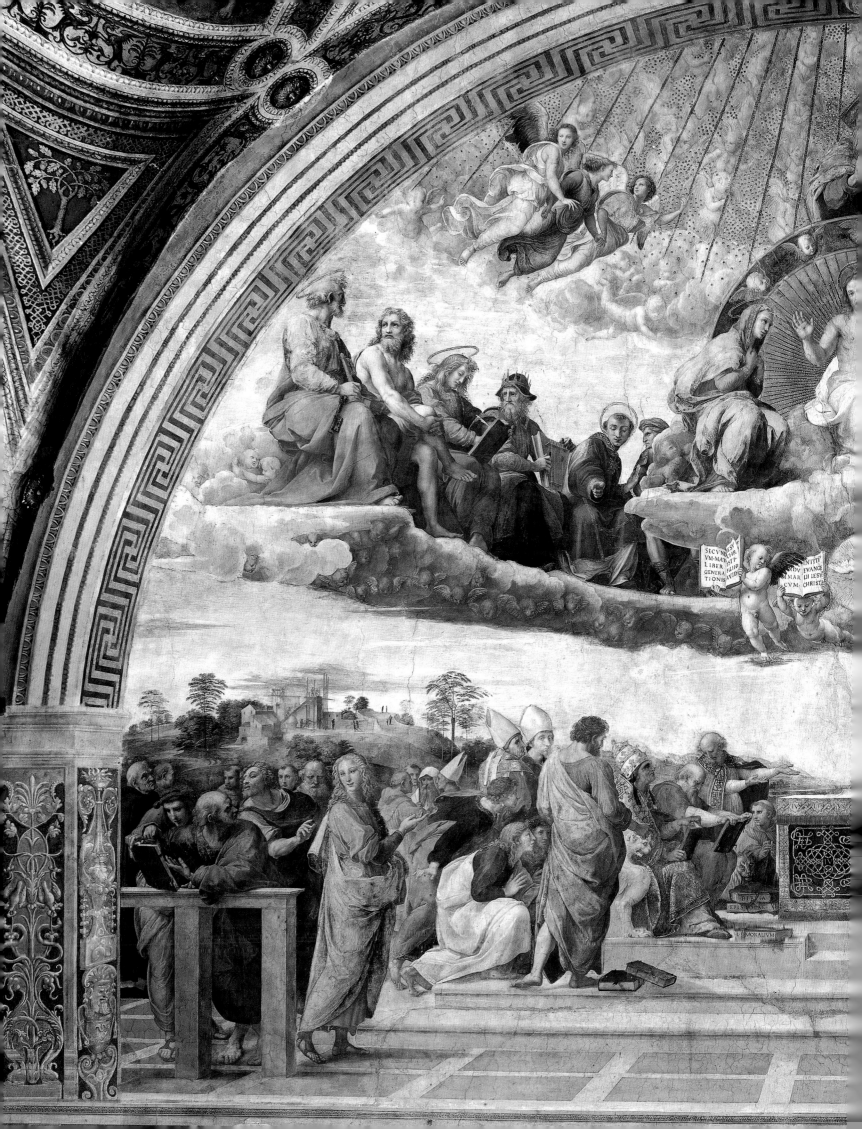

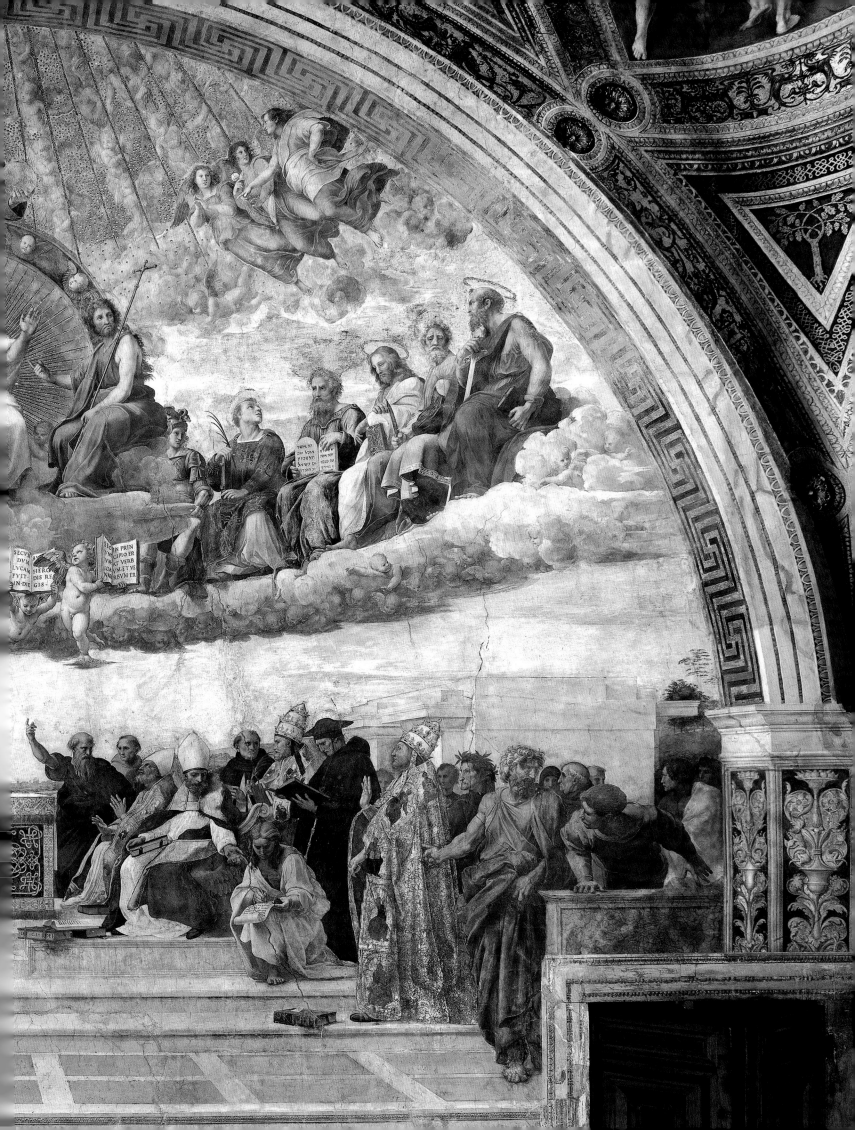

THE SOURCE OF CHRISTIAN KNOWLEDGE

Although the Apostolic Succession derived legitimacy from God, via St Peter, the practicalities of retaining such power required great erudition when faced with complex theological disputes. One such issue was the precise nature of the sacraments. As part of the decorations of his private apartments, Pope Julius II commissioned Raphael to produce a work to reinforce the accepted interpretation of the Mass. The result was the *Disputation over the Sacrament*, commonly known as the "Disputà".

At the Last Supper Jesus took bread, broke it and gave it to his disciples, saying "Take, eat; this is my body" (Matthew 26.26). This act is repeated during the celebration of the Mass, with the priest using the same words. When the bread – usually in the form of a circular wafer – is consecrated, it is lifted up by the priest. At this moment, known as the Elevation of the Host, Catholics believe that by a mysterious process known as transubstantiation, which we as humans cannot understand, the substance of the host changes and becomes – it actually *is* – the body of Christ. Most Protestants, on the other hand, believe that the bread only *represents* the body of Christ, and is a reminder of his sacrifice. The Reformation was yet to take place when Raphael painted this fresco, but one of Julius's concerns in commissioning this work was to counter the arguments that were already brewing.

Central to the subject of the painting is the Holy Trinity – God the Father, Son and Holy Spirit – shown on the central, vertical axis of the composition, directly above the consecrated host. On each side of Jesus are Mary and John the Baptist, surrounded by New Testament saints and early Christian martyrs in the company of Old Testament prophets. The semi-circular bank of clouds on which they sit and the choir of angels around God the Father create the effect of a church apse around the altar. Below them, on the earthly plane, the Doctors of the Church (nearest to the altar) and other religious authorities refer to texts inspired by God through the agency of the Holy Spirit to clarify aspects of theology.

⊙ DISPUTATION OVER THE SACRAMENT (THE "DISPUTA")

Raphael, 1510–1511 (VATICAN)

According to Vasari, Pope Julius II was so taken with Raphael's *School of Athens* (see pages 148–151) that he commissioned the artist to paint the rest of his private chambers. The *Disputation over the Sacrament*, or "Disputà", is on the wall opposite the *School of Athens*, and represents theological, rather than philosophical, knowledge. Julius's patronage of the fresco is confirmed by the della Rovere oak trees in the pendentives, seen in the top left and right corners of this illustration.

❺ The prominence of St Peter at the front of the arc of prophets (without haloes) and saints helps to emphasize the nature of papal authority, which comes by descent from Peter, who was given responsibility for the Church by Jesus himself.

❻ On either side of the Holy Spirit, four cherubs hold books – these are the four New Testament gospels on which knowledge of Christ is based.

❼ St Gregory the Great, in the papal triple tiara, looks up for inspiration from the Holy Spirit. He is often depicted with a dove by his ear.

St Augustine: *see pages 104 and 172–173;* **Dante:** *see pages 12 and 13;* **Holy Trinity:** *see page 96;* **St Jerome:** *see pages 36, 102 and 109;* **St John the Baptist:** *see page 108;* **Julius II:** *see pages 83–85;* **Last Supper:** *see pages 122–123;* **Latin Doctors of the Church:** *see pages 102–104;* **St Peter:** *see pages 95, 106 and 128–129;* **Reformation:** *see page 128;* **Vasari:** *see pages 15 and 16*

① Jesus clearly displays the wounds in his hands and chest, and his torso is uncovered – emphasizing the body and blood which are the theme of the Mass. He appears in a circular glory, and wears white, echoing the appearance of the host within the monstrance (see 9).

② God the Father appears at the top, against the gold "heaven", carrying a blue orb representing his omnipotence.

③ The Holy Spirit, in the form of a dove, is white against a circular gold ground: the decreasing size of the circles from Christ, to the Holy Spirit, to the monstrance serve to emphasize the nature of transubstantiation, almost as if the body of Christ is "funnelled" into the wafer.

④ John the Baptist points to Jesus and yet looks toward us: his role as "Precursor" of the Messiah was to announce the coming of Christ, which he does here with his gesture.

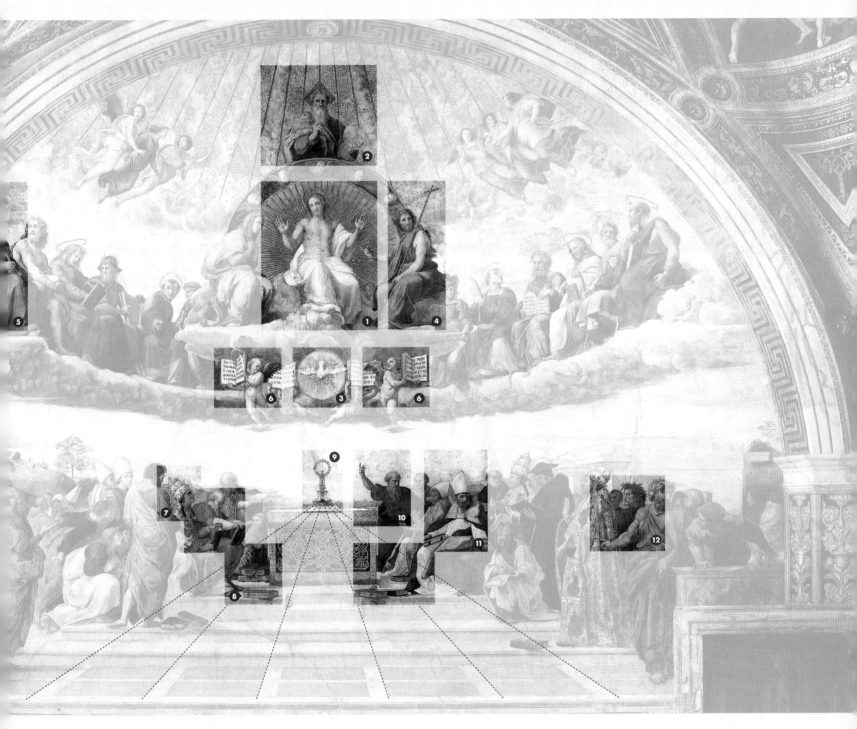

⑧ St Jerome is seated in contemplation of the Bible – with the volumes he has translated in front of his feet. As the only cardinal among the Doctors of the Church, his robes would be enough to identify him. Nevertheless, his lion peers out from behind the pile of books.

⑨ The consecrated host, in the form of a wafer, is displayed in a circular monstrance. As the focus of debate within the painting, it is also placed at the vanishing point of the perspective.

⑩ The upward gesture is equivalent to that of Plato on the opposite wall, and emphasizes that classical learning also comes from God, even if the philosophers preceded Christ.

⑪ St Augustine (front) is distinguished from St Ambrose (back) by the copy of his book, *De Civitate Dei* ("On the City of God"), which lies on the step next to him.

⑫ The laurel wreath shows this man to be a *laureate* – or poet. He is Dante, whose *Divine Comedy* was considered by some to be second only to the Bible in its status as religious source material.

HEAVEN & EARTH

As interest in the world around us grew, so did speculation on the relationship between Earth and the heavens: the former was increasingly explored and understood, whereas the latter could be seen but not visited. Renaissance artists chose to explore this relationship in symbolic terms, stressing the harmony of all God's creation. They were also keen to point out that their own part of the world was especially close to God, and therefore to heaven. The nature of astrology was widely disputed – was it God or the stars that governed our behaviour? – and so it too became a subject for art.

One of the major developments in Renaissance thought was that the world began to be seen from a human viewpoint, rather than being centred solely on God. Single vanishing-point perspective implies that the image is seen from our point of view, and the development of things such as land-scape painting reflected a growing appreciation of, and curiosity toward, the world we actually live in and experience.

In this spirit of enquiry, the Polish-German astronomer Nicolaus Copernicus (1473–1543) contended that the Earth revolved around the sun, rather than vice versa. Nevertheless, the common belief remained that God's universe had man at its centre. There were seven heavenly bodies – the sun, moon and five planets – and these revolved around the Earth in crystalline spheres. Beyond these was the sphere of what were known as the "fixed stars" – the ones that do not move in relation to each other – and beyond that, heaven. This idea can be seen in Domenico di Michelino's painting of Dante (see page 13), where the heavenly bodies are depicted in the blue arcs at the top of the painting, the crescent moon being clearly visible in the lowest of these as closest to the Earth, followed by Mercury, Venus and the sun.

The fact that there were seven heavenly bodies and that they move in harmony around us was related to the seven notes of the musical scale, and gave rise to the idea of the music of the spheres. The "fixed stars" rotate every year, and include the twelve signs of the zodiac, governing the months. The parallel with the number of apostles was clearly part of God's plan, the perfect and harmonious structure of

◐ CLOCK FACE
Paolo Uccello, 1443 (DUOMO, FLORENCE)

One of the ways in which man took control of his destiny during the Renaissance was in the development of instruments to measure time. The clock face painted by Paolo Uccello for the interior of Florence cathedral shows us another way of computing God's universe: the twenty-four hours of the day are a multiple of twelve, equivalent to the number of months in a year, apostles, and so on. The saints in each corner have not been positively identified. However, as there are four of them, it is most likely that they represent the Evangelists. The similarity between this and the view of Brunelleschi's dome is not entirely coincidental: they are both the result of the same worldview.

astrology: *see page 142;* **four:** *see pages 58–61;* **landscape painting:** *see pages 70–73;* **music of the spheres:** *see page 58;* **perspective:** *see pages 52–55;* **symmetry and harmony:** *see pages 58–61 and 146;* **twelve:** *see pages 61, 102 and 122*

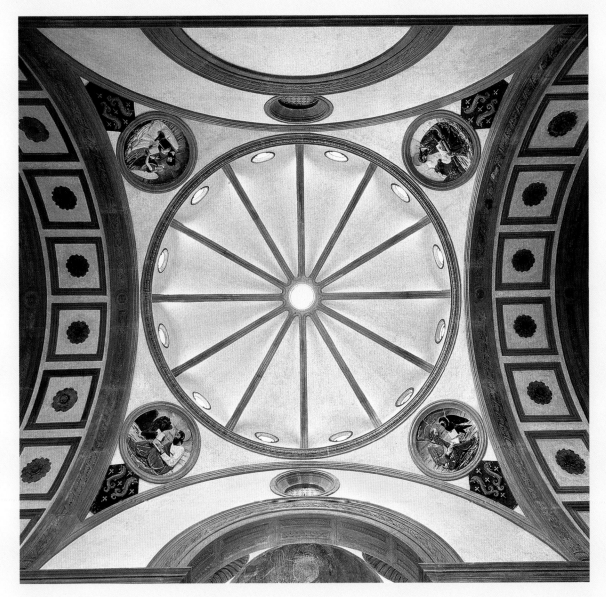

◐ PAZZI CHAPEL
Filippo Brunelleschi,
ca. 1433–1461 (FLORENCE)

The light of God streams through the lantern at the top of the dome, but there are also twelve circular windows (or *oculi*) at the base of the dome. The twelve apostles brought light to the world through their preaching, particularly after Pentecost (Acts 2.1–4), when they were filled with the Holy Spirit. If we read the lantern as the inspiration of the Holy Spirit, and the *oculi* as the apostles, this can be seen as an abstract representation of Pentecost.

his universe, which Adam and Eve had disrupted. It was a desire to return to this divine order that led architects such as Brunelleschi to create buildings with perfect symmetry.

The Circle and the Square

Heaven's perfection was expressed through the circle. Earth, on the other hand, was symbolized by the square, solid and structural. Consequently, any circular dome above a square room can be seen as an image of heaven above Earth. Brunelleschi created at least two such structures, in the Old Sacristy (see page 213) and the Pazzi Chapel (see above), both in Florence. The transition from circular dome to square supporting structure is made by four triangular sections known as pendentives. Both of the domes have twelve ribs supporting the central lantern. While these can be interpreted as the division of the heavens into the twelve months, the four pendentives being related to the four seasons, this is secondary to a biblical interpretation (see caption, above). In the Pazzi Chapel, for example, the pendentives contain polychrome reliefs of the four Evangelists by Andrea della Robbia.

Adam and Eve: *see page 120;* **apostles:** *see pages 102 and 122–123;* **Brunelleschi:** *see page 26;* **Evangelists:** *see page 102;* **light of God:** *see pages 169 and 172*

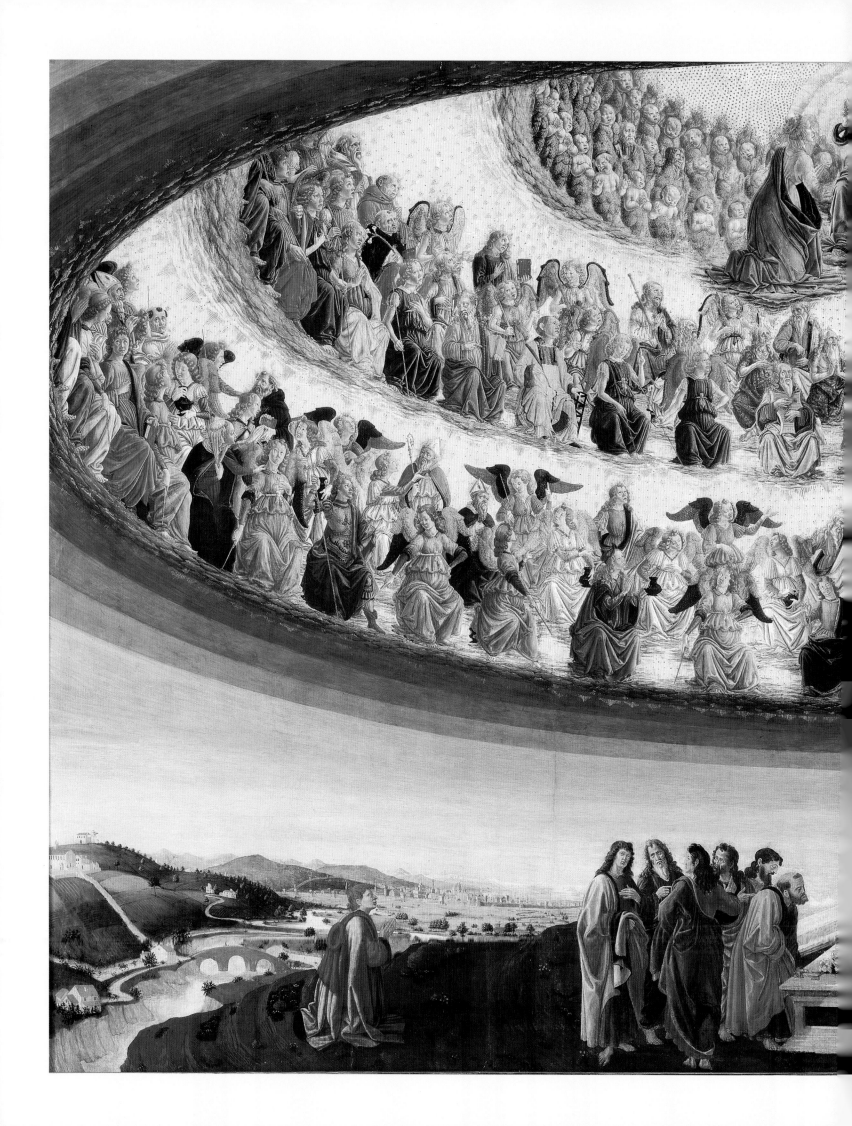

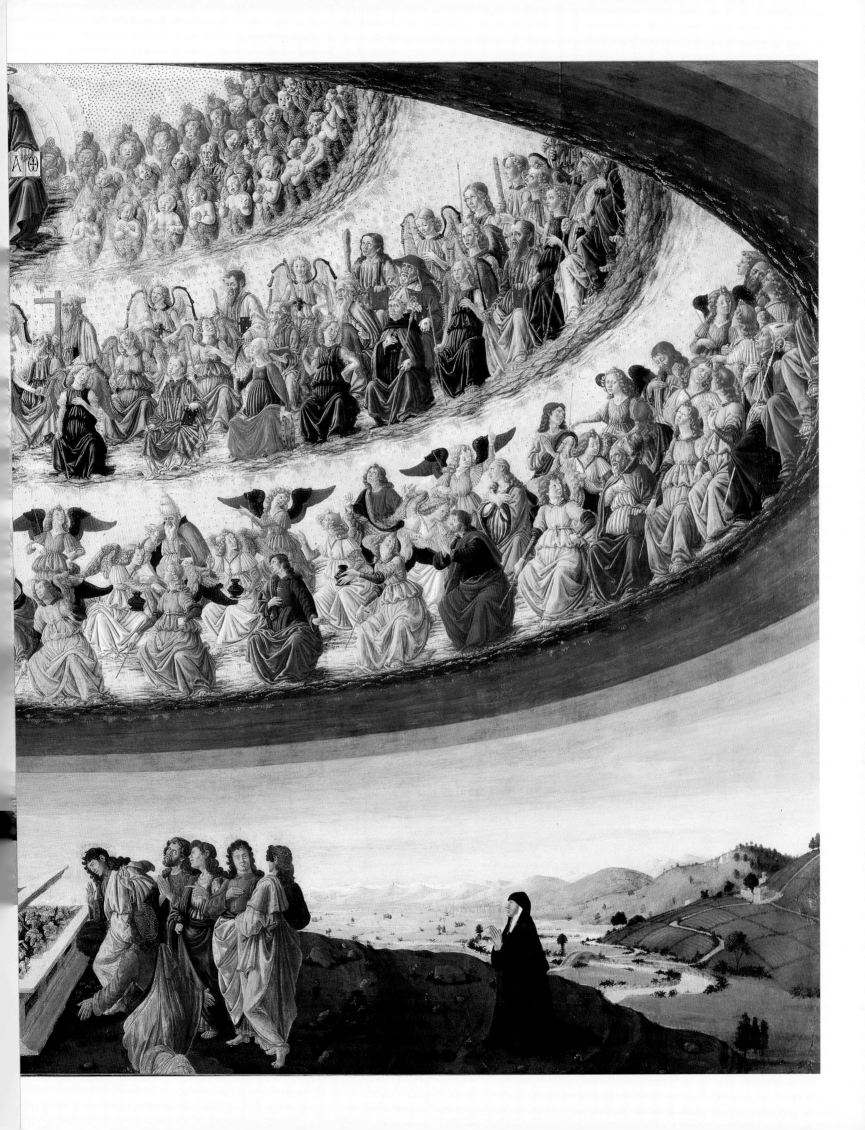

THE PULL OF THE STARS

Although astrology was the product of pagan philosophy, it still found a place in Christian society – even if its validity was frequently disputed. After all, if God had created the stars and put them in their place, he must also have arranged them into the groupings that the ancients had identified.

In a world where trade, industry and agriculture were governed by the seasons, certain tasks were associated with each month. The illustration of the "Labours of the Months" became a frequent subject of church decoration, in part as it represented the earthly tasks which God had allocated to us. These were often paralleled with the appropriate signs of the zodiac – heaven and Earth keeping pace with one another.

Commissioned by Borso d'Este, the cycle of the months (see opposite) painted for the Palazzo Schifanoia in Ferrara is altogether more complex. The name of the palace means "to avoid care": it was seen as a place of relaxation away from the stresses of the court. Arranged around a large chamber known as the Salone dei Mesi, or Room of the Months, the decoration for each month is divided into three tiers. In the top section is a depiction of the classical god or goddess who presides over that month, shown in triumph on a chariot, surrounded by activities associated with the deity. The central tier shows the relevant zodiacal sign. The labours associated with the month form a part of the lower tier, with the majority of the section taken up by images of Borso, his favourites and courtiers performing not only the duties of the court but also the pastimes appropriate to the time of year.

In the central tier around the signs of the zodiac are the less familiar decans. If the sphere of the fixed stars rotates fully in one year (360 degrees), then each of the twelve signs covers thirty degrees and each of the thirty-six decans presides over ten degrees – hence their name. The way in which they are represented by Cossa and others derives from a late manuscript, an abbreviated Latin version of an Arabic text, which was available in Ferrara at the time.

○ APRIL
Francesco del Cossa, 1469–1470
(SALONE DEI MESI, PALAZZO SCHIFANOIA, FERRARA)

Cossa was responsible for the months of March, April and May in the Salone dei Mesi: the identity of the other artists is still the subject of debate. Cossa's frescoes are in the best condition, partly because they are on an internal wall and so less susceptible to damp, but also because his technique was superior.

Venus, the goddess of love, presides over April. In the same way that she has subdued Mars in Botticelli's famous painting (see page 93), here he is chained and kneeling at her feet. Doves fly to either side of her head, and her constant companions, the **Graces** (see right), are seen at the top right of the fresco.

The association between music and love is underlined by this **pair of lovers** (see left), who are surrounded by other couples holding musical instruments.

The zodiacal sign of Taurus is surrounded by the three decans which also govern this month.

The month of April includes the feast day of St George, one of the patron saints of Ferrara, on the 23rd. The celebrations would include the Palio or horse race, as well as other "novelty" contests to entertain the crowds. Depicted here as if they are in one continuous race are donkeys, madmen and fat people. The **gentlemen of the court** (see right) watch from a bench in front of the palace, while the ladies watch from the balconies.

Borso d'Este (see left) appears more than once in each month. In this detail he is seen dealing with the business of court, whereas further left he is out hunting. The courtiers, like Venus's attendants in the upper section, wear red, white and green – the Este colours.

colour: *see pages 44–47;* **the Este:** *see page 174;* **Graces:** *see page 156;* **Mars and Venus:** *see page 93;* **music:** *see page 58;* **Venus:** *see page 114*

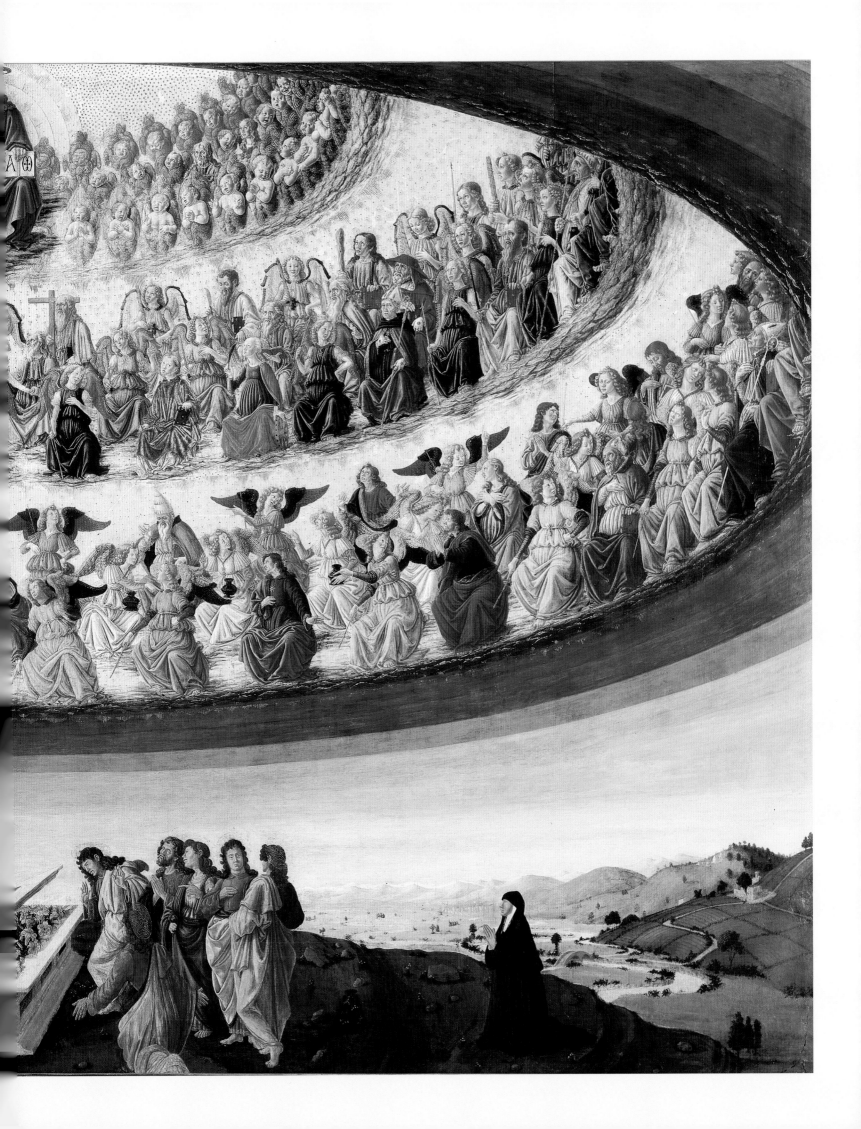

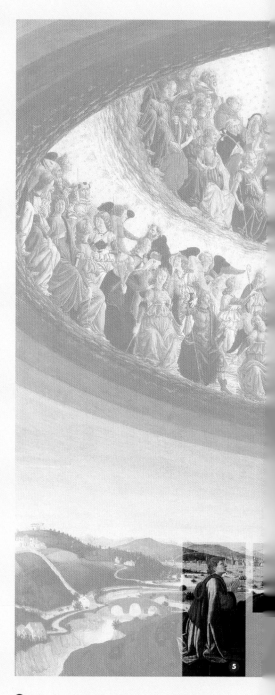

① The choir of angels surrounding Jesus and Mary are the angelic councillors, Seraphim, Cherubim and Thrones. Among their number, to Jesus' right, are St Peter (patron saint of the church) and St John the Baptist (patron saint of Florence).

A HOLY LAND

Botticini's painting allows us a simultaneous view of heaven and Earth, the one floating above the other in much the same way that a dome rests above a chapel or a church. Indeed, heaven is shown as circular, here foreshortened to an ellipse on the two-dimensional surface of the painting, with the angels arranged in three tiers to create the illusion of a golden, brilliantly illuminated dome. Below, on Earth, the apostles gather around a tomb, and, further away, a man and woman kneel to the left and right. They are the donor Matteo Palmieri and his wife Niccolosa, the painting having been commissioned for the altar of their burial chapel in San Pier Maggiore in Florence.

The image combines depictions of the Assumption and Coronation of the Virgin, events which have no foundation in the Bible, but which were widely reported in other texts from as early as the third and fourth centuries. According to these accounts Mary's body was carried up to heaven by angels, and all that remained in her tomb were lilies, symbolic of her purity and innocence.

The subject of the painting is ideally suited to its location: not only does it relate to burial, but also to a subsequent life in heaven, hoped for by all those who die. The way in which it is depicted is also relevant. Between Palmieri and the apostles is a distant view of Florence. The implication is not that Mary and the apostles actually lived in Florence, but that God is omnipresent and that all places are – or have the potential to be – holy. Florence is seen as a city especially dedicated to the Virgin and therefore it enjoys her protection.

◉ CORONATION OF THE VIRGIN
Francesco Botticini, ca. 1475–1476 (NATIONAL GALLERY, LONDON)

The mixture of saints and prophets among the angels in this painting may illustrate an idea developed by the donor, Matteo Palmieri, in a poem which he claimed had been inspired by visions of a dead friend. When Lucifer rebelled, the angels who supported him were cast down to hell and became devils, whereas those supporting God remained as angels. Palmieri's poem suggested that a third group, who remained neutral, were to become the souls of the mortal – that is to say, human. This heretical idea remained a secret during Palmieri's lifetime.

⑤ The donor Matteo Palmieri kneels at a respectful distance from the apostles, at Christ's right hand. Close inspection of the original painting reveals that the portrait has been defaced: there are numerous scratches across the head. It may be that a devout individual, outraged by Palmieri's heretical ideas (see caption), attacked his portrait.

Adam and Eve: *see page 120;* **alpha and omega:** *see page 41;* **St Andrew:** *see page 108;* **David:** *see pages 98–100;* **Florence cathedral:** *see pages 26–27;* **hierarchy of angels:** *see page 105;* **St John the Baptist:** *see page 108;* **lily:** *see page 36;* **St Peter:** *see pages 95, 106 and 128–129;* **right and left:** *see page 62*

2 Mary, already wearing the crown that identifies her as queen of heaven, kneels in humility in front of her son, and to his right – the position of honour.

3 Christ – identified by the cross on his halo – holds a book showing the first and last letters of the Greek alphabet, alpha and omega, to denote his dominion at all times.

4 The second group of angels are the governors – Dominions, Virtues and Powers. This choir also includes both saints and prophets, such as St Andrew, with the cross on which he was crucified, and David (shown here as the king responsible for writing the psalms – hence the lyre – rather than as a shepherd boy). Just behind David are Adam and Eve – directly beneath Jesus and Mary, who were interpreted as the New Adam and New Eve.

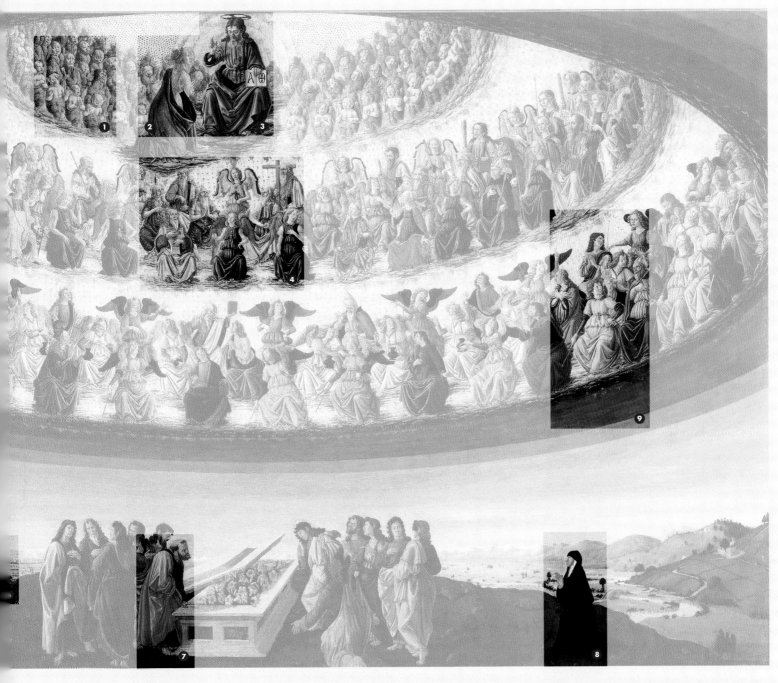

6 The most prominent structure in the view of Florence is the cathedral, which was dedicated to Santa Maria del Fiore – "St Mary of the Flower". This refers not only to the lily of Mary's purity, but also to the lily as a symbol of Florence. Some theologians likened the dome of the cathedral to Mary's crown.

7 The only apostle to touch the lily-filled tomb is St Peter, whose keys are given prominence. His centrality and his position under Christ's right hand further underline his status.

8 San Pier Maggiore formed part of a Benedictine convent, and Niccolosa Palmieri is shown here in the habit worn by its nuns.

9 The ministers – Principalities, Angels and Archangels – are also joined by saints. Around them, the vault of heaven is circled by blue rings of different intensities similar to those seen in Domenico di Michelino's painting of Dante (see page 13). Although not a full complement, they represent the crystalline spheres which were believed to hold the heavenly bodies.

THE PULL OF THE STARS

Although astrology was the product of pagan philosophy, it still found a place in Christian society – even if its validity was frequently disputed. After all, if God had created the stars and put them in their place, he must also have arranged them into the groupings that the ancients had identified.

In a world where trade, industry and agriculture were governed by the seasons, certain tasks were associated with each month. The illustration of the "Labours of the Months" became a frequent subject of church decoration, in part as it represented the earthly tasks which God had allocated to us. These were often paralleled with the appropriate signs of the zodiac – heaven and Earth keeping pace with one another.

Commissioned by Borso d'Este, the cycle of the months (see opposite) painted for the Palazzo Schifanoia in Ferrara is altogether more complex. The name of the palace means "to avoid care": it was seen as a place of relaxation away from the stresses of the court. Arranged around a large chamber known as the Salone dei Mesi, or Room of the Months, the decoration for each month is divided into three tiers. In the top section is a depiction of the classical god or goddess who presides over that month, shown in triumph on a chariot, surrounded by activities associated with the deity. The central tier shows the relevant zodiacal sign. The labours associated with the month form a part of the lower tier, with the majority of the section taken up by images of Borso, his favourites and courtiers performing not only the duties of the court but also the pastimes appropriate to the time of year.

In the central tier around the signs of the zodiac are the less familiar decans. If the sphere of the fixed stars rotates fully in one year (360 degrees), then each of the twelve signs covers thirty degrees and each of the thirty-six decans presides over ten degrees – hence their name. The way in which they are represented by Cossa and others derives from a rare manuscript, an abbreviated Latin version of an Arabic text, which was available in Ferrara at the time.

⏵ APRIL
Francesco del Cossa, 1469–1470
(SALONE DEI MESI, PALAZZO SCHIFANOIA, FERRARA)

Cossa was responsible for the months of March, April and May in the Salone dei Mesi: the identity of the other artists is still the subject of debate. Cossa's frescoes are in the best condition, partly because they are on an internal wall and so less susceptible to damp, but also because his technique was superior.

Venus, the goddess of love, presides over April. In the same way that she has subdued Mars in Botticelli's famous painting (see page 93), here he is chained and kneeling at her feet. Doves fly to either side of her head, and her constant companions, the **Graces** (see right), are seen at the top right of the fresco.

The association between music and love is underlined by this **pair of lovers** (see left), who are surrounded by other couples holding musical instruments.

The zodiacal sign of Taurus is surrounded by the three decans which also govern this month.

The month of April includes the feast day of St George, one of the patron saints of Ferrara, on the 23rd. The celebrations would include the Palio or horse race, as well as other "novelty" contests to entertain the crowds. Depicted here as if they are in one continuous race are donkeys, madmen and fat people. The **gentlemen of the court** (see right) watch from a bench in front of the palace, while the ladies watch from the balconies.

Borso d'Este (see left) appears more than once in each month. In this detail he is seen dealing with the business of court, whereas further left he is out hunting. The courtiers, like Venus's attendants in the upper section, wear red, white and green – the Este colours.

colour: *see pages 44–47;* **the Este:** *see page 174;* **Graces:** *see page 156;* **Mars and Venus:** *see page 93;* **music:** *see page 58;* **Venus:** *see page 114*

THE ANTIQUE

Interest in the past was the impetus for the Renaissance reclamation of things associated with antiquity – the knowledge that the Roman Empire had been born in the heart of the Italian peninsula gave each city-state the right to claim it as its heritage in different ways. There were many sources for such knowledge. The sculptures and buildings which survived, even if they were only fragments or ruins, were used as inspiration for contemporary works, and functioned as a challenge to understand and emulate the past – and even to go beyond the genius of the ancients. The classical texts were also a source of major importance, not only for what they said about Greek and Roman thought and lifestyle, but also for the greater value that they gave to the arts, an attitude that was readily adopted during the Renaissance.

One of the most famous sculptures to survive from antiquity was a bronze equestrian portrait of Emperor Marcus Aurelius (121–180; see right), which had stood since the days of the Roman Empire on the Lateran Hill, outside St John's Basilica, the home of the papacy for much of the early history of the Church. Its survival is attributed to the fact that for centuries it was misidentified as Constantine (272–337), the first Christian emperor, and the man responsible for legalizing Christianity within the empire. Had it been known earlier that it was in fact Marcus Aurelius, responsible for the deaths of many thousands of Christians, the sculpture would almost certainly have been melted down.

The earliest surviving bronze equestrian monument from the Renaissance is Donatello's *Gattamelata* (see opposite, left) – the nickname of the mercenary soldier Erasmo da Narni (1370–1443). He is dressed in a version of Roman armour and decorated with numerous details copied from classical sources. Donatello lived and worked in Rome from 1432 to 1433, and would have studied the ruins in close detail.

Erasmo's nickname means "honeyed cat", and Donatello has shown him as a leader who could slink up to the enemy unsuspected, and suddenly pounce. Part of this poise derives from the way in which one of the horse's front hooves is balanced on a cannon ball, unlike the mount of Marcus Aurelius with its front leg lifted off the ground. This may have been Donatello's intention – to suggest the delicacy and subtlety of

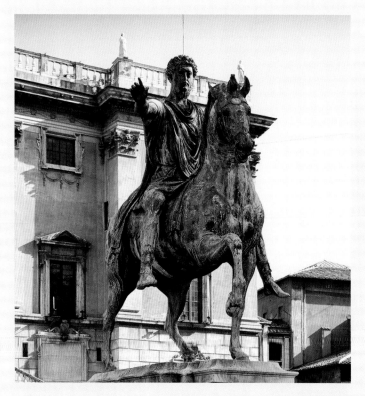

⬤ **MARCUS AURELIUS**
Classical, 2nd century AD (CAPITOLINE MUSEUMS, ROME)

Originally situated on the Lateran Hill, where it can be seen in the background of Filippino Lippi's *Triumph of St Thomas Aquinas* (see page 97), the statue of Marcus Aurelius was moved to the Capitoline by order of Pope Paul III, when Michelangelo designed the complex that we can see today.

Constantine: *see page 97;* **Lateran Palace:** *see page 128;* **Roman Empire:** *see page 66*

Erasmo's strategy. However, it is usually read as a reluctance on Donatello's part to risk balancing the sculpture on three legs. One of the most frustrating things for Renaissance artists and architects was the way in which the ancient Romans had managed to do things that were no longer understood. How did they balance an equestrian statue like that? The next attempt, the *Colleoni* by Verrocchio, succeeded. How could they have put the dome on the Pantheon? By the time that the *Gattamelata* had been cast, Brunelleschi had already built the dome of Florence cathedral, although using different – and in many ways, superior – engineering.

Despite the influence of sculpture and architecture, classical painting was relatively unimportant for the development of Renaissance art. No classical paintings were known until 1480, with the chance discovery of the Golden House of Nero in Rome, and even then the work was mainly decorative. As the house had become buried, the rooms were like grottoes under the ground, and the style of decoration was described as "grotto-like" – giving us the word grotesque.

◐ **EQUESTRIAN MONUMENT TO ERASMO DA NARNI ("GATTAMELATA")**
Donatello, 1447–1453 (S. ANTONIO, PADUA)

◑ **THE DWARF MORGANTE**
Valerio Cioli, 1561–1568 (BOBOLI GARDENS, FLORENCE)

A sign of the increasing status of the arts was the degree of erudition it took to appreciate them. Cioli's fountain, carved for the Boboli Gardens in Florence, may not appear sophisticated, as it seems merely to poke fun at Morgante, one of the favourite dwarves of Cosimo I de' Medici (1519–1574), Grand Duke of Tuscany. However, it can be interpreted in various ways. Often called the "Fountain of Bacchus", the representation of the dwarf (ironically named after a giant in a 15th-century poem of the same name by Luigi Pulci) makes him look more like Bacchus's tutor Silenus, who was similarly plump and often shown riding a donkey. The tortoise may be an allusion to the traditional Medici *impresa* relating to the motto "festina lente" ("make haste slowly"). However, from Morgante's position, astride a mount with his right arm raised, it also appears to be a joking reference to the *Marcus Aurelius* (see opposite). An educated courtier could demonstrate his wit and learning by bringing up all these associations in conversation.

Florence cathedral: *see pages 26–27;* **dwarves:** *see page 191;* **grotesques:** *see page 159;* **Cosimo I de' Medici:** *see page 160;* **Luigi Pulci:** *see page 199;* **Silenus:** *see page 153;* **tortoise:** *see page 42*

THE ANTIQUE RECREATED

The success of Bramante's small but perfectly formed building in emulating classical architecture can be gauged from the name by which it is known: the "Tempietto", or little temple. However, it is, in fact, a tiny church, or chapel, built to mark the site of St Peter's martyrdom (see box, below). It stands next to the church of San Pietro in Montorio – St Peter on the Hill – in the Trastevere district of Rome.

Although early churches commemorating Christian martyrs were often circular – in order to emphasize the spot on which the actual death had occurred – with an outer wall and an inner arcade, Bramante chose not to echo this form, but looked instead to the earlier classical era for his inspiration. One building was the temple of Vesta in Tivoli, some way outside Rome, and another a temple dedicated to Hercules on the banks of the Tiber. Both are circular, with a cylindrical chamber, surrounded by an arcade of columns. Although the precedents both use the Corinthian order, Bramante chose

Doric, because St Peter, a fisherman, was a solid, down-to-earth person. The Tempietto's frieze includes the triglyphs and metopes drawn from classical Doric buildings – notably the temple of Vespasian in the Roman Forum – although the carvings in the metopes have been transformed from trophies of war into objects used in the Christian liturgy.

The building is perfectly symmetrical and harmonious. There are four sets of four columns: Bramante considered the number sixteen to be "perfect". The steps that divide each set, together with the entrance doors, mean that the tiny interior chapel maintains an appropriately cruciform structure despite being circular in shape. The distance from the ground to the bottom of the balustrade is the same as the width of the building (that is, the diameter of the colonnade), and the proportion of the base of the column to its height is the same as that of the steps to the total height of the structure (the lantern is not original, but had been planned by Bramante).

Not all of the inspiration is classical: the dome is more typical of Christian churches, and so is the balustrade. Nevertheless, the building was immediately appreciated as classical. Within a decade of its completion, Raphael had included a version of the Tempietto in his cartoon for the tapestry of *St Paul Preaching in Athens* (see page 30) – suggesting that it was so good it could have been a pagan temple. It was also the only building included by Palladio in his *Four Books on Architecture* that was neither a classical ruin nor one of his own buildings. It has always been popular, despite its minute scale. In the seventeenth century, the French painter Claude used it on more than one occasion as the model for a classical temple, and Christopher Wren – who knew it only from Palladio's illustrations – used it as the inspiration for the dome of St Paul's in London.

IS THE TEMPIETTO IN THE RIGHT PLACE?

The location of the Tempietto was based on the tradition that St Peter had been crucified between two "metas". A meta was a pyramid-shaped obelisk erected at each end of a circus to mark the two turning points in a chariot race. As there was a pyramid in Rome, the Pyramid of Cestius, and an obelisk near the Vatican, the Tempietto was built at the midpoint between the two. However, this specification – between two points on different sides of the city – was extremely vague. In fact, St Peter was far more likely to have been crucified in Nero's circus as part of the public entertainment, between the metas at each end. And this point was located just next to where St Peter's Basilica, also designed in part by Bramante, stands today. Even if the Tempietto was not built in the right place, the basilica certainly was: the high altar is directly above what is believed to be St Peter's tomb.

○ TEMPIETTO
Donato Bramante, CA. 1504 (S. PIETRO IN MONTORIO, ROME)

architectural orders: *see pages 28–29;* **Bramante:** *see page 151;* **four:** *see pages 58–61;* **Palladio:** *see pages 27–28;* **St Peter:** *see pages 95, 106 and 128–129;* **proportion:** *see pages 56–57;* **symmetry and harmony:** *see pages 58–61 and 137;* **triglyphs and metopes:** *see pages 28–29*

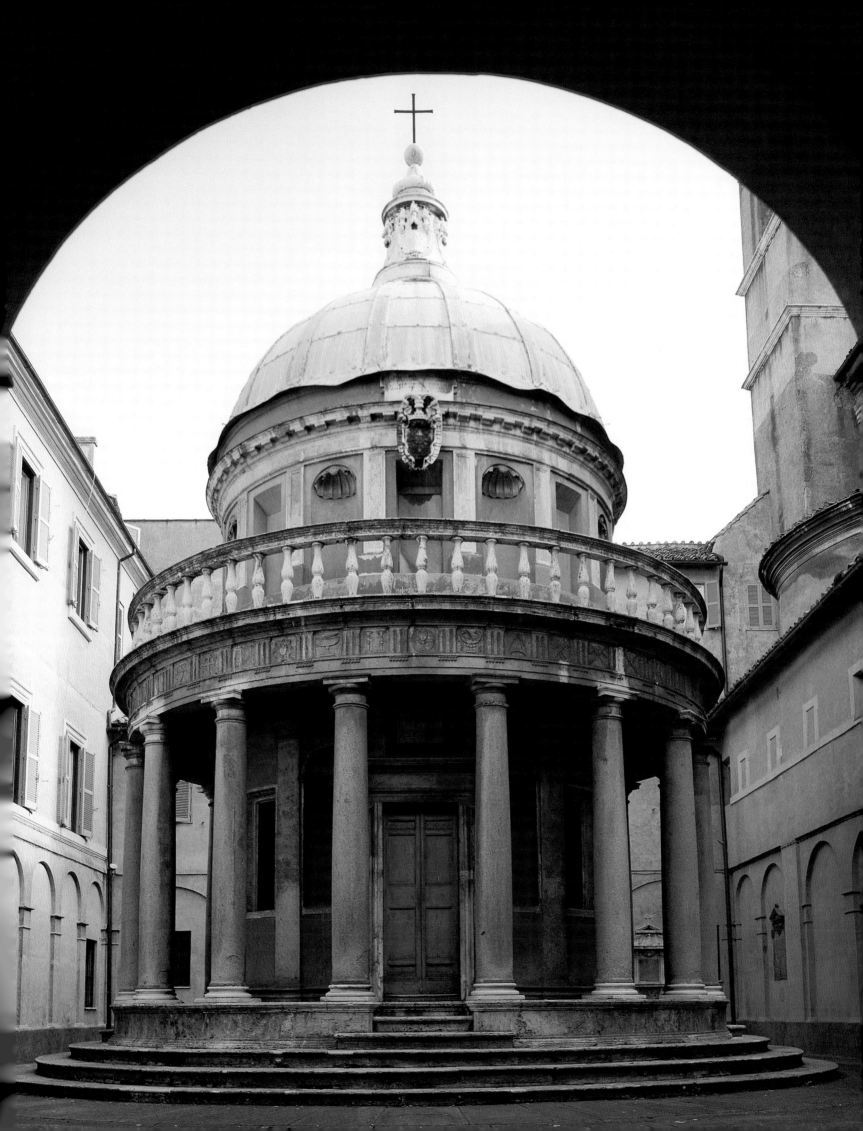

CLASSICAL PHILOSOPHY

The belief that the Old and New Testaments were linked was echoed in other contemporary ideas about classical thought: it was suggested that the ancients, without the benefit of the Law of Moses and living before Christ, had heard the message of God, but misunderstood it. As such, their insights contained valuable lessons, provided they could be aligned with an orthodox view of Christianity. The two pillars of classical philosophy were Plato and Aristotle. Plato believed that everything we see on Earth is the pale reflection of something that exists in an ideal form on a higher plane. In the *Timaeus* he proposes that our universe was created by a demiurge – a single creator god – as a unique, material copy of the ideal universe that exists in the realm of ideas. The demiurge was identified by Christians as the Creator – namely, God – as described in Genesis. The Neoplatonic thought that characterized much fifteenth-century humanism led to the idealization of forms that is seen particularly in Florentine painting. Aristotle, on the other hand, believed that we could understand the world only by the evidence presented to our eyes: we would learn best by studying the rich variety of things we see around us.

Raphael included both philosophers in his *School of Athens* (see right), painted for the library of Pope Julius II. The pope's books were laid flat on sloping shelves much in the way that Carpaccio depicts in the *Vision of St Augustine* (see pages 170–173). The shelves were just below the frescoes, and would have covered the lower part of the walls. The clue to the interpretation of the room is given by roundels painted on the ceiling, depicting personifications of the four branches of knowledge – Theology, Law (or Justice), Philosophy and Poetry. Julius's world is therefore seen as beautiful (poetry), good (law) and true (philosophy and theology), and the walls below these figures represent the same themes, theology being illustrated by the "Disputà" (see pages 132–135), and philosophy by the *School of Athens*.

◗ SCHOOL OF ATHENS

Raphael, 1510–1511 (VATICAN)

The names given to this fresco and the room in which it is located are both later inventions. After Julius II's death, his successor, Leo X, changed the function of the room from a library to a study in which he signed official documents: hence, it became known as the Stanza della Segnatura ("the room of the signature"). The title for the fresco does not appear until the 17th century.

❶ Apollo was seen as the god responsible for poetry and music, as well as representing our rational, civilized aspirations.

❺ Pythagoras is taking notes from a tablet which includes a formulation of his ideas on harmony and the musical scale: the numbers six, eight, nine and twelve are linked by lines which are labelled with the musical intervals of an octave, a fifth and a fourth.

Apollo: *see page 114;* Aristotle: *see page 180;* Julius II: *see pages 83–85;* libraries: *see pages 166–169;* linking the testaments: *see pages 120–121;* magi: *see pages 54–55 and 108;* mathematics and music: *see page 58;* Minerva: *see page 115;* Plato: *see page 180;* portraits within paintings: *see page 51;* Pythagoras: *see page 58*

2 Plato and Aristotle stand in the centre, and are also given prominence by the arch, which both frames and isolates them. Plato points up, to the world of ideas, and holds a copy of the *Timaeus*, while Aristotle gestures down toward the world that we can see and from which we can learn. He holds a copy of his *Ethics*, in which he suggests that our happiness can be increased by intellectual activity – this accords well with the room's function as a library.

3 The incomplete architecture is reminiscent of the new St Peter's, which was being built at the time. Plato and Aristotle appear to be advancing along the nave of the church to a higher truth, to be found at the altar of Christianity, represented in the "Disputà" (on the opposite wall).

4 Minerva, goddess of wisdom, is a natural patroness for the assembled philosophers. She was also goddess of war, hence the armour.

6 Although the identification of this character is not certain, it is usually thought to represent the astronomer and mathematician Democritus. What is universally accepted is that it is a likeness of Michelangelo. The figure is not present in Raphael's early drawings, and its inclusion is interpreted as a homage to the older master after Raphael had seen the first phase of his work on the ceiling of the Sistine Chapel.

7 Euclid is explaining a geometrical theory using a slate and a pair of compasses. Vasari identified this as a portrait of Bramante, who was building the new St Peter's at the time.

8 Ptolemy stands with his back to us, carrying a terrestrial globe. An astrologer from the second century AD, he is credited with the formulation of the planetary theory whereby the heavenly bodies revolve around the Earth. Facing us, holding the celestial globe, is Zoroaster, an Iranian prophet of the Persian empire. He was seen as the founder of the magi, or astrologer-priests, the most famous of which are the Three Wise Men.

9 Vasari identified the man in the black cap as a Raphael self-portrait. To his left is the artist Sodoma, whom Julius II dismissed, having been so impressed by Raphael's work on this fresco.

MYTHOLOGY

As well as using surviving classical sculptures and buildings as inspiration, there was an increased interest during the Renaissance in ancient Greek and Roman myths, and so gradually these pagan stories also became important as the subject matter of works of art. Not only did this give artists a chance to show off their skills of narrative and description in different ways, but it also allowed the patrons to demonstrate the extent of their learning: owning an illustration of a classical myth implied you knew and understood the original story, and hence were well read in ancient literature.

As the individual status of the artist increased – an idea which humanists had effectively learned from classical writings – so their works became collectable. Alfonso d'Este, the duke of Ferrara, wanted his study, or *studiolo*, to be decorated with works by the greatest artists: his list included Giovanni Bellini, Raphael, and Fra Bartolomeo, the last not as famous today as he was during his lifetime. Bellini provided one painting, but the other two did not. Titian then became involved in the project after the death of Bellini. Not only did he complete the *Worship of Venus* initially planned by Fra Bartolomeo, but he also went on to paint two other works, including *Bacchus and Ariadne* (see opposite). His choice of imagery was drawn from at least three texts: the *Carmina* by Catullus, the *Ars Amatoria* by Ovid, and *Imagines* by Philostratus. However, Titian was also keen to show off his awareness of the visual arts, and the painting includes several visual quotations from classical and contemporary works.

Ariadne has been abandoned on the island of Naxos by her lover Theseus, whom she had helped to slay the Minotaur. Bacchus, the god of wine, sees her, and falls madly in love. Ultimately, she is immortalized as a constellation. Titian employs numerous tools to make the narrative as clear as possible. Bacchus's love-struck stare is contrasted with Ariadne's tentative glance as she runs to the shore waving at a passing ship in the hope it will pick her up and take her home. Titian is using their expressions, gestures and body language to tell the story.

But he also uses other aspects of painting: a diagonal from the top right to the bottom left puts Bacchus and Ariadne on one side and all of the entourage of Bacchus, the fauns, satyrs and bacchantes – his wildly drunken female followers – on the other. While the top left area of the painting is calm, spacious and clear, using mainly blues and pinks, the other part is dark, crowded and noisy, using the more earthy browns and greens to reflect the more earthy characters depicted.

▶ BACCHUS AND ARIADNE

Titian, 1522–1523 (NATIONAL GALLERY, LONDON)

Although the subject is drawn from mythology, the context within which the story of Bacchus and Ariadne was presented tells us more about the patron's interest in classical learning. It was one of a series of paintings made for the study of Alfonso d'Este, duke of Ferrara. While we might expect him to be showing off his erudition, all of the stories were connected to food, drink, and falling in love.

The **cup** gives Titian the opportunity to follow Alberti's recommendation not to use gold in paintings, but to make paint look like gold. Titian does this extremely well here, and also shows off his ability with colour by distinguishing the gold from the similarly coloured yellow cloth on which it rests. He seems to be aware of his skill, as this is where he chooses to sign the painting, disguising the signature as an inscription on the cup.

Alberti: *see page 15;* **Bacchus:** *see page 114;* **colour:** *see pages 44–47;* **the Este:** *see page 174;* **gesture and body language:** *see pages 78–81;* **gold:** *see page 48;* **old and new:** *see pages 66–69*

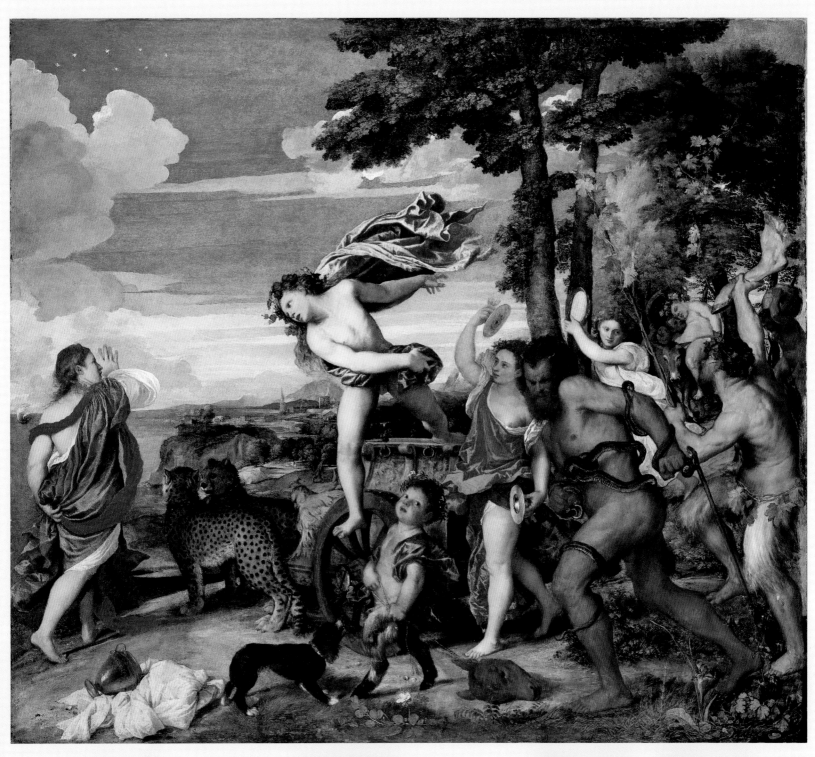

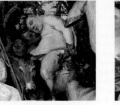

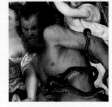

The **ship** in the distance has a white sail. According to the myth, Theseus returned home with a black sail on his ship: this, therefore, is probably not Theseus's ship, but another passing vessel which Ariadne is trying to attract, so that it can take her home.

Bacchus points back to the woods – an invitation to join him. However, the gesture is reminiscent of Michelangelo's *Creation of Adam* from the ceiling of the Sistine Chapel. Bacchus's pose was inspired by the *Discobolus* – a classical sculpture of a discus-thrower. It is as if Ariadne's crown has been thrown like a discus, and appears as a ring of stars in the top left corner of the painting.

Silenus was Bacchus's tutor – here, as usual, he is drunk, and being supported on a donkey. This detail was inspired by a Roman cameo.

The **horned man entwined with snakes** is cited in classical accounts of the story, but may also refer to the *Laocoön*, a famous ancient sculpture which was rediscovered in Rome in 1506.

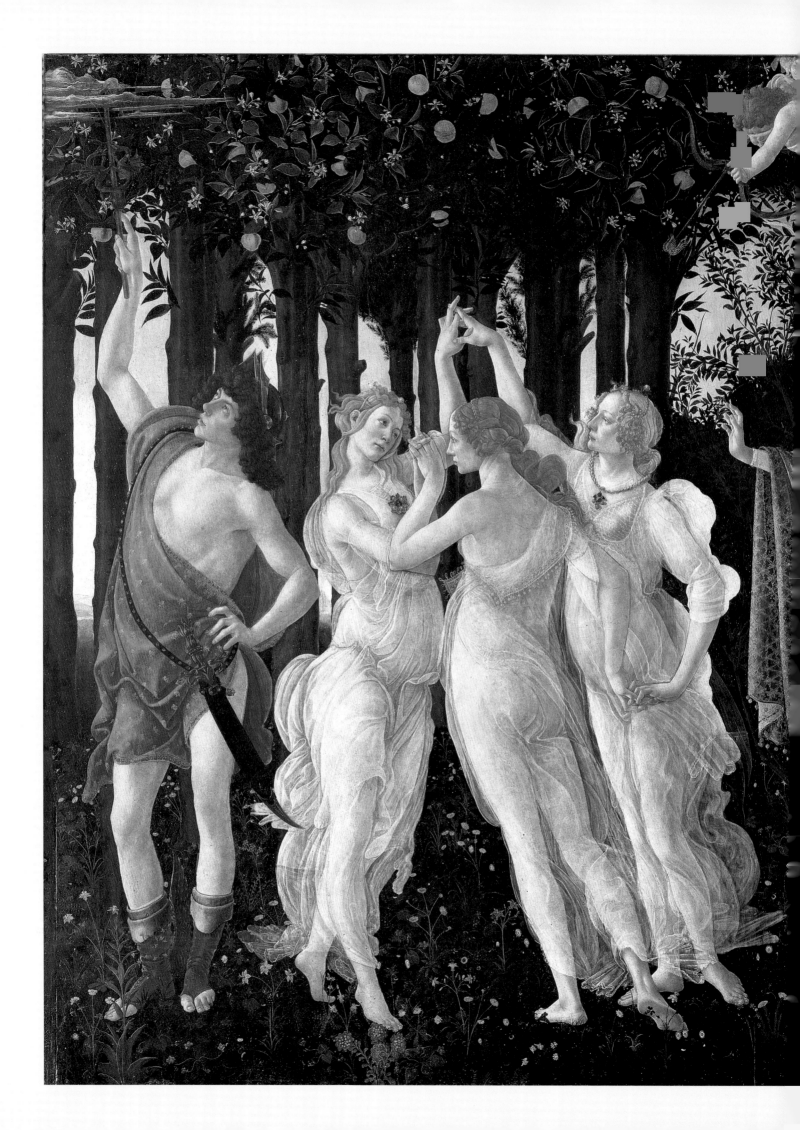

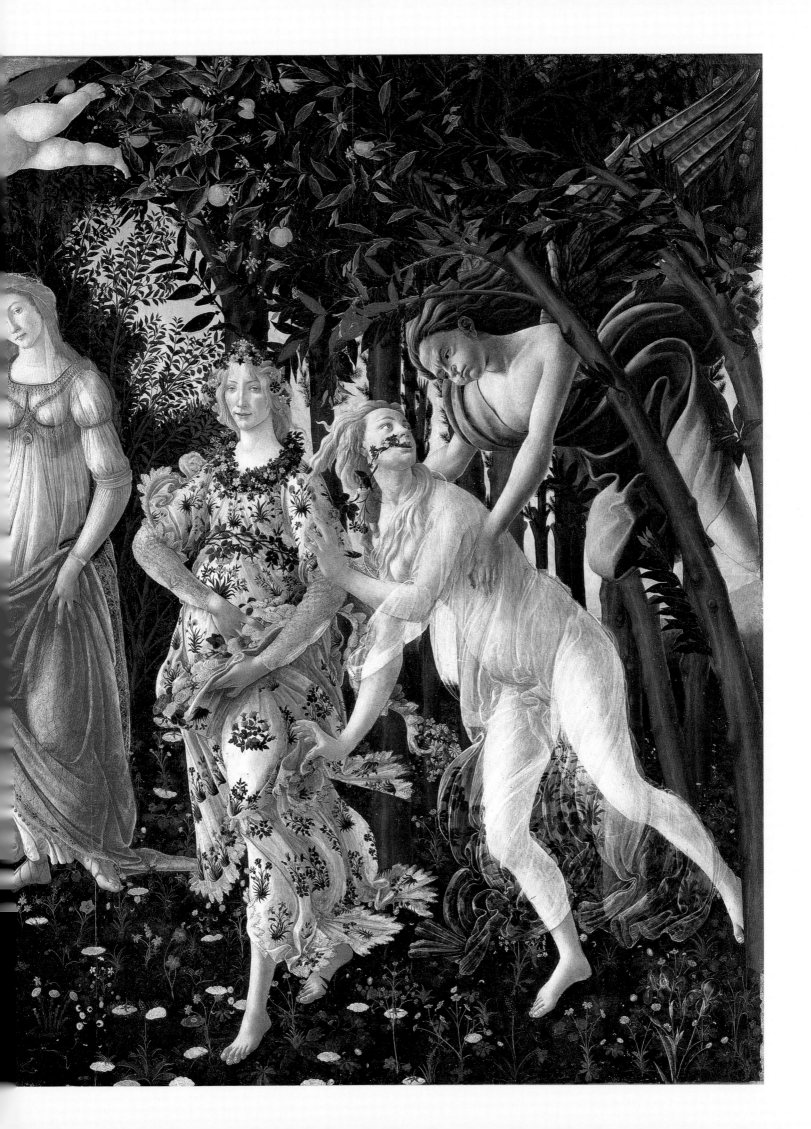

❶ Mercury chases the clouds away with his caduceus. Bad weather is not allowed in the Garden of Love: frosts and bitter winds were never known there. Mercury may also be present in his guise as the god of eloquence, essential for smoothing the path of love and romance.

INTO THE GARDEN OF VENUS

"Venus ... is a nymph of excellent comeliness, born of heaven and more than others beloved by God all highest. Her soul and mind are Love and Charity, her eyes Dignity and Magnanimity, her hands Liberality and Magnificence, the feet Comeliness and Modesty. The whole then is Temperance and Honesty, Charm and Splendour. Oh what exquisite beauty!" Marsilio Ficino

This quotation emphasizes the extent to which classical mythology was seen in a Christian context – for Ficino, one of the leading humanists of the fifteenth century, describes Venus not as a pagan goddess but as the personification of Christian virtues, and "beloved" by the Christian God. In Botticelli's painting *Primavera* (see right), it is Venus who welcomes us into the garden and it is only she and Flora, the goddess of spring, who look out of the painting toward us. The connection between the two is the idea of fertility which is embodied by spring, and expected in marriage. The painting is indeed concerned with the betrothal of the nymph Chloris to Zephyr, after which, according to the Roman poet Ovid, Chloris became Flora, as well as with the implied marriage that will follow when Cupid's arrow inspires love in one of the Graces. It is believed to have been commissioned to celebrate the wedding of Lorenzo di Pierfrancesco de' Medici, a second cousin of Lorenzo "the Magnificent", which took place in 1482: the soon-to-be love-struck Grace can be interpreted as an allegorical portrait of his bride.

▶ PRIMAVERA
Sandro Botticelli, ca. 1482 (UFFIZI, FLORENCE)

This charming painting can be read as a meditation on the nature of love and marriage. The different elements of the painting can be considered in a variety of poetic ways to both delight the eye and inspire speculation.

❺ The garden is so fertile that the orange trees bear blossoms and fruit at the same time. It is sometimes identified as the Garden of the Hesperides, where golden fruit (thought to have been apples) grew and were carefully guarded. The orange was known during the Renaissance as the *malus medicus*, or "medicinal apple". It is also a symbol of the Medici family.

❻ The dance of the three Graces was said to reflect the idea that any deed we perform will come back to us. Botticelli may have been inspired by Alberti, who said, "I should like to see those three sisters [the Graces] ... who were painted laughing and taking each other by the hand This symbolizes liberality, since one of these sisters gives, the other receives, the third returns the benefit."

Alberti: *see page 15;* **allegory:** *see pages 158–165;* **continuous narrative:** *see page 94;* **Cupid:** *see page 114;* **fruit:** *see page 38;* **gesture and body language:** *see pages 78–81;* **the Medici:** *see pages 42, 186–187, 198–199 and 202;* **Mercury:** *see page 115;* **puns:** *see pages 42–43;* **Venus:** *see page 114;* **virtues:** *see pages 110–112 and 164*

② According to fable, Cupid was the son of Mercury and Venus, and here he appears in the sky between them. He is shown blindfold, to illustrate the saying that "love is blind", and points a flaming arrow at one of the Graces, symbolic of the passion that will be lit in her heart.

③ Spring was believed to be heralded by breezes, and as a literal interpretation of this idea, Zephyr the god of the West Wind is shown with his cheeks puffed out, as if he is blowing. He is painted a pale blue, to imply that he is a manifestation of the air.

④ The trees in the top right corner have neither fruit nor flowers: spring is yet to reach this part of the painting. The evergreens are laurels, a punning reference to the name of the owner of the painting, Lorenzo di Pierfrancesco.

⑦ Venus's gesture welcomes us into her garden. She appears pregnant, but this is an illusion created by her gown, which is gathered high, just under the breasts, and is very full bodied. Known as a *gamurra*, this was a fashionable style of dress during Botticelli's time. By implying fecundity in this way, women would appeal to men wishing to continue their family line.

⑧ Flora is clothed by the flowers coming from Chloris's mouth. Flora also scatters them – a symbol of the arrival of spring. Botticelli uses continuous narrative: Flora *is* Chloris – after Chloris has been raped by Zephyr. Flora's costume is that of a Florentine bride, although the richly jewelled belt and necklace which would have been worn have been replaced by garlands of flowers.

⑨ The nymph Chloris has flowers coming from her mouth – she has been made fertile by Zephyr. In the myth she claimed that he had raped her, and he married her to restore her honour and make her a true goddess.

ALLEGORY

The nature of allegory is such that the message it is conveying is, of necessity, hidden: what may appear to be a simple story is in fact intended to communicate a more profound message. This idea, common to interpretations of the Bible (Old Testament stories were seen as allegorical versions of episodes in the New Testament), was also sanctioned by classical texts. Allegory was used by the great and the good as a vehicle for complex ideas which, as often as not, also expounded the patrons' own particular qualities and inevitably flattered their intelligence: few other people would have understood their meaning. It is in the world of allegory that the language of the Renaissance truly was "secret".

In his influential treatise *Della Pittura* ("On Painting"), Alberti describes a work by the artist Apelles – said to be one of the greatest painters of antiquity – which depicted "calumny" (false accusation or slander). The classical author Lucian had described Apelles' painting and praised the variety it contained. Alberti repeated Lucian's account, because, he says, "For their own enjoyment artists should associate with poets and orators who have many ornaments in common with painters and have a broad knowledge of many things." The reverence for artists in classical times helped to increase their status during the Renaissance, and the "self-improvement" advocated by Alberti helped them to meet this new-found respect. In particular, Alberti says, increased knowledge would help the artists' skills of "invention": it is precisely that which Lucian praises in the lost painting which has come to be known as the "Calumny of Apelles":

"Invention is praised when one reads the description of Calumny which Lucian recounts was painted by Apelles … In this painting there was a man with very large ears. Near him, on either side, stood two women, one called Ignorance, the other Suspicion. Farther, on the other side, came Calumny, a woman who appeared most beautiful but seemed too crafty in the face. In her right hand she held a lighted torch, with the other hand she dragged by the hair a young man who held up his hands to heaven. There was also a man, pale, ugly, all filthy and with an iniquitous aspect, who could be compared to one who has become thin and feverish with long fatigues on the fields of battle: he was the guide of Calumny and was called Hatred. And there were two other women, the serving women of Calumny, who arranged her ornaments and robes. They were called Envy and Fraud. Behind these was Penitence, a woman dressed in funeral robes, who stood as if completely dejected. Behind her followed a young girl, shameful and modest, called Truth."

Alberti's writing inspired several artists – including Botticelli – to follow Apelles' example: after all, the emulation of the antique was one of the main characteristics of the Renaissance, and the possibility that one might surpass the antique was the hoped-for goal. The depiction of Calumny on this dish (see opposite) is one such version.

The dish differs from Alberti's account in certain details. Calumny holds the torch in her left hand, whereas the text specifies her right. The artists who painted such dishes – which formed part of large dinner services – used woodcut prints as their models. One result of the printing process is the inversion of the original design – hence the transposition of the torch from right to left hand. There are other differences: the dish does not show both Ignorance and Suspicion; Hatred is standing behind the seated man (whose long, ass's ears show that he listens foolishly to bad advice); Penitence is seen in front of Calumny; and the young man does not hold up his arms to heaven. This does not mean that the artist "got it wrong" – rather he is demonstrating his own skills of invention to try to improve on the original formula.

Alberti: *see page 15;* **the antique:** *see pages 144–151;* **linking the testaments:** *see pages 120–121*

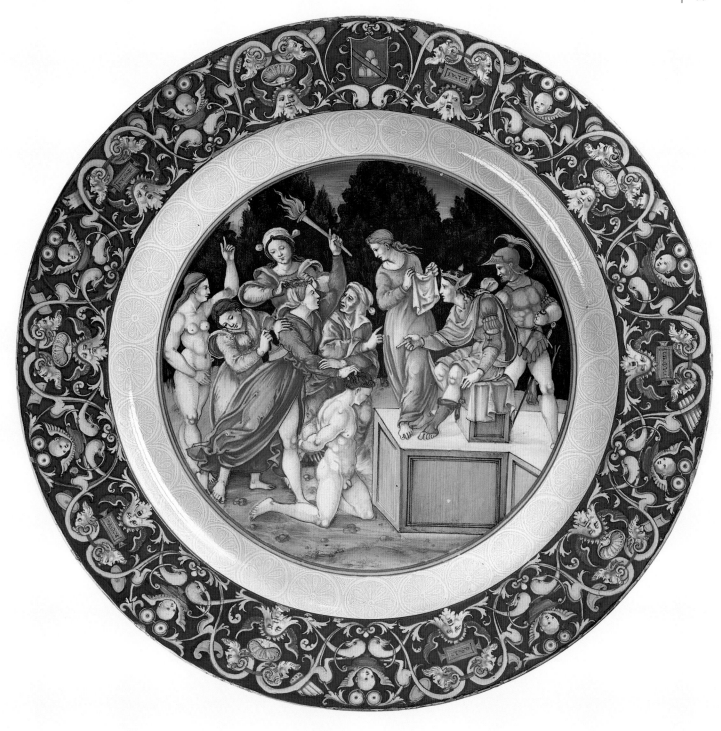

DISH SHOWING THE "CALUMNY OF APELLES"
Urbino school?, CA. 1520–1525 (RIJKSMUSEUM, AMSTERDAM)

Lucian's treatise "On calumny" was well known in the Renaissance – at least among the educated – so even without Alberti's retelling we would probably have been able to decipher the bizarre event depicted on this dish. The complex nature of the allegory may not seem an ideal backdrop for a relaxing meal, but the discussion of such issues was exactly what was expected of the refined.

The influence of classical culture on this dish is seen not only in the allegorical nature of the main image, but also in the circular border, a combination of leaves, masks and distorted animal forms, which is described as "grotesque".

ceramics: *see pages 32–33;* **grotesques:** *see page 145*

A DIPLOMATIC GIFT

Immediacy is often lacking in an allegory – it can take time for the message to be understood. In some cases this is intentional: the greater the effort required to uncover the meaning, the greater the eventual satisfaction and the more memorable the message. The allegorical nature of the depiction of David and Goliath in the Florentine context would probably have been widely understood. However, other allegories were designed for a specific and élite audience. Only people with the right education – including, first of all, the patron – would understand all the references. The original ideas invariably came from the patron's scholarly advisors – the wealthy retained humanist scholars not only as tutors, but also to help them to show themselves in a good light.

Such is the case with Bronzino's *Allegory with Venus and Cupid* (see opposite), which may be the painting Vasari mentions as having been commissioned by Cosimo I de' Medici as a gift for Francis I of France. This is a brilliant example of Cosimo's skills in diplomacy. First, he flatters Francis's intelligence by implying that he will understand all the references contained within the painting; second, he implies that he, Cosimo, is equally intelligent; and third, he caters to Francis's taste – elegant, refined and erotic.

Foreign Affairs

The figure of Jealousy in the painting has been subjected to a radically different interpretation. It has been suggested that it shows someone suffering the symptoms of advanced syphilis: pain, bleeding gums and scalp, and madness. The first outbreak of syphilis in Italy had been in the 1490s among French troops besieging Naples. As such, the French talked of it as the "Italian disease". The Italians called it the "mal francese", attributing the illness to the French. It would hardly have been diplomatic to refer to the illness in a gift, suggesting either that this theory is wrong or that this was one message that Cosimo didn't want Francis to understand.

● ALLEGORY WITH VENUS AND CUPID
Agnolo Bronzino, mid-1540s (NATIONAL GALLERY, LONDON)

Bronzino has created a "puzzle painting" alluding to the different qualities of love. Jest, or playfulness, is one of its few positive aspects, compared to Fraud, Jealousy and Deceit. At the top Time and Oblivion struggle with a blue cloth, in an attempt to reveal – or forget – the truth, while Venus, goddess of love, disarms her own son Cupid.

The golden apple (see right) identifies this figure as **Venus**. It was given to her by the shepherd Paris, who was asked to judge which of the three goddesses, Venus, Juno or Minerva, was the most beautiful. His reward for choosing Venus was Helen, the most beautiful woman in the world, and his choice led directly to the Trojan War.

Venus has removed one of Cupid's arrows from his quiver – she has effectively disarmed him.

In the top left corner there is a face, but the back of the head is missing (see left). This character has no brain, and therefore no memory: this is **Oblivion**.

The boy with roses is **Jest**. He has bells on his ankle, which announce his arrival, and has also stepped on a thorn (see right): a symbol of the pleasure and pain of love.

The old bearded man in the top right corner has wings, and an hourglass rests on his shoulder: he is Time.

The old woman who is screaming and tearing her hair (see left) symbolizes **Jealousy**. It has also been suggested that the figure represents someone suffering from syphilis (see main text, left).

The masks (see below) are used as a representation of **Deceit**.

The sweet-faced girl just in front of Time and behind Jest has an equally sweet honeycomb in one hand, but holds a sting in the other: she has a scaly body and a serpent's tail, but with the paws of a lion. She is Fraud.

Cupid: *see pages 114 and 157;* **David:** *see pages 98–100;* **Francis I:** *see page 33;* **scholarship:** *see pages 166–173;* **Venus:** *see page 114*

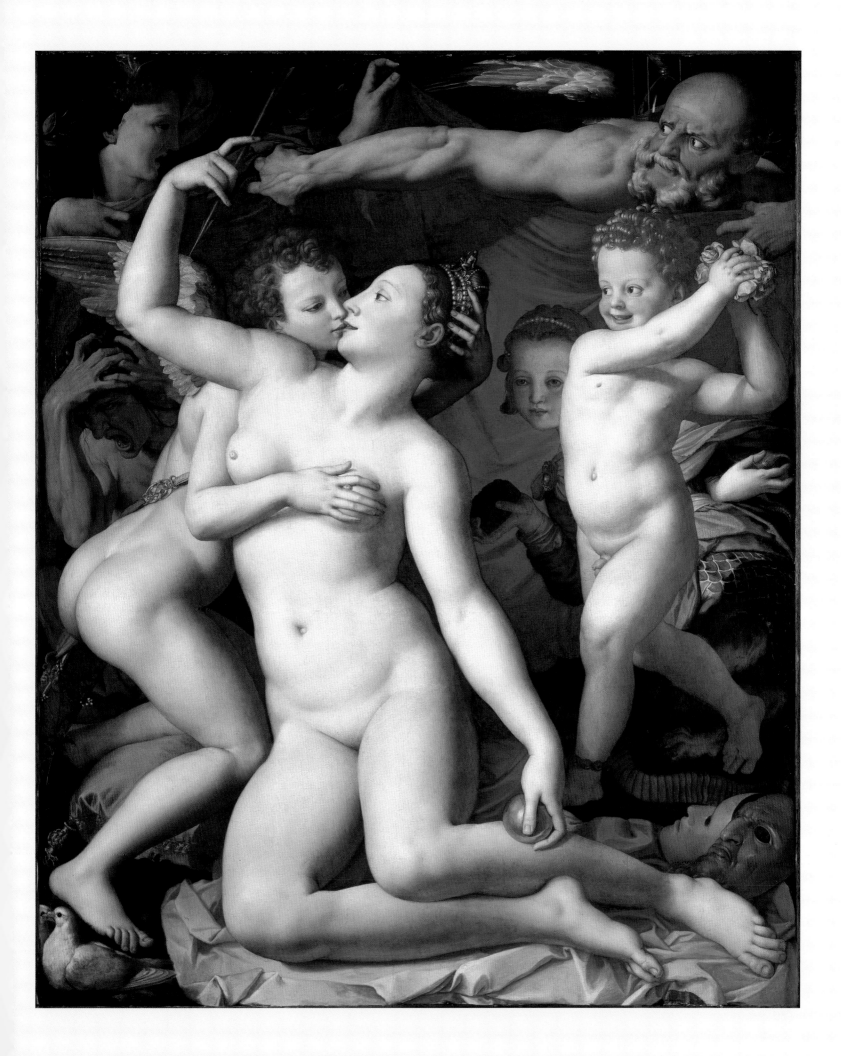

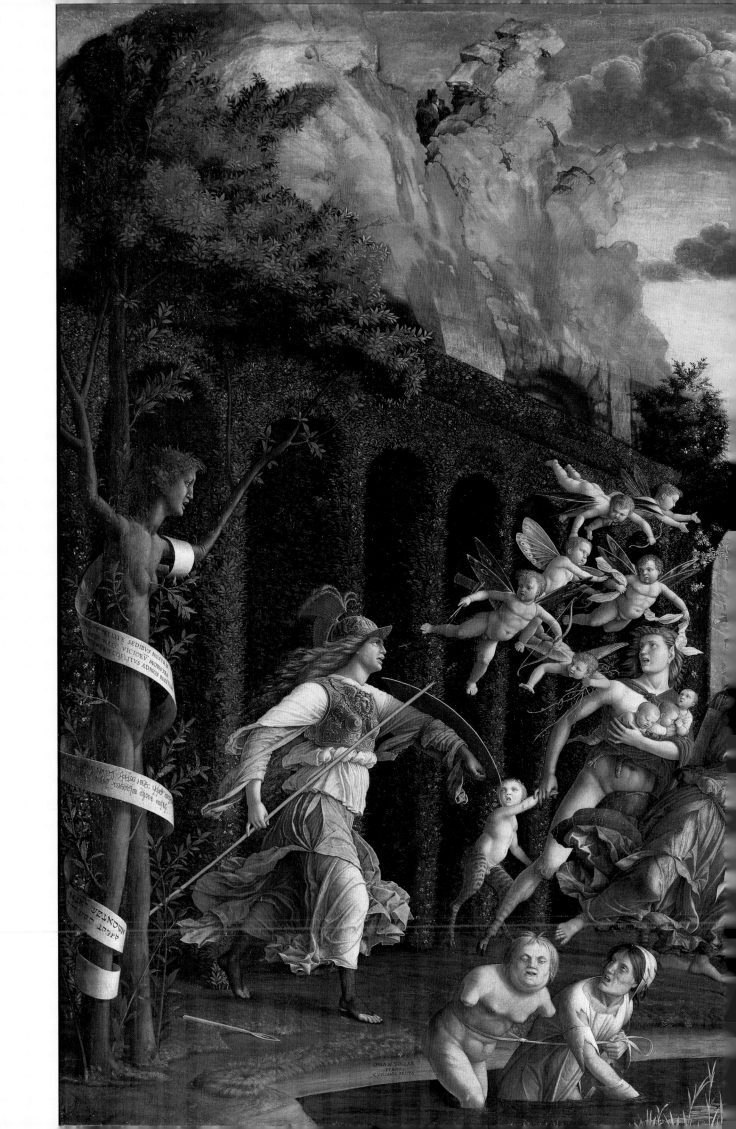

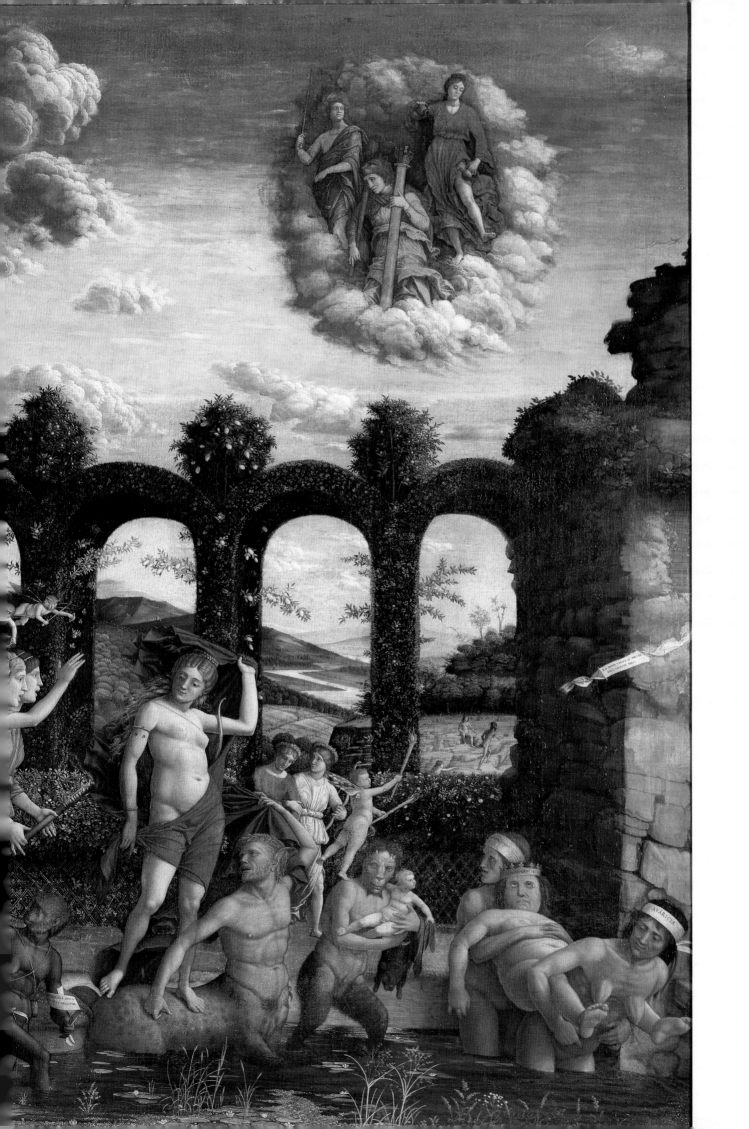

A GARDEN OF THE MIND

Renaissance Italy was a masculine world – men governed, traded and fought, and commissioned and created most art and architecture. In this context, Isabella d'Este (1474–1539), who commissioned this painting, was remarkable, and in any context was one of the great patrons of art. The daughter of Ercole d'Este, duke of Ferrara, and Eleonora d'Aragona, a Neapolitan princess, her background and education were unlike those of other women. In 1490 she married Francesco Gonzaga, marquis of Mantua, and soon after decided that she, like her uncles Leonello and Borso, should have her own *studiolo*.

This allegory is particularly complex – Isabella explained that she liked a painting to be an illustration of a literary idea – and as a result Mantegna is required to portray things that do not have a standard pictorial format. The idea of adding inscriptions to paintings was not new – characters had often been labelled in art, as they are for example in Ambrogio Lorenzetti's *Allegories of Good and Bad Government* (see pages 113 and 180–183). The often represented – and so readily recognizable – cardinal virtues are not labelled, nor are the well-known goddesses Pallas Athena (or Minerva) and Venus.

The two goddesses are contrasted with each other – a particularly immodest Venus has invaded a beautifully cultivated garden, accompanied by numerous vices. Fortitude, Temperance and Justice have been driven away, Prudence imprisoned and Chastity abandoned. Pallas Athena, goddess of wisdom, arrives to drive away the vices, so that the virtues can return. The setting can be seen as a metaphorical Garden of the Mind – if occupied by noble pursuits and learning it will be free of the sins of Ignorance, Idleness and Lust. The two female protagonists – Venus and Pallas – allude to the different ways in which Isabella can choose to conduct herself, and she clearly places herself on the side of Wisdom and Chastity.

❹ Daphne, denoting Chastity, is shown as an olive tree rather than the original laurel, because that is the tree associated with Athena. The inscription reads: "Come, divine companions of the virtues who are returning to us from Heaven, expel these foul monsters of vices from our home."

▷ **PALLAS EXPELLING THE VICES FROM THE GARDEN OF VIRTUE**
Andrea Mantegna, ca. 1499–1502 (LOUVRE, PARIS)

Isabella could read and write in Latin – although with difficulty – and she appointed her own humanist tutor. She also commissioned translations from the Greek, and was interested in Hebrew literature: the painting includes inscriptions in all three languages. The work is one of two that Mantegna completed for Isabella's study; a third was left unfinished.

broken spear: *see page 194;* **Daphne:** *see page 73;* **the Este:** *see page 174;* **the Gonzaga:** *see pages 190–191;* **Minerva:** *see page 114;* **studioli:** *see pages 39 and 172;* **Venus:** *see page 114;* **virtues and vices:** *see pages 110–113 and 156;* **Wisdom:** *see page 180*

❶ Pallas Athena, fighter for all things good, enters the garden to banish the vices. Her broken spear implies that she has struck her enemy a powerful blow, and is a symbol of victory. With her shield she wards off the arrows of the *amoretti* – little figures of love – which shoot at her to challenge her chastity.

❷ The garden, with its white rose bushes, delicate fence and well-maintained hedges and fruit trees is a refined, cultivated and, above all, civilized place: nature has been subjected to the organizing mind of man. It has only recently been taken over by the vices and so is not yet rundown.

❸ Three of the cardinal virtues, Justice, Fortitude and Temperance, are seen clearly in the sky, standing on a cloud which is descending toward the garden.

❺ The inscription follows on from that on the left of the painting: "and you, O gods, help me, the Mother of the Virtues". It is attached to a wall which imprisons Prudence, called the "Mother of the Virtues" as it was considered necessary for the development of the others. Prudence was the virtue with which Isabella most associated herself.

❾ Avarice and Ingratitude carry Ignorance – who is lazy and cannot be bothered to seek the truth – out of the garden. The crown implies that Ignorance rules the world.

❻ Idleness has no hands, so cannot work, and is led by Inertia: nothing will be achieved. Behind Idleness is an inscription from Ovid's *Remedy for Love*: "If you do away with idle hours, Cupid's bows have already perished."

❼ The monkey is often associated with Lust – but the inscriptions borne by this creature tell us that it represents Immortal Hatred, Fraud and Malice. The bags tied around its body contain the evils it spreads.

❽ Venus, representing Lust, stands brazenly on the back of a centaur, which physically embodies man's animal nature – the primitive urges which Wisdom teaches us to suppress.

SCHOLARSHIP

The "rebirth" of culture which the Renaissance embodies occurred first within the sphere of learning: the developments within the visual arts are just one manifestation of this. It was the scholars who devised the complex allegories, and who could give possible interpretations of a Bible story. They advised the rich on which books to collect, and oversaw their libraries. Books themselves were the subject of artistic elaboration, and inevitably libraries had to be built to house them. There was also a reverence for the isolated scholar, enlightened, yet still seeking greater knowledge and understanding – particularly when it could help to unite different systems of thought, such as the Christian and the classical.

Scholarship was the powerhouse of the Renaissance. The depiction of religious events, based on a theology which had been thoroughly elaborated during the Middle Ages, began to be increasingly influenced by the development of Neoplatonism – the idealization and symmetry seen in Florentine art in particular being just one example. Public speakers might rely on Cicero's writings on rhetoric. Indeed, Alberti's *Della Pittura* is strongly influenced by Cicero: the way in which he builds up painting through its constituent elements parallels Cicero's construction of an argument through words. For people whose wealth was based increasingly on trade, Ptolemy's *Geography* was invaluable. Similarly, the ability to build safe and efficient ships relied upon the complex mathematics available in Euclid's *Geometry*. Banking systems rapidly advanced – by 1395 the Medici were already using a recognizable form of double-entry book-keeping. Beyond these practical applications, there was also a growing interest in learning for learning's sake.

However, the books themselves were not so easy to come by – serious scholars would travel around Europe to locate rare manuscripts, and, once located, each book had to be copied by hand. The expense of doing this made the items immensely collectable, and to enhance their value they were often richly decorated. Even when printing presses were introduced to Italy – in the 1460s and 1470s – books were still relatively expensive. Nevertheless, the number of books in circulation was vastly increased and a new form of public

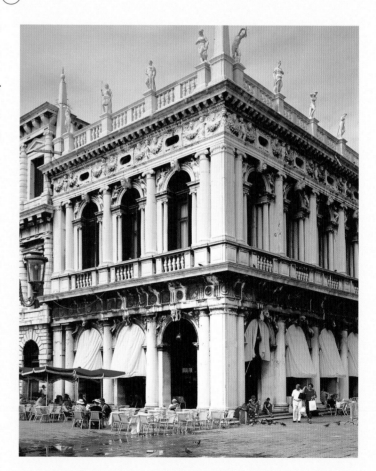

⬤ ST MARK'S LIBRARY (THE "MARCIANA")
Jacopo Sansovino, begun 1537 (VENICE)

The Marciana was built directly opposite the Doge's Palace, the centre of Venice's administration. The prominence of the library was designed to emphasize that Venetian government was guided by wisdom.

Alberti: *see page 15;* **Cicero:** *see page 12;* **government:** *see pages 174–183;* **Neoplatonism:** *see page 150;* **symmetry and harmony:** *see pages 58–61, 137 and 146;* **Wisdom:** *see pages 164 and 180*

building developed: the library. These had, of course, existed for years in monasteries and universities, which were the centres of learning, but were not open to all. The Vatican Library was the first to open its doors: by the death of Sixtus IV in 1484 it held some 3,600 manuscripts.

Jacopo Sansovino's library (see opposite), known as the "Marciana" because it was built for the Basilica of San Marco in Venice, uses a balanced architecture based on classical models. In line with the "rules" of the orders, the ground floor is Doric – firm and supporting. The library and reading room themselves are on the first floor, and are represented by the Ionic order, suitable, according to Sansovino's contemporary Serlio, for men of learning.

◉ PORTRAIT OF CARDINAL BESSARION

Gentile Bellini, ca. 1472–1473 (NATIONAL GALLERY, LONDON)

The Marciana was built to house the volumes acquired over the years by the most important church in Venice. This collection was greatly enhanced in 1468 by a gift of the library of Cardinal Bessarion, a Greek Orthodox priest who had initially come to Italy in 1438 for the Ecumenical Council that tried to unite the Eastern and Western churches. He stayed after the Council and decided to spend the rest of his life in Italy when Constantinople fell to the Ottoman Empire in 1453. His presence in the country, and his collection of books, were of enormous importance to the Italian humanists because, although they were well versed in Latin, their knowledge of Greek – and access to the works of the ancient Greeks – was limited.

Bessarion's approach to scholarship is best described in his own words: "I tried, to the best of my ability, to collect books for their quality rather than their quantity, and to find single volumes of single works; and so I assembled almost all the works of the wise men of Greece, especially those which were rare and difficult to find. ... They must be preserved in a place that is both safe and accessible, for the general good of all readers, be they Greek or Latin."

As well as books, he brought with him a reliquary containing fragments of the True Cross – the cross on which Jesus was crucified. This portrait of him, kneeling in prayer in front of the reliquary, was painted on the door to the cupboard in which it was kept. A keyhole is still visible, although filled in, at the top left of the second scene down on the right of the painting.

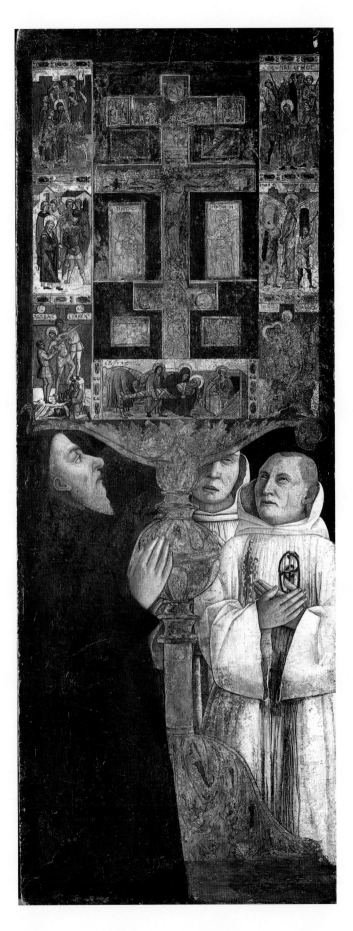

architectural orders: *see pages 28–29;* **Cardinal Bessarion:** *see pages 172–173;* **Ottoman Empire:** *see page 192;* **Serlio:** *see page 28;* **Sixtus IV:** *see pages 84, 175 and 198;* **True Cross:** *see page 200*

OUT OF DARKNESS

More than a decade before Sansovino was commissioned to build the Marciana in Venice (see page 166), Michelangelo had started work on an equivalent project in Florence – the Laurenziana, or Laurentian Library, which was so called because it was attached to the Basilica of San Lorenzo. While the reading room itself was erected fairly rapidly, in 1524 and 1525, work on the vestibule was delayed, and it had still not been completed by the time Michelangelo left Florence in 1534, never to return. Construction was, however, continued according to the original architectural plans, assisted by a regular correspondence with Michelangelo, who was by this time in Rome.

In contrast to Sansovino's regular and balanced building, Michelangelo's vestibule for the Laurentian Library (see below) appears cluttered and confused. The architectural elements do not seem to function properly. The brackets, which should be designed to support some other element, project from the wall, and have nothing directly above them. The columns, which would usually be in front of the walls, are buried within them, and the window frames – which do project strongly – are blind: no light comes through them. The majority of the floor space is taken up by a disproportionately large staircase. The way in which the different elements of the architecture seem to work against each other is equivalent to Michelangelo's depiction of the human form in his more mature works, in which his figures adopt complex poses and emphasize the possibilities of movement within the body. Stylistically this can be described as Mannerism – art or architecture which relies on our knowledge of something to see the distortions which the artist is making, and which is very much about an artistic display of skill. But for Michelangelo such techniques were not just cynical games,

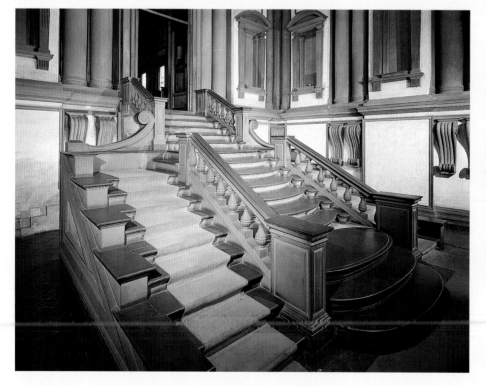

◖ VESTIBULE OF THE LAURENTIAN LIBRARY
Michelangelo, begun 1524
(S. LORENZO, FLORENCE)

Michelangelo thought of himself primarily as a sculptor: his paintings are sculptural and so is his architecture. The building, with its whitewashed walls articulated by grey *pietra serena*, uses the materials advocated by Brunelleschi, but whereas the earlier master used them to emphasize the harmony in the structure of the building, Michelangelo uses them sculpturally. He excavates the walls and makes the architectural elements project in ways that create light and shade, thus emphasizing their solidity.

Brunelleschi: *see page 26;* **Mannerism:** *see pages 21 and 29;* **symmetry and harmony:** *see pages 58–61, 137 and 146*

The illuminated manuscript page shows the text beginning:

PRAEFATIO IOHANNIS ARGIROPYLI BIZÃ
TII IN PHISICORVM ARISTOTELIS LIBROS AD
PRESTANTISSIMVM VIRVM PETRVM MEDI
CEM

OHANNES ARGI
ROPILVS BIZAN
TIVS MAGNIFIC
VIRO PETRO ME

◖ **ARISTOTLE'S "PHYSICS, ET AL"**
Francesco Rosselli, ca. 1460s (LAURENTIAN
LIBRARY, FLORENCE)

The Laurentian Library was commissioned by
Pope Clement VII (1478–1534), a member of
the Medici family, to house the books which
had been collected by successive generations
of the family. This illustration shows the title
page of a collection of volumes by Aristotle,
including his *Physics* and *Metaphysics*, which
was translated for – and dedicated to –
Clement's grandfather Piero de' Medici (1416–
1469). The richness of the illustration makes it
clear that these books were prized as much for
their inherent beauty as for their contents: only
relatively little of this page is taken up by the
text. The remainder is delicately and intricately
illuminated, with a portrait of Piero's father
Cosimo (1389–1464) in the border on the right
(see detail, above), and an illustration of a
medal of Piero himself at the bottom. There
are also numerous depictions of the Medici
coat of arms – at the top and left, and held by
the dragons on the right and at the bottom.

with no purpose other than to dazzle the viewer, but part of
the overall experience.

The sense of unease about this space – its darkness, and
the tension in the architecture – was intentional. Light does
enter the vestibule – from a second storey above the door
to the reading room, and from the door to the reading
room itself. The light comes from above, and represents
inspiration descending from God. The overlarge staircase
encourages us to seek enlightenment, to escape the darkness
and confusion of our ignorance by climbing physically –
and then intellectually – toward the source of inspiration.
It should come as no surprise, then, to learn that the
reading room itself is simple, balanced, orderly and bril-
liantly lit throughout.

Aristotle: *see pages 150–151 and 180;* **light of God:** *see pages 137 and 172;* **medals:** *see pages 15 and 40;* **the Medici:** *see pages 42, 186–187, 198–199 and 202*

VICTOR
CARPATHIVS
FINGEBAT·

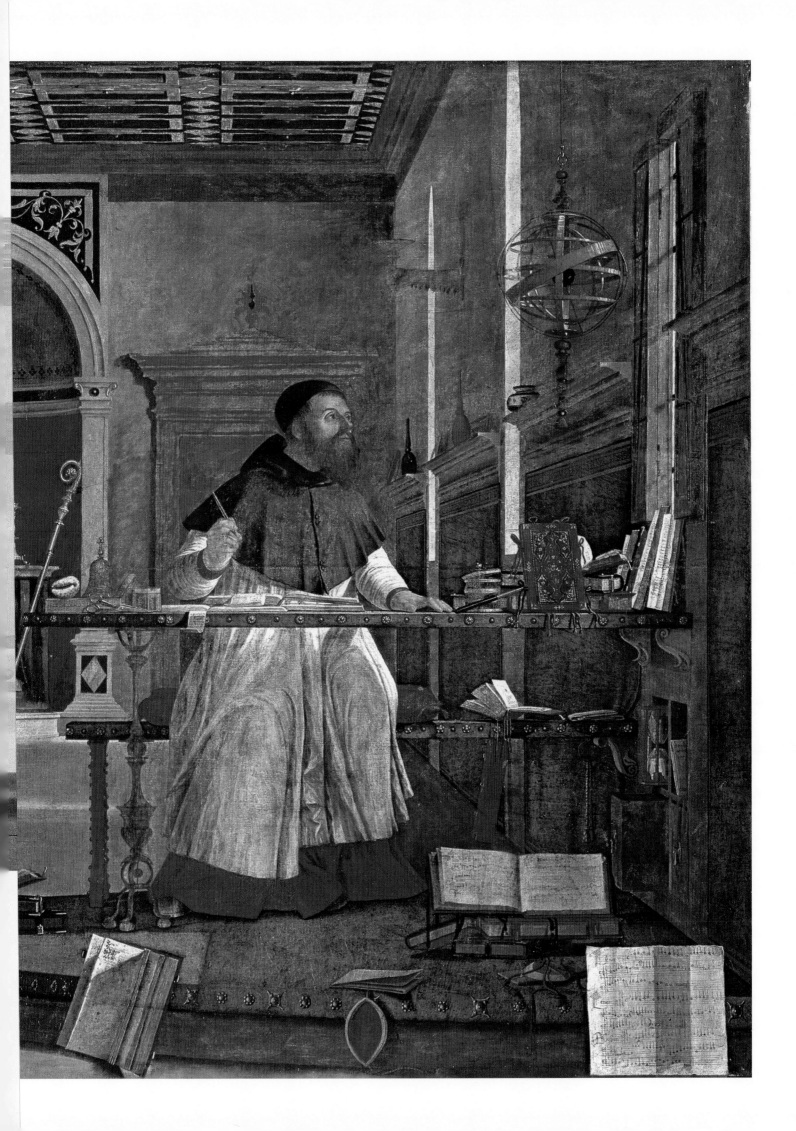

GOVERNMENT

Prior to the unification of the state in 1871, Italy consisted of a series of rival – and often warring – city-states, each with different jurisdictions and subscribing to a variety of forms of government. There were monarchies, such as the hereditary kingdoms of Naples and Sicily, republics of different forms (notably Florence and Venice), and states ruled by those members of the nobility who had been granted their right to rule by major European authorities such as the papacy and the Holy Roman Empire.

The political complexities of Renaissance Europe were in many ways a legacy of the disintegration of the Roman Empire, which eventually resulted in the rise of the three major powers, the papacy, the Holy Roman Empire and the Byzantine Empire. The chaos was particularly marked in the Italian peninsula, where the weakening of imperial authority meant that in the fifth century Rome was liable to be ransacked by tribes from northern Europe trying to seize the remaining wealth of empire.

Western Church leaders found it increasingly necessary to try to protect their people, and so the papacy began to acquire its status, beginning with Pope Leo I ("the Great"; reigned 440–461) who negotiated to avert Hun and Vandal attacks at the same time as he was resisting Constantinople's attempts to attain ecclesiastical parity with Rome. The growing power of the bishopric of Rome was confirmed in the late fifth century when the Byzantine emperor was reproached for interfering in Church affairs. By the time of Pope Gregory I (reigned 590–604), it had become clear that in the West the future lay with a new civilization, that of Latin Christendom.

At the same time as Christianity in western Europe began to be centred on the papacy in Rome, there arose secular rulers who sought to emulate the imperial greatness of Byzantine emperors and offered to use their military power on behalf of the Church. Foremost among these imitators was the king of the Franks, Charlemagne ("Charles the Great"; reigned 768–814), who in 800 was appointed "Holy Roman Emperor" by Pope Leo III. In placing the crown on Charlemagne's head, the pope implied that any claim to unrivalled power would not be unchallenged. Although the Church had secured theological independence from the secular authorities, the struggle for dominance within Christendom – and the earthly, territorial control that it entailed – was to continue for centuries. It pitted the papacy against both the Holy Roman Empire and a variety of more local Italian powers.

For example, the Este of Ferrara were granted their right to rule by the pope when Ferrara was made a marquisate at the end of the fourteenth century, and in 1470 the state was elevated to a dukedom. The Este were also appointed dukes of Modena and Reggio Emilia, but by the Holy Roman Emperor in the middle of the fifteenth century. At the end of the sixteenth century there were no legitimate Este heirs, and whereas popes in the past had been only too happy to "legitimize" an appropriate member of the family, Clement VIII was not – he wanted to get his hands on the family's wealth. The Este abandoned Ferrara, transferring their court and many belongings to Modena, but leaving much behind. One indirect result of this is the ownership of Titian's *Bacchus and Ariadne* (see page 153) by the National Gallery in London.

An Elected Monarchy

Rome and the Papal States were ruled over by the pope, an elected rather than hereditary monarch. He was elected from among the cardinals, the highest rank of priest, who themselves would have been appointed by previous popes. It was a

Constantine: *see pages 97 and 144;* **fall of Constantinople:** *see page 167;* **Ottoman Empire:** *see page 192;* **Roman Empire:** *see pages 66 and 144*

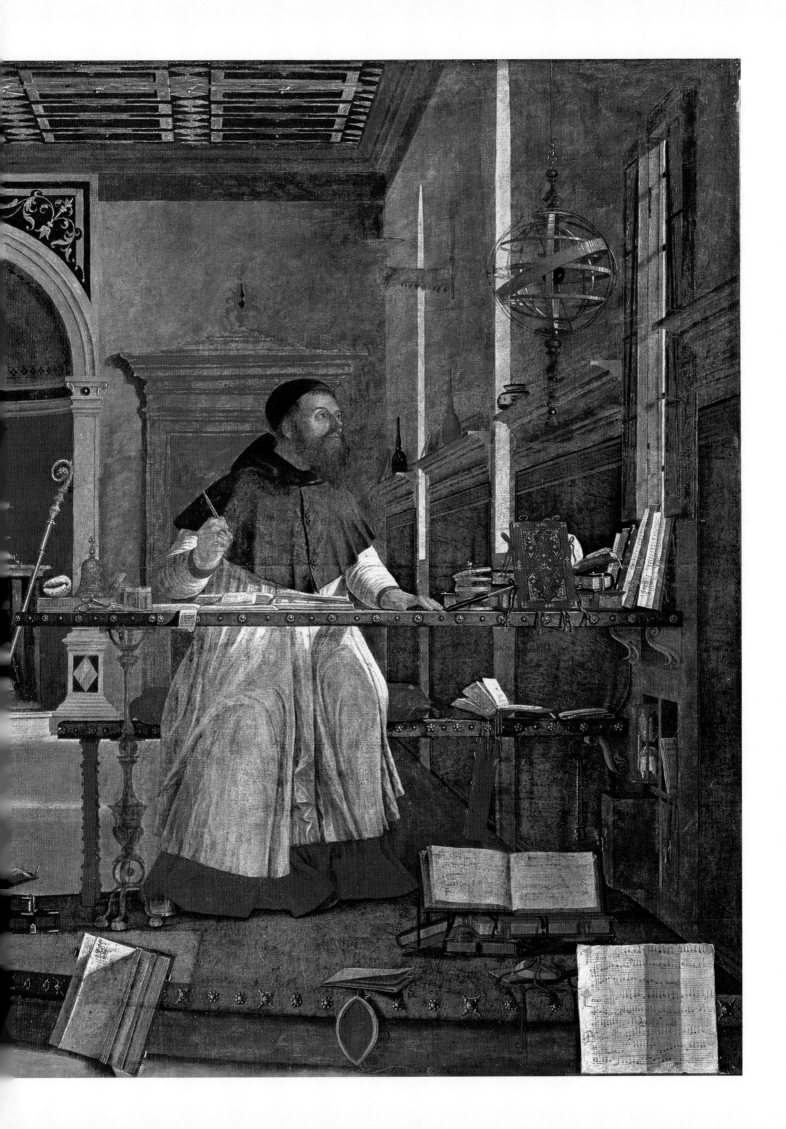

THE TOOLS OF STUDY

As well as in libraries, scholars worked on their own in their studies, but these were rarely as spacious as that illustrated by Carpaccio in his *Vision of St Augustine* (see right). We are most familiar with these rooms from the *studioli* of leading figures of society. These were places where the owner could retreat and delight in his or her possessions, be they expensive books or exquisite *objets d'art*. But private libraries were not unknown: Raphael's "Disputà" (see pages 132–135) and *School of Athens* (see pages 148–151) decorate what was the personal library of Pope Julius II.

What Carpaccio shows us is a combination of private library, study and chapel. As well as the books necessary for study, there are the precious items which collectors coveted – small bronzes, delicate ceramics and even, on the end of Augustine's table, an exotic shell. This place of learning is one of worship, and the objects depicted combine to suggest that Augustine is the ideal humanist, striving to unite the word of God with the learning of the ancients. It can also be seen as an illustration of Augustine's own history. In *Confessions* he describes how his youthful exuberance and joy of worldly things was moderated under the influence of St Ambrose, the combination of sacred and profane reflecting the balance between the worldly life he renounced, and the ideals of the Church he then entered. And on a further level, it can also be interpreted as a homage to Cardinal Bessarion, the Greek scholar and orthodox priest who left his library to San Marco, thus bringing ancient knowledge to the Christian community.

Carpaccio painted the image for the Scuola degli Schiavoni, which had been founded in 1451 by immigrants from Dalmatia (*Schiavoni*, or Slavs). When, in 1464, they offered their help toward a projected crusade, Bessarion granted a special indulgence on the feast days of the *scuola*'s patron saints George, Jerome and Tryphon, as well as on Corpus Domini, the feast day of the "Body of the Lord". Both this, and Bessarion's gift of his library, seem to be commemorated here.

❍ VISION OF ST AUGUSTINE

Vittore Carpaccio, ca. 1502–1507 (SCUOLA DEGLI SCHIAVONI, VENICE)

The *Vision of St Augustine* is actually the conclusion of a cycle of three paintings relating to St Jerome. While writing to the saint on a complex matter of theology, Augustine saw an "indescribable light" and heard Jerome's voice, which told Augustine that he had died, and was with Christ in heaven.

❶ In early libraries each book had its own place – the reader would go to the book rather than the book being brought to the reader. Books were displayed flat on sloping shelves, their exquisite bindings marking them out as objects of physical beauty worth collecting regardless of their content.

❺ The statuette of a naked Venus is the profane counterpart to that of Christ. There is also an imitation of one of the four classical statues of horses which had been brought to Venice after the Sack of Constantinople in 1204, and displayed on the façade of San Marco.

St Ambrose: *see pages 103–104;* St Augustine: *see page 104;* Cardinal Bessarion: *see page 167;* ceramics: *see pages 32–33;* flag of Christ Triumphant: *see page 44;* St George: *see pages 64, 65, 75–76 and 194;* St Jerome: *see pages 36, 102 and 109;* light of God: *see pages 137 and 169;* scuole: *see page 177;* small bronzes: *see page 24*

2 This bronze is of Christ at the Resurrection – he is naked apart from the shroud, now worn like a toga. He carries the flag of Christ Triumphant, which was adopted as the flag of St George – of particular significance as the *scuola* was dedicated to this warrior saint.

3 Augustine pauses, pen in hand, to gaze out of the window at a miraculous light. He is framed by a door, although not centrally, emphasizing his movement toward the window. The face has been identified as an idealized portrait of Cardinal Bessarion.

4 The armillary sphere – one made up of loops, rather than being solid – implies that Augustine's study of the heavens is of a scientific as well as theological nature. It also shows Carpaccio's skill in representing complex three-dimensional objects on a two-dimensional surface.

6 The dog is a symbol of faith and fidelity. However, as well as witnessing to Augustine's faith, it is also the only evidence we have that something extraordinary is happening. Augustine might just be looking out of the window, but the dog's rapt attention and pricked ears tell us he is not only seeing something, but also listening.

7 What could be a scrap of paper which Augustine has discarded in fact bears Carpaccio's signature. Contemporaries such as Bellini often included their signature on what looked like a piece of paper stuck to the painting, but was actually part of the painting, as a way of showing that their work was good enough to deceive us.

8 The seal hanging over the dais is that of Cardinal Bessarion: the document may give details of his indulgence.

9 The musical scores include a hymn and a popular song. Although most was handwritten, music was first printed in Venice in 1481. By the 1490s it was the centre of music printing in Europe.

GOVERNMENT

Prior to the unification of the state in 1871, Italy consisted of a series of rival – and often warring – city-states, each with different jurisdictions and subscribing to a variety of forms of government. There were monarchies, such as the hereditary kingdoms of Naples and Sicily, republics of different forms (notably Florence and Venice), and states ruled by those members of the nobility who had been granted their right to rule by major European authorities such as the papacy and the Holy Roman Empire.

The political complexities of Renaissance Europe were in many ways a legacy of the disintegration of the Roman Empire, which eventually resulted in the rise of the three major powers, the papacy, the Holy Roman Empire and the Byzantine Empire. The chaos was particularly marked in the Italian peninsula, where the weakening of imperial authority meant that in the fifth century Rome was liable to be ransacked by tribes from northern Europe trying to seize the remaining wealth of empire.

Western Church leaders found it increasingly necessary to try to protect their people, and so the papacy began to acquire its status, beginning with Pope Leo I ("the Great"; reigned 440–461) who negotiated to avert Hun and Vandal attacks at the same time as he was resisting Constantinople's attempts to attain ecclesiastical parity with Rome. The growing power of the bishopric of Rome was confirmed in the late fifth century when the Byzantine emperor was reproached for interfering in Church affairs. By the time of Pope Gregory I (reigned 590–604), it had become clear that in the West the future lay with a new civilization, that of Latin Christendom.

At the same time as Christianity in western Europe began to be centred on the papacy in Rome, there arose secular rulers who sought to emulate the imperial greatness of Byzantine emperors and offered to use their military power on behalf of the Church. Foremost among these imitators was the king of the Franks, Charlemagne ("Charles the Great"; reigned 768–814), who in 800 was appointed "Holy Roman Emperor" by Pope Leo III. In placing the crown on Charlemagne's head, the pope implied that any claim to unrivalled power would not be unchallenged. Although the Church had secured theological independence from the secular authorities, the struggle for dominance within Christendom – and the earthly, territorial control that it entailed – was to continue for centuries. It pitted the papacy against both the Holy Roman Empire and a variety of more local Italian powers.

For example, the Este of Ferrara were granted their right to rule by the pope when Ferrara was made a marquisate at the end of the fourteenth century, and in 1470 the state was elevated to a dukedom. The Este were also appointed dukes of Modena and Reggio Emilia, but by the Holy Roman Emperor in the middle of the fifteenth century. At the end of the sixteenth century there were no legitimate Este heirs, and whereas popes in the past had been only too happy to "legitimize" an appropriate member of the family, Clement VIII was not – he wanted to get his hands on the family's wealth. The Este abandoned Ferrara, transferring their court and many belongings to Modena, but leaving much behind. One indirect result of this is the ownership of Titian's *Bacchus and Ariadne* (see page 153) by the National Gallery in London.

An Elected Monarchy

Rome and the Papal States were ruled over by the pope, an elected rather than hereditary monarch. He was elected from among the cardinals, the highest rank of priest, who themselves would have been appointed by previous popes. It was a

Constantine: *see pages 97 and 144;* **fall of Constantinople:** *see page 167;* **Ottoman Empire:** *see page 192;* **Roman Empire:** *see pages 66 and 144*

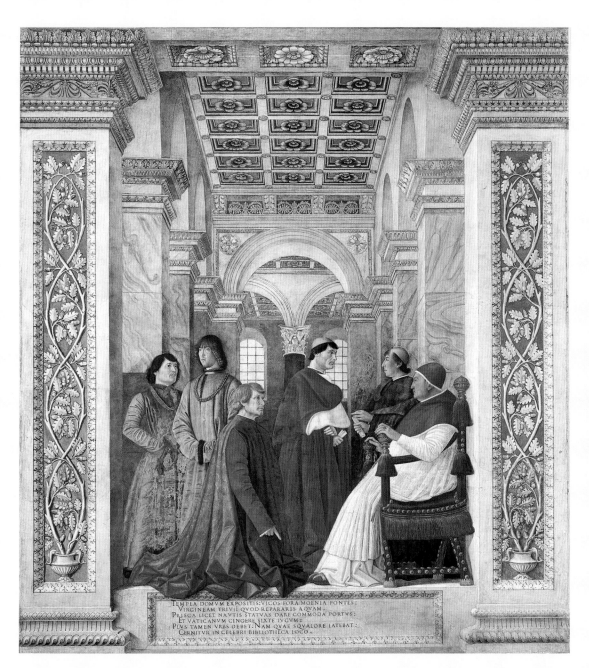

○ **POPE SIXTUS IV WITH HIS NEPHEWS**
Melozzo da Forlì, ca. 1477
(VATICAN)

As Julius II, Cardinal
Giuliano (standing in
the centre) would later
be portrayed seated in
a throne similar to that
used here by his uncle
Sixtus IV. Curiously,
Giuliano's position in
relation to Sixtus is
echoed by our viewpoint
in Raphael's portrait
(see page 85).

system which was not always free of corruption. Nepotism, the practice of awarding offices to relatives, derives from the Italian word *nipote*, meaning "nephew". However, *nipote* also means "grandchild", or, in the plural, "descendants", and more than one pope, notably Paul III, disguised his illegitimate descendants as "nephews".

Melozzo da Forlì's painting (see above) reveals the contemporary importance of family status. Seated on the right is Pope Sixtus IV, a member of the della Rovere family –

their emblematic acorns and oak leaves can be seen on the pilasters on each side. The pope is being flattered by his recently appointed librarian Bartolomeo Platina, who kneels and points to a list of Sixtus's accomplishments. The other four figures are Sixtus's nephews – not humble enough to have to kneel, and yet not sufficiently honoured to sit in his presence. Notable among them is Giuliano della Rovere, second from the right in the red robes of a cardinal, who went on to become Pope Julius II.

cardinals' clothing: *see page 199;* Julius II: *see pages 83–85;* libraries: *see pages 166–169;* oak trees and acorns: *see page 43;* pope: *see page 128;* Sixtus IV: *see pages 84 and 198*

THE MOST SERENE REPUBLIC

In its early days, from the sixth century to the late eighth century, Venice was nominally subject to the Byzantine Empire. However, the city cultivated a large degree of autonomy by carefully balancing the controlling interests of outside forces. As early as the seventh century, the populace gathered to elect a leader, called the doge. Although it was the Byzantine emperors who granted the doges the right to rule, this maritime powerhouse of the eastern Mediterranean used the currency of the Holy Roman Emperors. San Pietro – its cathedral until 1807 – was built on an island at a distance from the administrative and financial centres. In this way the city kept the pope at arm's length, and Venice – known as La Serenissima, the "Most Serene Republic" – metaphorically floated amid three powers, secure in its independence, its growing wealth and increasing naval strength.

However, as the population grew, the election of the doge became increasingly complicated, leading to struggles between old, established families, and newer, recently enriched merchants. The Venetians developed a novel solution. Until the end of the thirteenth century, any adult male could, in theory, have been elected doge. But from 1297 the names of those families whose representatives were deemed to be eligible were inscribed in a Golden Book, which was effectively "locked". The *serrata*, or "closing", as it was known, meant that only an élite of families took any part in government, and only their members could be elected doge.

The position of doge was not necessarily an enviable one – and if Giovanni Bellini's exquisite portrait of Leonardo Loredan (see right) makes him look a little like a chess piece, that could be because the doge was a ceremonial figurehead with no real power. Although he presided over council meetings, he could only agree to their decisions, and the council could in any case meet without him. He could not accept any gifts that were not intended for the state as a whole, nor could he engage in trade. Venice was effectively a

⬥ DOGE LEONARDO LOREDAN
Giovanni Bellini, 1501–1504 (NATIONAL GALLERY, LONDON)

This portrait may have been commissioned to celebrate Loredan's election as doge in 1501. The doge was known for his extravagance of dress and here he is wearing expensive damask – a new material that would have been imported from the east, reminding us of the importance of the trade routes to the Ottoman Empire that were the source of much Venetian wealth.

constitutional monarchy. However, it was officially a republic, although it shared features of an oligarchy (government by a small group). This unique form of government proved to be remarkably stable. From its origins in the sixth and seventh centuries, Venice was not only powerful and influential, but it remained unconquered for more than a millennium.

Holy Roman Emperor: *see page 174;* **Ottoman Empire:** *see page 192;* **portraiture:** *see page 88;* **Venetian art:** *see page 44*

⬠ INTERIOR OF THE SCUOLA GRANDE DI SAN ROCCO
(VENICE)

Given that a large proportion of the Venetian population had no say in the government of their republic, it may seem surprising that there was little social unrest. However, people gained a sense of inclusion in local affairs through a system of *scuole*. Literally translated as "school", a *scuola* was a form of confraternity, a charitable organization of which the main aims included the mutual support of its members: for example the care of the widows and children of deceased members, or the provision of dowries for girls from families who could not afford a respectable marriage.

You might belong to a *scuola* because you practised a certain trade, because you shared a common origin with other members, or because you were interested in a specific form of charity. The *scuole* varied in size. The Florentine *scuola* (for people from Florence who now lived in Venice) was relatively small, and met in a chapel in the church of Santa

Maria dei Frari: Donatello made a wooden sculpture of John the Baptist (patron of Florence) for this chapel. The Slavs were more numerous, and their relatively modest Scuola degli Schiavoni was decorated by Vittore Carpaccio in the early 16th century (see pages 170–173).

There were also six *scuole grandi* – notably larger institutions – the most impressive being the Scuola Grande di San Rocco. It owed its wealth to a popular devotion to San Rocco, one of the saints most often invoked in times of plague, a particular problem for maritime Venice.

All the paintings inside the Scuola Grande di San Rocco are by Tintoretto, and follow a typological scheme – those on the ceiling are the types, with the antitypes on the walls. For example, Jonah being spat out from the belly of the whale is set against Christ's resurrection. The paintings also echo the charitable aims of the institution and so include depictions of caring for the sick and feeding the hungry.

Jonah: *see pages 38 and 120;* **Scuola degli Schiavoni:** *see page 172;* **Tintoretto:** *see pages 64–65;* **types and antitypes:** *see page 120*

AMBROSIVS · LAVRENTII · DESENIS · H

MAGNANIMITAS · TENPERANTIA · IVSTITIA

XIT · VTRINQVE

❶ Wisdom is shown above Justice at the same level as the theological virtues, and thus is seen as one of the most important qualities of good government, in accordance with Plato.

THE IDEAL RULER

The political writings of philosophers from the classical world, such as Plato and Aristotle, were important influences on discussions of the nature of government. It was from Plato's *Republic*, for example, that the idea of the four cardinal virtues was derived. One of the work's major themes is the nature of justice, and this virtue is depicted twice in Ambrogio Lorenzetti's fresco allegorizing good government (see right). For Plato, government should be carried out by the wise few, those who understand justice and "goodness", and they should govern on behalf of the majority. For Aristotle, too, the harmony of society was of prime importance. He believed that power should rest with the good, as they would know how to govern the citizens in their best interests. Although benevolent monarchy was his preferred form of government, he realized that there was an ever-present danger of a tyrant – the worst kind of ruler – taking the throne, and so decided that a limited democracy was the most practical way to avert this possibility.

Limited democracy is perhaps the best description of the government in Siena in the mid-fourteenth century when Lorenzetti decorated the Room of the Nine in the Palazzo Pubblico. Like many northern Italian city-states, Siena had become a commune in the twelfth century, which meant that it was ruled by representatives of the citizens rather than being subject to an overlord, whether pope, emperor or king. Siena in the 1330s and 1340s was a republic, with a governing council known as "the Nine", which was chosen from the populace. Although Lorenzetti shows the personification of Good Government as a single figure, he is not a ruler as such, but the embodiment of the combined efforts of the nine members of the council. By including two extra virtues, Magnanimity and Peace, in addition to the traditional seven virtues, he is emphasizing that the Nine represented the best – and most virtuous – form of government.

❖ ALLEGORY OF GOOD GOVERNMENT
Ambrogio Lorenzetti, 1338–1340 (PALAZZO PUBBLICO, SIENA)

The frescoes in the Room of the Nine were there to remind the council members of the qualities that they should embody, as much as to reassure citizens of their council's virtue. An inscription below this fresco starts: "Where this holy virtue [Justice] rules, she induces the many souls of the citizens to unity, and they … make the common good their lord." The Italian "ben commune" can be translated not only as the "common good", but also the "good community", or even "good government".

❻ Concord carries a carpenter's plane: for agreement to be reached all difficulties and disagreements must be smoothed out. There are two threads, which are each tied to one of the pans of the scales, keeping them balanced. The threads are wound together in Concord's left hand and she passes them on to the nearest person.

Aristotle: *see pages 150–151;* **communes:** *see page 182;* **Plato:** *see pages 150–151;* **republican rule:** *see pages 176 and 182;* **virtues:** *see pages 110–112;* **Wisdom:** *see page 164*

2 Justice is enthroned between the balanced pans of her scales. On each side angels perform different types of Justice, rewarding to our right and punishing to our left.

3 Peace reclines on a suit of armour, and tramples more armour underfoot – she has overcome war. She holds an olive branch, symbolic of peace, and wears an olive garland on her head.

4 The figure of Good Government wears black and white – the colours of the coat of arms of Siena. Around his head are the letters CSCV, which stand for "Commune Saenorum Civitatis Virginis" ("Commune of Siena, City of the Virgin").

5 The three theological virtues are seen in the sky around the ruler's head. Faith, in white, carries the Cross, and Charity, in red, holds a flaming heart, a symbol of her burning love for God. Hope is not in green, as might be expected, a reminder that colour symbolism is unreliable. She looks up toward a vision of Christ in the sky.

7 Dressed in contemporary clothes these people are clearly intended to be citizens of Siena. Between them they hold onto the wound threads of Justice, which eventually lead to Good Government and are tied to his right wrist.

8 Fortitude and Prudence sit on Good Government's right. Prudence points to three lamps, standing for the past, present and future, with an abbreviation of the motto seen in Titian's *Allegory of Prudence* (see page 112).

9 The twins Romulus – founder of Rome – and Remus are suckled by a she-wolf. Siena was a Roman colony called Sena Iulia: the twins refer to its imperial origins and its status as heir to the Roman tradition.

10 Magnanimity, Temperance and Justice are seated to the ruler's left, the last of these appearing twice in the painting. Magnanimity is represented by the dish of coins in her lap: Good Government will be generous, whether financially or in the judgments it makes.

THE POWER OF THE GUILDS

The development of government by commune in northern Italian cities had a number of beneficial consequences. Because the cities were now governed by citizens and noblemen who actually lived in them, rather than by distant overlords, the inhabitants were more motivated to defend them and living conditions improved. This led to an increase in population, and also to an increase in trade. To protect their interests, the tradesmen formed guilds. As professional bodies first and foremost, the guilds guaranteed standards by limiting membership to those who had carried out the proper training and could demonstrate their competence. Only members of the guild were allowed to trade, which benefited both the members, whose livelihood was protected, and the clients, who were guaranteed a good product or service.

Guilds would also settle disputes between members and clients, and they fulfilled a charitable function, assisting the dependents of deceased members, for example. This benevolence extended to the patronage of important buildings: for example, in Florence the wool guild was responsible for the building and decoration of the cathedral, while the cloth importers' and refiners' guild patronized the Baptistery.

Although theoretically democratic, in practice the communes tended to be controlled by a small number of wealthy families. As the wealth of the guilds increased, they also aspired to a role in government. The Florentine guilds seized control of their city in 1250, calling themselves the "people", or *popolo*. Although this particular regime was short-lived, a second *popolo* was established in 1283, and was considerably more successful. Members of the major guilds were elected to govern the city as *priori*, or priors, and for more than a century Florence was run along relatively democratic, republican lines. However, by the beginning of the fifteenth century, the wealthiest families – notably the Medici – had reasserted control. The Medici continued to support the guilds, but the family's dynastic rule betrayed the spirit of the *popolo*.

◔ "THE GUILDS" FROM *DE SPHAERA*
Lombard School, 1400s (BIBLIOTECA ESTENSE, MODENA)

This illustration of various guildspeople, including painters, sculptors and armourers, carrying out their business comes from a manuscript called *De Sphaera*, "About the Spheres", which discusses the planets and their influence. This page relates to Mercury: those who were born under this planet were considered to be particularly creative. As the messenger god, Mercury was also responsible for methods of interaction, including eloquent discourse and commerce.

communes: *see page 180;* **Florence Baptistery:** *see pages 22–23, 52 and 119;* **Florence cathedral:** *see pages 26–27;* **the Medici:** *see pages 42, 186–187, 198–199 and 202;* **republican rule:** *see pages 176 and 180–181*

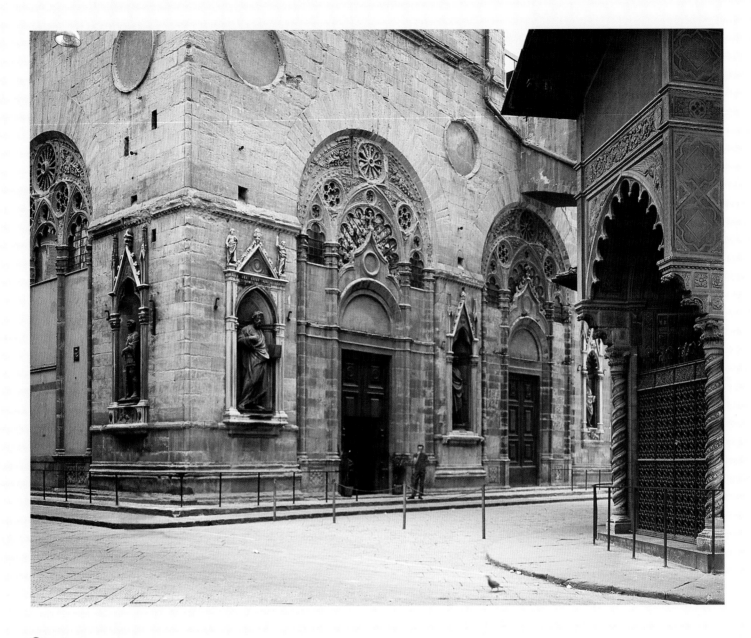

◉ ORSANMICHELE

Various (FLORENCE)

The Guild House of Orsanmichele is a typical embodiment of Florentine government of the 14th and 15th centuries. Named after the oratory of Orto San Michele – the garden of St Michael – this structure was built in the 1330s and 1340s as a communal grain market: the arches were originally open, and grain was stored on the first and second floors. By the beginning of the 15th century the building was enclosed, and had become a form of church, celebrating a miraculous image of the Virgin and Child. The niches in the piers outside were each allocated to one of the guilds for them to erect an image of their patron saint. By 1406 relatively few of these images had been finished, and so the guilds were given an ultimatum: if they didn't fill their niche within ten years it would be reallocated to another guild. As an additional incentive the major guilds were allowed to commission bronze sculptures, more impressive as they were far more expensive.

The cloth importers' and refiners' guild, which at that time was employing Ghiberti to make his first set of bronze doors for the Baptistery (see page 119), commissioned him to make a larger-than-lifesize bronze sculpture of their patron saint, John the Baptist, while the armourers' guild commissioned a marble sculpture of St George from Donatello (see page 75).

Orsanmichele is on the street that leads from the cathedral to the town hall (now known as the Palazzo Vecchio) – located between the centre of the religious life of the city and its seat of government. Representing the sponsorship of the arts through the creation of sculptures of the patron saints of the guilds from which were elected members of the government, the building is an unsurpassable symbol of the Florentine Renaissance, balancing as it does art, trade, politics and religion – and also, of course, money.

St George: *see pages 64, 65, 75–76 and 194;* **Ghiberti:** *see pages 22–23 and 52;* **St John the Baptist:** *see page 108*

POWER & WEALTH

There were many ways of displaying both power and wealth, and many reasons for wanting to do so – although most of these came down to maintaining the status that was being displayed in the first place. In the religious field, the use of art to display power and wealth may seem hypocritical, and it is a charge that has been levelled against many of the great patrons. Nevertheless, it was one of the most common ways of asserting rank – whether through the religious connections one could boast (as Jacopo Pesaro did by using St Peter to allude to his association with the papal court), or those you were aspiring to (for example, the Medici presented themselves as part of the entourage of the Three Wise Men). But images could be used simply to depict the patron as they wanted to be seen, as Ludovico Gonzaga did by showing his family and courtiers gathered around him, leaving no doubt about his role as head of an influential court.

Titian's *Pesaro Altarpiece* (see opposite) was probably a joint commission between two brothers, Jacopo and Francesco Pesaro, and both are seen kneeling at the bottom of the painting, on the left and right respectively. Behind Francesco there are three more brothers, and their nephew Leonardo, looking out so as to involve us in the scene: like the members of the family, we are gathered around an altar or throne, a vantage point for us being guaranteed by the space between Jacopo and Francesco.

POWER DRESSING

Francesco Pesaro's richly coloured and textured brocade was an extremely expensive item of clothing that could be worn only by the highest ranks of Venetian society. According to your rank you were allowed only a certain amount of jewelry, and a certain number of different clothes in restricted materials. In Venice, for example, normal citizens were not allowed to wear any gold, whereas members of the Great Council could wear a limited amount of jewelry. Senators, such as Francesco Pesaro, could wear red damask robes, and Procurators – one rung up the ladder – could also wear a stole. These different ranks can be seen in Giovanni Mansueti's *Miraculous Healing ...* (see page 201).

Although the two brothers are symmetrically placed, and are both seen in profile, the symmetry does not continue beyond the front plane. What could have been a standard *sacra conversazione* – the Madonna and Child with a balanced array of saints on each side – has shifted its centre. This allows Titian to display the different levels of power and wealth embodied by the members of the Pesaro family.

While Mary and Jesus maintain their status, as they are the highest in the painting, they are not central. In this respect it is St Peter who grabs our attention. With his keys, the symbol of papal authority, at his feet, Peter looks down toward Jacopo, acting as an intercessor on his behalf – and Mary too looks down toward Jacopo. Meanwhile, the Christ Child looks to St Francis, who recommends the other patrons, including Francesco. Even though both are being introduced, it is Jacopo who has the privileged position. Not only is he in the position of honour, at the right hand of Jesus, he is also directly in front of the throne. This is Titian's great innovation: whereas in most paintings of the Madonna and Child we see the throne from the front, here it is only Jacopo Pesaro who kneels at the foot of the throne – we are pushed to the side. Why should he have such access?

A clue is given by the banner held by the soldier on the left. It includes the coat of arms of the Borgia pope Alexander VI – his papal status underlined by the triple tiara and

Madonna and Child: *see pages 214–215;* **St Peter:** *see pages 95, 106, 128 and 129;* **portraiture:** *see page 88;* **position of honour:** *see page 62;* **sacra conversazione:** *see page 64;* **sumptuary laws:** *see pages 87–88 and 200;* **symmetry:** *see pages 60, 61, 137 and 146;* **triple tiara:** *see page 103*

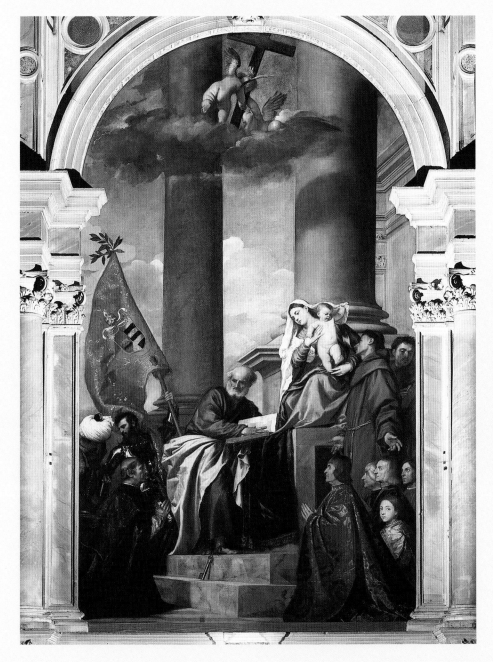

PESARO ALTARPIECE
Titian, 1519–1526 (S. MARIA DEI FRARI, VENICE)

As a large work by Venice's leading artist, this would have been an expensive commission. It is part of a bigger complex, including the altar itself, a wall tomb for Jacopo Pesaro and a vault in which other members of the family were buried. Jacopo's brother Francesco also endowed the church with sufficient money for a Mass to be spoken daily in perpetuity for the souls of the deceased. Clearly the spiritual welfare of the family is being provided for, but such conspicuous expenditure could not have gone unnoticed by anyone worshipping in the church, which of course helped to bolster the standing of the family within the community.

crossed keys depicted above it – with another, smaller coat of arms (that of the Pesaro family) shown below. Laurels – a sign of victory – are attached to the top of the banner, and two prisoners, one black and one turbaned (and by implication, a Muslim) are held at bay behind. Jacopo Pesaro had fought against the Ottoman Empire. In this altarpiece he shows that his authority – and therefore power – comes from the pope, not only through the clear display of the pope's coat of arms but also through the central position of St Peter. The cowering prisoners are also a clear display of military power – this shows the claim of the Papal States to rule much of Italy. After all, Jacopo was not primarily a military man, but bishop of Paphos, and as such he would have been appointed by the pope.

keys: *see pages 128 and 129;* **Ottoman Empire:** *see page 192*

COSTLY DISPLAY

The outstanding banking family of Florence was undoubtedly the Medici, although they only achieved their status in the fifteenth century. In the preceding century the Bardi and Peruzzi families had been bankers to the kings of France and England – although both financial empires collapsed when Edward III of England defaulted on his debts in 1342. In the first quarter of the fifteenth century the richest man in Florence was Palla Strozzi (1372–1462), who in one year paid 100,000 of the 610,000 florins which made up the total tax declarations of the city. The extent of his wealth was displayed in the magnificent altarpiece he commissioned from Gentile da Fabriano for the funeral chapel of his father Onofrio in the church of Santa Trinità (see page 71).

However, the Strozzi fell foul of the growing power of the Medici. Cosimo de' Medici was exiled in 1433, which was in part an attempt to curb his influence – the excuse being that he had persuaded the Florentines to enter an almost ruinous war with Lucca, a battle from which is commemorated in Uccello's *Rout of San Romano* (see page 193). However, to popular acclaim Cosimo returned the following year, exiling Palla Strozzi and the other male members of his family, and subjecting their fortunes to ruinous taxation. From this point until his death thirty years later, Cosimo was the unofficial ruler of Florence, without holding any elected position. Government by the guilds continued, but through his skill at diplomacy and his business acumen Cosimo held sway. Perhaps his most important strategy was to ensure that the city was financially indebted to him, with the implied threat that if matters displeased him he could call in his debt.

Through banking and extensive trade, the Medici soon became the wealthiest Florentines, and in 1457 they paid four times more tax than any other family – their nearest rivals being the Benci and Rucellai. By this time the Medici's new palace (see page 203) was nearing completion, and Cosimo's son Piero took charge of its decoration.

▶ PROCESSION OF THE MAGI (NORTH WALL)
Benozzo Gozzoli, 1459–1462 (PALAZZO MEDICI, FLORENCE)

The procession winds around three walls of the chapel in the Medici Palace, with one magus on each wall. The two horses at the right have turned, and the procession continues in the direction they are facing, along the wall to our right.

Cosimo de' Medici (see right) was the head of the family when the chapel was decorated, but he does not ride at the front of the entourage. He is astride a donkey – something that he is known to have done in real life to emphasize his modesty and humility. It should be remembered, however, that Jesus also rode on a donkey.

Piero de' Medici ("Piero the Gouty"; see left) was the family member responsible for the decoration of the chapel in the Medici Palace. Piero's hat was changed after it was first painted – the outline of a smaller one can be seen clearly: Piero himself may have requested this.

Cosimo's servant (see right) wears his master's red, white and green livery in a simple, bold style typical of Cosimo's character. This could be a portrait of Bastiano, the servant of the cardinal of Portugal, who had arrived in Florence with his master in 1459.

Piero's servant (see left) wears an elaborate, patterned version of the Medici colours, and his doublet is emblazoned with the Medici diamond ring. To his right, Piero's horse has diamond rings picked out in gold on both collars, the lower one including the motto "semper" – "always".

Lorenzo de' Medici (see right) is easily recognizable – even at the age of ten – by his long nose with its bulbous end. Next to him is his younger brother **Giuliano**, aged about six. The hat of the man behind them is inscribed "OPUS BENOTII", the "work of Benozzo": this is a **self-portrait of the artist**. The spelling of his name is possibly a pun on the Latin "nota bene" which we still use, and the signature could be translated as "take good note of this work".

colour: *see pages 44–47;* **diamonds:** *see pages 42 and 43;* **guilds:** *see pages 182–183;* **magi:** *see pages 54–55, 108 and 151;* **the Medici:** *see pages 42, 198–199 and 202;*
Giuliano de' Medici: *see page 198;* **Lorenzo "the Magnificent" de' Medici:** *see pages 198–199;* **Piero "the Gouty" de' Medici:** *see page 101*

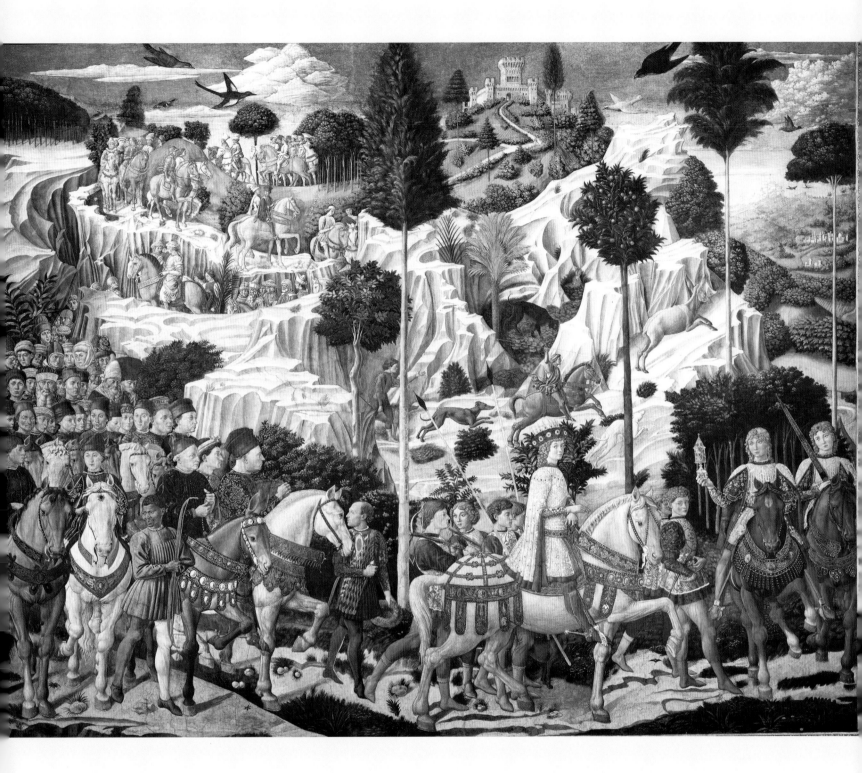

The palace chapel has an altarpiece of the Birth of the Virgin, by Filippo Lippi, and around the walls – frescoed by Benozzo Gozzoli – the magi process toward the Christ Child (see above). Not only is the implied subject – the Adoration of the Magi – precisely that of the altarpiece of the family's Strozzi rivals, but the depiction of the procession is akin to that in Gentile's work: the entourage winding through the hills, the finery, the reference to aristocratic pursuits such as hunting – and the inclusion, in prime position, of the donors. Gentile da Fabriano depicted not only Palla Strozzi, but also his father Onofrio, who had died six years earlier. In Gozzoli's fresco the majority of faces are portraits of members of the Medici family, followers, friends and even servants. The similarities emphasize that Medici wealth now exceeded that of the Strozzi, and that the family could afford to display it not just on one panel, but across the entire chapel.

infant Christ: *see page 215;* **portraits within paintings:** *see page 51*

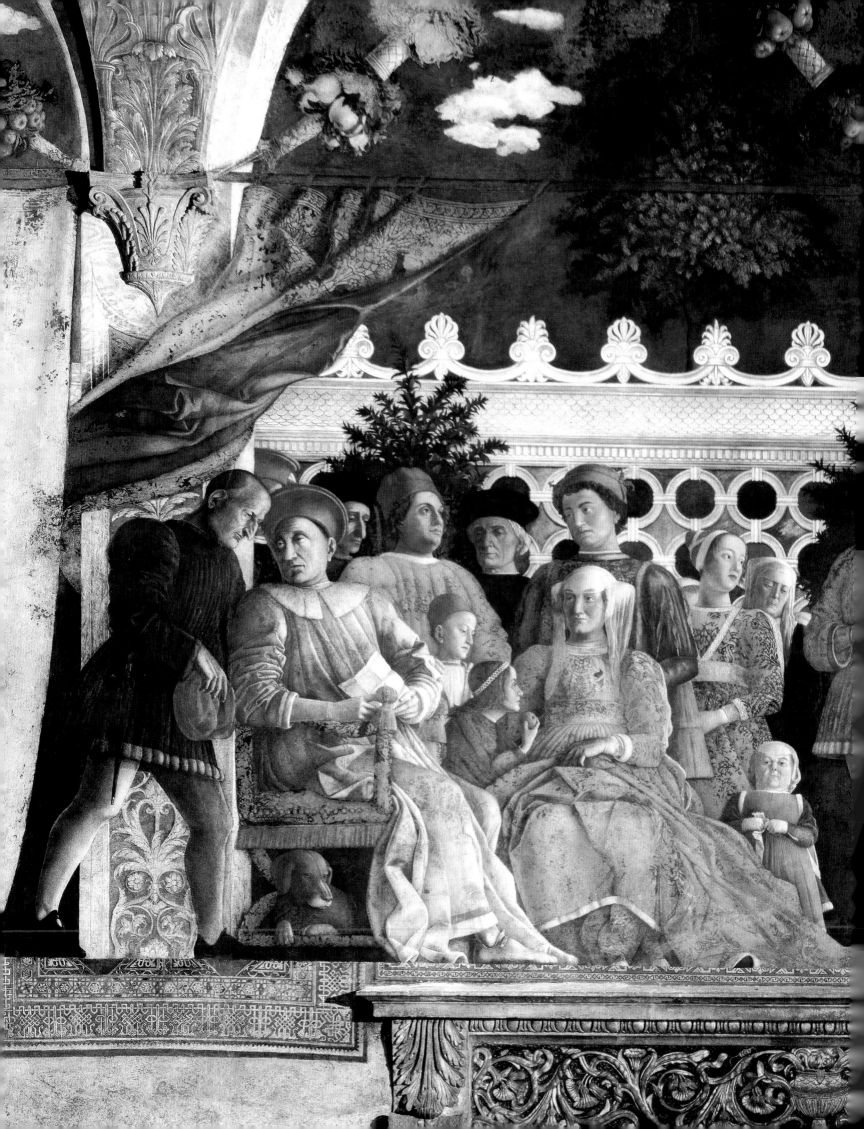

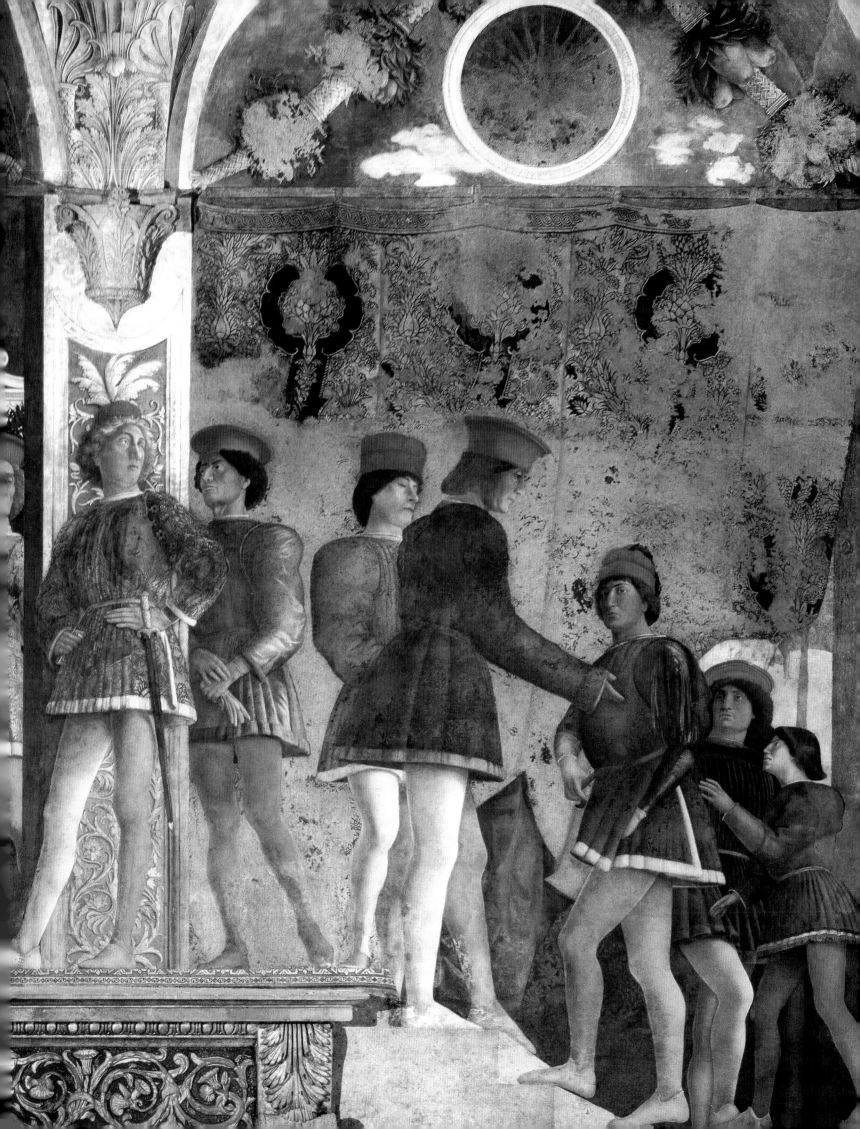

❶ By including this curtain, Mantegna, well versed in classical literature, may well be alluding to the story of Zeuxis and Parrhasius, ancient Greek artists who had a competition to see which was the better painter. Zeuxis painted a bunch of grapes so realistic that birds flew down to peck at it, but when he asked Parrhasius to draw back the curtain in front of his painting, it turned out to be a painting of a curtain. Parrhasius was therefore deemed the better artist, as he had managed to trick the eye of his rival.

❷ The severe dress of this man suggests he is some form of tutor or advisor. It was long thought to represent Vittorino da Feltre (see opposite), but as he had died in 1446 that is unlikely. The presence of a tutor in the painting would emphasize the learned nature of Ludovico's court.

❸ Rodolfo, Ludovico's third son, was married twice, the first time to Anna de' Malatesta, thus allying the family to the ruling house of Rimini.

❺ Ludovico Gonzaga receives a message from a servant. Only he and his wife are seated, a mark of their status; the plushness of Ludovico's chair is a sign of his wealth.

❻ Ludovico's favourite dog, Rubino, was buried near the castle after its death in 1467.

❼ There are two rugs, one arranged lengthways over the fireplace, and another at right angles hanging over the wall. Mantegna is using the solid, three-dimensional fireplace and the ingenious placement of the painted rugs to make the scene look more realistic. The rugs also allude to Ludovico's wealth and status.

❽ The youngest son and daughter, Ludovico and Paola, are shown here. Just behind is the fourth son, Gianfrancesco, later lord of Bozzolo and Sabbioneta.

❾ Ludovico's wife, Barbara of Brandenburg, is seated, in keeping with her status as consort.

❹ Barbara, the eldest daughter, married the duke of Württemburg, thus maintaining the family links with Germany and the Holy Roman Empire.

ESTABLISHING YOUR CREDENTIALS

Power, once secured, could not be taken for granted. Families protected and increased their status through carefully judged marriages and alliances. An instructive example is provided by the Gonzaga family, which took control of Mantua in 1328. For the next century they oversaw the city as "Captains General of the People" and steadily acquired wealth from the region's fertile lands and their service as *condottieri* – mercenary soldiers who led the troops of other powers. In 1433 Gianfrancesco Gonzaga was appointed marquis of Mantua, and in line with his new status appointed the humanist Vittorino da Feltre to tutor his son Ludovico.

Ludovico was determined that the family should be advanced further. He married "above" himself: his wife, Barbara of Brandenburg, was the granddaughter of the imperial elector of Bavaria, Frederick I of Hohenzollern, and she claimed that her uncle was "very well known in the court of His Majesty Emperor Frederick III" (the Holy Roman Emperor). Barbara's sister Dorotea married King Christian I of Denmark, so Ludovico could also boast a royal brother-in-law. When in 1459 Pope Pius II determined to organize a crusade to recover Constantinople, Ludovico persuaded him to hold the Church congress in Mantua, and hoped to use his wife's influence to persuade the Holy Roman Emperor to attend. Although Frederick never arrived, Ludovico's work did not go unrecognized: two years later his second son, Francesco, was appointed cardinal at the tender age of seventeen. Thus Ludovico's link with the papacy was formally established. Connections to other ruling families in Italy and the north of Europe were achieved through the marriages of his children. This continued in later generations: Ludovico's grandson, also called Francesco, married Isabella d'Este, thus connecting the family with the powerful ruling family of Ferrara. Finally, in 1530, the Gonzagas' machinations were rewarded when Mantua was elevated to a dukedom.

◁ **CAMERA PICTA (THE NORTH WALL)**
Andrea Mantegna, 1465–1474 (PALAZZO DUCALE, MANTUA)

Ludovico Gonzaga's efforts to glorify his family's name were captured for posterity in art. He commissioned Mantegna to decorate his bedroom and audience chamber with scenes of life at the Gonzaga court. An inscription on the fresco – made to look like graffiti carved into the plasterwork – is dated 1465, which is generally taken to be the date that Mantegna started work on this remarkable room, although progress was slow and the decoration was not completed until 1474.

❿ Like many noble households, the Gonzagas employed dwarves such as this lady-in-waiting, who were treated as both servants and entertainers.

⓫ The raised platform emphasizes the status of the court: we have to "look up to" Ludovico and his family.

condottieri: see page 86; **the Este:** *see page 174;* **fall of Constantinople:** *see page 167;* **Holy Roman Emperor:** *see page 174;* **humanism:** *see page 12;* **illusionism:** *see pages 39, 172 and 214–215;* **Isabella d'Este:** *see page 164;* **nepotism:** *see page 174;* **tapestry:** *see page 31*

WAR & PEACE

War was a constant feature of life in Italy throughout the Renaissance – each city-state wanted to expand its borders, and so tended to be at war with its neighbours on a regular basis. But armed conflict was not just "domestic". In 1494 a French army marched on Italy, and for a while it took over Pisa and nearly conquered Florence. In 1508 Pope Julius II called on the help of the French, the English and the Holy Roman Empire to limit the power of Venice, only to change allegiance later and ask the Venetians to help expel the French. The Ottoman Empire provided the external threat which had the potential to unify Christian Europe – and only once Malta had been successfully defended in 1565 by the Knights of St John and victory attained at the Battle of Lepanto in 1570 was that threat significantly diminished.

Florence was often in the middle of the power struggles between city-states. For example, at the beginning of the fifteenth century Florence had been threatened by Milanese forces, a threat which only receded with the death, in 1402, of Giangaleazzo Visconti, duke of Milan. In 1406 Florence gained control of Pisa, vital for trade as it was near the mouth of the River Arno, but in 1429 a war with neighbouring Lucca started, as the Lucchesi, together with their allies Genoa, Siena and Milan, wanted to limit the power of Florence and take Pisa for themselves. The Rout of San Romano (1432), commemorated by Paolo Uccello (see opposite), was one of the minor battles in this war, which lasted until 1433. Florence was again at war in 1478, this time with Rome and Naples, in part as a result of Pope Sixtus IV's ambitions to expand his family's territories near Florence: he played on the grudges of other banking families in Florence in an attempt to depose the Medici and break their hold on power.

Uccello's painting cannot be seen as a realistic representation of battle, even if the details of arms and armour are

◖ DESIGN FOR A BALLISTIC WEAPON
Leonardo da Vinci, CA. 1499 (AMBROSIANA, MILAN)

When Leonardo da Vinci left Florence for Milan in the early 1480s, he wrote a letter to Ludovico Sforza, duke of Milan, in order to request employment. In his letter, Leonardo listed all of his achievements. Oddly, perhaps, painting and sculpture come last in a list of ten things – the preceding nine are all military projects, including a portable bridge, battering rams and exploding shells. This drawing, just one of many projects that were never executed, shows a giant catapult intended to fire up to 100 pounds of stone, modelled on the action of a crossbow. Its scale is suggested by the tiny figure of a man next to the writing on the right of the drawing.

Holy Roman Empire: *see page 174;* **Leonardo da Vinci:** *see page 6;* **the Medici:** *see pages 42, 186–187, 198–199 and 202;* **Sixtus IV:** *see pages 84, 175 and 198;* **Giangaleazzo Visconti:** *see page 99*

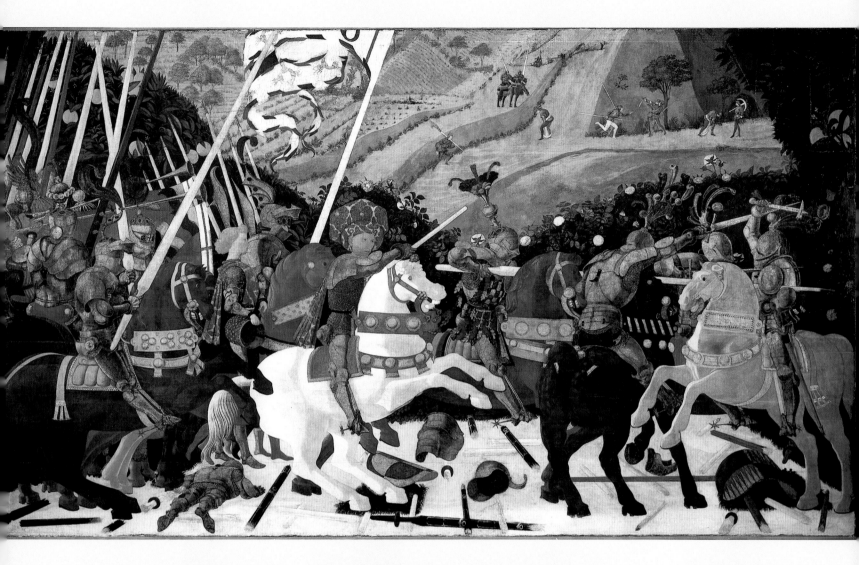

accurate, and date the painting to the 1430s – the decade in which the battle itself took place. The artist has, however, combined field armour with details more suited to a chivalric tournament, and shown the hero of the battle, Niccolò da Tolentino, with the baton he was awarded in 1433 as a sign "of absolute authority and obedience". Despite the fragmented lances on the floor, and the dead soldier on the left, it is not a scene of great violence – there is no blood, and to illustrate his skills with perspective Uccello has arranged lances and corpse parallel to one another and at right angles to the front of the painting – along the orthogonals. It is a richly coloured pageant which does much to emulate the splendour of a tapestry, and would have been commissioned to commemorate and glorify this event rather than to evoke

◐ ROUT OF SAN ROMANO
Paolo Uccello, ca. 1438–1440 (NATIONAL GALLERY, LONDON)

the horrors of war. In 1492 this painting was listed in the Medici Palace, along with two other panels depicting other scenes from the battle (now in the Louvre and the Uffizi). For years they were believed to have been commissioned by Cosimo de' Medici, who signed the peace treaty with representatives of the ruling Visconti family of Milan in 1433, but it has recently been discovered that Uccello painted them for the Bartolini-Salimbeni, another prominent Florentine family. Lorenzo the Magnificent liked the paintings so much that, when he was not offered them as a "gift", he sent his men round to steal them.

Cosimo "il Vecchio" de' Medici: *see page 186;* **Lorenzo "the Magnificent" de' Medici:** *see pages 198–199;* **orthogonals:** *see pages 52 and 53;* **Palazzo Medici:** *see page 202;* **tapestry:** *see page 31*

GIVING THANKS FOR VICTORY

Victory in battle was seen not merely as the result of military superiority, but as a sign of God's favour. In the 1490s, after the French assault on Italy had faltered, Francesco Gonzaga – grandson of Ludovico – was made general of the army responsible for stopping their retreat, and seeking to curtail French interference in Italy. His own account of a battle at Fornovo in July 1495 tells us how he sought help:

"We were fighting among the thickets of the enemy, with danger on every side and there seemed no way of escape. We therefore sought refuge ... in the most certain protection of Mary, spotless Mother of God. As soon as we had implored it, our courage was raised, our strength was renewed, and thereupon our enemy, who were pursuing our troop with level spears and drawn swords, began to flee as if terrified by God, so much so that we cut them down in their tracks."

After the battle Francesco was referred to as the "liberator of Italy". He commissioned the building of a new church, dedicated to the Madonna della Vittoria, thanking Mary for the victory she had ensured, with an altarpiece painted by Andrea Mantegna (see opposite). Negotiations for the building of the church and its decoration were carried out before Francesco's return. The victory at Fornovo did not put an end to France's claims on Italy, and as the following extract from a letter to Francesco about the altarpiece shows, future victories may still have needed divine intervention:

"M. Andrea Mantinia is to make two saints, one to either side of the Madonna, who are to hold up her mantle, under which is to be Your Lordship, fully armed & c. These saints are to be St George and St Michael, which pleased everyone greatly, and me more than all, on account of the words that he added, sagely, and as I believe inspired by God, saying that these two saints were bringers of victory, one to the body, the other to the soul, and that together with the Most Holy Mother of Christ, your most devout advocate and only hope, they would grant victory to your Most Illustrious Lordship."

◉ MADONNA OF VICTORY
Andrea Mantegna, ca. 1495 (LOUVRE, PARIS)

The basic image of the painting is a *Madonna della Misericordia* – the Virgin Mary protecting her subjects under her cloak. Mantegna has combined this iconography with that of the Madonna and Child enthroned, implying the additional protection of the Christ Child, and has added the two warrior saints who hold the garment. Also appearing are the patron saints of Mantua, Andrew and Longinus, as well as St John the Baptist and his mother St Elizabeth.

Coral (see left) was seen as a talisman that would provide protection in battle. Its brilliant red hue also suggested an association with Christ's blood, some of which was preserved in Mantua as a relic. In classical mythology, coral was formed when blood from the Medusa's severed head flowed onto seaweed, petrifying it and turning it red.

The **circular motif** (see right) on the back of the throne would act as a secondary halo if Mary were sitting upright – its visibility emphasizes her movement toward Francesco. It is decorated with the sun – one of the *imprese* of the Gonzaga family.

St Andrew, carrying a small **cross** (see left) to represent the one on which he was crucified, was one of the patron saints of Mantua. The church of San Andrea was designed by Alberti, who had come to the city as secretary to Pope Pius II.

Like the coral, the bright red of the **lance** (see right) refers to Christ's blood. It is held by Longinus, the centurion who pierced Christ's side during the Crucifixion, who was said to have gathered some of the blood and brought it to Mantua. The lance itself had been given to the pope in 1491.

The broken lance held by **St George** (see left) signifies his defeat of the dragon, which was often depicted with the end of the spear stuck through its head. It also refers to a lance which Francesco Gonzaga broke at the Battle of Fornovo, and sent as a trophy to Isabella d'Este – a chivalric gesture implying he had fought on her behalf.

Alberti: *see page 15;* **St Andrew:** *see page 108;* **broken spear:** *see page 165;* **St George:** *see pages 64, 65 and 75–76;* **the Gonzaga:** *see pages 190–191;* **Gonzaga** *imprese: see page 40;* **iconography:** *see page 100;* **Isabella d'Este:** *see page 164;* **St John the Baptist:** *see page 108;* **Madonna and Child:** *see pages 214–215;* **St Michael:** *see page 104*

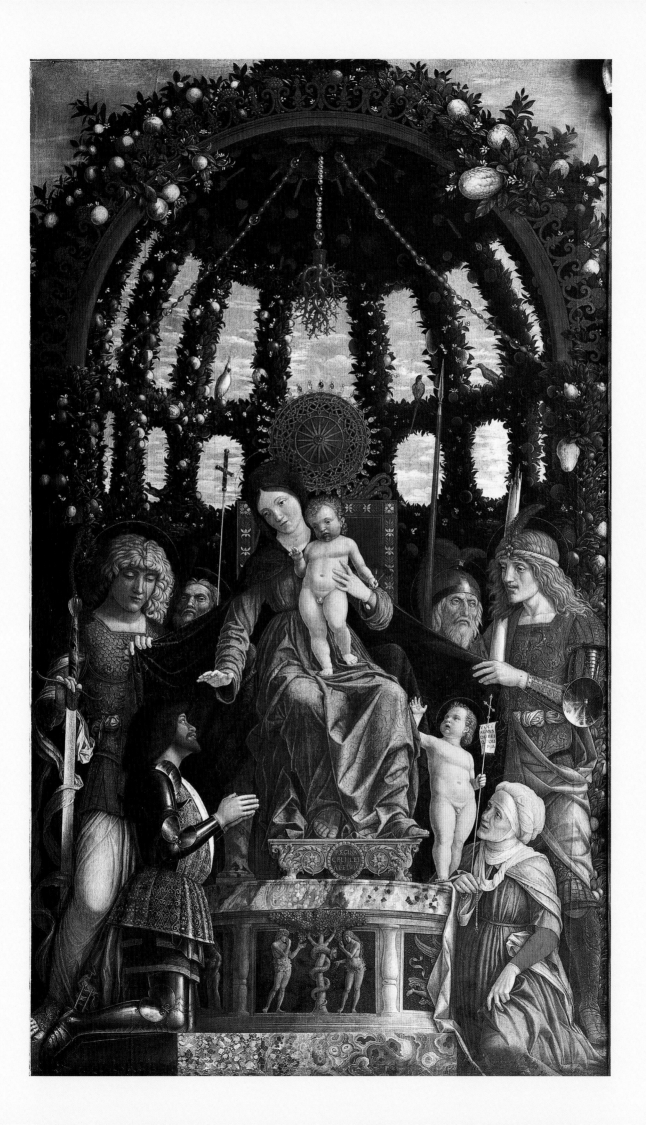

THE BENEFITS OF PEACE

The Medici family were the *de facto* rulers of Florence for more than half of the fifteenth century, even though they held no elected position. Empowered by their enormous wealth, the result of astute banking and business enterprises, the Medici inevitably attracted jealousy from the other leading families of Florence. They were also unpopular elsewhere in Italy. Lorenzo de' Medici turned down Pope Sixtus IV's request for a loan to help buy land not far from Florence for one of his nephews, and he also opposed Sixtus's appointment of Francesco Salviati as the bishop of Pisa. It was, therefore, not hard for the pope to enlist the aid of other banking families in Florence, including the Pazzi and the Baroncelli, in an attempt to end the power of the Medici once and for all. The Pazzi Conspiracy, as it became known, was to involve assassinating Lorenzo and his younger brother Giuliano during Mass in the cathedral on Sunday 26 April, 1478. Meanwhile, Salviati, the unwelcomed bishop of Pisa, would take the Palazzo della Signoria, seat of the city government, by force. The plot failed: although Giuliano was killed, Lorenzo escaped with minor wounds. A frenzied mob attacked the bishop and his men, and Salviati was unceremoniously seized and hanged from a window of the Palazzo.

Realizing that the plan had been thwarted, the pope excommunicated the entire city of Florence. He joined forces with the king of Naples, Ferrante of Aragon, and declared war. This lasted nearly two years, and was financially ruinous for all parties. The war was effectively ended by Lorenzo's skills as a tactician and diplomat. He negotiated personally with Ferrante, taking with him, among other gifts, a beautifully illustrated manuscript: art and diplomacy have often gone hand in hand. After reconciliation with Naples, it was not long until conflict with Rome also ceased, although for the remainder of Sixtus's reign – he died in 1484 – this was an uneasy peace. Advantages followed on both sides: the pope had recently completed construction of the chapel which still bears his name – the Sistine – and he was able to summon some of Florence's best artists to decorate it, including Botticelli and Ghirlandaio. Meanwhile, the accord between the Church and Florence was celebrated in the funerary chapel of Francesco Sassetti, the general manager of the Medici bank (see right).

○ CONFIRMATION OF THE FRANCISCAN RULE
Domenico Ghirlandaio, ca. 1483–1486
(STA. TRINITÀ, FLORENCE)

The fresco is part of a cycle illustrating the life of St Francis of Assisi, chosen as the name saint of the patron, Francesco Sassetti. As well as the frescoes, the decoration of the chapel includes an altarpiece of the Nativity and wall tombs for Sassetti and his wife (subsequent members of the family would be buried in the vault under the chapel).

❹ The only sculpture in the Piazza della Signoria at this stage was a lion bearing an inscription in support of the freedom of the people of Florence. Its inclusion here conveys the idea that the Medici continued to support republican rule, even if they were very much in control.

Alberti: *see page 15;* **colour:** *see pages 44–47;* **lion:** *see page 36;* **the Medici:** *see pages 42, 186–187 and 202;* **Lorenzo "the Magnificent" de' Medici as a child:** *see page 186;* **Morgante:** *see page 145;* **Sistine Chapel:** *see page 84;* **Sixtus IV:** *see pages 84 and 175;* **triple tiara:** *see page 103*

❶ According to Alberti: "One of the great ornaments ... of a square ... is a handsome portico, under which the old men may spend the heat of the day ... the presence of the fathers may deter and restrain the youth, who are ... diverting themselves in the other part of the place, from the mischievousness and folly natural to their age." Ghirlandaio could almost be illustrating this idea.

❷ The baldachin is coloured red, white and green – the Medici colours – implying that the pope is now under the family's protection.

❸ The triple tiara identifies this as a pope: Francis had initially received recognition for his order from Pope Innocent III during a visit to Rome in 1209–1210. However, this scene represents a later event, when Pope Honorius III sanctioned a revised form of the Franciscan rule in 1223.

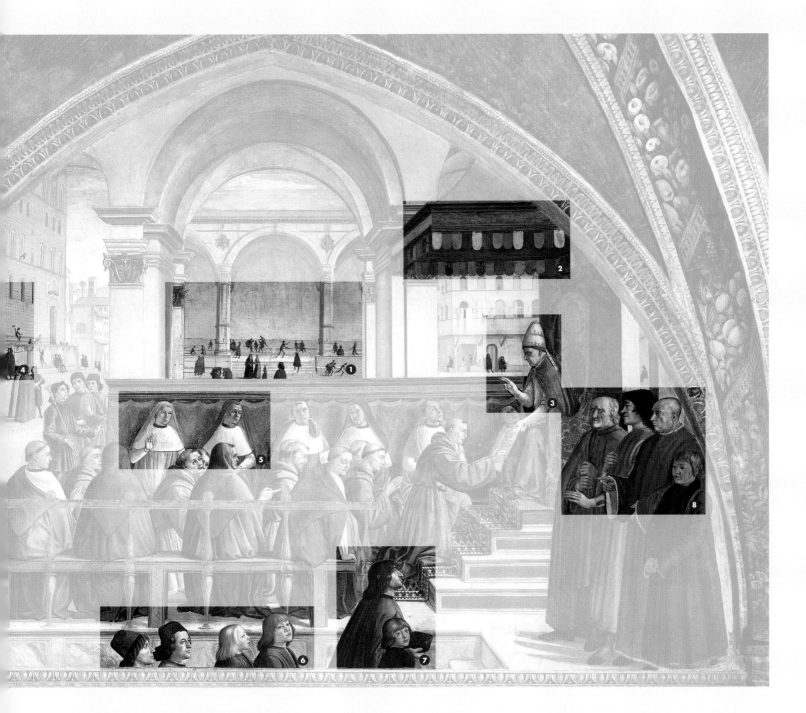

❺ The cardinals wear different colours: they were supposed to wear "purple", but the meaning of this term was not fixed, and could refer to almost any shade between blue and red.

❻ Lorenzo's eldest and youngest sons Piero and Giuliano are followed by a tutor, Matteo Franco, and the poet Luigi Pulci, whose work included the poem *Morgante*.

❼ The humanist and tutor Angelo Poliziano – possibly the man responsible for devising the ideas behind Botticelli's *Primavera* (see pages 154–157) – is accompanied by Lorenzo's second son Giovanni. Born in 1475, Giovanni was admitted into a minor order of the Church at the age of eight. In 1513 he succeeded Julius II as Pope Leo X, the first Medici pope.

❽ Lorenzo de' Medici – identifiable by his bulbous nose and projecting jaw – stands next to the patron of the chapel, his employee Francesco Sassetti (wearing red robes), and raises his left hand in greeting to his sons and their tutors. Francesco's son Federigo stands next to him, while his brother-in-law Antonio Pucci stands to the other side of Lorenzo.

LIFE & SOCIETY

Inevitably, the visual records of everyday life do not show a balanced view of Renaissance society – works of art were commissioned by those wealthy enough to afford them, and so they usually reflect the comfort of the rich. Nor can we guarantee an understanding of everyday life from art, as paintings were usually devotional objects removed in some way from the physical world, or representations of extraordinary events. Nevertheless, paintings do give us many valuable insights into the way in which life was lived, and the many surviving homes (although these tend to be the palaces and villas of the wealthy) allow us to see the style in which people lived. There are also a few surviving examples of art commissioned by institutions other than the Church, which show us what was expected by lay members of society.

Giovanni Mansueti's *Miraculous Healing of the Daughter of Ser Niccolò Benvegnudo of San Polo* (see opposite) is one of a series of works painted for the Scuola of St John the Evangelist in Venice. The prized relic of the Scuola was a fragment of the True Cross (another fragment was owned by Cardinal Bessarion). In 1414 Niccolò Benvegnudo, a member of the Scuola, had touched the head of his daughter with three candles with which he had touched the relic. Blind and suffering from tremors since birth, she was instantly healed. It is this event which is shown here, although Mansueti imagines a flock of visitors come to witness the miraculously healed child – to the extent that it is hard for us to locate her. The proud father is kneeling in the centre of the painting, more or less at the vanishing point of the perspective, with his wife kneeling behind him. The daughter is visible between them, sitting up in her cot and framed by the window.

Although not a realistic representation, this painting does tell us a lot about the lives of the wealthy. Whereas the ground floor was used for business, living and entertaining would take place on the first floor, known as the *piano nobile*. Land was at a premium in Venice, and so staircases were frequently external: apart from removing a wall to allow us to see into the room, this is a reasonable representation of the courtyard of a grand Venetian palace. The splendour of the first floor room accords with contemporary accounts of real homes. In 1494, a decade before this work was painted, a priest from Milan gave the following account of a private palace he had visited in Venice – and many of the features he describes are visible in Mansueti's painting:

"The fireplace was all of Carrara marble, shining like gold, and carved so subtly … that Praxiteles and Phidias could do no better. The ceiling was so richly decorated with gold and ultramarine and the walls so well adorned, that my pen is not equal to describing them … There were so many beautiful and natural figures and so much gold everywhere that I do not know whether in the time of Solomon … in which silver was reputed more common than stones, there was such abundance as was displayed here."

In addition to the architecture and its interior decoration, other aspects of daily life become clear. For example, there are no women on the street – a woman's life was more or less restricted to the domestic sphere – and there were strict regulations concerning dress, known as sumptuary laws. The two men in the foreground, with black stoles, are Procurators, while the men in black are of a lower rank. Those in brightly coloured hose are servants, wearing the livery of their masters. The highest ranking person is climbing the stairs – he is wearing an elaborate cloth of gold.

▶ **MIRACULOUS HEALING OF THE DAUGHTER OF SER NICCOLÒ BENVEGNUDO OF SAN POLO**
Giovanni Mansueti, 1505 (ACCADEMIA, VENICE)

male and female: *see pages 86–89;* **scuole:** *see page 177;* **sumptuary laws:** *see pages 87–88 and 184;* **True Cross:** *see page 167;* **vanishing point:** *see pages 52–55*

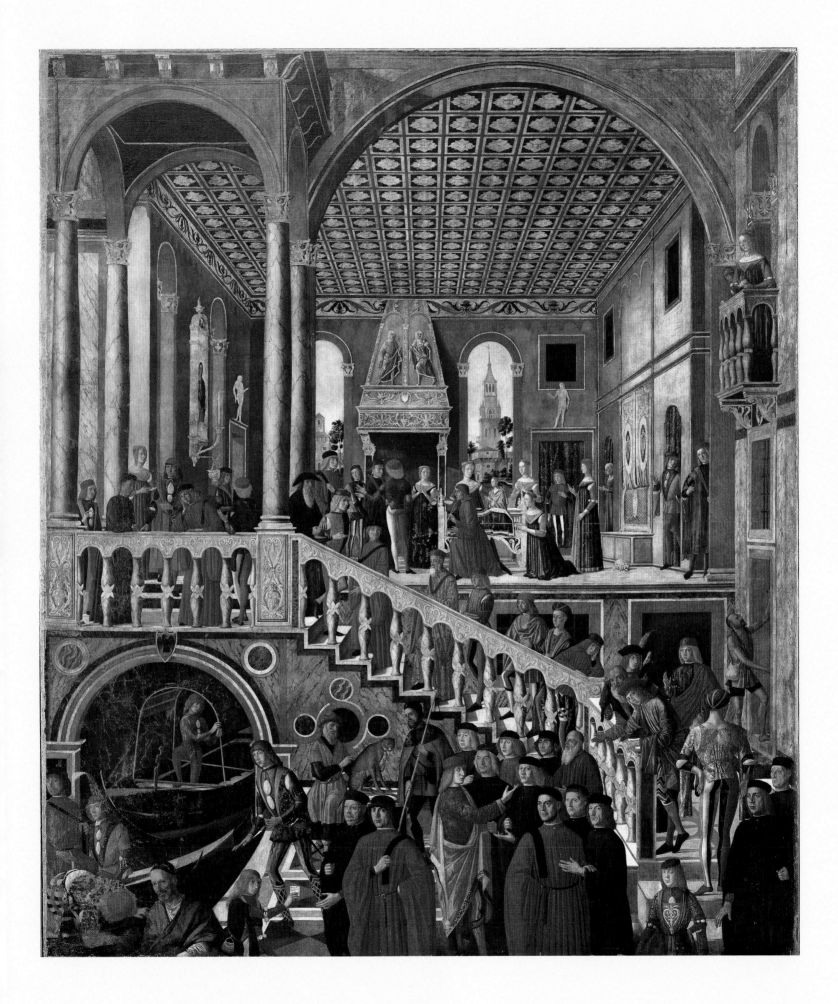

A SECURE HOME

According to Vasari, when Cosimo de' Medici wanted to build a new palace for his family he first asked Brunelleschi, but he found the design too grand and sumptuous. He turned instead to Michelozzo, who provided this more low-key alternative (see opposite), but even as completed in the fifteenth century (it was not as big as we see it today) it was still one of the largest family palaces in Florence. By the end of his life, and after the death of his second son, Cosimo was heard to mutter "Too large a house for so small a family".

As a design it is typical of the Early Renaissance – a transitional style following on from medieval palaces, strongly defensive to protect the family's interests, and predating the sophistication of later buildings. The ground floor is extremely rough and ready. It looks as if stones have been piled up fresh from the quarry: this finish is known as rustication and was often used as a sign of fortification. The first floor has been more smoothly finished, although the joints between the blocks are left clearly visible, whereas on the second floor the surface of the walls is completely smooth. Thus there is an image of increasing sophistication as we move away from the bustle of the street. Unusually, the *piano nobile* is not taller than the ground floor. In fact, each successive floor is lower: it is possible that Michelozzo intended this as a form of perspective – making the building look taller by decreasing the height of each floor, as if it were further up.

Of course, town houses were only one type of dwelling. Families with lands outside the city would build villas – increasingly so in the sixteenth century, as knowledge of the villas of antiquity increased. The most wealthy also built retreats. The Este family of Ferrara had a number of what were called *delizie* ("delights") – for example, the Palazzo Schifanoia, whose name means "to avoid care". Palladio's Villa Rotonda (see page 28) was also built more for entertainment – close enough to the city to visit it for parties, but lacking the facilities necessary for permanent residency.

◉ PALAZZO MEDICI
Michelozzo di Bartolomeo, 1444–1460 (FLORENCE)

The imposing palace was not this large originally. Completed by 1460, it remained in the possession of the Medici until 1659 when it was sold to the Riccardi family, who extended the palace, adding the two furthest arches on the ground floor. Originally there were only three arches at the front (on the right in this picture), with the entrance to the courtyard through the central arch.

The **windows** (see right) are biforate, meaning that they have two openings. This is a medieval type of window which Michelozzo has adapted into a Renaissance form by giving each opening a rounded top, and by dividing the two openings with a classical column. Above the column are the balls of the Medici coat of arms.

The balls on the **Medici coat of arms** (see left) are thought to represent either pills (as "Medici" means "doctors") or coins – they were a family of bankers. All major palaces would have had a coat of arms on the corner of the building like this to make the family's presence in the neighbourhood more obvious.

The **corner arches** (see right) were originally open, creating a small loggia used as a trading point for the bank. It was only closed off in the 16th century: the windows are said to have been designed by Michelangelo.

The rough stonework on the ground floor is called **rustication** (see right). It shows the palace to be strong and impregnable, important both for the security of the inhabitants and for the banking activities which took place here. The original ground floor windows were high up, small, and barred for security.

A **stone bench** (see left) runs along the front and side of the building, allowing people to rest – effectively a public facility provided by the Medici. The iron loops were used to tie up horses, and have brackets above them in which torches can be set.

Brunelleschi: *see page 26;* **the Este:** *see page 174;* **Early Renaissance:** *see pages 16 and 19–20;* **the Medici:** *see pages 42, 186–187, 198–199 and 202;* **Cosimo "il Vecchio" de' Medici:** *see page 186;* **Palazzo Schifanoia:** *see page 142;* **perspective:** *see pages 52–55;* ***piano nobile:*** *see page 200;* **rustication:** *see page 29;* **Vasari:** *see pages 15 and 16*

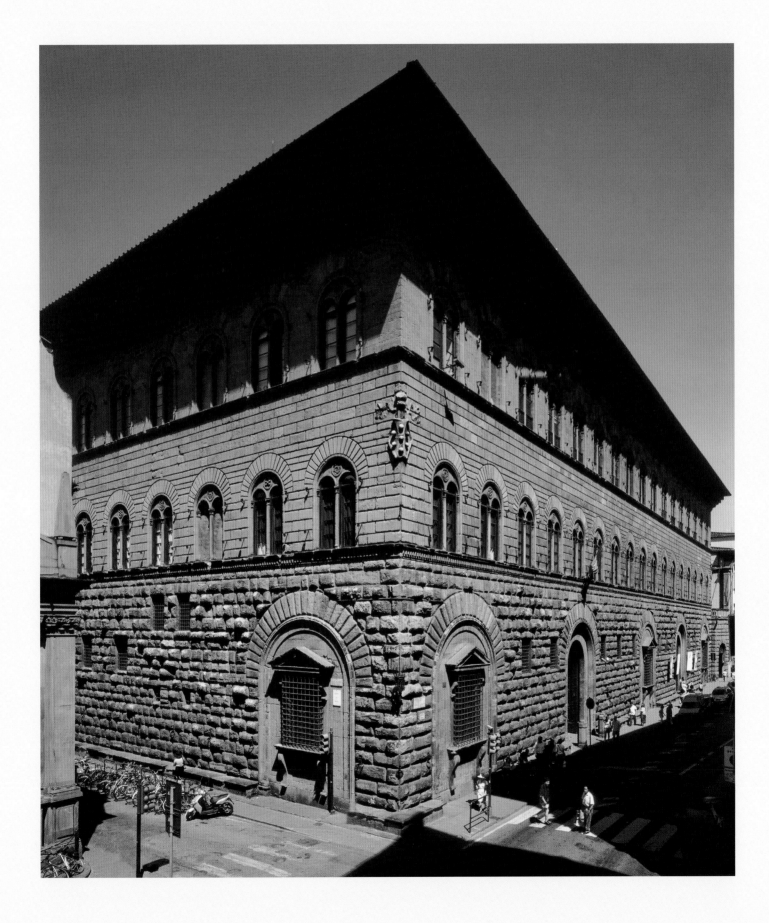

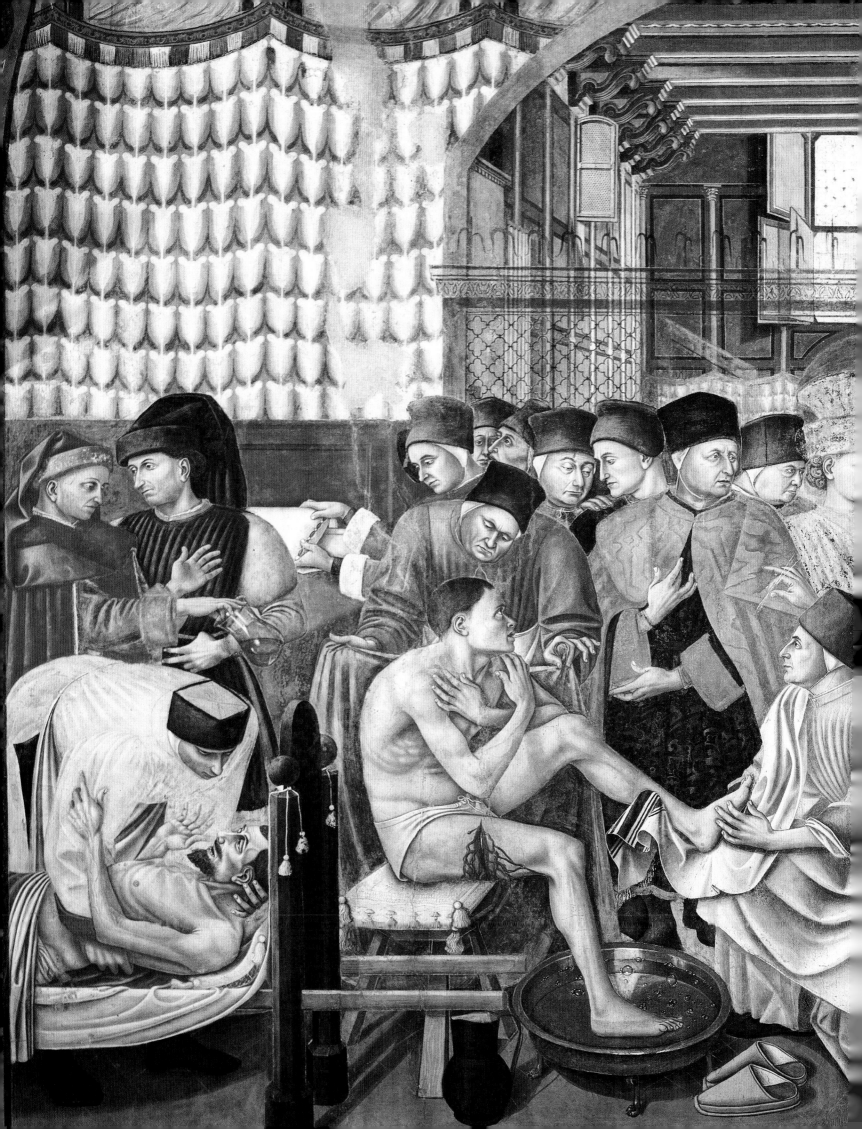

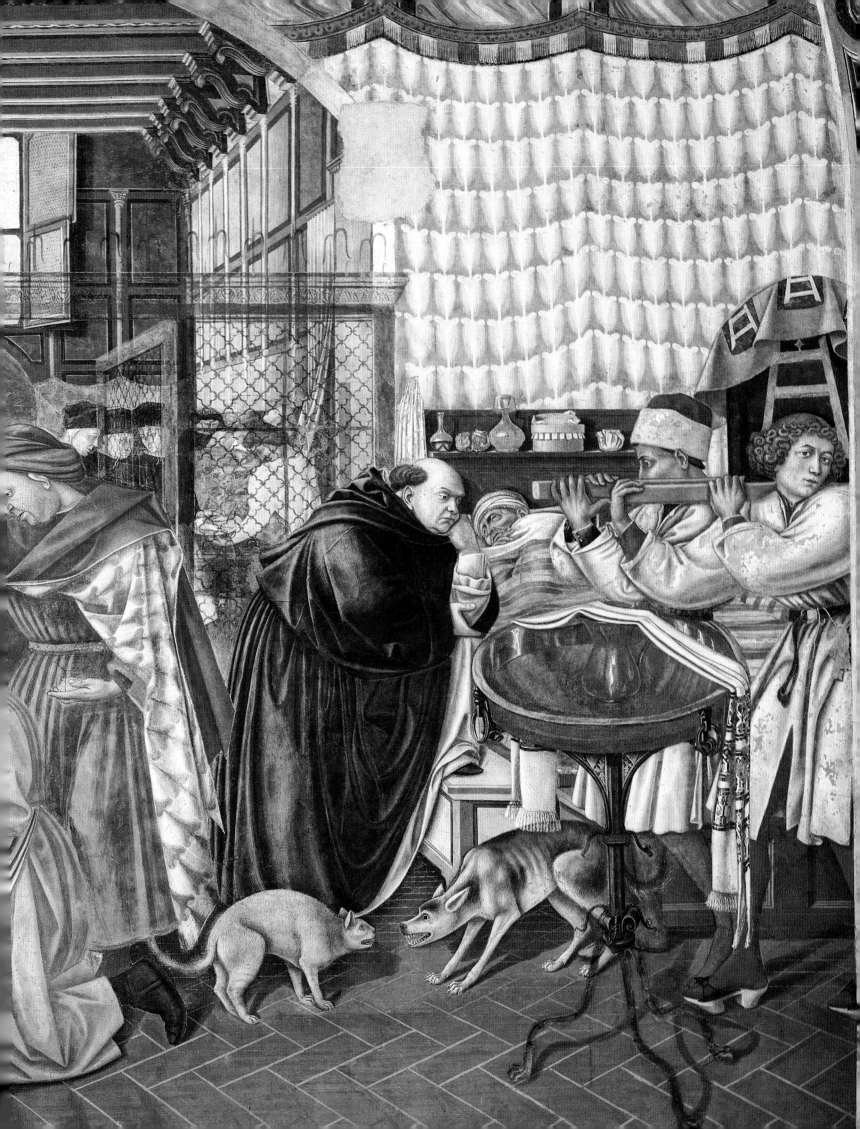

THE DUTIES OF SOCIETY

In St Matthew's gospel Jesus describes those who will inherit the kingdom of God as sitting at the right hand of the Lord, explaining why they were chosen: "For I was an hungred, and ye gave me meat; I was thirsty, and ye gave me drink; I was a stranger and ye took me in; Naked and ye clothed me; I was sick, and ye visited me; I was in prison, and ye came unto me" (Matthew 25.35–36). From this developed the idea of the Seven Acts of Mercy – although Jesus only mentions six (the burial of the dead became one of the acts in the Middle Ages). Jesus makes the charitable relevance of these acts explicit: "Inasmuch as ye have done it unto one of the least of these my brethren, ye have done it unto me" (Matthew 25.40). Different institutions were founded to perform some or all of these deeds, and charitable acts were included among the duties of members of confraternities such as the Venetian *scuole*. The Seven Acts also laid the foundations for some of our own institutions, such as hospitals.

The Ospedale della Scala in Siena was founded in 1090 to care for pilgrims on their way to Rome. As an increasingly wealthy charitable institution, it also started to treat the sick, and to care for orphans. The hospital was named after a steep staircase – or *scala* – which ran from the entrance of the hospital to the cathedral square, and its symbol is a ladder, also *scala* in Italian. This was interpreted as a route to heaven, particularly in the light of a medieval legend that the institution had been founded after a dream in which the souls of the "innocents" (the orphans) climbed a ladder to heaven.

The main ward of the hospital was decorated with frescoes by leading Sienese artists. It is an unusual cycle as it is not drawn from Christian stories or classical mythology, but is, like Ambrogio Lorenzetti's *Allegories of Good and Bad Government* (see pages 113 and 178–181), an example of the Sienese belief in the power of art to instruct and inform. It is also unusual in that it gives us an insight into the way in which the less fortunate members of society – the poor, needy, and sick – might hope to be treated.

▶ THE CARE AND TENDING OF THE SICK
Domenico di Bartolo, 1443 (OSPEDALE DELLA SCALA, SIENA)

Domenico's fresco is one of a cycle of paintings which, unusually, illustrates an imaginative history of the hospital on one wall, with its duties and responsibilities opposite. Other scenes include the distribution of alms – feeding the hungry and clothing the naked – and the arrangement of marriages for the orphans who had been brought up by the institution.

❶ The physician's task was to investigate sicknesses, which were believed to result from imbalances between four humours in the body: blood, phlegm, melancholy and choler. Medical ideas were still based on the writings of the classical physicians Hippocrates and Galen. Diagnosis was carried out from the appearance of saliva, faeces and urine (which is what we see here), and by other physiological symptoms such as pain or swelling – these may be characterized by the man on the stretcher below the physician.

four: *see pages 58–61;* **ladder:** *see page 43;* **Last Supper:** *see pages 122–123;* **pomegranate:** *see page 38;* **scuole:** *see page 177;* **sumptuary laws:** *see pages 87–88, 184 and 200*

❹ At the centre of a group of men with similar modest black hats (the lay friars responsible for the running of the hospital), is the rector, marked out by his rich black robes with fur-trimmed sleeves beneath a buff-coloured cloak. Between the rector and the surgeon is a visitor, a nobleman with far more extravagant headgear.

❺ The kitchens are next to the ward. Patients were prescribed specific diets, and servants were required to wash their hands before delivering the food.

❻ A monk is listening to the confession of a dying man: as well as the physical well-being of the patients, the hospital also attended to their spiritual health. Above the head of the patient are brilliantly observed still-life details, including a pomegranate split in half, a symbol of resurrection and therefore hope for the dying man.

❼ The hospital was also responsible for burying the dead. The coffin and the cloth over it bear the emblem of a ladder – the *scala* – which can also be seen in the frieze at the top of the wall.

❷ The friar is washing this man's feet – not just for reasons of hygiene, but also as an act of humility. Christ performed the same deed at the Last Supper, a ritual which is still performed during Maundy Thursday celebrations. The patient's slippers have been placed on the floor next to the brass bowl.

❸ The surgeon holds a needle with which to sew up the wound of the man whose feet are being washed. Surgery was seen as one of two distinct branches of medicine. The statutes of the hospital, written in 1318, stated that "This hospital must have at its own expense two doctors, that is one physician and the other a surgeon, and one pharmacist, who should be friars of this hospital, with appropriate salaries so that they will care for the sick gladly and graciously."

DEATH & ETERNITY

Although today we try to avoid thinking about and discussing death, in earlier days such denial was impossible. Life expectancy was far shorter, and infant mortality rates were high. Although each individual death would have been no less tragic, there was at least the comfort to be had from the religious belief that death was not the end, but a transition to the afterlife. The question was where you would spend eternity – in heaven or hell. It was important to be mindful of the hereafter because the way you lived your life determined your fate after death: it meant living for others as much as for yourself, and spending your money more for the glory of God and in charitable deeds than for your own pleasure.

"All you that do this place pass bye, Remember death for you must dye. As you are now even so was I, And as I am so shall you be. Thomas Gooding here do staye, Wayting for God's Judgement Daye."

Memorial tablet, Norwich Cathedral, ca. 1600

Preparations for accommodation after death were in some cases as elaborate as buildings were during life, and the wealthy and wise would pay handsomely for the decoration of chapels to guarantee a suitable burial place for themselves and their families. Ghirlandaio's fresco cycle of the Life of St Francis, for Francesco Sassetti (see pages 196–199), and Titian's altarpiece for the Pesaro family (see page 185) are the results of such preparations, as, for that matter, are Brunelleschi's Old Sacristy and Pazzi Chapel.

However, in some cases preparations could not be made. The Portuguese cardinal Prince James of Lusitania died in Florence in 1459 while he was still young. Cousin of the king of Portugal, and brother of the empress of Austria, it was decided a fitting burial place should be constructed in Florence, even though he had only been passing through. The resultant structure (see opposite) remains one of the best and most complete collaborative works of the Renaissance.

The chapel was built onto the church of San Miniato, in the hills just outside Florence. It was designed by a pupil of Brunelleschi, Antonio Manetti, but as he died in the year after the cardinal his input to the project must have been limited. Responsibility for the construction of the chapel passed to Giovanni Rossellino, while the sculpture was commissioned from Giovanni's brother Antonio. As well as the sarcophagus with its effigy of the deceased, this also included two kneeling angels (only one is visible here), and a relief of the Madonna and Child, who are depicted in a garland supported by two more angels – they could also be imagined as looking through a window. Opposite the tomb there is a marble throne, representing the cardinal's royal status. The work was not all executed by Antonio Rossellino himself, but was the product of his extensive workshop, which included master sculptors such as his elder brother Bernardo.

The altarpiece, with the cardinal's name-saint James in central position, was also a collaborative work, painted by Antonio and Piero del Pollaiuolo in tempera on panel. They also painted – in fresco – the two angels pulling back the curtains. The chapel is square, with an arched recess on each side, the entrance to it being through one of the four arches. There are round windows above the altarpiece and above the throne, and these are echoed by the garland around the Madonna and Child. Above the throne there is a painting of the Annunciation, again in tempera on panel, by Alesso Baldovinetti, who also frescoed the saints and prophets in the spandrels. The ceiling, depicting the Holy Spirit and the four cardinal virtues was executed in glazed terracotta by Luca della Robbia (see page 111), while the floor is made of a geometrical mosaic of stones referred to as cosmatesque.

Annunciation: *see pages 48 and 80–81;* **Brunelleschi:** *see page 26;* **cardinal virtues:** *see pages 110–112;* **four:** *see pages 58–61;* **glazed terracotta:** *see page 25;* **Madonna and Child:** *see pages 214–215;* **Old Sacristy:** *see page 213;* **Pazzi Chapel:** *see page 137;* **spandrels:** *see page 121;* **square:** *see page 137;* **symmetry and harmony:** *see pages 58–61, 137 and 146*

Thus the physical structure of the chapel consisted of a remarkable and consistent collaboration between architects, sculptors and painters, involving the workshops of at least two of each, using a wide range of different techniques. But the construction of the chapel would also have involved the endowment of money to enable requiem masses to be said, as well as the provision of chalices, candlesticks, vestments and so on. Even if the chapel is surprisingly well preserved, we see only an empty shell unless we witness it "coming to life" when it is put to use during the liturgy.

GOD & MAN

The reminder that death comes to us all is also present in this fresco. At its base a skeleton lies on a sarcophagus, above which is a verse referring to the inevitability of death. In the top section the death of Christ is witnessed not only by Mary, his mother, and John the Evangelist, but also by two kneeling donors. The Cross is supported by God the Father who stands on a structure which has three panels similar to those on the sarcophagus below: this is an image of Christ's own sarcophagus. Our death, that of an ordinary human represented by the skeleton, is compared to that of Christ, through whose crucifixion there is the possibility of our salvation, and of an afterlife with him in heaven.

Masaccio combines a number of images. The Crucifixion is combined with the Trinity, in a form known as the "Throne of Mercy", in which God the Father would usually be seated. It is also shown as a standard "Calvary", with Mary and John beside the Cross. The tradition that Christ was crucified directly over the burial place of Adam is expressed by the presence of the skeleton, which can also be seen as the decayed corpse of the donor, whose identity has not been established with any certainty. However, records show that there was originally a tomb slab dated 1426 in front of the fresco with the name Domenico Lenzi: it may be that Masaccio has painted portraits of Lenzi and his wife kneeling in attendance outside the imaginary chapel.

❍ TRINITY (with detail, opposite)
Masaccio, ca. 1425 (S. MARIA NOVELLA, FLORENCE)

The survival of Masaccio's fresco is in some ways surprising. Vasari installed an altarpiece in front of it in 1570, the frame damaging the edges of the fresco and the area between the upper and lower sections. In 1860–1861 Vasari's altarpiece was removed, and the upper section of the fresco detached from the wall, leaving some of the painted entablature in place. The lower section, with the skeleton, was still hidden behind the altar. The detached section was installed inside the façade of the church only to be returned to its original location in 1952.

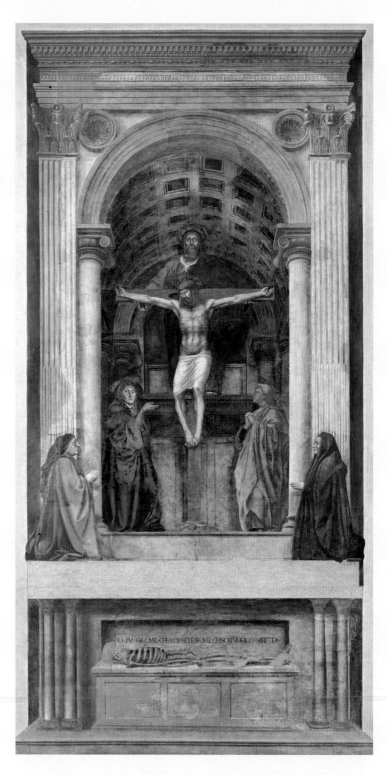

Adam's skull: *see page 126;* **church of Santa Maria Novella:** *see pages 82–83;* **Crucifixion:** *see pages 126–127;* **entablature:** *see page 28;* **Holy Trinity:** *see page 96;*
St John the Evangelist: *see pages 106 and 123;* **Vasari:** *see pages 15 and 16*

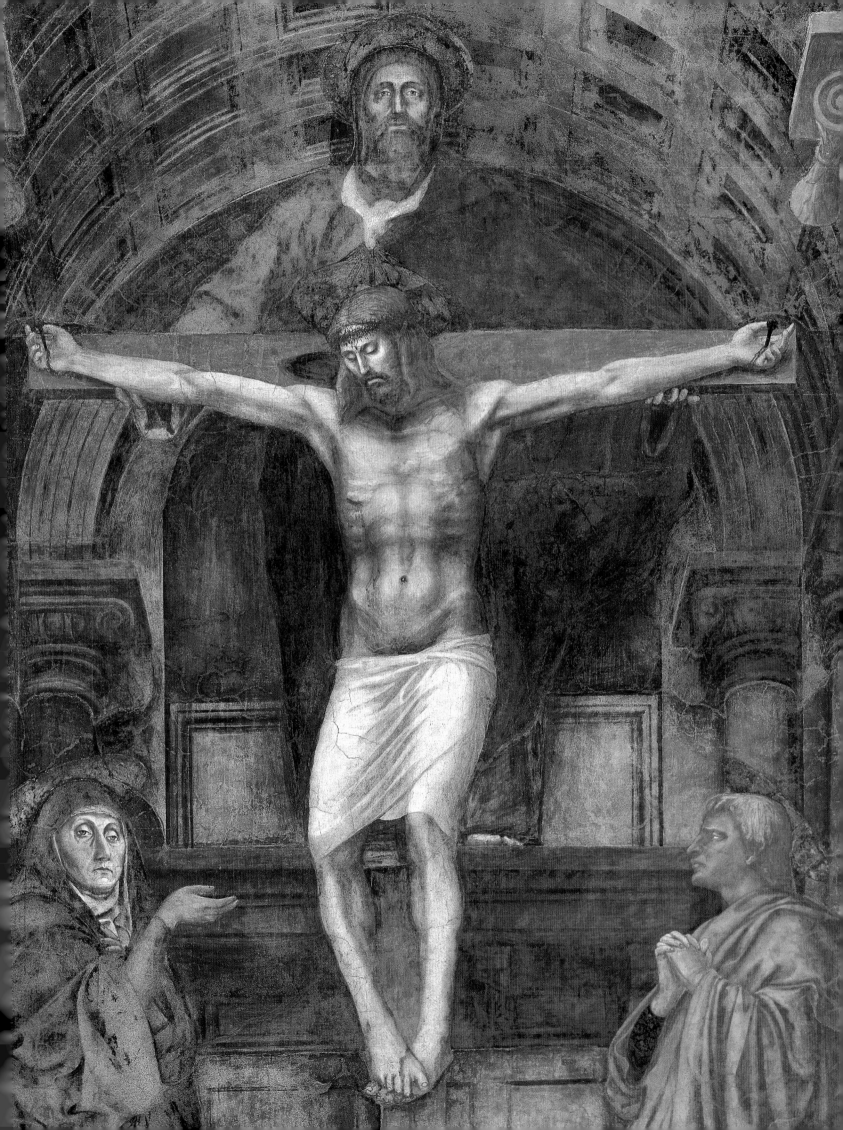

❶ God the Father, like Jesus, is seen frontally. His shoulders are framed by the arch at the back of the chapel, and his head stands out in front of the vaulted ceiling – it is at the same level as the Ionic capitals of the columns supporting the entrance arch. Below his bearded face is the Holy Spirit, in the form of a dove, flying above Jesus' head.

❷ Mary looks at us and gestures toward Christ with an expression of suppressed grief. This engages our attention and gives us an emotional empathy with the painting.

❸ God the Father is standing on a red cornice which adorns the top of a large stone sarcophagus within the imaginary chapel. The sides of this sarcophagus are hidden behind Mary and John, which adds to an uncertainty about his position and also to the mysterious nature of the representation. The heads of Mary and John are on this level, which also coincides with Jesus' knees.

❹ Although the donors are the same size as the holy figures, they are kneeling outside the imaginary chapel – like us, they are human, and so are in the same space as us. They kneel on a level with the vanishing point, but their heads are at the level of Jesus' feet: their eye level is at the same position that Masaccio places the vanishing point in his Pisa Altarpiece (see page 55).

❺ The skeleton appears to be lying on a sarcophagus projecting from the wall. The verse above it is written in Italian, rather than the standard Latin, to drive its message home: "I was once what you are now, and what I am you will become."

❻ The chapel is framed by Corinthian pilasters which support a classical entablature. In the spandrels the circular *paterae* are designed as if seen from below.

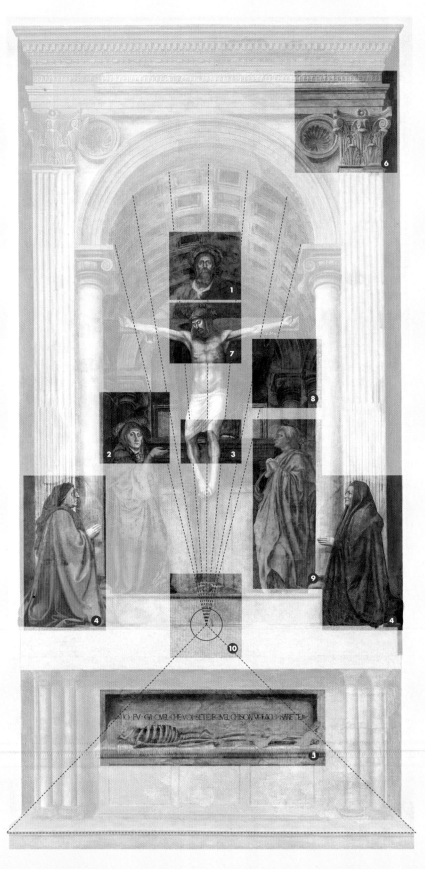

❼ Our eye level is below the foot of the Cross, but we do not seem to be looking up to Jesus' face. It is as if we are directly in front of him. There are two points of view in the painting. The architecture is seen from our point of view, and is imagined as being in our space (with the exception of the arches, which are not foreshortened as they should be). However, the figures of the Trinity are seen straight on, as if we are floating nine or ten feet above the ground. This gives us a sense of being taken out of the world: a feeling of spiritual uplift.

❽ The chapel has a coffered barrel vault, supported at front and back by a red marble arch resting on Ionic columns, and along the sides by a red entablature, also supported by columns.

❾ Both Mary and John are standing within the physical space of the imaginary chapel, which can be reconstructed because of the precision of the perspective. However, the viewpoint means that we cannot see their feet: although they are apparently the same size as the donors, we cannot "measure" them, as we cannot tell exactly where they are. Thus Masaccio subtly puts them at a slight remove, and emphasizes their holy status.

❿ The vanishing point is, roughly speaking, at our eye level. This is how we would see the chapel if it was a real extension to the church, making the characters in it more accessible: the space in which the holy figures are located is continuous with the space we are in. Just above the vanishing point is a small mound of earth in which the Cross is buried. This represents Calvary, the hill on which Jesus was crucified.

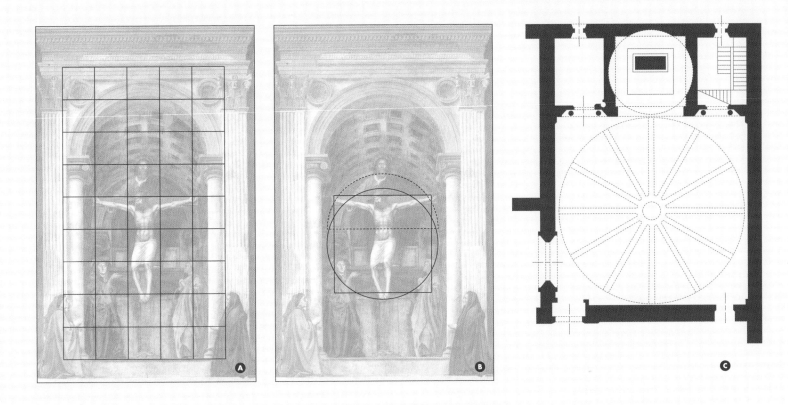

Masaccio's *Trinity* is the earliest surviving fresco that includes a coherent single-point perspective (and in all probability it was the first to be painted). The technique was developed by Brunelleschi roughly a decade before, and first described a decade later in Alberti's *On Painting*. The existence of this painting suggests that Alberti's ideas were derived in part from works he had seen. Alberti was later to recommend "someone who admonishes and points out what is happening there; or beckons with his hand to see", something like the chorus in a Greek tragedy. He may well have been thinking about Masaccio's depiction of Mary when he wrote this. Similarly, he recommends that a figure in the painting should be divided into three, and that the base of the painting should be divided into "as many parts as it will receive". Diagram A (see above, left) shows that the figure of Christ is three units tall, and that this unit is used as a module for the whole painting.

This structure gives the image its extraordinary order and balance. What is truly remarkable is that not only does the perspective work to create a coherent, imaginary room in three dimensions, with the figures all placed within that space, but the painting is also clearly structured as a pattern on a two-dimensional surface – and all this was achieved in what was probably the first attempt. As well as being divided into three by height, Jesus' outstretched arms also encompass three units: the body is contained within a square (three by three), in a manner similar to that suggested by Vitruvius, and illustrated by Leonardo some sixty years later (see page 56). Christ is also seen in relationship to the semi-circle of the arch at the back of the chapel – emphasized in Diagram B (see above, centre) by a dotted line – which is not foreshortened as it should be from this point of view. If a circle of the same diameter is centred on Christ, it encloses the parts excluded by the square. The combination of circle and square is relevant: symbolic of heaven and Earth, they show Christ to be both God and man – as man, dying for our sins, and as God, promising life everlasting.

The fact that it was Brunelleschi who developed single-point perspective, and that Masaccio has used Brunelleschian architecture, might suggest collaboration between the two. In this context it is worth looking again at the architect's Old Sacristy (see Diagram C; above, right). While the body of the chapel is a square with a circular dome above it – heaven above Earth – the chancel has curved niche-like walls: the same overlapping of circle and square that we see in the *Trinity*. It is in the chancel that Mass is performed, and with the Elevation of the Host the bread becomes the body of Christ. Jesus, as God and man, is again present on Earth.

Alberti: *see page 15;* **architectural orders:** *see pages 28–29;* **Brunelleschi:** *see page 26;* **circle and square:** *see page 137;* **grief:** *see pages 76–77;* **heaven and Earth:** *see pages 136–143;* **Leonardo da Vinci:** *see page 6;* **man as a measure:** *see page 15;* **perspective:** *see pages 52–55;* **spandrels:** *see page 121;* **transubstantiation:** *see page 134;* **vernacular:** *see page 12*

THE PROMISE OF ETERNITY

Cosmè Tura's *Virgin and Child* (see opposite) embodies many of the ideas that have been discussed in this book. Although the work of a single artist, it is also collaborative as the frame, even if designed by Tura, would have been executed by another skilled craftsman, a carpenter. Within the carved, wooden frame is another, painted one. It is pink, and the inside of the frame can be seen brilliantly illuminated on the right, and in shadow at the top, but not on the left: it is like a window through which we look, our viewpoint being from the lower left, and is reminiscent of Alberti's advice that he starts a painting by drawing a rectangle "which is considered an open window through which I see what I want to paint." To enhance this sense of realism, the Madonna and Child project into our space, Mary's draperies interrupting the painted frame on the right, and falling over it at the

♥ PIETA
Michelangelo, 1498–1499 (ST PETER'S, ROME)

The beauty and delicacy of this sculpture can disguise some of Michelangelo's intended meaning. One of the first inconsistencies to strike people is that Mary appears incredibly young – but then she often does. The reason for this can be found in the doctrine of the Immaculate Conception (one of the most misunderstood aspects of Catholicism), which concerns the conception of Mary by her mother Anna, rather than Mary's conception of Jesus. It was believed that Mary was conceived "without a mark", or "immaculate" – in other words, free from the stain of Original Sin. Being without sin she would not have grown old and died, but would have appeared the same as when she gave birth to Christ, which was commonly believed to have been when she was fifteen. From this doctrine follows the idea of the Assumption of the Virgin – rather than growing old and dying, Mary was taken up to heaven.

It is also not immediately clear that Mary is much larger than Christ. This is not Michelangelo getting the proportions "wrong", but altering them to suit his needs: the image is far more contained and harmonious as a result. Any larger and Christ's body would look ungainly and project awkwardly on each side. The resizing also stresses Mary's maternal role. In the same way that Tura's *Virgin and Child* looks forward to Christ's death, Michelangelo's *Pietà* looks back, and reminds us that this was the little baby she had held on her lap, thus heightening her grief.

● VIRGIN AND CHILD
Cosmè Tura, ca. 1453 (ACCADEMIA, VENICE)

bottom: she is effectively seated on the window sill. The illusionism is such that Tura can play games: the Madonna's veil lies across Christ's halo, which is conceived as a solid object floating above his head. In the lunette at the top of the painting, two angels hold the name of Jesus. The abbreviation "IhS", with the "h" turned into a cross, is ringed by tongues of fire – it was in exactly this form that Bernardino of Siena would have displayed it, suggesting perhaps that this painting was originally located in a Franciscan church.

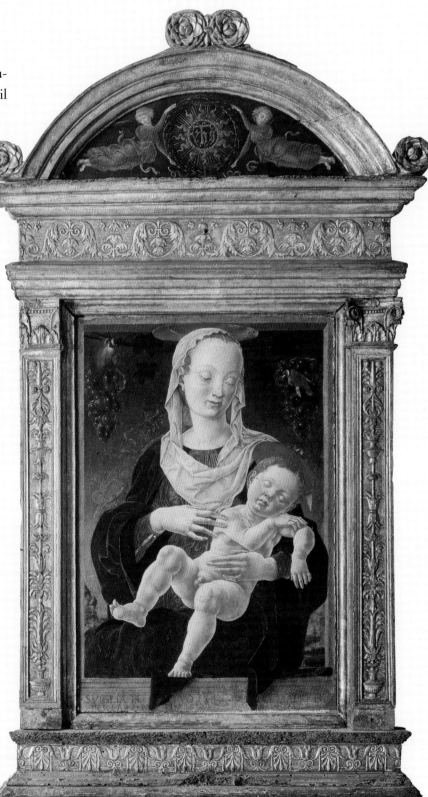

The still-life details in the background are symbolic, the grapes referring to Jesus' blood, and the goldfinch at the top right a reminder of his suffering – although the precise implications of the wood creeper at the top left are still not clear. Behind Mary, framing her shoulders, a delicate gold decoration illustrates the signs of the zodiac, identifying her as queen of heaven. Virgo, the Virgin, and clearly the sign with which she was most associated, appears prominently above her right elbow. The Christ Child is asleep, although his left hand hangs down as if he were dead, and Mary touches him with her right hand. The verse apparently inscribed on the windowsill can be translated "Waken your son, sweet holy mother, to make my soul happy at last."

The implication is not just that the viewer will be overjoyed by seeing the Christ Child awaken. The similarity of this painting with Michelangelo's celebrated *Pietà* (see opposite) is not coincidental. For Mary, and so also for us, the sight of her sleeping baby is a reminder of his future death, which is also foretold by the grapes and goldfinch at the top of the painting. However, the fact that the sleeping baby will wake, reminds us that the death of Christ was followed by his resurrection. This should provide comfort for us all; given the inevitability of death, we are also promised life everlasting.

Alberti's "open window": *see page 15;* **Assumption of the Virgin:** *see page 140;* **astrology:** *see page 142;* **St Bernardino of Siena:** *see page 41;* **distorted representations of the human form:** *see pages 20–21;* **St Francis:** *see pages 46, 76, 78 and 108;* **grapes:** *see page 38;* **IhS:** *see page 41;* **illusionism:** *see pages 39, 172 and 190*

INDEX

▶ VIRGIN AND CHILD
Cosmè Tura, ca. 1453 (ACCADEMIA, VENICE)

bottom: she is effectively seated on the window sill. The illusionism is such that Tura can play games: the Madonna's veil lies across Christ's halo, which is conceived as a solid object floating above his head. In the lunette at the top of the painting, two angels hold the name of Jesus. The abbreviation "IhS", with the "h" turned into a cross, is ringed by tongues of fire – it was in exactly this form that Bernardino of Siena would have displayed it, suggesting perhaps that this painting was originally located in a Franciscan church.

The still-life details in the background are symbolic, the grapes referring to Jesus' blood, and the goldfinch at the top right a reminder of his suffering – although the precise implications of the wood creeper at the top left are still not clear. Behind Mary, framing her shoulders, a delicate gold decoration illustrates the signs of the zodiac, identifying her as queen of heaven. Virgo, the Virgin, and clearly the sign with which she was most associated, appears prominently above her right elbow. The Christ Child is asleep, although his left hand hangs down as if he were dead, and Mary touches him with her right hand. The verse apparently inscribed on the windowsill can be translated "Waken your son, sweet holy mother, to make my soul happy at last."

The implication is not just that the viewer will be overjoyed by seeing the Christ Child awaken. The similarity of this painting with Michelangelo's celebrated *Pietà* (see opposite) is not coincidental. For Mary, and so also for us, the sight of her sleeping baby is a reminder of his future death, which is also foretold by the grapes and goldfinch at the top of the painting. However, the fact that the sleeping baby will wake, reminds us that the death of Christ was followed by his resurrection. This should provide comfort for us all: given the inevitability of death, we are also promised life everlasting.

Alberti's "open window": *see page 15;* **Assumption of the Virgin:** *see page 140;* **astrology:** *see page 142;* **St Bernardino of Siena:** *see page 41;* **distorted representations of the human form:** *see pages 20–21;* **St Francis:** *see pages 46, 76, 78 and 108;* **grapes:** *see page 38;* **IhS:** *see page 41;* **illusionism:** *see pages 39, 172 and 190*

CHRONOLOGY

313	Emperor Constantine legalizes Christianity within the Roman Empire
330	Constantine moves the centre of the Roman Empire to Byzantium and renames the city Constantinople
800	Pope Leo III appoints Charlemagne first Holy Roman Emperor
1204	Sack of Constantinople by the Venetians
1228	Canonization of St Francis of Assisi
1234	Canonization of St Dominic
1250	Guilds establish the first *popolo* in Florence
1260	Fall of the first *popolo*
1283	Second *popolo* established in Florence
1294	Work begins on Florence cathedral
1297	In Venice the *serrata* restricts membership of the Grand Council to selected families
1305	Giotto completes decoration of the Scrovegni Chapel in Padua
1308–21	Dante writes *The Divine Comedy*
1309	Papacy takes up residence in Avignon
1342	Collapse of the Bardi and Peruzzi banks in Florence
1347–48	Black Death ravages Italy
1350s	Boccaccio finishes *The Decameron*
1378	Beginning of the Great Schism
1397	The Medici bank is founded in Florence
1401	Competition for the North Doors of the Baptistery in Florence
ca. 1415	Brunelleschi paints two panels demonstrating single vanishing-point perspective
1417	Election of Pope Martin V ends the Great Schism
1434	Cosimo "il Vecchio" de' Medici returns to Florence after a year in exile. For the next sixty years the Medici are the unofficial rulers of Florence.
1435	Alberti publishes *De Pictura* ("On Painting") in Latin, and soon after translates it into Italian
1436	The dome of Florence cathedral is completed – the lantern being added later
1438	An Ecumenical Council is held to try to unite the Catholic and Orthodox churches, without lasting success
1447–55	Reign of Pope Nicholas V, during which he founds the Vatican Library

1450	Canonization of St Bernardino of Siena
1452	Alberti finishes writing *De Re Aedificatoria*
1453	Fall of Constantinople to the Ottoman Empire
1465	First printing press in Italy established near Rome
1468	Cardinal Bessarion bequeaths his library to the Venetian state
1471–84	Reign of Francesco della Rovere as Pope Sixtus IV
1473	Leonardo da Vinci produces the earliest known landscape drawing to survive
1477–81	Building of the Sistine Chapel
1478	Pazzi Conspiracy fails in its aim to depose the Medici
1494	Charles VIII of France invades Italy and attempts to occupy Florence
1494	Medici expelled from Florence
1495	Charles VIII defeated at the Battle of Fornovo
1497	Savonarola institutes the "Bonfire of the Vanities" in Florence
1498	Execution of Savonarola
1503–13	Reign of Giuliano della Rovere as Pope Julius II
1506	Bramante starts the construction of the new basilica of St Peter in Rome
1512	Medici return to power in Florence
1513–21	Reign of Giovanni de' Medici as Pope Leo X
1517	Martin Luther nails a list of ninety-seven complaints to the doors of Wittenberg cathedral, a key point in the development of the Reformation
1527	Sack of Rome by Charles V's army
1527	Medici expelled from Florence
1528	Publication of the *The Book of the Courtier* by Baldassare Castiglione
1530	The definitive return to power in Florence of the Medici: their rule lasts until the 18th century
1543	Publication of *On the Revolution of Heavenly Orbs* by Copernicus
1550	Publication of *The Lives of the Artists* by Vasari
1570	Publication of *Four Books of Architecture* by Palladio
1571	Spanish and Venetian fleets defeat the Ottomans at the Battle of Lepanto
1860	Jacob Burckhardt writes *Die Kultur der Renaissance in Italien* – the book which introduced the term "Renaissance" into common usage

FURTHER READING

Of the "primary sources" the most important is undoubtedly the Bible – all of the quotations in this book are from the King James version. Of the Italian books that are referred to, the following are the most important:

– Alberti, Leon Battista. *On Painting*. Trans. John R. Spencer. Yale University Press: New Haven and London, 1966.

– Castiglione, Baldassare. *The Book of the Courtier*. Trans. George Bull. Penguin Classics: Harmondsworth, 1967.

– Cennini, Cennino. *The Craftsman's Handbook*. Trans. Daniel V. Thompson Jr. Dover Publications: New York, 1933.

– Vasari, Giorgio. *The Lives of the Artists*. A selection, 2 vols. Trans. George Bull. Penguin Classics: Harmondsworth, 1965.

There are many different ways of thinking about the Italian Renaissance. Each of these books considers the topic from a different point of view. Although written more than a century ago, Burckhardt's book is still one of the best introductions, and Hall's dictionary is invaluable for understanding art in general – not just the Renaissance!

– Baxandall, Michael. *Painting and Experience in Fifteenth-Century Italy*. Oxford University Press: Oxford, 1985.

– Burckhardt, Jacob. *The Civilization of the Renaissance in Italy*. Penguin Classics: Harmondsworth, 1990.

– Burke, Peter. *The Italian Renaissance: Culture and Society in Italy*. Polity Press: Cambridge, 1999.

– Campbell, Gordon. *Renaissance Art and Architecture*. Oxford University Press: Oxford, 2004.

– Cole, Alison. *Art of the Italian Renaissance Courts*. Everyman Art Library: London, 1995.

– Fortini Brown, Patricia. *The Renaissance in Venice*. Everyman Art Library: London, 1997.

– Hall, James. *Dictionary of Subjects and Symbols in Art*. John Murray: London, 1994.

– Jardine, Lisa. *Worldly Goods: A New History of the Renaissance*. Papermac: London, 1997.

– King, Margaret L. *The Renaissance in Europe*. Laurence King Publishing: London, 2003.

– Paoletti, John T. and Radke, Gary M. *Art in Renaissance Italy*. 3rd edition. Laurence King Publishing: London, 2005.

– Summerson, John. *The Classical Language of Architecture*. Thames and Hudson: London, 1980.

– Syson, Luke and Thornton, Dora. *Objects of Virtue*. British Museum Press: London, 2001.

The following are not only some of the best guide books you can read, but also have a thorough grounding in art history:

– Borsook, Eve. *The Companion Guide to Florence*. Companion Guides, Boydell & Brewer: Woodbridge, Suffolk (UK), 2001.

– Honour, Hugh. *The Companion Guide to Venice*. Companion Guides, Boydell & Brewer: Woodbridge, Suffolk (UK), 2001.

For anyone wanting to take the subject even further, there are numerous monographs on individual artists. These are some that were particularly useful when writing this book, although you may have to seek them out in libraries or second-hand bookshops:

– Gould, Cecil. *Leonardo: The Artist and the Non-Artist*. New York Graphic Society: Boston, 1975.

– Janson, H. W. *The Sculpture of Donatello*. Princeton University Press: Princeton, 1957.

– Joannides, Paul. *Masaccio and Masolino*. Phaidon: London, 1993.

– Lightbown, Ronald. *Sandro Botticelli: Life and Work*. Abbeville Press: New York, 1989.

– Lightbown, Ronald. *Mantegna*. Phaidon/Christie's: Oxford, 1986.

INDEX

ACKNOWLEDGMENTS

The publisher would like to thank the following people, museums, and photographic libraries for permission to reproduce their material. Every care has been taken to trace copyright holders. However, if we have omitted anyone we apologize and will, if informed, make corrections to any future edition.

Key

AA The Art Archive, London
BAL The Bridgeman Art Library, London
NG The National Gallery, London
Scala Scala Archives, Florence
V&A V&A Images/Victoria and Albert Museum, London

l = left, r = right, a= above, b = below

Endpapers Accademia, Venice/Scala; **2–3** Detail of p.4; **4** NG; **7** Louvre, Paris/Scala; **9** Accademia, Venice/Scala; **10** Uffizi, Florence/Scala; **13** Duomo, Florence/Scala; **14** Bodleian Library, Oxford/AA; **15** Bargello, Florence/Scala; **17** Scrovegni Chapel, Padua/Scala; **18** Uffizi, Florence/Scala; **19** Uffizi, Florence/Scala; **20** Uffizi, Florence/Scala; **21** Uffizi, Florence/Scala; **22(l)** Bargello, Florence/Scala; **22(r)** Bargello, Florence/Scala; **24** V&A; **25** Bargello, Florence/Scala; **27** Florence/Scala; **28(l)** Vicenza/AA; **28(r)** Books and Periodicals Collections/RIBA Library, London; **29** Books and Periodicals Collections/RIBA Library, London; **30** The Vatican, Vatican City/Scala; **32** Statens Museum for Kunst, Copenhagen; **33** Kunsthistorisches Museum, Vienna/AKG-images, London; **34** NG; **36** Bargello, Florence/Scala; **37** NG; **38** Details of p.37; **39** Palazzo Ducale, Urbino/Scala; **40** The British Museum, London; **41** NG; **42** San Lorenzo, Florence/Scala; **43** V&A; **45** NG; **46** NG; **47** Uffizi, Florence/Scala; **48** Details of p.49; **49** NG; **50** Brancacci Chapel, Sta. Maria del Carmine, Florence/Scala; **53** Museo dell'Opera del Duomo, Florence/Scala; **54** Staatliche Museen zu Berlin/Bildarchiv Preußischer Kulturbesitz, Berlin; **55** NG; **56** Accademia, Venice/Scala; **57** S. Francesco, Arezzo/Scala; **58** Private Collection; **59** Museo di Capodimonte, Naples/Scala; **60** NG; **62** Details of p.63; **63** Arena Chapel, Padua/Scala; **64** S. Zaccaria, Venice/BAL; **65** Accademia, Florence/Scala; **66** The Royal Collection © 2006, Her Majesty Queen Elizabeth II; **67** The Royal Collection © 2006, Her Majesty Queen Elizabeth II; **69** National Gallery of Scotland, Edinburgh/BAL; **71** Uffizi, Florence/Scala; **72** Uffizi, Florence/Scala; **73** NG; **74** Chiesa del Carmine, Florence/Scala; **75** Bargello, Florence/Scala; **76** Sta. Maria della Vita, Bologna/Scala; **77** Sta. Maria della Vita, Bologna/Scala; **78** Details of p.79; **79** NG;

80 Private Collection; **81** Uffizi, Florence/Scala; **83** Florence/Profimedia.CZ s.r.o./Alamy; **84** The Metropolitan Museum of Art, Robert Lehman Collection, 1975. 1.1015 © 1998 The Metropolitan Museum of Art, New York; **85** NG; **86** Uffizi, Florence/Scala; **87** Uffizi, Florence/Scala; **88** Museo dell'Opera del Duomo, Florence/Scala; **89** NG; **90–91** NG; **91(a)** Palazzo Pitti, Florence/Scala; **92** Alberto Bruschi di Grassina Collection, Florence/BAL; **93** NG; **94** Chiesa del Carmine, Florence/Scala; **96** Details of p.97; **97** Sta. Maria sopra Minerva, Rome/BAL; **98** Bargello, Florence/Scala; **99** Bargello, Florence/BAL; **100** Palazzo Vecchio, Florence/Scala; **101** NG; **103** Accademia, Venice/Scala; **104** Uffizi, Florence/Scala; **105** Museo di Capodimonte, Naples/Scala; **106–107** NG; **110** V&A; **111** S. Miniato, Florence/Scala; **112** NG; **113** Palazzo Pubblico, Siena/Scala; **115** Villa Farnesina, Rome/AKG; **116** NG; **119** Baptistery, Florence/Scala; **121** NG; **122** Private Collection; **123** Sta. Maria della Grazie/Scala; **124–125** The Vatican, Vatican City/Scala; **125–126** Details of pp.124–125; **129** V&A; **130** Details of p.131; **131** Sta. Maria Novella/Scala; **132–133** The Vatican, Vatican City/Scala; **134–135** Details of pp.132–133; **136** Duomo, Florence/Scala; **137** Pazzi Chapel, Florence/Scala; **138–139** NG; **140–141** Details of pp.138–139; **142** Details of p.143; **143** Palazzo Schifanoia, Ferrara/BAL; **144** Museo Capitolino, Rome/Scala; **145(l)** Padua/Angelo Hornak, London; **145(r)** Boboli Gardens, Florence/Scala; **147** S. Pietro, Rome/Angelo Hornak, London; **148–149** The Vatican, Vatican City/Scala; **150–151** Details of pp.148–149; **152** Detail of p.153; **153(a)** NG; **153(b)** Details of p.153(a); **154–155** Uffizi, Florence/Scala; **156–157** Details of pp.154–155; **159** The Rijksmuseum, Amsterdam; **160** Details of p.161; **161** NG; **162–163** Louvre, Paris/BAL; **164–165** Details of pp.162–163; **166** Scala; **167** NG; **168** Biblioteca Laurenziana, Florence/Scala; **169** Biblioteca Laurenziana, Florence/Scala; **170–171** Scuola di S. Giorgio degli Schiavoni, Venice/Scala; **172–173** Details of pp.170–171; **175** The Vatican, Vatican City/Scala; **176** NG; **177** Scuola Grande di S. Rocco, Venice/Scala; **178–179** Palzzo Pubblico, Siena/Scala; **180–181** Details of pp.178–179; **182** Biblioteca Estense Modena/Dagli Orti/AA; **183** Florence/Scala; **185** Sta. Maria Gloriosa dei Frari, Venice/Scala; **186** Details of p.187; **188–189** Palazzo Ducale, Mantua/Scala; **190–191** Details of pp.188–189; **192** Biblioteca Ambrosiana, Milan/AKG-images, London; **193** NG; **194** Details of p.195; **195** Louvre, Paris/Scala; **196–197** Sta. Trinità, Florence/Scala; **198–199** Details of pp.196–197; **201** Accademia, Venice/Scala; **202** Details of p.203; **203** Florence/Alinari Archives, Florence; **204–205** Sta. Maria della Scala Hospital, Siena/AA; **206–207** Details of pp.204–205; **209** S. Miniato, Florence/Scala; **210** S. Giocanni, Florence/Scala; **211** Detail of p.210; **212** Details of p.210; **213** Private Collection; **214** The Vatican, Vatican City/Scala; **215** Accademia, Venice/BAL.

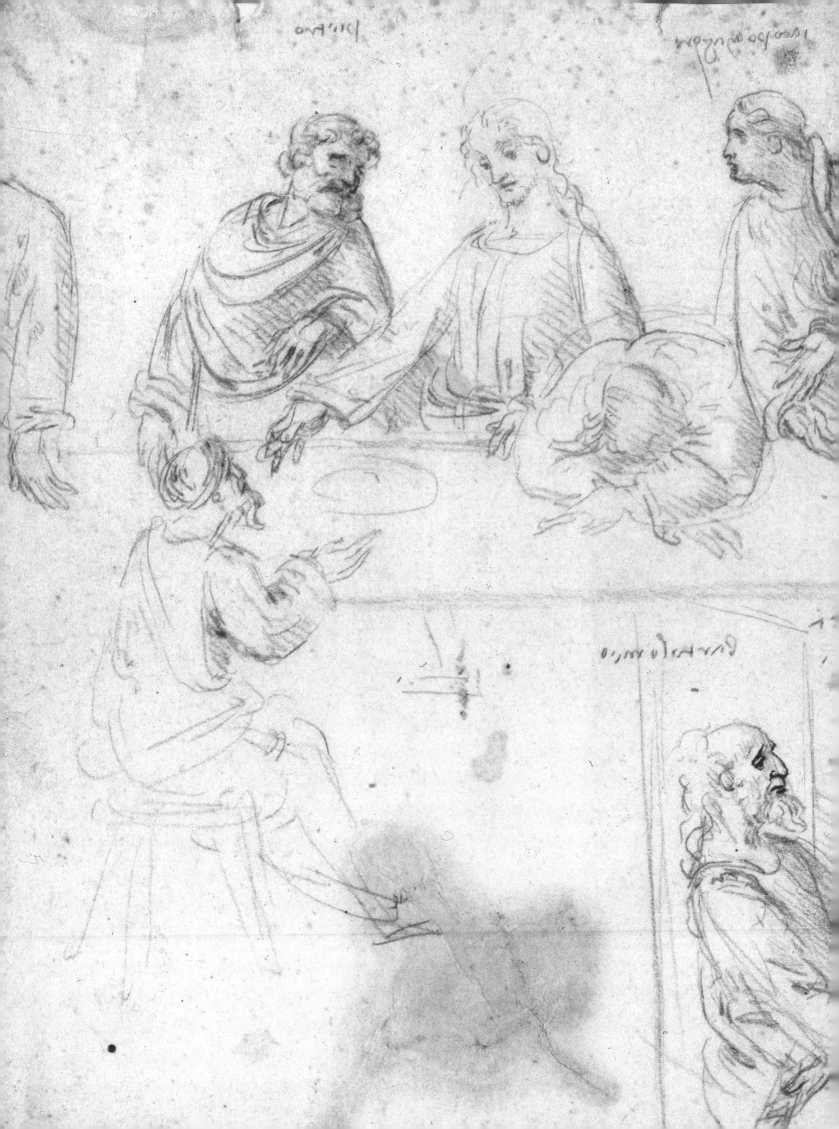